ΝΑΝΟ
ΚΟΣΜΟΣ

ΝΑΝΟ ΚΟΣΜΟΣ

Richard Jones

Μετάφραση: Παναγιώτα Σιετή

ΕΚΔΟΣΕΙΣ ΚΑΠΟΝ

Nano Nature
© Πρώτη έκδοση 2008: HarperCollins Publishers Limited
Κείμενα © Richard Jones 2008
Φωτογραφίες © ανήκει στους φωτογράφους

© 2009 Για την ελληνική έκδοση
Εκδόσεις Καπόν, Αθήνα, Ελλάδα

Επιμέλεια κειμένου: Ντιάνα Ζαφειροπούλου
Σύνθεση εξωφύλλου και καλλιτεχνική επιμέλεια: Emma Jern
Design: Marc Marazzi
Ευρετήριο: Ben Murphy
Παραγωγή: Keeley Everitt

ISBN 978-960-6878-13-8

ΕΚΔΟΣΕΙΣ ΚΑΠΟΝ
Μακρυγιάννη 23-27, 117 42 Αθήνα, τηλ./Fax: 210 9235098, 210 9214089
www.kaponeditions.gr e-mail: kapon_ed@otenet.gr

ΠΕΡΙΕΧΟΜΕΝΑ

Το βιβλίο ΝΑΝΟΚΟΣΜΟΣ παρουσιάζει στον αναγνώστη άγνωστες πτυχές της πολύπλοκης δομής και της ομορφιάς του φυσικού κόσμου μέσα από εικόνες που μόνον το ηλεκτρονικό μικροσκόπιο σάρωσης μπορεί να αποτυπώσει. Το μικροσκόπιο αυτό, τεχνολογικό επίτευγμα της εποχής μας, έχει τη δυνατότητα να μεγεθύνει ένα αντικείμενο μέχρι και 200.000 φορές και να δημιουργεί εναργείς εικόνες για απειροελάχιστα δείγματα ζωής που δεν είναι ορατά με γυμνό μάτι.

Οι εικόνες αυτές, μικρογραφήματα σουρεαλιστικής τέχνης, μας αποκαλύπτουν, σε συνδυασμό με τα επιστημονικώς τεκμηριωμένα κείμενα του Richard Jones, την απαράμιλλη ομορφιά και το μεγαλείο της φύσης.

Αυτήν ακριβώς την ομορφιά θελήσαμε να μοιραστούμε μαζί σας, γι' αυτό και αποφασίσαμε να εκδώσουμε το βιβλίο αυτό στην ελληνική γλώσσα. Οι δυσκολίες ήταν πολλές λόγω της ιδιαιτερότητας του θέματος. Ξεπεράστηκαν χάρη στην κ. Παναγιώτα Σιετή που ανέλαβε τη μετάφραση και στην κ. Ντιάνα Ζαφειροπούλου, υπεύθυνη για την επιμέλεια των κειμένων. Ιδιαίτερα χρήσιμες ήταν οι παρατηρήσεις του βιολόγου Γεωργίου Μαλάμη. Τους ευχαριστούμε όλους από καρδιάς.

ΜΩΥΣΗΣ ΚΑΙ ΡΑΧΗΛ ΚΑΠΟΝ

Το μέγεθος έχει σημασία. Διότι τόσο για τους τεράστιους όσο και για τους μικροσκοπικούς οργανισμούς το μέγεθος είναι άκρως καθοριστικός παράγοντας του σχήματος, της σύνθεσης και της δομής του σώματος. Σε γιγαντιαία φυτά και ζώα τα πάντα εξαρτώνται από το πόσο δυνατό είναι το οικοδόμημα πάνω στο οποίο στηρίζεται ο κορμός του δέντρου ή ο σκελετός του ζώου, ώστε να υπερνικήσουν τη βαρύτητα και να μείνουν όρθια, και ταυτόχρονα από το πόση ενέργεια απαιτείται ώστε να φτάσουν οι θρεπτικές ουσίες μέχρι τα τελευταία άκρα των φύλλων ή τις απολήξεις των άκρων. Οι ελέφαντες μπορούν να είναι τόσο μεγαλόσωμα ζώα, επειδή έχουν σχετικά τεράστια οστά ικανά να τους μεταφέρουν, ενώ οι γιγαντιαίες σεκόγιες δεν μπορούν να φτάσουν ψηλότερα, γιατί υπάρχει ένα όριο στην απόσταση μεταξύ κορμού και ριζών.

Οι άνθρωποι είμαστε κάτοικοι αυτού του μεγαλύτερου κόσμου. Ακόμα και τα πιο γιγαντιαία φυτά και ζώα του πλανήτη δεν είναι και τόσο πολύ μεγαλύτερα από εμάς. Τα βλέπουμε καθαρά, τα αγγίζουμε, τα αισθανόμαστε, τα μετράμε, ακόμα και τα χρησιμοποιούμε – έχουμε στενή σχέση και οικειότητα μαζί τους.

Στο άλλο άκρο του φάσματος των μεγεθών, η βαρύτητα φτάνει στο σημείο να μην έχει σχεδόν καμία σημασία για κάποιους μικροσκοπικούς οργανισμούς. Πώς αλλιώς θα μπορούσαν οι οικιακές μύγες να περπατούν ανάποδα στο ταβάνι; Η μεταφορά οξυγόνου, διοξειδίου του άνθρακα, θρεπτικών ουσιών στο σώμα και η αποβολή των περιττών, είναι εύκολο και σύντομο ταξίδι. Σε τούτο τον κόσμο υπάρχουν διαφορετικοί, παράξενοι, αλλόκοτοι περιορισμοί που αφορούν το μέγεθος και τη μορφή του σώματος πολύ μικρότερων πλασμάτων.

Χωρίς βοήθεια το ανθρώπινο μάτι μόνο μέχρι εδώ μπορεί να φτάσει. Να όμως που ακόμα και ο ταπεινός μεγεθυντικός φακός μάς αποκαλύπτει έναν θαυμαστό κρυφό κόσμο – αλλόκοτο και όμορφο – ενώ ένα οπτικό μικροσκόπιο μάς δείχνει ακόμα μεγαλύτερα θαύματα, αφού μας επιτρέπει να βλέπουμε με ευκρίνεια μία μία τις σμήριγγες πάνω σε κάθε ένα ξεχωριστά μέρος των εντόμων. Τώρα στο έσχατο σημείο της ανθρώπινης τεχνολογίας, το μικροσκόπιο ηλεκτρονικής σάρωσης μάς αποκαλύπτει έναν εκπληκτικό κόσμο απίθανων δομών και φανταστικών σχεδίων. Κάθε οικειότητα χάθηκε· γιατί τούτος είναι ένας εντελώς άλλος κόσμος, ο νανόκοσμος.

Στον νανόκοσμο μέγεθος, μορφή και δομή ελέγχονται σε επίπεδο μεμονωμένων κυττάρων ή ακόμα και μεμονωμένων μορίων. Εδώ λαμβάνουν χώρα διαδικασίες στα όρια της ανθρώπινης νόησης. Όπως ακριβώς τα πρώτα μικροσκόπια φανέρωσαν έναν ολόκληρο μικρόκοσμο σε μια σταγόνα νερό ή τη μικροδομή της άρθρωσης στο πόδι μιας μέλισσας, έτσι και το ηλεκτρονικό μικροσκόπιο σάρωσης μάς δίνει εικόνες απρόσμενων σχηματισμών που υπερβαίνουν κάθε φαντασία.

Οι εικόνες του ΝΑΝΟΚΟΣΜΟΥ, πιο σουρεαλιστικές από κάθε έργο τέχνης, πιο περίπλοκες από οτιδήποτε φτιάχτηκε από χέρι ανθρώπου, είναι εικόνες που μεταφέρονται από το υψηλής τεχνολογίας επιστημονικό εργαστήριο στην επικράτεια της δημοσιότητας. Οι φευγαλέες τούτες ματιές είναι τόσο εντυπωσιακές και πρωτοπόρες σήμερα όσο ήταν 150 χρόνια παλαιότερα οι πρώτες γκρο-πλαν έγχρωμες φωτογραφίες καραλλιογενών πολύποδων και αιμοσφαιρίων που συνάρπασαν τους Βικτωριανούς προγόνους μας.

Μικροσκόπιο ηλεκτρονικής σάρωσης

Σε αντίθεση με τα οπτικά μικροσκόπια, που χρησιμοποιούν φακούς για να εστιάσουν το φως στο παρατηρούμενο αντικείμενο, το ηλεκτρονικό μικροσκόπιο σάρωσης (SEM) χρησιμοποιεί μαγνητικά πηνία για να εστιάσουν μια λεπτή δέσμη ηλεκτρονίων στον στόχο. Η αντανάκλαση ορισμένων από αυτά τα ηλεκτρόνια προσπίπτει σε μια ευαίσθητη οθόνη, όπου μετατρέπεται σε ηλεκτρικά σήματα τα οποία αναλύονται ψηφιακά, ώστε να μετατραπούν σε εικόνα. Για να αυξηθεί η αντανακλαστικότητα και για να είναι καλύτερο το κοντράστ, το υπό παρατήρηση αντικείμενο πρέπει να συντηρηθεί με διαλυτικά και έπειτα να ψυχθεί και να ξηρανθεί για να στερεωθεί. Στη συνέχεια πρέπει να καλυφθεί με μια λεπτότατη μεταλλική στιβάδα, συνήθως από χρυσό ή λευκόχρυσο, που το πάχος της να είναι μόλις λίγα άτομα. Αυτό επιτυγχάνεται με τη λεγόμενη μέθοδο της ιοντοβολής: ηλεκτρικό ρεύμα περνά μέσα από το μεταλλικό ηλεκτρόδιο μέχρις ότου πυρακτωθεί και από την άκρη του αρχίζει να εκτοξεύεται μια βροχή ατόμων.

Σε αντίθεση με το φως, που ο άνθρωπος (και άλλα ζώα) το βλέπουν πολύχρωμο, οι εικόνες του ηλεκτρονικού μικροσκοπίου σάρωσης είναι μονόχρωμες. Και μολονότι αυτό μπορεί να εκπλήξει, μπορούν να βελτιωθούν εντυπωσιακά, εάν υποστούν χρωματική επεξεργασία. Η διαδικασία αυτή, ανάλογη με την καλλιτεχνική προσθήκη χρωμάτων σε φωτογραφίες σέπιας το πάλαι ποτέ, στις απαρχές της φωτογραφικής μηχανής, δεν έχει στόχο την παραποίηση ή την αλλοίωση, ούτε τη δημιουργία ψευδής εντύπωσης ως προς το τι βλέπει το μικροσκόπιο. Απλώς εμπλουτίζει τις φωτογραφίες, παράγοντας τις εξαίρετες εικόνες που μπορούμε τώρα να δούμε.

Για το ανά χείρας βιβλίο

Το ΝΑΝΟΚΟΣΜΟΣ διαιρείται σε δύο μέρη, το πρώτο έχει ως αντικείμενο «νανομορφές», το δεύτερο «νανολειτουργίες». Στο πρώτο μέρος η αφηρημένη ομορφιά εικόνων γκρο-πλαν επιτρέπουν να δούμε τη μορφή υπό άλλη οπτική γωνία. Η ενδελεχής εξέταση ενός αντικειμένου μεταβαίνει από την απλώς κλινική εξέταση στην εκτίμηση της θαυμαστής δεξιότητας της φύσης. Αυτό οφείλεται σε μία από τις πλέον εκπληκτικές δυνατότητες που προσφέρει η ηλεκτρονική μικροσκοπία σάρωσης – στην ευκρίνεια των εικόνων και στο μεγάλο βάθος εστίασης. Κατ' αυτό τον τρόπο παράγονται οι πιο καταπληκτικές απόψεις μορφών που μοιάζουν πραγματικά τρισδιάστατες. Είναι εξαιρετικά εντυπωσιακές εικόνες, ειδικά όταν θέμα τους είναι αντικείμενα που συνήθως θεωρούνται μάλλον επίπεδα, όπως το φτερό μιας πεταλούδας, η επιφάνεια ενός φύλλου, το δέρμα του καρχαρία, που τώρα εμφανίζονται σαν σειρές επιτύμβιων λίθων, σαν δάση τριχών ή σαν ποταμοί δοντιών.

Στο δεύτερο μέρος εξετάζονται λεπτομερώς τα εργαλεία, τα όπλα και τα αισθητήρια όργανα φυτών και ζώων από λειτουργική άποψη. Πρόκειται για την ακριβή απεικόνιση ζωτικών μηχανισμών, μέσω των οποίων φυτά και ζώα τρέφονται, ενηλικιώνονται και αναπαράγονται. Και πάλι η απίστευτη ευκρίνεια των εικόνων αποκαλύπτει πλήθος λεπτομέρειες. Το κεντρί της μέλισσας δεν είναι πια απλώς μια βελόνα που σε τσιμπά, αλλά μια δολοφονική στην όψη, ακιδωτή, ακονισμένη, απειλητική λόγχη. Ο αναπνευστικός πόρος στην επιφάνεια ενός φύλλου σίγουρα μορφάζει, σουφρώνει τα χείλη έτοιμος να μας πει τα μυστικά του.

Οι εικόνες που παρουσιάζονται εδώ έχουν επιλεγεί κυρίως με κριτήριο την έντονη εντύπωση δράματος που δίνουν. Η καθεμιά είναι ένα έργο τέχνης αφ' εαυτού. Καθώς όμως συνυφαίνονται με το κείμενο, είναι συνάμα τα θέματα της φύσης, τα θέματα της βιολογίας.

Κύριος σκοπός κάθε έμβιου οργανισμού είναι η αναπαραγωγή, η μεταβίβαση γονιδίων στην επόμενη γενιά – έτσι λοιπόν παρουσιάζονται μηχανισμοί οχείας, απόθεσης αυγών και παραγωγής σπορίων. Για να επιτευχθεί η γενετική τους αθανασία, οι οργανισμοί πρέπει να τρέφονται και να αναπνέουν, καθώς επίσης να αποφεύγουν να φαγωθούν ή να θανατωθούν και να ζήσουν αρκετά, ώστε να μπορέσουν να αναπαραχθούν – έτσι λοιπόν σε αυτές τις σελίδες παρουσιάζονται ποικίλες στρατηγικές προκειμένου να τρέφονται και να αναπνέουν, καθώς και στρατηγικές άμυνας εναντίον των αρπακτικών και του εχθρικού περιβάλλοντος.

Ένα βιβλίο σαν το παρόν δεν θα μπορούσε ποτέ να είναι ένας περιεκτικός οδηγός της φύσης, αλλά, όπως και το ίδιο το ηλεκτρονικό μικροσκόπιο σάρωσης, προσφέρει μια επιλογή εναργών εικόνων απειροελάχιστων δειγμάτων της ζωής, στιγμιαίων φωτογραφιών ενός θαυμαστού κόσμου σε μικρογραφία.

Η μέτρηση του νανόκοσμου

Η κοινή μονάδα μέτρησης, που έχει υιοθετήσει ο επιστημονικός, αλλά και μεγάλο μέρος του μη επιστημονικού κόσμου, είναι το μέτρο. Το μέτρο ορίστηκε για πρώτη φορά από τη γαλλική κυβέρνηση το 1791 ως ίσο με το ένα δεκάκις εκατομμυριοστό του τεταρτημορίου του μεσημβρινού που διέρχεται από το Παρίσι. Αυτή η εκτίμηση ήταν μάλλον προϊόν μεθοδολογικής επέκτασης, καθώς εκείνο τον καιρό το μόνο μέρος της γήινης σφαίρας που είχε μετρηθεί ήταν η απόσταση ανάμεσα στη Δουγκέρκη και τη Βαρκελώνη. Το πρότυπο του μάλλον αυθαίρετου αυτού μέτρου κατασκευάστηκε αρχικά (1795) από ορείχαλκο και αργότερα (1799) από λευκόχρυσο. Το πρότυπο αυτό, το λεγόμενο Mètre des Archives, ακόμα υπάρχει. Αργότερα αντιγράφτηκε και καθιερώθηκαν διεθνή πρότυπα.

Οι μεταλλικές ράβδοι, όμως, διαστέλλονται και συστέλλονται ανάλογα με τη θερμοκρασία, και επιπλέον οι αρχικοί υπολογισμοί δεν έλαβαν υπόψη το πεπλατυσμένο σχήμα της γης λόγω της περιστροφής της.

Σήμερα το μέτρο ορίζεται ως το μήκος της απόστασης που διανύει το φως στο κενό σε χρόνο ίσο με το 1/299.792.458 του δευτερόλεπτου.

- 1 μέτρο = 1.000 mm – χιλιοστά
- 1 χιλιοστό = 1.000 μm – μικρόμετρα
- 1 μm – μικρόμετρο = 1.000 νανόμετρα (nm)

1

Η φύση είναι γεμάτη ομορφιές. Το μεγαλειώδες θέαμα μιας χιονισμένης βουνοκορφής ή μιας καταπράσινης δασωμένης κοιλάδας μπορούν να το δουν και να το θαυμάσουν οι πάντες, πολλά όμως είναι αόρατα στον γυμνό οφθαλμό. Η επιστημονική προσέγγιση του φυσικού κόσμου δεν θεωρεί πλέον αυτού του είδους την ομορφιά ως ένδειξη της τέχνης του Πλάστη, παρ' όλα αυτά οι φυσικές μορφές εξακολουθούν να συναρπάζουν και ενυπάρχει πολλή ομορφιά στο μικρογράφημα του ματιού μιας μύγας ή της γλώσσας ενός γυμνοσάλιαγκα, όπως και στο περίπλοκο σχέδιο στο φτερό μιας πεταλούδας. Στο μέρος αυτό οι λεπτομέρειες που αποκάλυψε το ηλεκτρονικό μικροσκόπιο σάρωσης αντιμετωπίζονται σαν αφηρημένες εικόνες, πολλές από τις οποίες δεν θα φάνταζαν εκτός τόπου εάν τις βλέπαμε σε κάποια αίθουσα τέχνης. Οι εικόνες έχουν ταξινομηθεί ανά ομάδες με κριτήριο τη μορφή.

NANOM

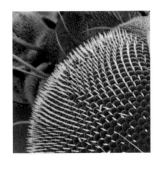 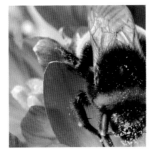

μονοκύτταροι οργανισμοί · λέπια · τρίχες · γλώσσες πτυχές · γυρεόκοκκοι και σπόρια · φύλλα · θόλοι επιφανειακές προεκβολές

ΊΟΡΦΕΣ

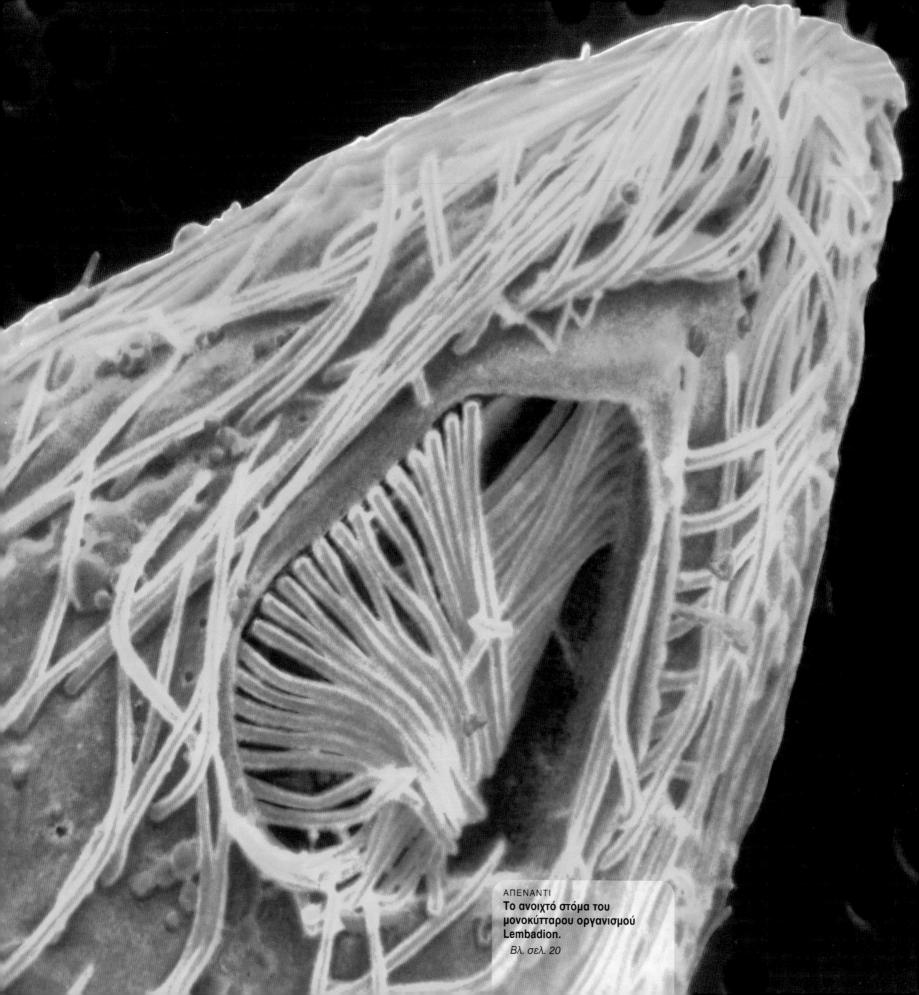

ΑΠΕΝΑΝΤΙ
Το ανοιχτό στόμα του μονοκύτταρου οργανισμού Lembadion.
Βλ. σελ. 20

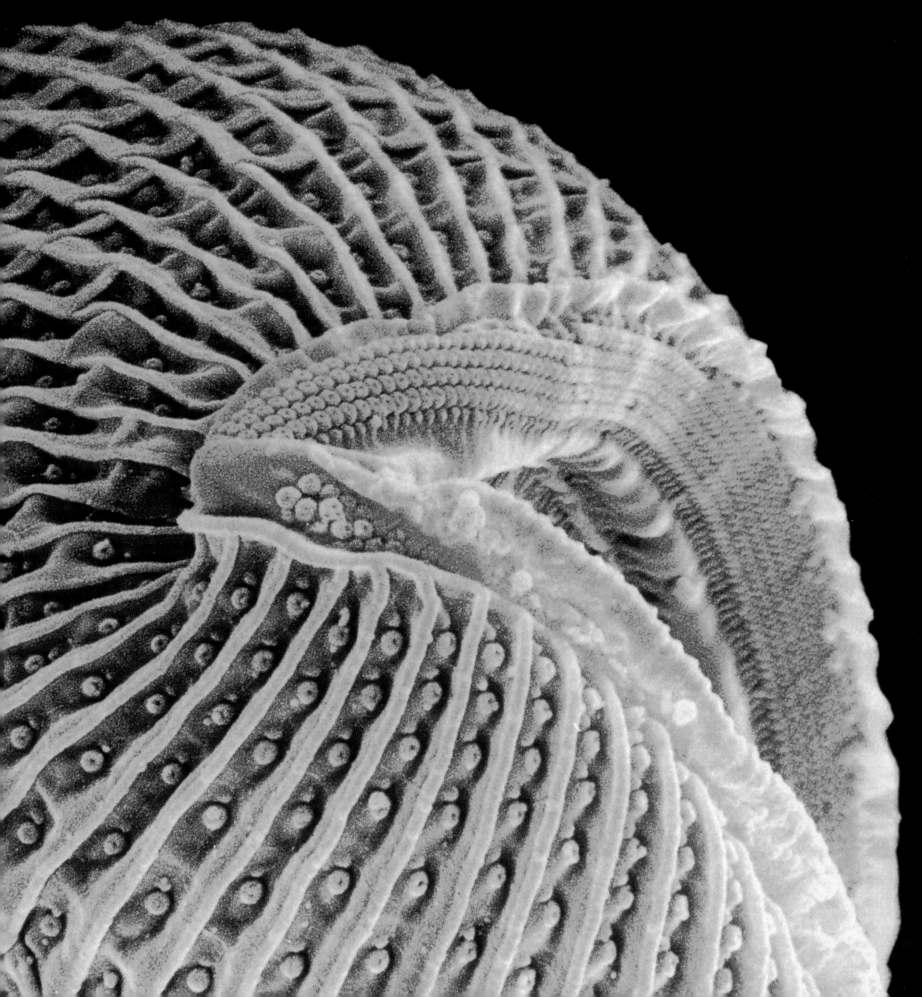

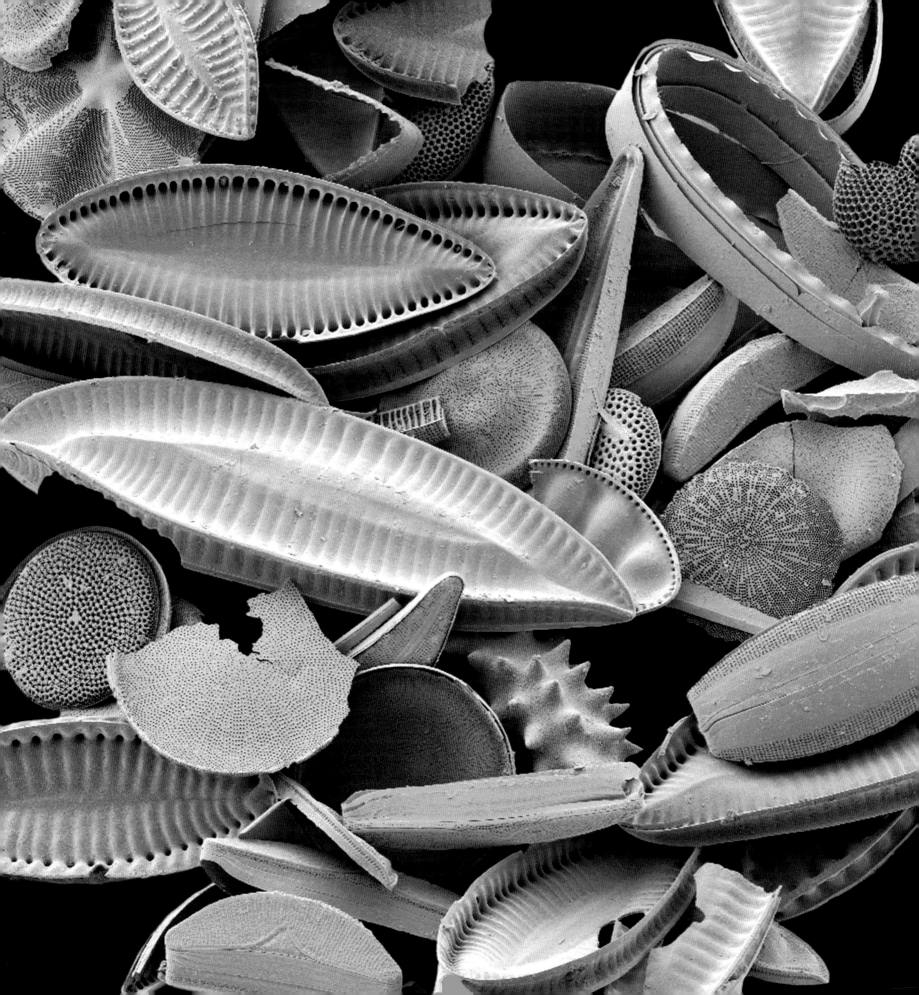

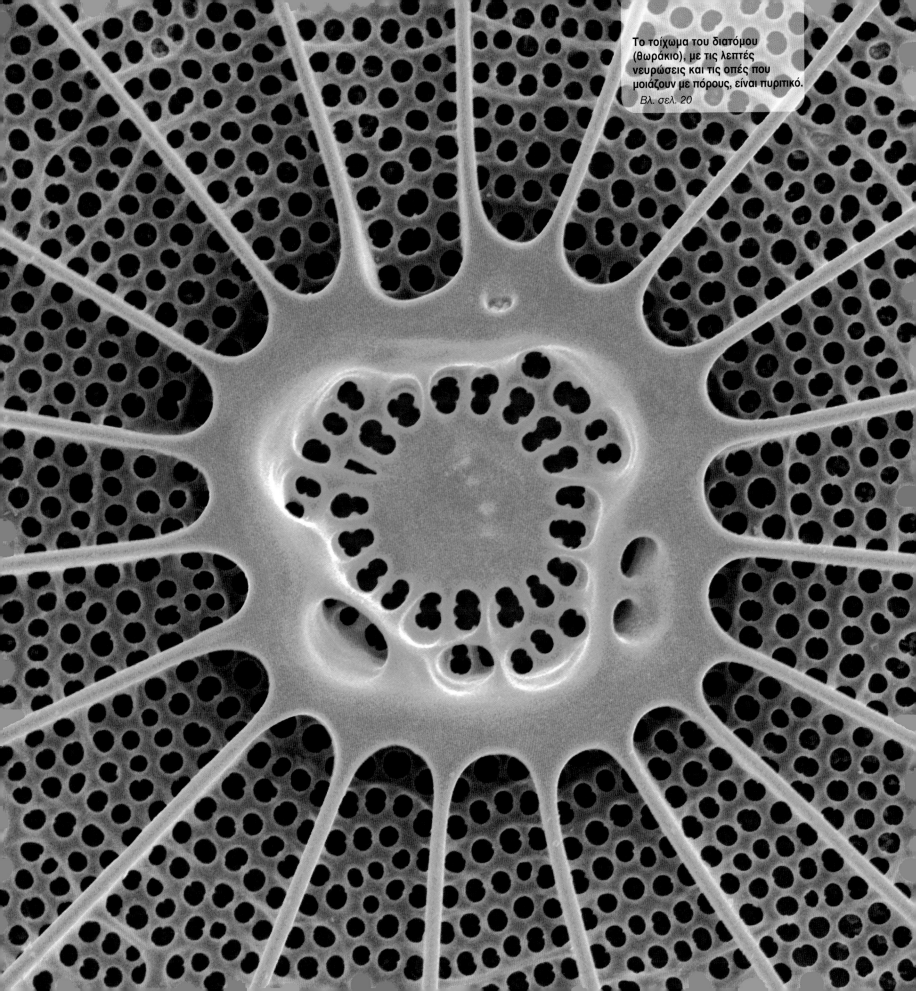

Το τοίχωμα του διατόμου (θωράκιο), με τις λεπτές νευρώσεις και τις οπές που μοιάζουν με πόρους, είναι πυριτικό.

Βλ. σελ. 20

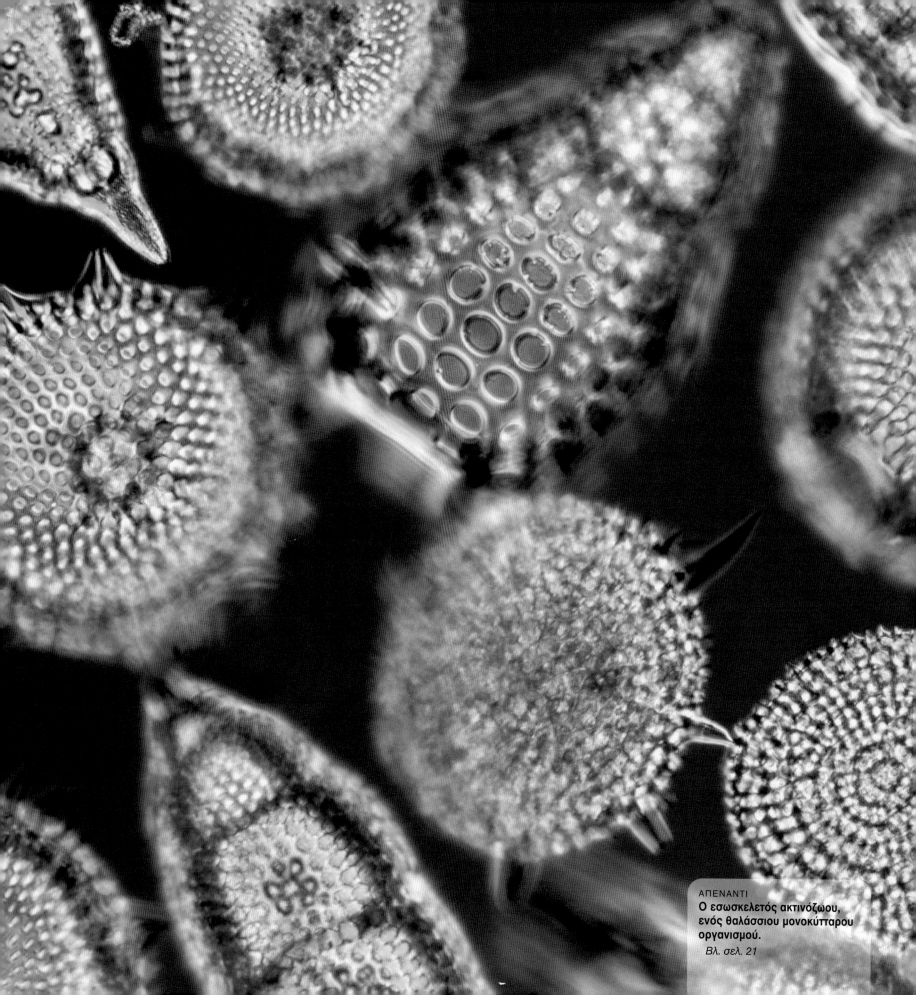

ΑΠΕΝΑΝΤΙ
Ο εσωσκελετός ακτινόζωου,
ενός θαλάσσιου μονοκύτταρου
οργανισμού.
Βλ. σελ. 21

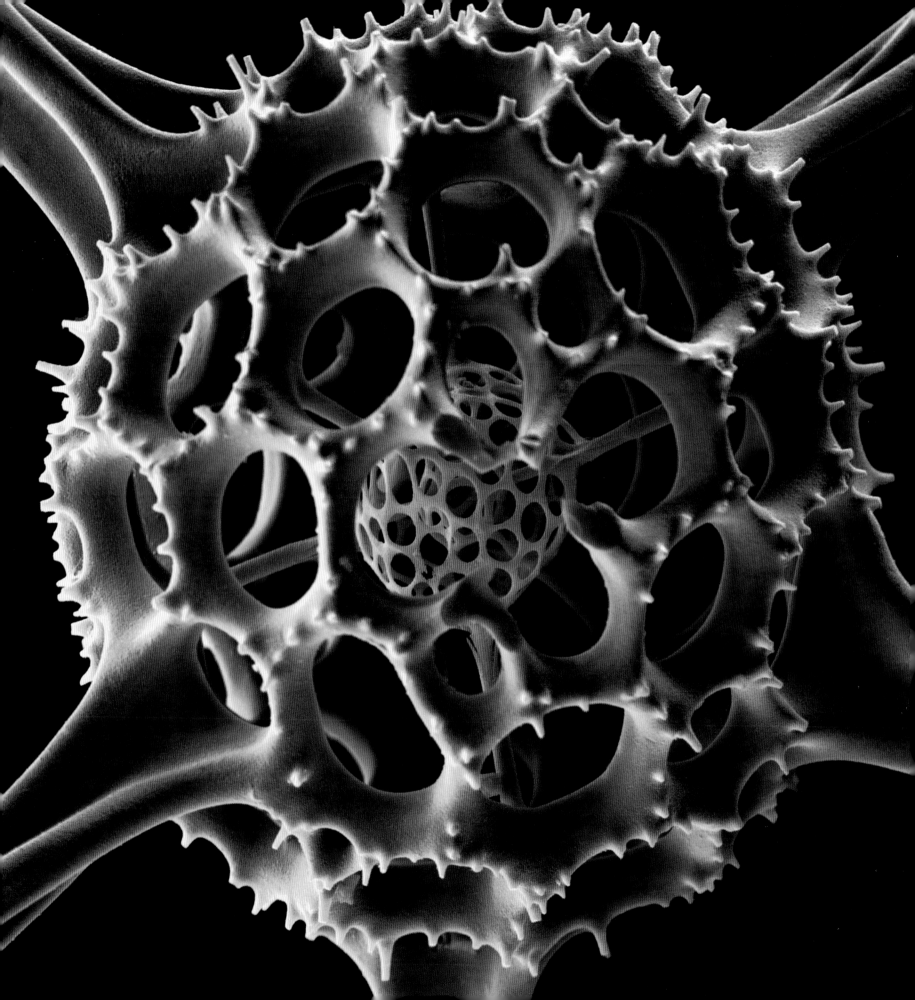

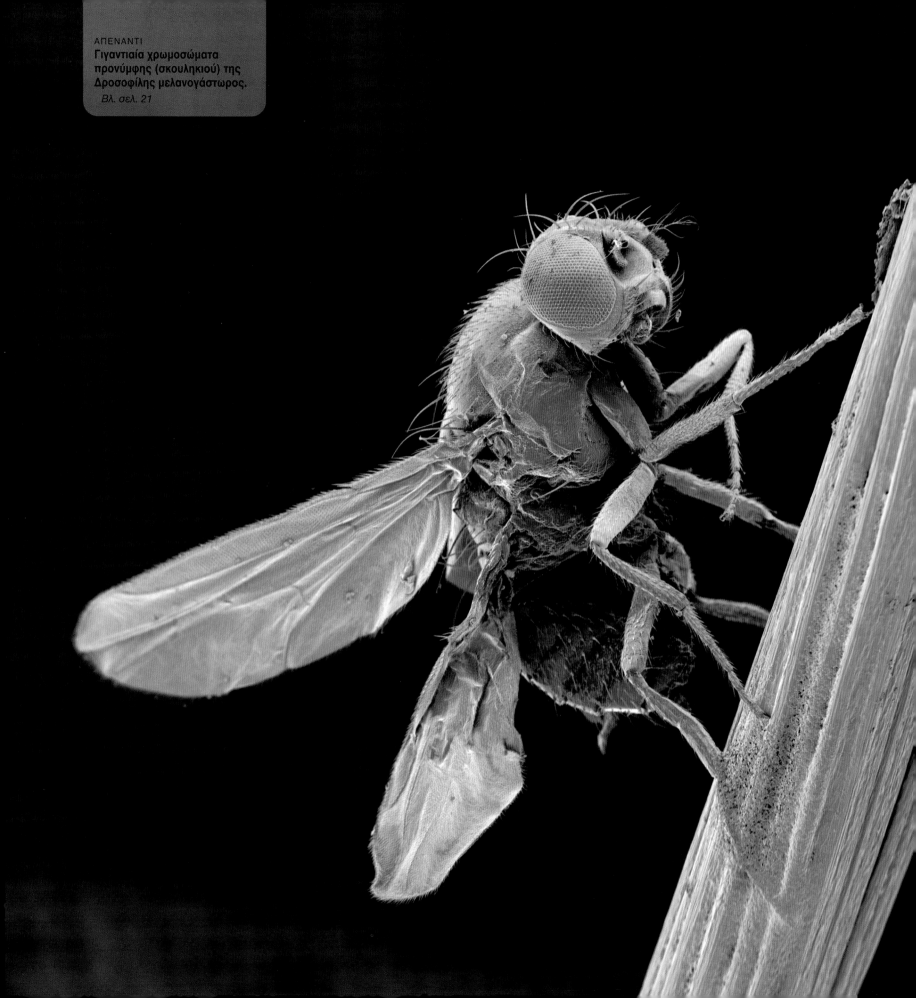

ΑΠΕΝΑΝΤΙ
Γιγαντιαία χρωμοσώματα προνύμφης (σκουληκιού) της Δροσοφίλης μελανογάστωρος.
Βλ. σελ. 21

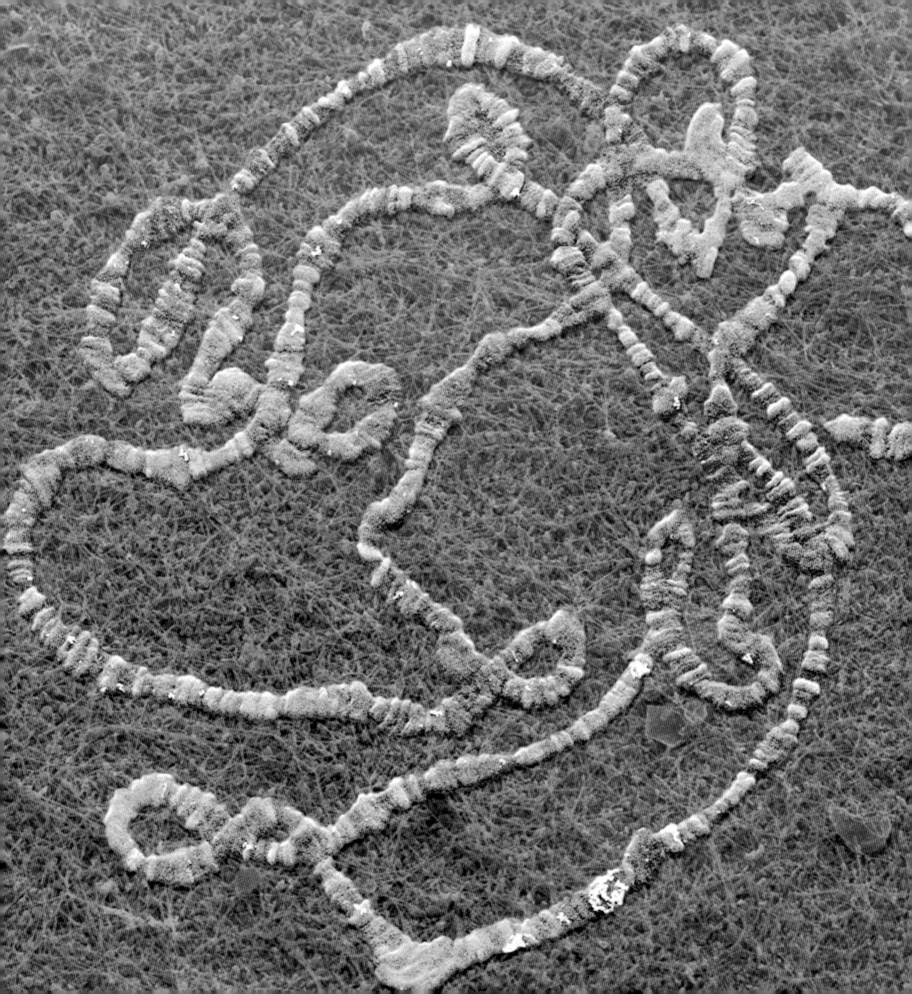

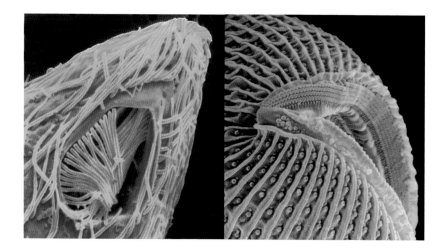

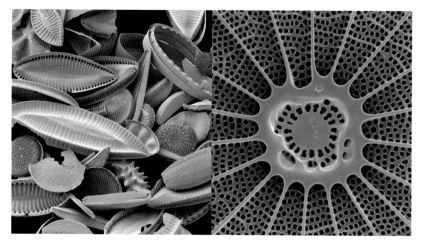

Όμοιο με κακοπλεγμένο ή φτιαγμένο με πιέτες πορτοφόλάκι για κέρματα με ανοιχτό το φερμουάρ του στόματος έτοιμο να καταπιεί μετρητά, το Lembadion bullinum, πρωτόζωο της ομοταξίας των Βλεφαριδωτών, εξωτερικά έχει τη δομή μικρού σάκου, μόνο που το άνοιγμα είναι πραγματικό στόμα, έτοιμο να καταπιεί τη λεία του. Το λεμβάδιο είναι μονοκύτταρος οργανισμός που ζει στα δροσερά νερά λιμνών και αργοκίνητων ρευμάτων. Έχει σχήμα οβάλ ή νεφρού και στο κάτω μέρος του σώματός του ένα μόνο τεράστιο στόμα που λέγεται κυτόστομα (πράσινο στην εικόνα). Μετακινείται κινώντας ρυθμικά σαν μαστίγια μικροσκοπικές τρίχες, τις λεγόμενες βλεφαρίδες (cilia) που καλύπτουν το μεγαλύτερο μέρος του σώματός του. Πριν μπει κάτω από το μικροσκόπιο αφαιρέθηκαν οι τριχούλες αυτές, αλλά τη θέση τους δείχνουν στο μικρογράφημα οι σειρές των πόρων (κινητοσωμάτων) από τους οποίους άλλοτε πρόβαλλαν αυτά τα νημάτια. Το πρωτόζωο αυτό έχει περίπου 50-65 σειρές κινητοσωμάτων και 40-55 βλεφαρίδες ανά σειρά.

Οι βλεφαρίδες κινούνται είτε μαζί είτε ανά κύματα μετακινώντας το ζώο στο νερό, ώστε να καταδιώκει άλλους μικροσκοπικούς μονοκύτταρους οργανισμούς, καθώς και βακτηρίδια και άλγη που αποτελούν την τροφή του. Επίσης, τα ρυθμικά κινούμενα νημάτια ωθούν τροφές στο ανοιχτό στόμα. Άλλα βλεφαριδωτά εξαρτήματα γύρω από το κυτόστομα κάμπτονται, σπρώχνοντας τις τροφές στο εσωτερικό του κυττάρου σαν τεράστιος μηχανισμός κατάποσης.

Τα περισσότερα λεμβάδια έχουν μήκος το πολύ 100-120 μm, έχουν όμως βρεθεί και γιγαντιαία μήκους 200 μm εκεί όπου η τροφή δεν επαρκεί. Επίσης, υπάρχουν και μορφές μέτριες σε μέγεθος, καθώς οι οργανισμοί αυτοί προσαρμόζονται κάθε φορά στο διαφορετικό μέγεθος των θηραμάτων τους.

Τα περισσότερα πρωτόζωα αναπαράγονται μονογονικά, δηλαδή το κύτταρο διαιρείται και δίνει δύο θυγατρικά κύτταρα. Όταν αυτή η διαδικασία καθυστερεί λόγω έλλειψης τροφής, το λεμβάδιο μπορεί να διπλασιάσει το μέγεθός του. Όταν, ωστόσο, πάψει να υπάρχει έλλειψη τροφής, μιτωτικοί αναδιπλασιασμοί ανά σύντομα χρονικά διαστήματα το επαναφέρουν στο φυσιολογικό του μέγεθος.

Λεπτές ακτίνες που ξεκινούν από μια πλήμνη στο κέντρο είναι αρχαίο σχέδιο τροχού. Αυτός εδώ όμως είναι πολύ αρχαιότερος από τον πρώτο τροχό που επινόησαν οι πρόγονοί μας, γιατί αναπτύχθηκε πριν από εκατοντάδες εκατομμύρια χρόνια. Τα διάτομα είναι μικροσκοπικά φύκη που το καθένα τους αποτελείται από ένα φυτικό κύτταρο μέσα σε μια θήκη από διοξείδιο του πυριτίου που λέγεται θωράκιο (frustule). Το μεγαλύτερο γνωστό είδος έχει μέγεθος 2 χιλιοστά, τα περισσότερα όμως είναι ορατά μόνο με μικροσκόπιο. Εκτιμάται ότι υπάρχουν πάνω από 100.000 είδη διατόμων στους ωκεανούς, με πολύ διαφορετικά σχήματα, μορφές και διακοσμητικά σχέδια.

Την άνοιξη και αρχές του καλοκαιριού, όταν τα επίπεδα της τροφής στα ανώτερα στρώματα των υδάτων είναι υψηλά, τα διάτομα αναπαράγονται ταχύτατα και σύντομα δεσπόζουν στην κοινότητα του φυτοπλαγκτόν (μονοκύτταρων φυκών).

Κάθε θωράκιο διατόμου αποτελείται από δύο θήκες σαν δύο μακρόστενες ρηχές φόρμες κέικ που η μία είναι ελαφρώς πλατύτερη και εφαρμόζει πάνω στην άλλη. Την περίοδο του αναπαραγωγικού μπουμ, το διάτομο διαιρείται σχηματίζοντας δύο θυγατρικά κύτταρα (μίτωση). Κάθε νέο κύτταρο κληρονομεί μία από τις αρχικές θήκες και έπειτα εκκρίνει μία δεύτερη ελαφρώς μικρότερη μέσα στην πρώτη. Με τη συνεχή επανάληψη της μίτωσης το μέσο μέγεθος των διατόμων μικραίνει, μέχρις ότου φτάσουν ένα ελάχιστο μέγεθος, πέρα από το οποίο το κύτταρο δεν μπορεί να επιζήσει. Σε αυτό το σημείο, το οποίο συνήθως συμπίπτει με τη μείωση των θρεπτικών ουσιών στο νερό, τα διάτομα παράγουν πολύ μεγαλύτερα σπόρια, τα οποία πέφτουν σε λήθαργο μέχρις ότου τα εποχικά ρεύματα φέρουν νέες θρεπτικές ουσίες τον επόμενο χρόνο. Το μοναδικό κέλυφος του διατόμου δημιουργείται στο εσωτερικό του οργανισμού με πολυμερισμό μορίων πυριτικού οξειδίου που σχηματίζουν μακριές πυριτικές αλυσίδες, οι οποίες στη συνέχεια ωθούνται στην επιφάνεια του κυττάρου και προστίθενται στο τοίχωμά του. Νανοτεχνολόγοι σήμερα επιδίδονται στη γενετική και μοριακή μελέτη των διατόμων με την ελπίδα ότι η κατανόηση των εύτακτων και ακριβέστατων μικροσκοπικά μηχανισμών απόθεσης οξειδίου του πυριτίου θα συμβάλει στην παραγωγή ολοκληρωμένων κυκλωμάτων (chips) πυριτίου.

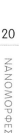

ΔΕΞΙΑ
Οι σειρές μικρών πόρων στην επιφάνεια του λεμβάδιου δείχνουν πού ήταν προσκολλημένες οι βλεφαρίδες.

ΑΡΙΣΤΕΡΑ
Οι βλεφαρίδες ενός στενού συγγενούς του λεμβάδιου, του βλεφαριδωτού πρωτόζωου Tetrahymena, είναι ακόμα στη θέση τους, ενώ οι ειδικές βλεφαρίδες γύρω από το κυτόστομα μόλις έχουν συνδράμει στην «κατάποση».

ΔΕΞΙΑ
Οι λεπτές νευρώσεις και οι σαν πόροι οπές (striae) στο θωράκιο του διατόμου είναι πυριτικές προσδίδοντας ωραία μορφή και δομή στο φυτικό μονοκύτταρο.

ΑΡΙΣΤΕΡΑ
Τα απλά αλλά ωραία σχήματα των διατόμων παρουσιάζουν τεράστιες διαφορές, με γνωστά είδη που υπολογίζεται ότι φτάνουν τα 100.000.

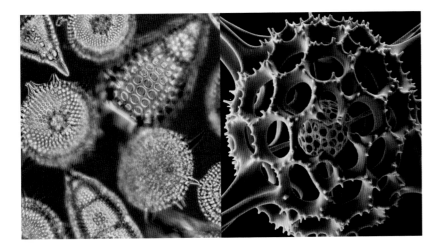

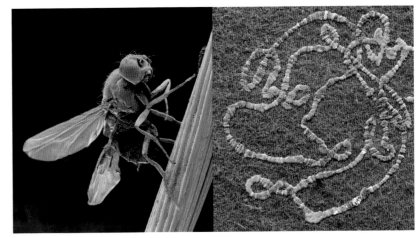

Αυτό το αγκαθωτό, πολυεδρικό σφαιρίδιο σαν μπαλάκι του γκολφ είναι ο άδειος ενδοσκελετός ενός ακτινόζωου και, όπως οι σκελετοί των σπονδυλωτών, έχει διπλή λειτουργία: αφενός προστατεύει το σώμα, αφετέρου διατηρεί το σχήμα του. Τα ακτινόζωα είναι μονοκύτταροι ζωικοί οργανισμοί του θαλάσσιου πλαγκτόν. Το μέγεθός τους ποικίλλει από μερικά δέκατα έως μερικά εκατοστά του χιλιοστού. Μολονότι το μαλακό, ζελατινώδες σώμα τους έχει υφή αμοιβάδας, διατηρούν το κανονικό σχήμα τους χάρη στον σύνθετο πυριτικό ενδοσκελετό που παίρνει παράξενα και όμορφα σχήματα.

Ο εσωτερικός θάλαμος του σκελετού, που περιβάλλεται από μεμβράνη, περιέχει το ενδόπλασμα και κυτταρικά οργανίδια, όπως τον πυρήνα (με το DNA του οργανισμού), τα μιτοχόνδρια (που παράγουν ενέργεια) και το σύστημα του Golgi (που έχει την ευθύνη σύστασης πρωτεϊνών και λιπιδίων). Το ενδόπλασμα καλύπτεται από το εξώπλασμα (το λεγόμενο κάλυμμα), μια παρόμοια πρωτεϊνική γέλη που εκτείνεται μέχρι τις σκελετικές άκανθες καλύπτοντάς τες, και η οποία συχνά περιέχει μικροσκοπικά φύκη. Αυτά τα συμβιωτικά φύκη βοηθούν τον ξενιστή τους δεσμεύοντας την ηλιακή ενέργεια μέσω φωτοσύνθεσης, παίρνοντας για αντάλλαγμα το διοξείδιο του άνθρακα που παράγει το ακτινόζωο.

Το εξώπλασμα τρέφει το ακτινόζωο. Ακανόνιστες εκβλαστήσεις, τα ψευδοπόδια, προεκτείνονται έως αυτό και συλλέγουν θρεπτικά σωματίδια που στη συνέχεια απορροφώνται από το σώμα του κυττάρου. Στα εργαστήρια ένα ακτινόζωο μετακινείται και σε δοκιμαστικό σωλήνα χρησιμοποιώντας για τους ελιγμούς του τα ψευδοπόδια σαν κεραίες, κάτι που δεν έχει παρατηρηθεί σε κανένα άλλο ζώο στη φύση.

Λόγω του πυριτικού ενδοσκελετού τους, τα ακτινόζωα έχουν διατηρηθεί σχετικά καλά μεταξύ των απολιθωματικών απογραφών, από όπου βλέπουμε ότι σε διάστημα πάνω από 600 εκατομμύρια χρόνια ανέπτυξαν πλήθος περίπλοκων σχημάτων. Παρά την πολυμορφία τους, όμως, βλέπουμε να επαναλαμβάνονται δύο βασικά δομικά θέματα: το ακτινόζωο Spumellaria με το σφαιρικό κέλυφος (που απεικονίζεται εδώ) και το ακτινόζωο Nassellaria με το κωνικό κέλυφος.

Με όση προσοχή και αν το κοιτάξουμε, αποκλείεται να ορίσουμε τις χάντρες αυτού του περιδέραιου ως στέρεες και διακριτές, γιατί τα περιγράμματά τους συγχωνεύονται και αλλοιώνονται. Φυσικό, αφού πρόκειται για πολλαπλές αλυσίδες DNA, οι δε χρωματιστές ταινίες είναι η πλησιέστερη δυνατή απεικόνιση του τρόπου με τον οποίο διατάσσονται τα γονίδια σε έναν ζώντα οργανισμό.

Τα χρωμοσώματα είναι συγκεντρώσεις DNA (γενετικού υλικού) στον πυρήνα ζωικών και φυτικών κυττάρων. Συνήθως είναι ορατά μόνο (μέσα από άκρως ισχυρά μικροσκόπια) κατά τη διαίρεση των κυττάρων, όταν το DNA συμπυκνώνεται και συστέλλεται μεταβαλλόμενο από μια σταγόνα σε μια σειρά διακριτών οντοτήτων που μοιάζουν με λουκάνικα· τα χρωμοσώματα αυτά πολλαπλασιάζονται με διαίρεση σχηματίζοντας δύο ίδια θυγατρικά κύτταρα.

Τα χρωμοσώματα κανονικά είναι πάρα πολύ μικρά, ωστόσο το 1881 ο Γάλλος εμβρυολόγος Edouard-Gérard Balbiani ανακάλυψε τεράστια δείγματα χρωμοσωμάτων στους σιελογόνους αδένες της προνύμφης του χειρονόμου. Έκτοτε έχουν εντοπιστεί στις προνύμφες πολλών και διαφόρων μυγών, μεταξύ άλλων και της Δροσοφίλης μελανογάστωρος, της κοινής μύγας των φρούτων. Το 1935, η αλυσίδα των γιγαντιαίων χρωμοσωμάτων της Δροσοφίλης σχεδιάστηκε από τον Αμερικανό γενετιστή Calvin Bridges και τα διαγράμματα αυτά εξακολουθούν και σήμερα να είναι εν χρήσει ως χάρτες της γενετικής δομής των εντόμων αυτών.

Γιγαντιαία ή αλλιώς πολυταινικά χρωμοσώματα σχηματίζονται από διαδοχικούς αναδιπλασιασμούς των χρωμονημάτων, χωρίς όμως διαχωρισμό θυγατρικών χρωμοσωμάτων και χωρίς κυτταρική διαίρεση. Αντ' αυτού το κύτταρο που εμπεριέχει το DNA αναπτύσσεται αποκτώντας πολύ μεγαλύτερο μέγεθος από το φυσιολογικό. Τα πολλαπλά αντίγραφα του DNA, μέχρι 2.000 περίπου τον αριθμό, παραμένουν παρατεταγμένα κατά σειρά, αλλά διογκωμένα σημεία δείχνουν πού ξετυλίγονται όταν δρουν παράγοντας κυτταρικά προϊόντα. Θεωρείται ότι τα μυγάκια των φρούτων ωφελούνται από τα πολυταινικά χρωμοσώματα, διότι ένα κύτταρο που εμπεριέχει πολλαπλά αντίγραφα ενός γονιδίου μπορεί να παράγει πρωτεΐνες με πολύ ταχύτερο ρυθμό από ό,τι συνήθως.

ΔΕΞΙΑ
Ο εσωτερικός σκελετός του ακτινόζωου είναι πυριτικός και δίνει σχήμα αμοιβαδοειδές στο πρωτόζωο που διαφορετικά θα ήταν άμορφο.

ΑΡΙΣΤΕΡΑ
Η γυαλιστερή διάτρητη γέλη ζωντανών ακτινόζωων απαντά σε πολλές μορφές, οι οποίες όμως χονδρικά ανήκουν σε δύο κατηγορίες, τις σφαιρικές και τις κωνικές.

ΔΕΞΙΑ
Γιγαντιαία χρωμοσώματα προνύμφης της Δροσοφίλης μελανογάστωρος που το καθένα περιέχει μέχρι και 2.000 αντίγραφα του DNA των χρωμοσωμάτων ενός φυσιολογικού κυττάρου. Οι αλυσίδες της Δροσοφίλης μπορούν να χρησιμοποιηθούν ως χάρτες σε μελέτες γενετικής.

ΑΡΙΣΤΕΡΑ
Μεταλλαγμένη Δροσοφίλη σε ομοιωτικό γονίδιο της περιοχής bithorax με συνέπεια διπλασιασμό του θωρακικού μεταμερούς και τέσσερα αντί δύο φτερά.

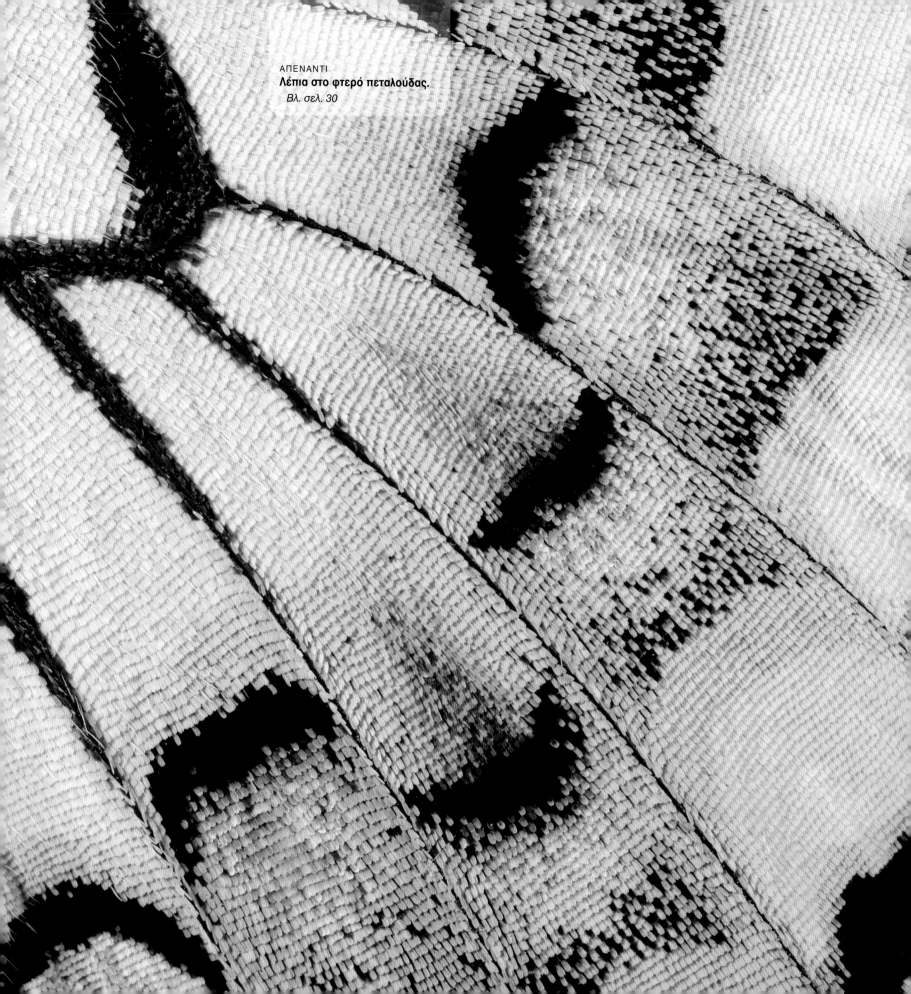

ΑΠΕΝΑΝΤΙ
Λέπια στο φτερό πεταλούδας.
Βλ. σελ. 30

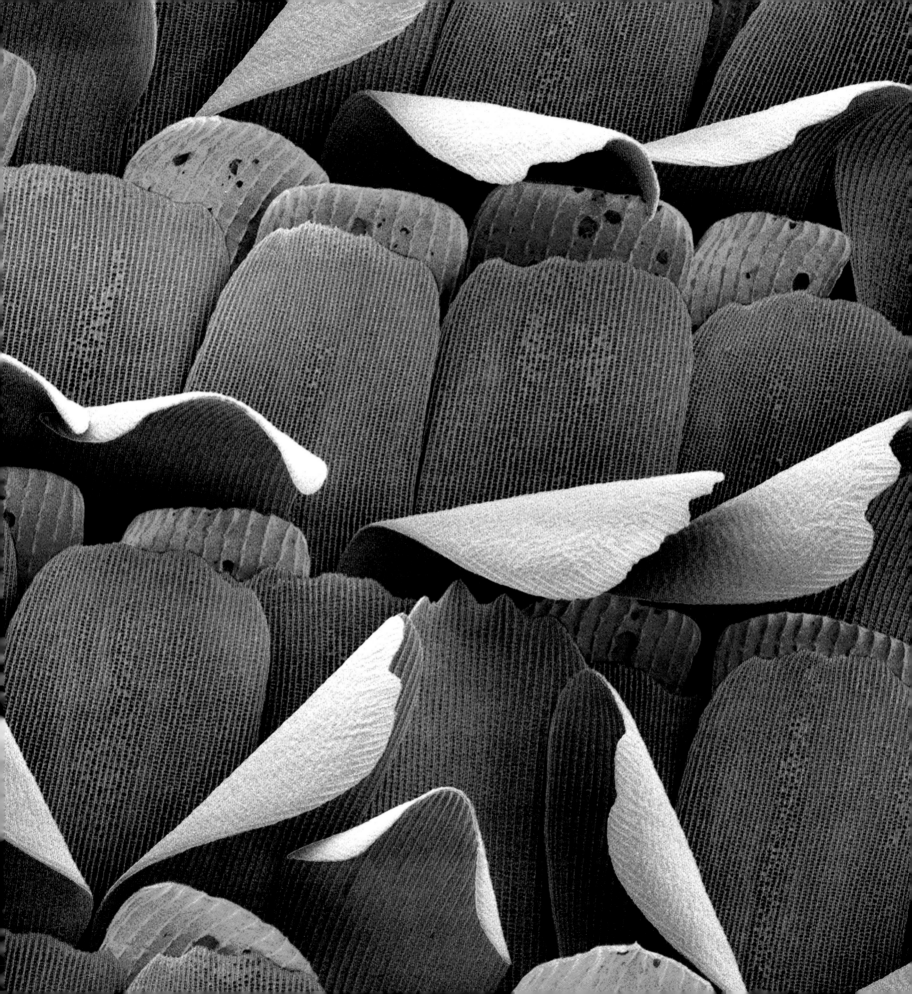

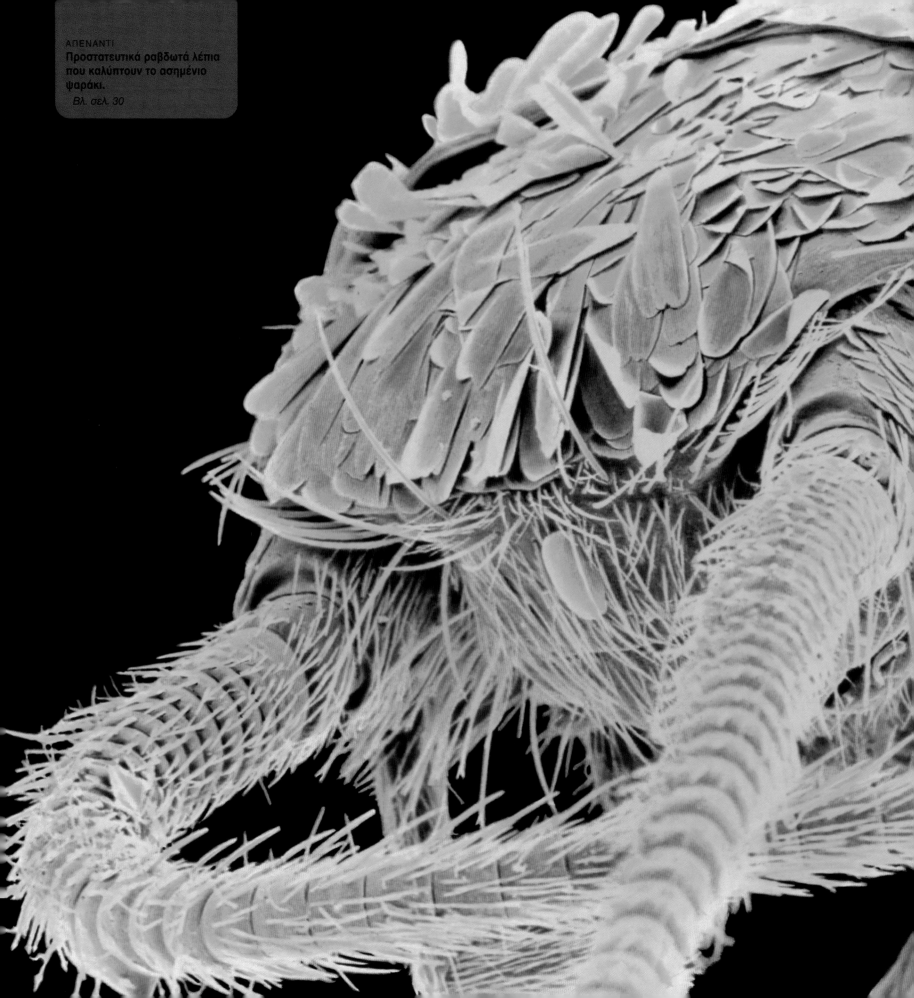
ΑΠΕΝΑΝΤΙ
Προστατευτικά ραβδωτά λέπια που καλύπτουν το ασημένιο ψαράκι.
Βλ. σελ. 30

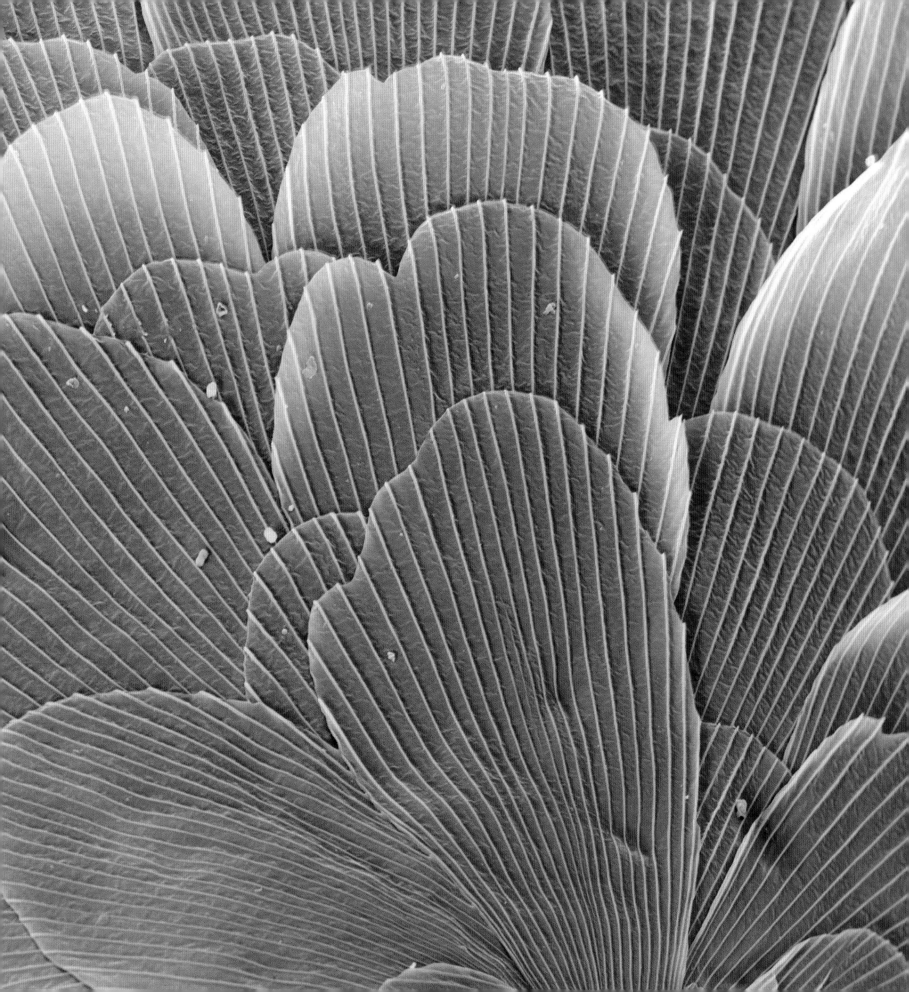

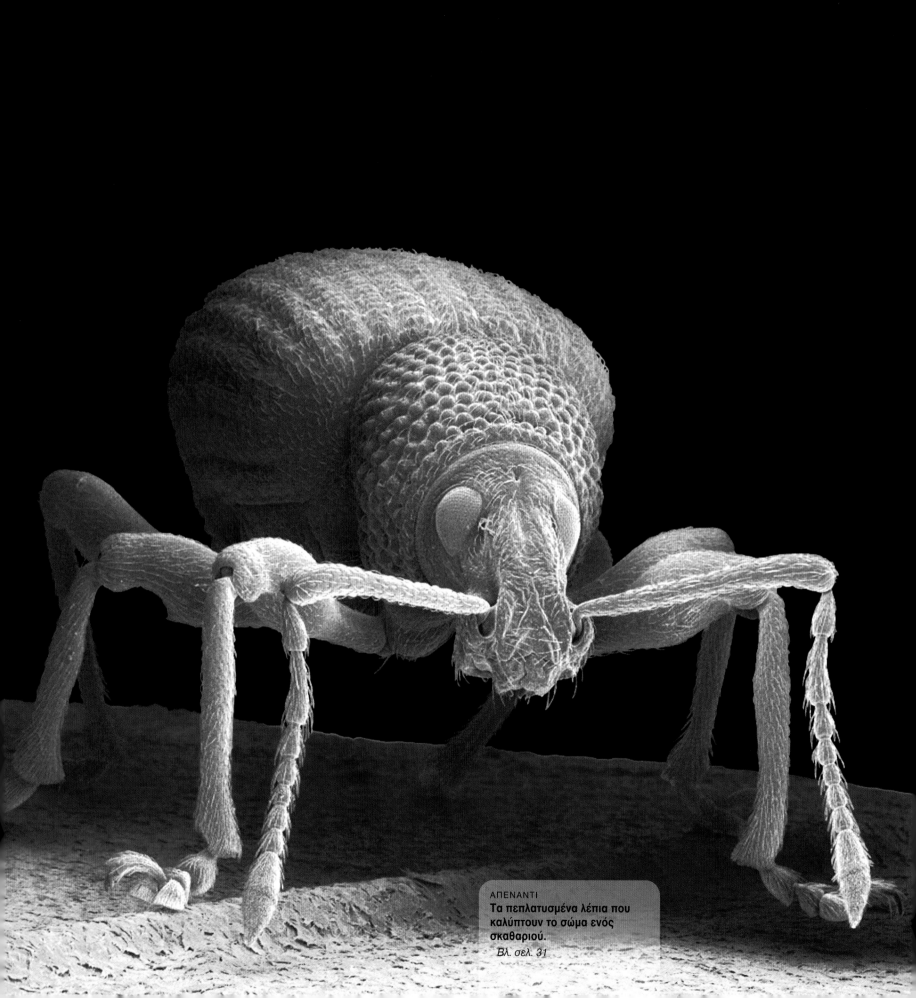

ΑΠΕΝΑΝΤΙ
Τα πεπλατυσμένα λέπια που καλύπτουν το σώμα ενός σκαθαριού.
Βλ. σελ. 31

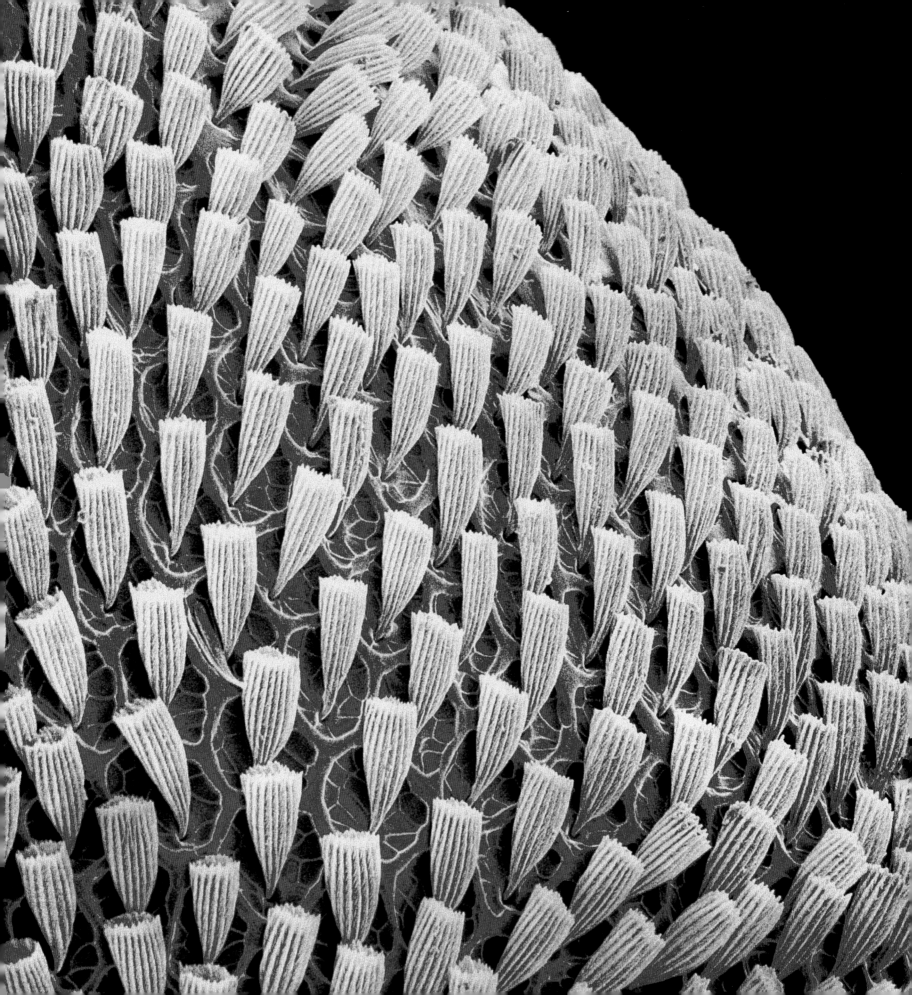

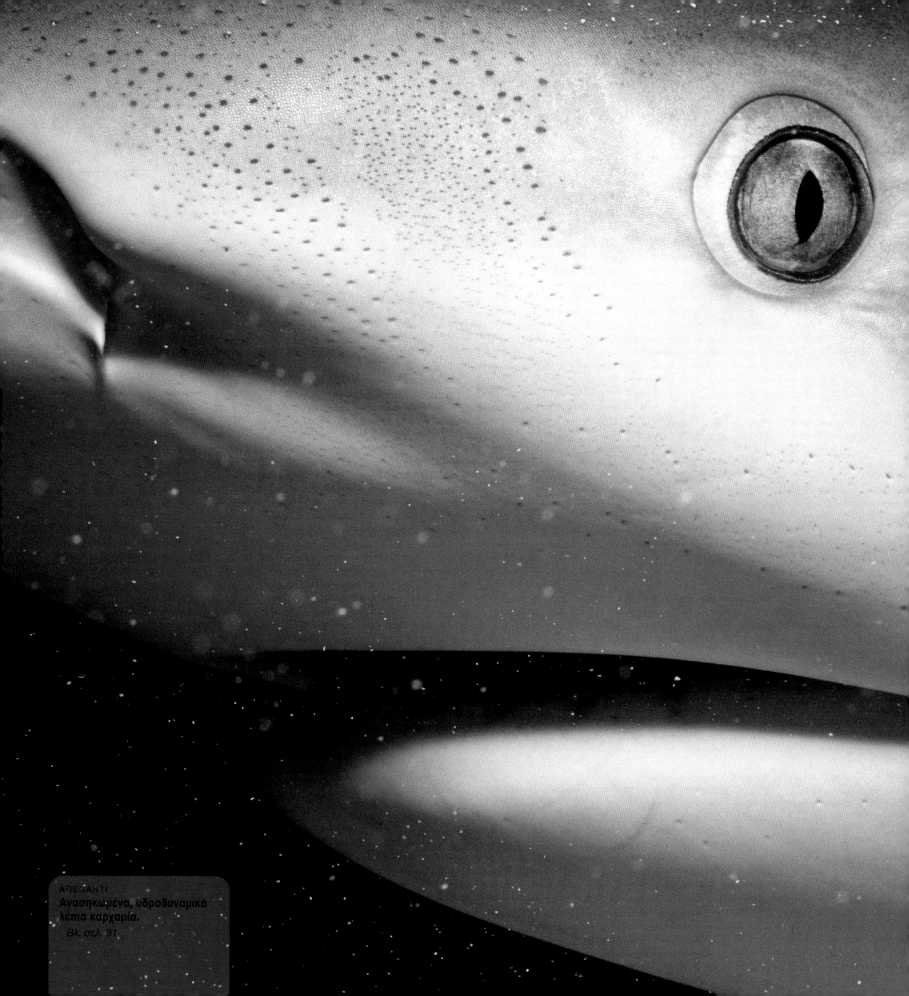

ΑΠΕΝΑΝΤΙ
**Ανασηκωμένα, υδροδυναμικά
λέπια καρχαρία.**
Βλ. σελ. 31

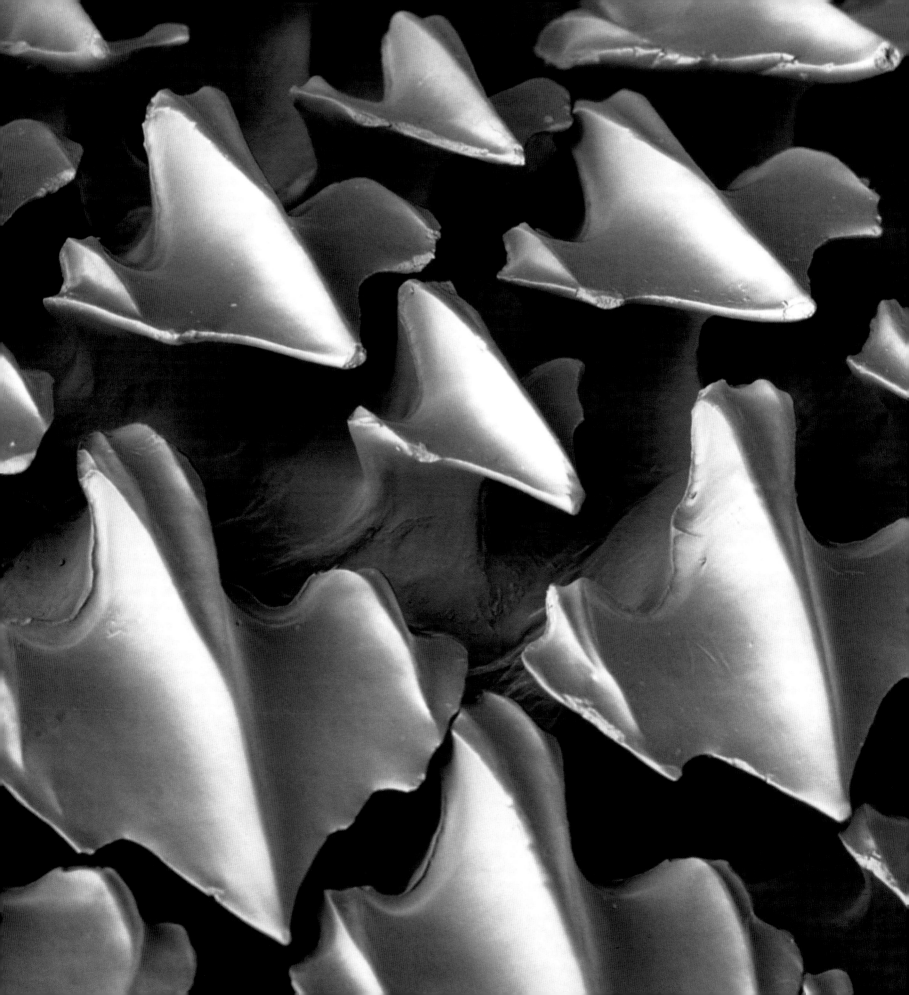

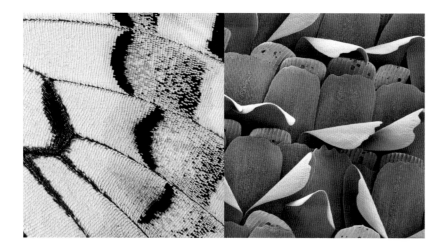

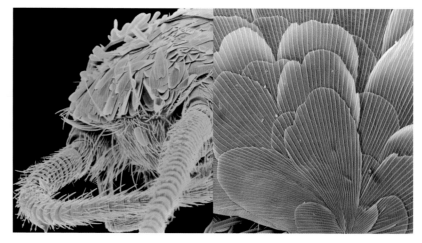

Διατεταγμένα σαν σειρές καθισμάτων σε αμφιθέατρο, που το ύφασμα του καλύμματος ορισμένων έχει ξεθωριάσει και φθαρεί, αυτά τα επίπεδα πλακίδια μπορεί να φαίνονται λεκιασμένα από πολύ κοντά, αλλά ιδωμένα από τη σωστή απόσταση απεικονίζουν άψογα τα λέπια στο φτερό μιας πεταλούδας.

Οι πεταλούδες και οι σκόροι («νυχτοπεταλούδες») ανήκουν στην τάξη των Λεπιδόπτερων, των εντόμων που τα φτερά τους καλύπτονται από λέπια, δηλαδή μικροσκοπικές χρωματιστές φολίδες που συνθέτουν τα πυκνά και ευδιάκριτα σχέδια πάνω τους. Τα λέπια είναι πεπλατυσμένα και παραμορφωμένα τριχία (setae, trichia) και, όπως και του εξωσκελετού των εντόμων, συστατικό τους είναι η χιτίνη.

Τα λέπια μιας πεταλούδας εύκολα αναγνωρίζονται από τους κανονικούς ζυγούς της στρατιωτικού τύπου παράταξής τους. Οι σκόροι τείνουν προς πολύ πιο τυχαίες διατάξεις, χωρίς αυτό να σημαίνει πως τα σχέδια δεν είναι ακριβώς διατεταγμένα κατά μήκος των φτερών. Και στις πεταλούδες και στους σκόρους τα έγχρωμα σχέδια των φτερών καθορίζονται γενετικά.

Τα λέπια αναλαμβάνουν διάφορες λειτουργίες απαραίτητες στις πεταλούδες, τους σκόρους και τα πλήθος άλλα έντομα με λέπια, όπως για παράδειγμα στα σκαθάρια, τα θυσάνουρα (ψαράκια), τα τριχόπτερα και τους κοριούς. Από τον συνδυασμό των χρωμάτων τους προκύπτουν άπειρα σχήματα σαν μωσαϊκά. Λόγω της κεκλιμένης, τρισδιάστατης μορφής τους, προσδίδουν στα έντομα υπέροχα χρώματα και μεταλλική λάμψη, επειδή πυκνές, παράλληλες μικροσκοπικές αύλακες και δίοδοι διαθλούν το φως σε όλα τα χρώματα του φάσματος τονίζοντας το κυανό (όπως στις υπέροχες πεταλούδες Morpho των τροπικών δασών) ή το πράσινο (όπως στις πεταλούδες του γένους των Ορνιθόπτερων της Νοτιοανατολικής Ασίας) ή το χρυσό και το ασήμι (όπως στις νυχτοπεταλούδες Autographa gamma και Autographa pulchrina της Βρετανίας και της Ευρώπης).

Τα λέπια μπορούν επίσης να προστατεύουν σε περίπτωση κινδύνου. Μια πεταλούδα είναι προτιμότερο να χάσει μερικά από τα λεπτότατα λέπια της, από το ράμφος ενός πτηνού ή τα κολλώδη νήματα του ιστού μιας αράχνης ή τα δάχτυλα ενός παιδιού, παρά τη ζωή της.

ΔΕΞΙΑ
Στο μικρογράφημα τα λέπια έχουν επιχρωματιστεί τεχνητά μοβ ή γαλάζια για να φανεί η διαφορετική λεία ή ραβδωτή επιφάνειά τους, στην πραγματικότητα όμως τα χρωματιστά μοτίβα είναι άπειρα.

ΑΡΙΣΤΕΡΑ
Το όμορφο σχέδιο στο φτερό μιας πεταλούδας του γένους παπίλιος είναι ένα σύνθετο μωσαϊκό φτιαγμένο με λέπια, το καθένα διαφορετικού χρώματος.

Αυτά τα σαν χτένια λέπια με τις νευρώσεις δεν θα φαίνονταν παράξενα στην πανοπλία ενός ιππότη του Μεσαίωνα ή σε έναν φρέσκο σολομό στον πάγκο του ιχθυοπώλη. Ο λόγος είναι απλός: τα λεπτότατα, μικροσκοπικά αυτά πλακίδια που εν μέρει επικαλύπτονται εξυπηρετούν τον ίδιο σκοπό με τις φολίδες του θώρακα μιας πανοπλίας ή με τα λέπια του ψαριού – σκληρά αλλά εύκαμπτα καθώς είναι προστατεύουν το έντομο.

Τα ασημένια ψαράκια (Lepisma saccharina) είναι μικρά έντομα μήκους 10-15 χιλιοστών και ανήκουν στην τάξη των Θυσάνουρων. Σε ορισμένα είδη αυτής της τάξης το τελευταίο μεταμερές της κοιλιάς καταλήγει σε τρεις προεκβολές που μοιάζουν με τρίχες. Υπάρχουν 400 περίπου είδη θυσάνουρων γνωστών σε όλο τον κόσμο.

Τα ασημένια ψαράκια ανήκουν σε μία από τις αρχαιότερες και πιο πρωτόγονες ομάδες εντόμων, αλλά τώρα έχουν πλέον μετατραπεί σε πλάσματα σχεδόν αποκλειστικά οικόσιτα. Τρέφονται με υπολείμματα τροφών, σπόρους δημητριακών, ψίχουλα και κόκκους ζάχαρης, αλλά και με ρούχα, χαλιά, βιβλία, ταπετσαρίες τοίχων και κόλλα. Ένα άλλο είδος η Thermophila furnorum ή Thermobia domestica ονομάστηκε έτσι επειδή εντοπίστηκε σε κτίρια όπου επικρατεί ζέστη και ειδικά σε φούρνους όπου τρέφεται με χυμένο αλεύρι. Συχνά η παρουσία τους δεν γίνεται αισθητή παρά μόνο από τα ίχνη της νυχτερινής τους λεηλασίας. Την ημέρα κρύβονται σε σχισμές και χαραμάδες, πίσω από σοβατεπιά και ξεκολλημένες ταπετσαρίες, καθώς και κάτω από χαλιά.

Τα ασημένια ψαράκια δεν έχουν φτερά και τα πόδια τους είναι σχετικά κοντά, αλλά είναι εξαιρετικά ευκίνητα και γυρίζουν με εκπληκτική ταχύτητα στην κρυψώνα τους όταν τα πειράξει κανείς, έχοντας το πολύ χάσει λίγη από την ασημόσκονη που τα καλύπτει.

ΔΕΞΙΑ
Το ασημένιο ψαράκι χρωστά το όνομά του στα αργυρά λέπια που το προστατεύουν χωρίς να το κάνουν δύσκαμπτο.

ΑΡΙΣΤΕΡΑ
Τα ασημένια ψαράκια είναι πρωτόγονα έντομα δίχως φτερά, με μακριές κεραίες αποτελούμενες από πολλά άρθρα και μασητικό στοματικό μόριο.

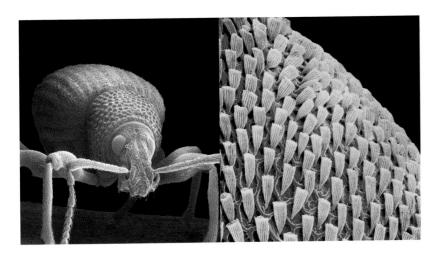

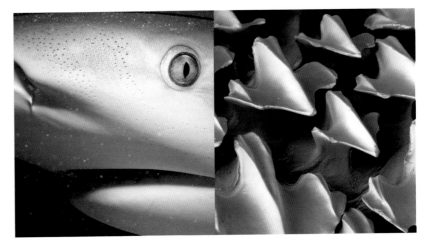

Αυτό θα μπορούσε να είναι φουτουριστικό αεροδρόμιο επιστημονικής φαντασίας στο οποίο συνωστίζονται υπερηχητικά τζετ με φτερά σε σχήμα κεφαλαίου δέλτα. Κάθε αεροσκάφος φαίνεται προσγειωμένο στη δική του πλατφόρμα, στον ρηχό τεχνητό κρατήρα στην επιφάνεια κάποιου εξωκόσμιου πλανητοειδούς. Στην πραγματικότητα πρόκειται για μικροσκοπικά λέπια που καλύπτουν τη ράχη ενός πολύ γήινου σκαθαριού.

Ορισμένα έντομα, ιδίως πεταλούδες και σκόροι, αλλά και πλήθος σκαθάρια, καλύπτονται από μικροσκοπικά, επίπεδα λέπια. Όπως και ολόκληρο το σκληρό κέλυφος του σώματός τους, έτσι και τα λέπια είναι από χιτίνη, οργανική ουσία ανθεκτική και αδιάλυτη στο νερό. Αυτό το μόριο πολυσακχαρίτη εναποτίθεται σε στιβάδες, οι οποίες, αν και ελαφρότατες, είναι πολύ ισχυρές – όπως ισχυρό και εύκαμπτο είναι και το κόντρα πλακέ που αποτελείται από περισσότερα του ενός φύλλα ξύλου.

Τα λέπια των εντόμων αποτελούν εξέλιξη τριχών και φυτρώνουν σε πόρους διάσπαρτους σε όλο το σώμα. Σε μερικά έντομα αυτά τα χιτινώδη τριχία (setae) έχουν εξελιχθεί σε όργανα αφής ή ανιχνεύουν ηχητικούς παλμούς και τα ρεύματα στην ατμόσφαιρα. Άλλα έχουν μετεξελιχθεί σε αμυντικές ή επιθετικές σμήριγγες. Όπου έχουν μετατραπεί σε επίπεδα λέπια, είναι σαν ψηφίδες που σχηματίζουν υπέροχα μωσαϊκά.

Κάθε λέπι έχει ένα γενετικά κωδικοποιημένο χρώμα, το οποίο συνήθως βασίζεται στη φυσιολογική χρωστική μελανίνη που είναι διαδεδομένη σε όλο το ζωικό βασίλειο και, ανάλογα με την πυκνότητά της, παράγει όλο το φάσμα των χρωμάτων. Επιπλέον αόρατες εγκοπές διαθλούν το φως και αντανακλούν ένα φωτεινό γαλάζιο, πράσινο ή κόκκινο του χαλκού που έχει τη λάμψη του μετάλλου.

Τα λέπια μπορεί να διατάσσονται έτσι ώστε να δημιουργούν γραμμές ή κουκίδες ή λωρίδες χρωμάτων. Τα συγκεκριμένα, τα οποία καλύπτουν τη ράχη του σκαθαριού δερμάτων που τρέφεται με ψοφίμια και αποθηκευμένα δέρματα και γούνες, σχηματίζουν μια σύνθεση από κουκίδες για να μην διακρίνεται μέσα στις γούνες και τα φτερά.

Αυτά τα αιχμηρά και οδοντωτά δόντια, που μοιάζουν έτοιμα να γδάρουν ό,τι αγγίξουν, θα μπορούσαν να είναι τα σκληρά δόντια ενός εκσκαφέα ή τα υνία κάποιου γιγαντιαίου άροτρου ή τα λειασμένα δόντια ενός μηχανήματος εξόρυξης ορυκτού άνθρακα ή ακόμα η επιφάνεια ενός πελώριου τρίφτη τυριού. Οι φολίδες αυτές με τις τρεις αιχμές είναι ανασηκωμένες, θαρρείς για να φεύγουν τα σκύβαλα και τα απορρίμματα. Στην πραγματικότητα αυτά τα οστέινα πλακίδια είναι τα μικροσκοπικά λέπια στο δέρμα του καρχαρία και το μόνο που κόβουν είναι το νερό.

Η ομοιότητα ωστόσο με δόντια δεν είναι τυχαία, καθώς διατυπώθηκε η άποψη ότι αναπτύχθηκαν με τον ίδιο τρόπο, και πολλά επιμέρους χαρακτηριστικά της δομής τους είναι κοινά. Ονομάζονται πλακοειδή λέπια και συστατικό τους είναι η οδοντίνη, ένα σκληρό ασβεστούχο υλικό πυκνότερο από οστό· η οδοντίνη αποτελείται από μια σκληρή κρυσταλλική ουσία, τον απατίτη, ενσωματωμένη σε μια ελαστική πρωτεΐνη, το κολλαγόνο, που αποτελεί μείζονος σημασίας συστατικό του δέρματος. Η επιφάνειά τους καλύπτεται από λείο σμάλτο και τρέφονται από τριχοειδή αγγεία. Μοιάζουν τόσο πολύ με δόντια, ώστε οι περισσότερες σύγχρονες πηγές χρησιμοποιούν τον όρο «δερματικά δόντια».

Τα δόντια εκτός του ότι σχηματίζουν έναν σκληρό αλλά εύκαμπτο θώρακα που αποτρέπει τις πεταλίδες και τα παράσιτα να προσκολληθούν στον καρχαρία, χρησιμοποιούνται και ως μέσον τραυματισμού των θηραμάτων του. Ίσως όμως η χρησιμότερη ιδιότητά τους είναι ότι του δίνουν τη δυνατότητα να κινείται αθόρυβα στο νερό χωρίς να γίνεται αντιληπτός.

Με μια πρώτη ματιά οι κοφτερές αιχμές των δοντιών φαίνονται σαν να είναι η εμπρόσθια όψη τους, στην πραγματικότητα όμως είναι τα οπίσθια άκρα τους, το κεφάλι δηλαδή του καρχαρία είναι στο νοητό άκρο άνω αριστερά της εικόνας. Οι τρεις ράχες και οι τρεις αύλακες κάθε δοντιού είναι απόρροια υδροδυναμικής προσαρμογής, διότι μειώνουν την αντίσταση κατά την κίνησή του στο νερό. Καθώς το νερό περνά πάνω από το δέρμα, μειώνεται η ένταση της τύρβης και αποφεύγονται οι στροβιλισμοί με αποτέλεσμα να μην ακούγεται το νερό καθώς περνά πάνω από το σώμα του και έτσι να μην ειδοποιείται το θήραμα.

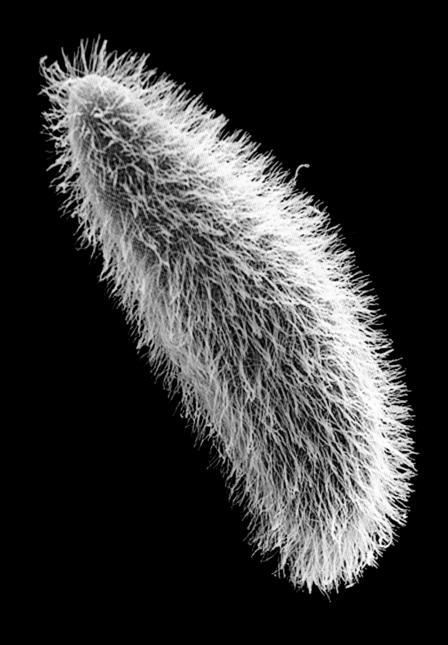

ΑΠΕΝΑΝΤΙ
**Βλεφαρίδες (κινούμενες τρίχες)
που καλύπτουν το σώμα ενός
μικροσκοπικού μονοκύτταρου
ζωικού οργανισμού.**
Βλ. σελ. 40

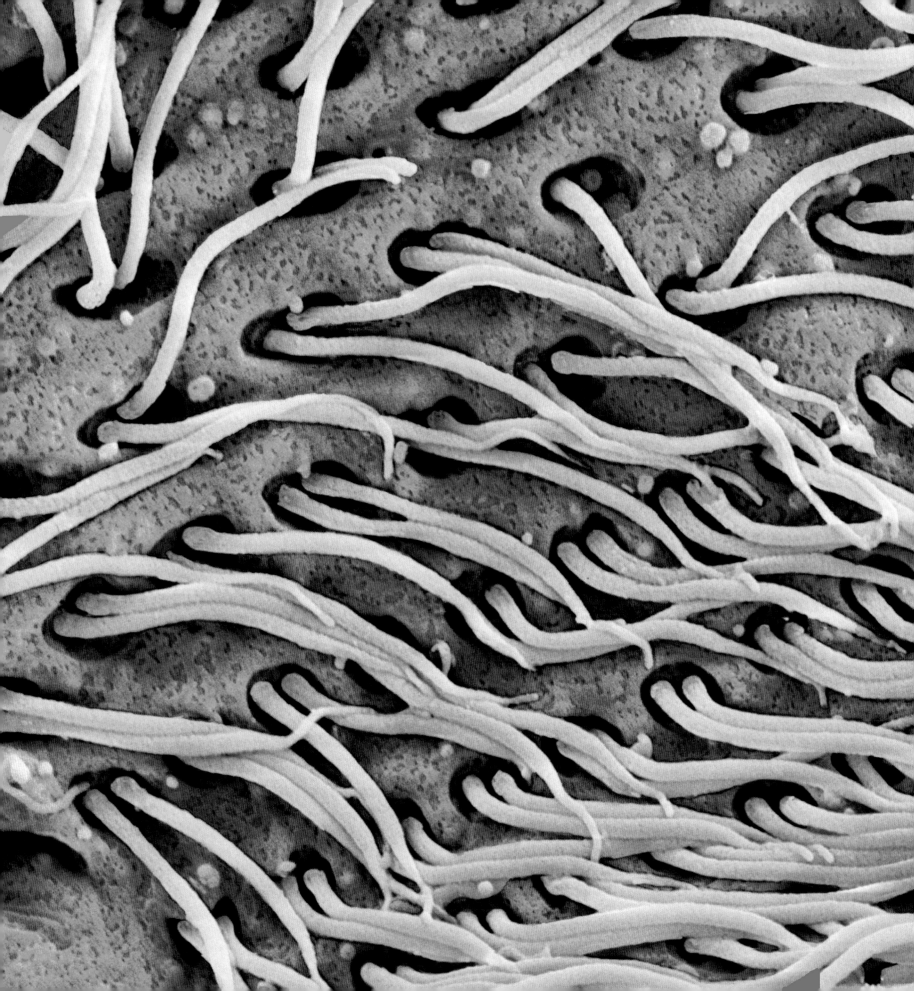

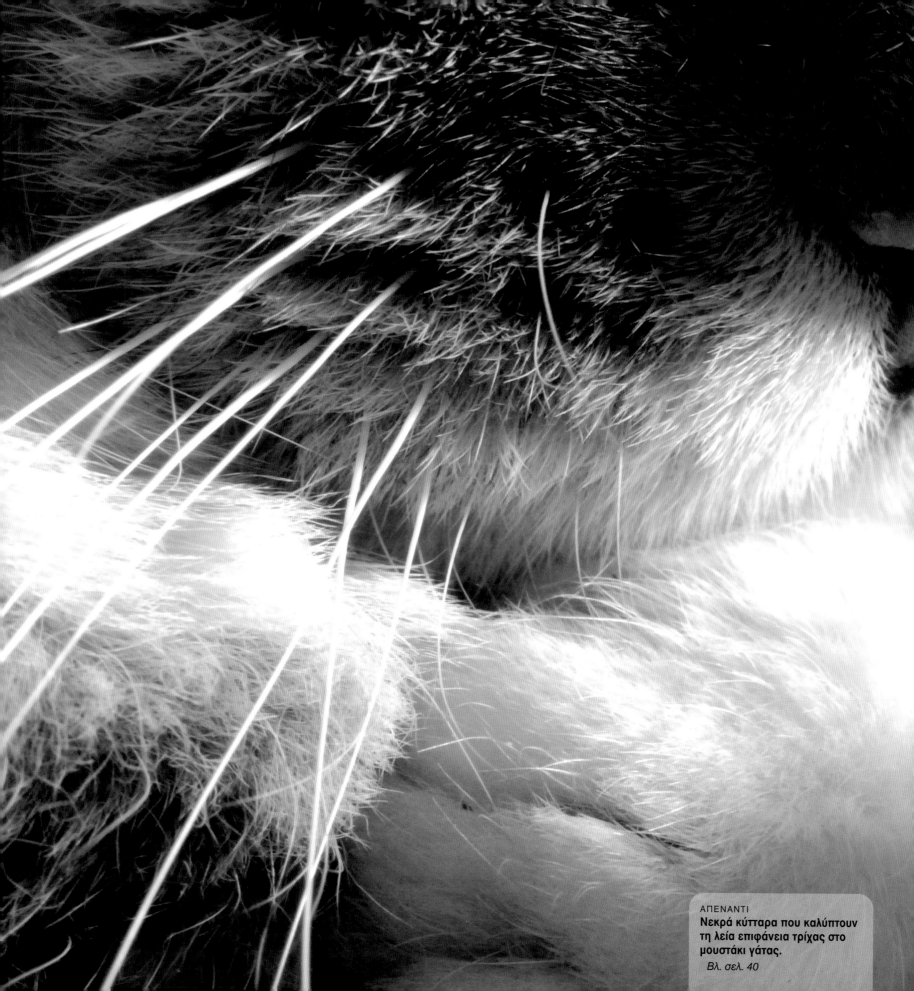

ΑΠΕΝΑΝΤΙ
Νεκρά κύτταρα που καλύπτουν τη λεία επιφάνεια τρίχας στο μουστάκι γάτας.
Βλ. σελ. 40

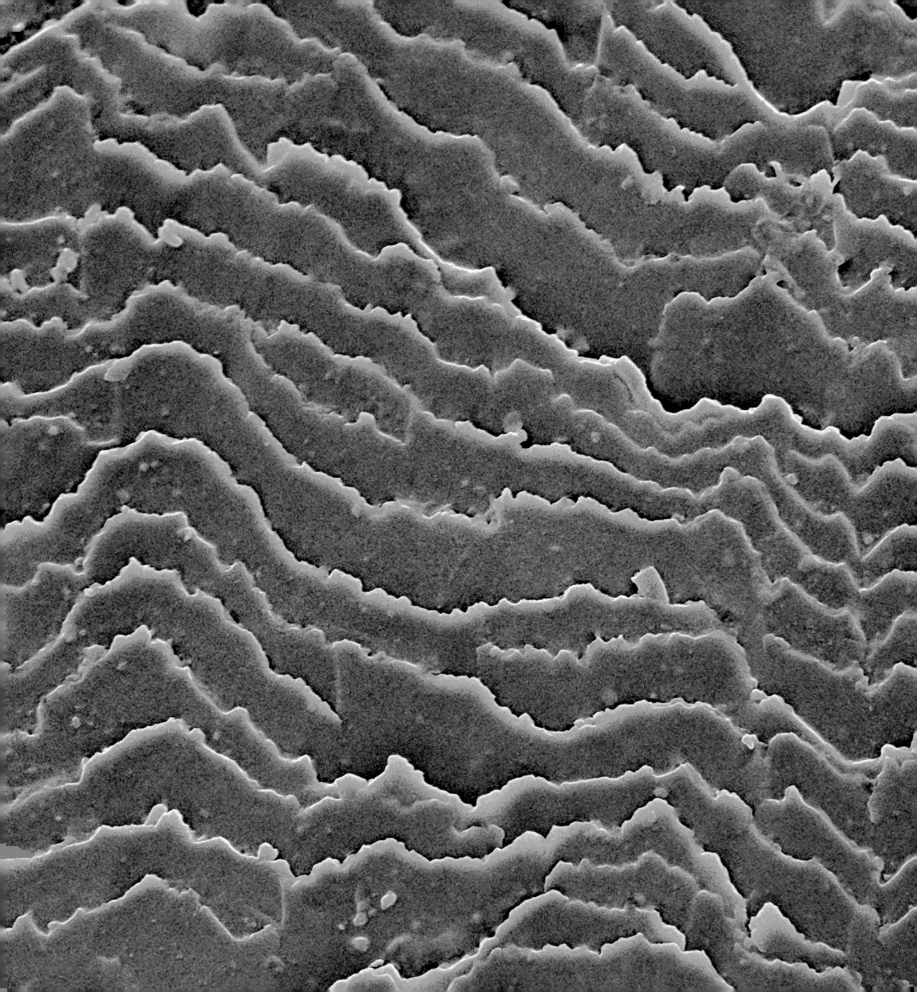

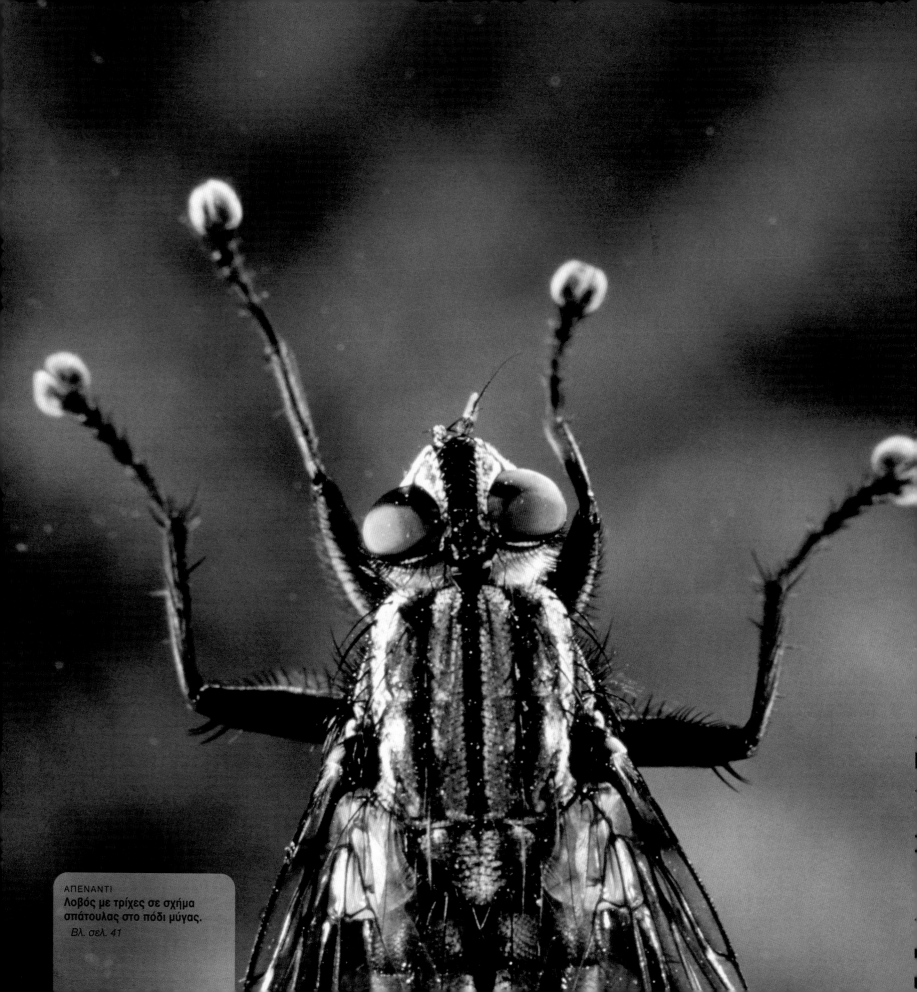

ΑΠΕΝΑΝΤΙ
Λοβός με τρίχες σε σχήμα σπάτουλας στο πόδι μύγας.
Βλ. σελ. 41

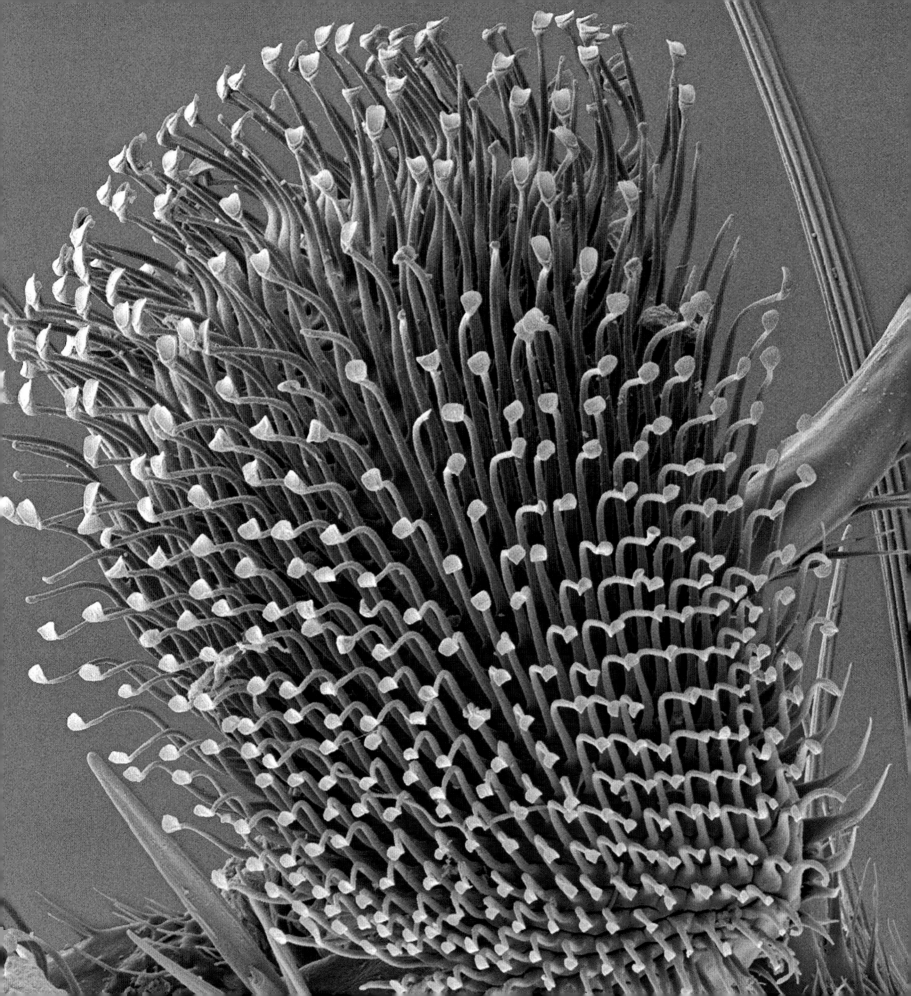

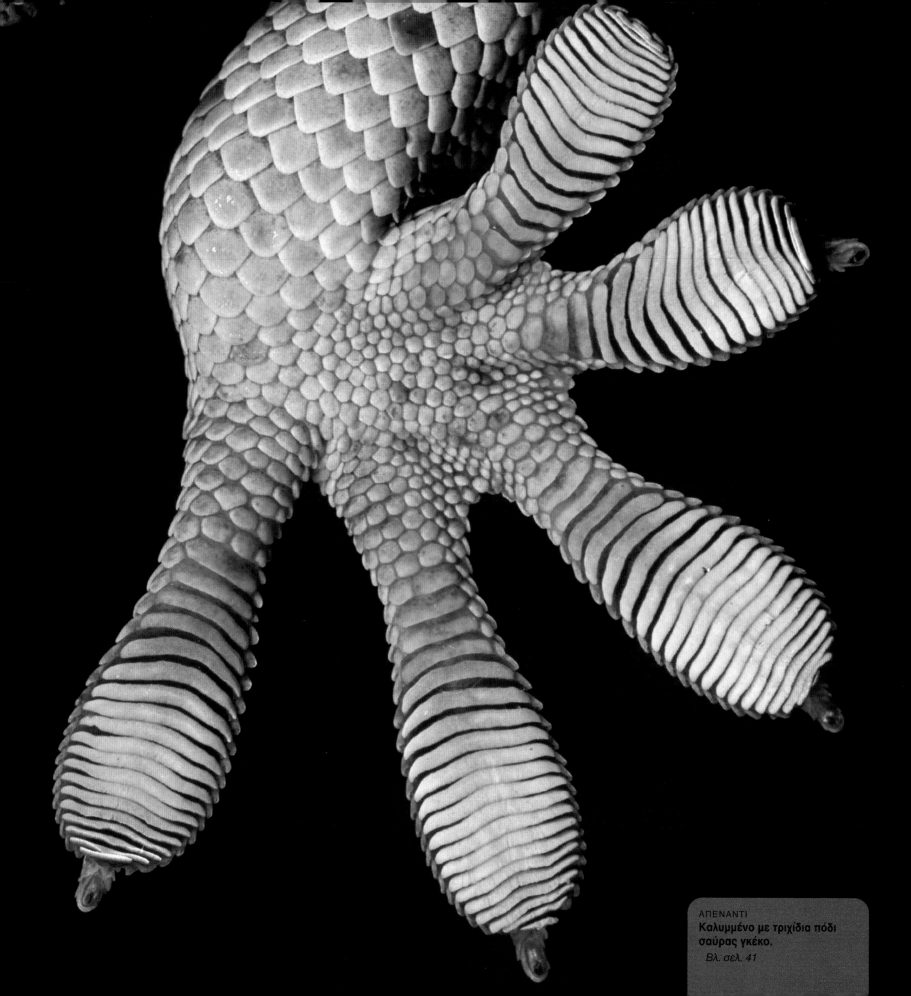

ΑΠΕΝΑΝΤΙ
Καλυμμένο με τριχίδια πόδι σαύρας γκέκο.
Βλ. σελ. 41

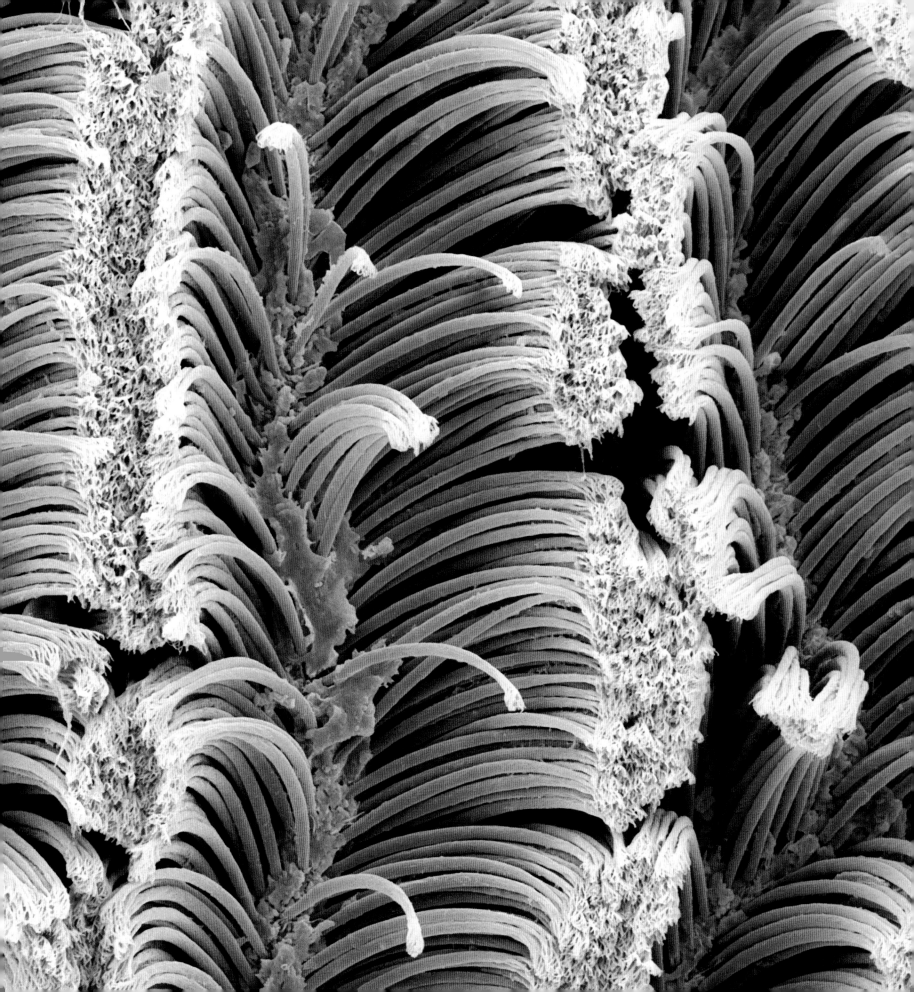

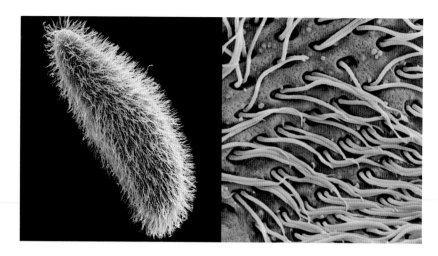

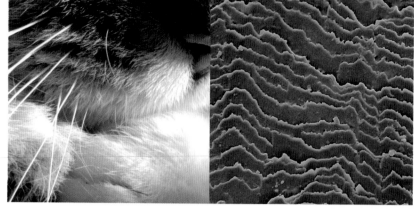

Τα εύθραυστα τριχίδια που προβάλλουν από την εξωτερική μεμβράνη αυτού του μικροσκοπικού μονοκύτταρου ζώου φαίνονται εδώ πεσμένα και αχτένιστα, αλλά όταν ζούσε ήταν άκαμπτα και στητά ή κινούνταν στον ίδιο ρυθμό σαν σειρές μικροσκοπικών κουπιών. Τα βλεφαριδωτά ονομάστηκαν έτσι από αυτό το κάλυμμα λεπτότατων τριχών ή βλεφαρίδων. Είναι η σπουδαιότερη ομάδα μονοκύτταρων ζώων που περιλαμβάνει περίπου 10.000 γνωστά είδη και απαντώνται όπου υπάρχει νερό: στους ωκεανούς, τους ποταμούς, τις λίμνες, το χώμα.

Οι βλεφαρίδες κινούνται ρυθμικά όλες μαζί ή ανά κύματα και προωθούν το μικροσκοπικό ζώο μέσα στο νερό. Συνήθως διατάσσονται σε σειρές, φυτρώνουν δε μία ή, όπως στην εικόνα, δύο σε κάθε πόρο (κινητόσωμα) του κυττάρου. Η κίνησή τους έχει παραλληλιστεί με του μαστίγιου, αλλά πρόσφατες εξελίξεις στη μικροσκοπία αποκάλυψαν ότι μοιάζει μάλλον με την κίνηση φτερού. Όταν κινείται προς τα κάτω ωθώντας το νερό προς τα πίσω σχετικά ίσια και άκαμπτη, όταν επανέρχεται στην αρχική θέση κάμπτεται.

Ο ακριβής μηχανισμός των βλεφαρίδων δεν έχει ακόμα γίνει πλήρως κατανοητός, πάντως ο βαθμός της κάμψης τους ελέγχεται από μικροσκοπικούς σωληνίσκους πρωτεϊνών που τις διατρέχουν εσωτερικά. Κάθε τρίχα στο εσωτερικό της έχει δύο μικροσωλήνες που περιβάλλονται από εννέα ζεύγη άλλων μικροσωλήνων. Η ελεγχόμενη, ολισθαίνουσα κίνηση των ζευγών αυτών των μικροσωλήνων επιτρέπει στις τρίχες να κάμπτονται σε διαφορετικά σημεία του μήκους τους.

Οι βλεφαρίδες ή αλλιώς μαστίγια (flagella) παρουσιάζουν αξιοσημείωτες ομοιότητες σε όλο το φάσμα του ζωικού βασιλείου. Σε μεγαλύτερους οργανισμούς είναι συνήθως προσκολλημένες στο εξωτερικό ενός ακίνητου κυττάρου και οι κινήσεις τους μετακινούν, για παράδειγμα, ρύπους και βλέννες από τους πνεύμονες στην τραχεία ή το ωάριο από τις σάλπιγγες στη μήτρα.

Βλέποντας τις ακανόνιστες ακμές αυτών των επικαλυπτόμενων πλακών φαντάζεσαι πως είχαν επωμιστεί ένα έργο δύσκολο, σαν φθαρμένα από τη χρήση λέπια ψαριού. Ωστόσο, η τραχιά αυτή επιφάνεια δεν έχει καμία σχέση με τα λεία και γυαλιστερά μουστάκια της γάτας που βλέπουμε εδώ μεγεθυμένα.

Ο παραλληλισμός με λέπια ψαριών είναι εύστοχος, γιατί οι τρίχες προέρχονται από το δέρμα και περιβάλλονται από νεκρά δερματικά κύτταρα. Τα κύτταρα αυτά δημιουργούν το κύριο συστατικό της τρίχας – τη μακριά ελικοειδή αλυσίδα μορίων της πρωτεΐνης κερατίνη, ένα φυσικό πολυμερές που κάνει την τρίχα δυνατή και ευλύγιστη.

Τα μουστάκια (vibrissae) είναι πολύ πιο μακριά, χοντρά και σκληρά από τις κανονικές τρίχες και έχουν εξελιχθεί σε σημαντικά αισθητήρια όργανα για μερικά ζώα. Στις γάτες σχηματίζουν συνήθως τέσσερις ή πέντε σειρές στους λοβούς πάνω από το άνω χείλος. Τέτοιες τριχοειδείς ίνες αλλά πιο κοντές έχει και πάνω από τα μάτια. Ο θύλακος κάθε τέτοιας τρίχας εισχωρεί πολύ βαθύτερα στο δέρμα από ό,τι των κανονικών τριχών, και τη βάση του περιβάλλει κάψα γεμάτη αίμα, ο λεγόμενος κόλπος (sinus), που και αυτός περιβάλλεται από νεύρα. Ακόμα και η πιο ανεπαίσθητη κίνηση μιας τρίχας μουστακιού κάμπτει τη ρίζα μεταβάλλοντας την πίεση σε διάφορα σημεία γύρω από τον κόλπο του αίματος, πράγμα που γίνεται αισθητό από το πλήθος νευρικών κυττάρων της περιοχής.

Οι γάτες χρησιμοποιούν τα μουστάκια ως όργανο αφής, ιδίως στο σκοτάδι, αλλά επίσης για να αντιλαμβάνονται και την πιο ανεπαίσθητη κίνηση στην ατμόσφαιρα. Η άποψη, ότι το μήκος των μουστακιών τους ισούται με το πλάτος του σώματός τους και ότι έτσι καταλαβαίνουν εάν μπορούν να περάσουν από ένα στενό πέρασμα, είναι μύθος. Το μήκος τους είναι γενετικά καθορισμένο και διαφέρει από ράτσα σε ράτσα, απλώς όλες τα χρησιμοποιούν για να βρίσκουν ψηλαφητά τον δρόμο τους και ως μέσον επικοινωνίας: τα κατεβάζουν και τα γέρνουν προς τα πίσω όταν είναι θυμωμένες ή σε συναγερμό, τα σηκώνουν και τα γέρνουν προς τα μπρος όταν είναι σε επιφυλακή και περίεργες.

ΔΕΞΙΑ
Οι βλεφαρίδες είναι μικροσκοπικές τρίχες στο σώμα μονοκύτταρων ζώων που κινούνται ρυθμικά σαν κουπιά έλκοντας το ζώο μέσα στο νερό.

ΑΡΙΣΤΕΡΑ
Παραμήκιο βλεφαριδωτό πρωτόζωο της τάξης των Ολότριχων που χρησιμοποιεί τις χιλιάδες βλεφαρίδες του για να καταδιώκει βακτήρια και άλλα μικροσκοπικά θηράματα.

ΔΕΞΙΑ
Νεκρά κύτταρα του δέρματος που καλύπτουν τα μουστάκια της γάτας τα οποία, όπως και οι τρίχες άλλων θηλαστικών, προέρχονται από το δέρμα.

ΑΡΙΣΤΕΡΑ
Στη ρίζα κάθε τρίχας μουστακιού υπάρχει κοιλότητα γεμάτη αίμα περιβαλλόμενη από νεύρα που αντιλαμβάνονται κάθε κίνηση της τρίχας.

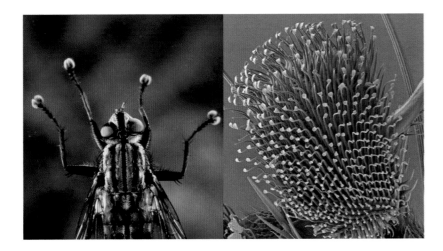
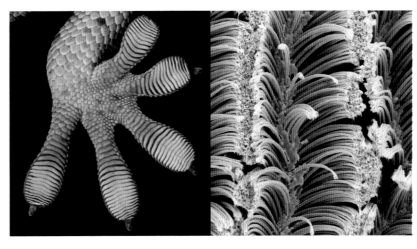

Ένα σύνθετο και ντελικάτο γαϊδουράγκαθο ή νεράγκαθο θα μπορούσε κάλλιστα να περιλαμβάνεται στα είδη κάποιου φυτώριου. Τα ελαφρώς καμπυλωτά πέταλα του άνθους έρχονται σε αντίθεση με τα αιχμηρά αγκάθια του στελέχους, δημιουργώντας μια εικόνα εκπληκτική και συνάμα γοητευτική. Αλλά αυτό που εικονίζεται εδώ δεν ανήκει στο βασίλειο των φυτών, καθώς είναι η απόληξη του ποδιού μιας μύγας και η γοητεία του έγκειται στη μοριακή συνάφεια.

Ο ταρσός μιας μύγας χωρίζεται σε τέσσερα ή πέντε αρθρωτά μέρη, τα ταρσομερή, και κάτω από το τελευταίο ταρσομερές υπάρχει ένας λοβός σαν μαξιλαράκι (pulvillus). Ο λοβός αυτός καλύπτεται από χιλιάδες μικροσκοπικές τρίχες που έχουν σχήμα σπάτουλας και λέγονται προσκολλητικές σμήριγγες (setae). Στις πεπλατυσμένες αυτές τρίχες οφείλεται το γεγονός ότι οι μύγες μπορούν να σεργιανούν στο ταβάνι και να προσκολλώνται ακόμα και σε πεντακάθαρα, λεία τζάμια. Η ακριβής λειτουργία τους εξακολουθεί να μελετάται. Τα ίχνη των ποδιών της σε γυαλί δείχνουν πως η μύγα χρησιμοποιεί κάποιο

υγρό, ίσως όμως να έχουμε έναν συνδυασμό υγρής και «στεγνής» προσκόλλησης μέσω των δεσμών Van der Waals, των δυνάμεων μεταξύ των μορίων που τα συνέχουν, τις οποίες χρησιμοποιεί και η σαύρα γκέκο.

Όταν η μύγα προσγειώνεται σε μια λεία επιφάνεια, ο προσκολλητικός λοβός πιέζεται και η άκρη κάθε τρίχας εκκρίνει μια απειροελάχιστη ποσότητα υγρού – είναι το υγρό που κρατά τη μύγα κρεμασμένη ανάποδα στο ταβάνι ή τη συγκρατεί στο γυαλί. Η δύναμη που κρατά το έντομο έτσι δεν είναι δύναμη τριβής, αλλά μοριακή δύναμη έλξης παρόμοια με την επιφανειακή ένταση που κρατά αιωρούμενα σταγονίδια νερού στο ταβάνι του μπάνιου. Παράγεται από μεμονωμένα μόρια μέσα στο υγρό, τα οποία έλκουν το ένα το άλλο έλκοντας ταυτόχρονα μόρια στα άκρα των σμηρίγγων και στο υλικό του ταβανιού.

Αν και ισχυρή, η δύναμη αυτή μπορεί να ηττηθεί. Σαρκοβόρα φυτά καλύπτουν τα γεμάτα νερό ασκίδιά τους, που είναι ταυτόχρονα και παγίδες, με ένα ελαιώδες κερί που διαλύει τις εκκρίσεις της μύγας: το έντομο αδυνατεί να κρατηθεί, γλιστρά μέσα και βρίσκει το θάνατο.

Τα θυσανωτά νήματα που μοιάζουν να ανήκουν σε παχύ, πυκνό χαλί φαίνονται ελαφρώς φθαρμένα και ξεφτισμένα στις άκρες. Ωστόσο, ο λόγος δεν είναι ότι περπάτησαν πολλά πόδια πάνω τους, αλλά ότι αποτελούν το τριχωτό πέλμα ποδιού που περπατά. Το πιο εντυπωσιακό, όμως, δεν είναι αυτό, είναι ότι το πόδι αυτό περπατά κυρίως σε τοίχους και ταβάνια. Είναι το πόδι ενός γκέκο που καθιστά τη σαύρα αυτή ικανή να προσκολλάται ακόμα και στα πιο λεία φύλλα του δάσους και στα πιο αστραφτερά γυάλινα δοχεία του εργαστηρίου.

Η ικανότητα του γκέκο σχεδόν να προσφύεται σε επίπεδες επιφάνειες συναρπάζει ανέκαθεν. Το γκέκο μπορεί να κρέμεται από το ταβάνι μόνο από το ένα δάχτυλο του ποδιού, αλλά χρησιμοποιεί κάτι παραπάνω από νύχια για να πιάνεται. Έχουν διατυπωθεί διάφορες υποθέσεις σχετικά, μεταξύ άλλων η υπόθεση της έλξης μέσω της τριβής ή των τριχοειδών (που βασίζεται στην επιφανειακή ένταση

του νερού), αλλά ο ακριβής μηχανισμός μόνο πρόσφατα έχει ερμηνευτεί.

Κάθε πόδι του γκέκο φέρει μισό εκατομμύριο μικροσκοπικές τρίχες, τις σμήριγγες, μήκους 30-130 μm και κάθε τρίχα καταλήγει σε πολλές εκατοντάδες ακόμα μικρότερες προεκβολές μήκους 0,2-0,5 μm. Όταν βάζει το πόδι σε μια λεία επιφάνεια τα τριχίδια έρχονται τόσο κοντά της, ώστε δυνάμεις που συνήθως έλκουν και συγκρατούν τα μόρια μεταξύ τους κρατούν και το ζώο κρεμασμένο.

Κάθε σμήριγγα παράγει ελάχιστη δύναμη, όλες μαζί όμως δημιουργούν μια τόσο ισχυρή δύναμη έλξης με ό,τι και να αγγίξουν, ώστε χρειάζεται δύναμη δεκαπλάσια του βάρους του για να ξεκολλήσει το ζώο. Αυτό το μέσον «στεγνής» συγκόλλησης (δίχως υγρή ή κολλώδη ουσία), που μπορεί να χρησιμοποιείται αέναα, έχει ήδη βάλει στον πειρασμό κατασκευαστές να προχωρήσουν στην παραγωγή ενός σελοτέιπ γκέκο για καθημερινή χρήση.

ΔΕΞΙΑ
Τα μικροσκοπικά πεπλατυσμένα τριχίδια του λοβού στο άκρο του ταρσού εκκρίνουν σταγονίδια υγρού, επιτρέποντας στη μύγα να κολλά σε λείες επιφάνειες, όπως στο γυαλί.

ΑΡΙΣΤΕΡΑ
Μια κρεατόμυγα κρέμεται από ένα τζάμι χρησιμοποιώντας τους πλατείς, ριπιδοειδείς λοβούς (μαξιλαράκια) στα πόδια της.

ΔΕΞΙΑ
Εκατοντάδες χιλιάδες τριχίδια στα πέλματά του επιτρέπουν στο γκέκο να περπατά σε λείες επιφάνειες εκμεταλλευόμενο την ελκτική δύναμη μεταξύ των μορίων.

ΑΡΙΣΤΕΡΑ
Καθώς πιέζονται πάνω σε κάποιον υαλοπίνακα τα τριχωτά πέλματα απλώνουν αυξάνοντας την επιφάνεια προσκόλλησης.

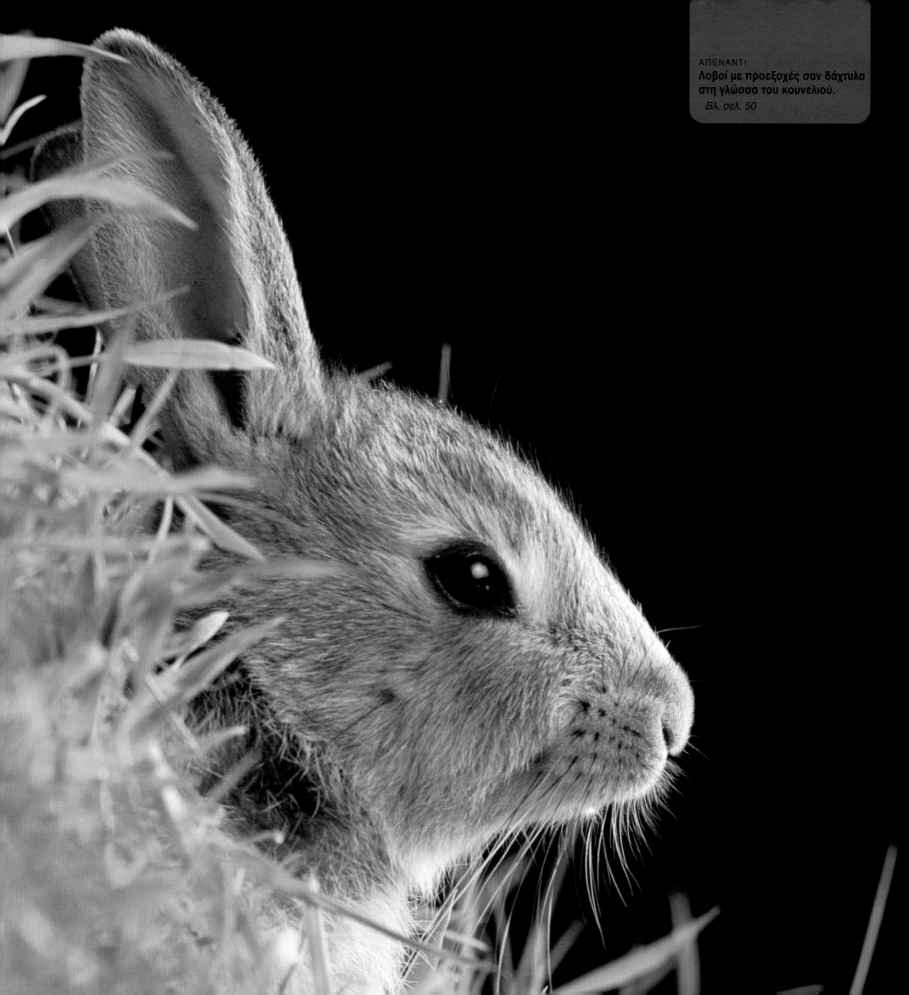

ΑΠΕΝΑΝΤΙ
**Λοβοί με προεξοχές σαν δάχτυλα
στη γλώσσα του κουνελιού.**
Βλ. σελ. 50

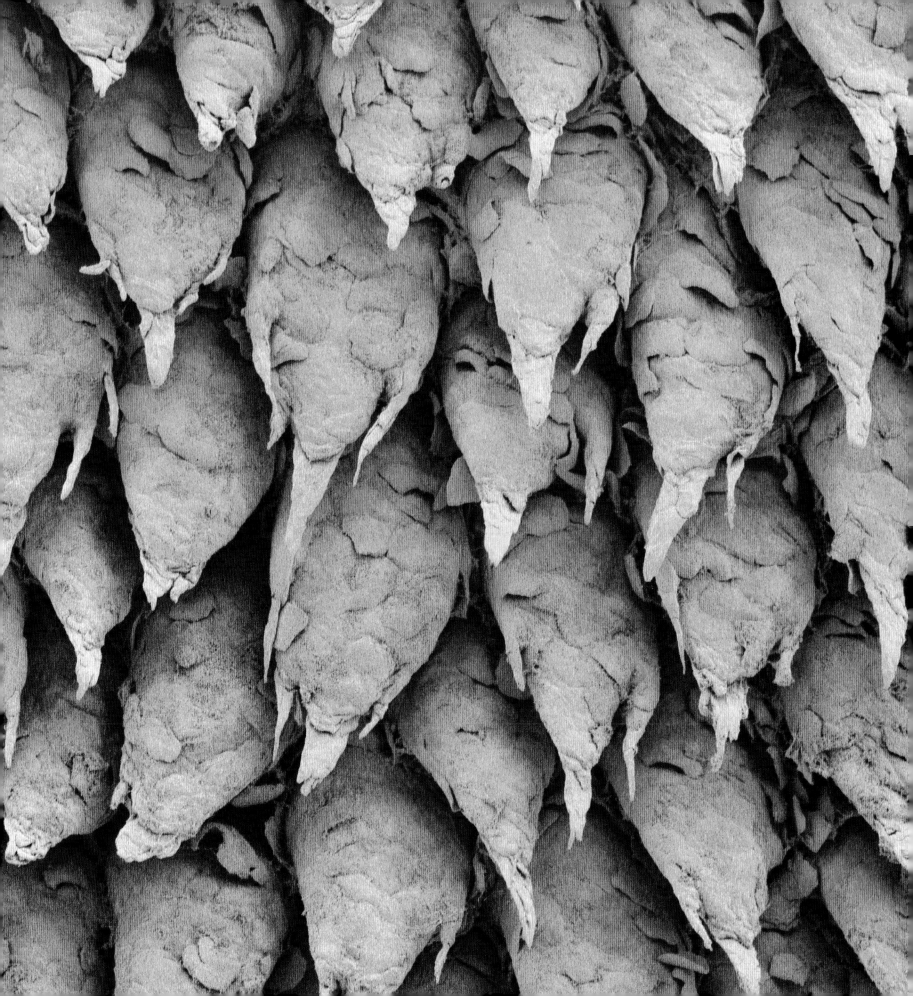

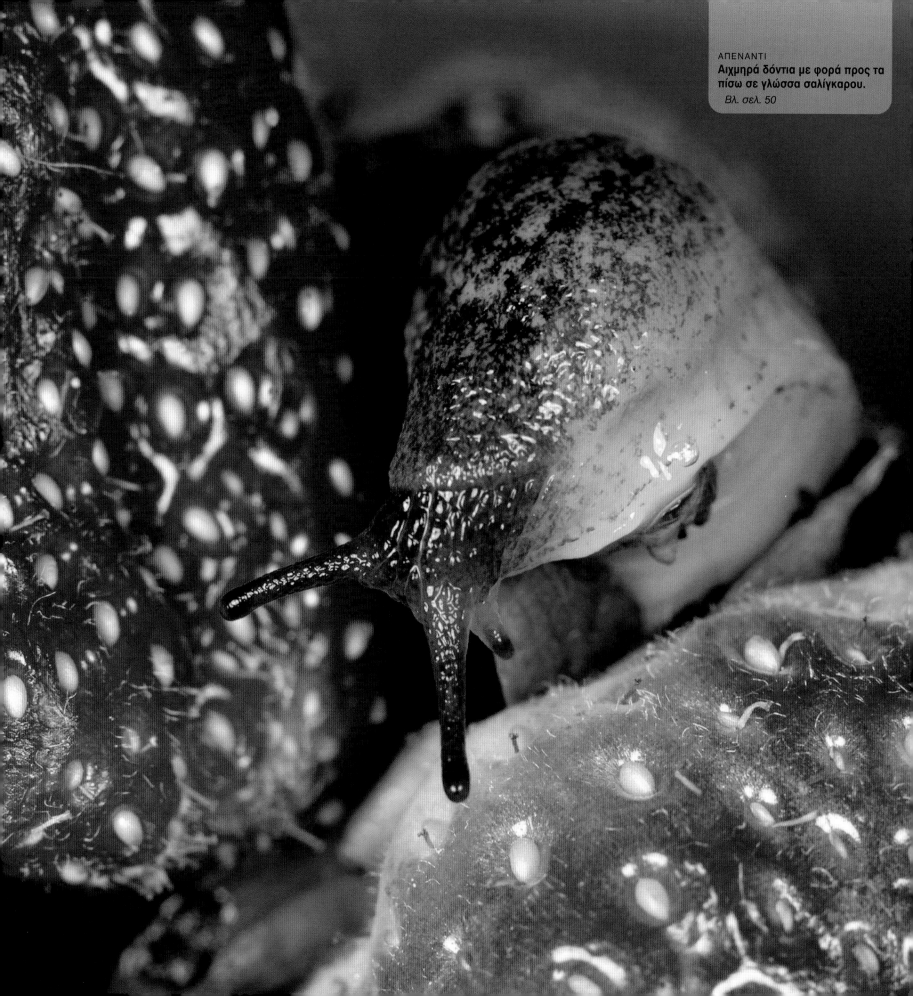

ΑΠΕΝΑΝΤΙ
Αιχμηρά δόντια με φορά προς τα πίσω σε γλώσσα σαλίγκαρου.
Βλ. σελ. 50

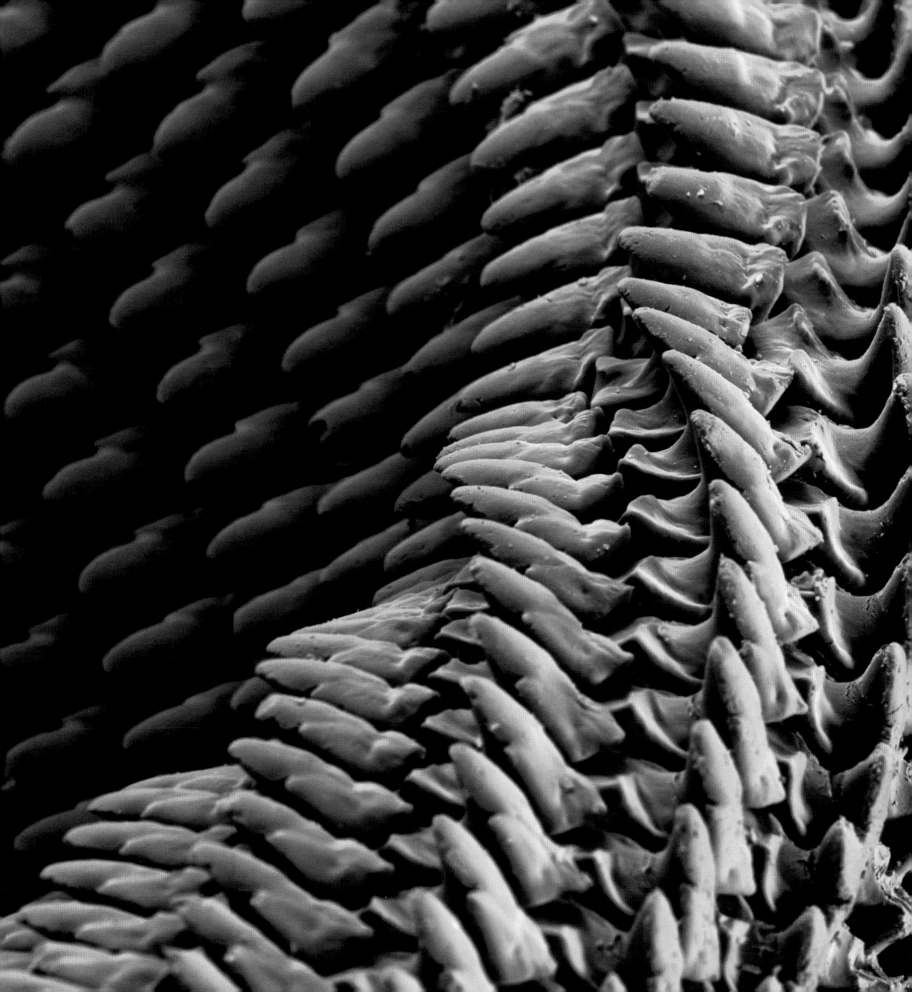

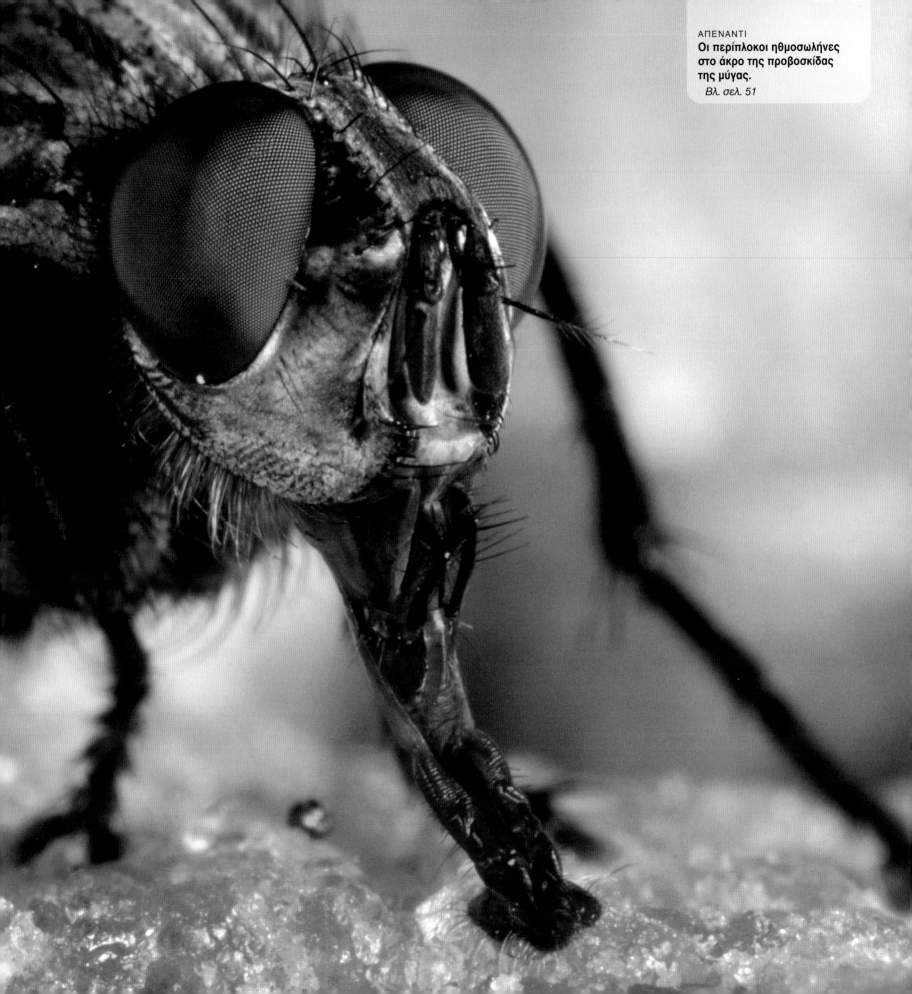

ΑΠΕΝΑΝΤΙ
Οι περίπλοκοι ηθμοσωλήνες στο άκρο της προβοσκίδας της μύγας.
Βλ. σελ. 51

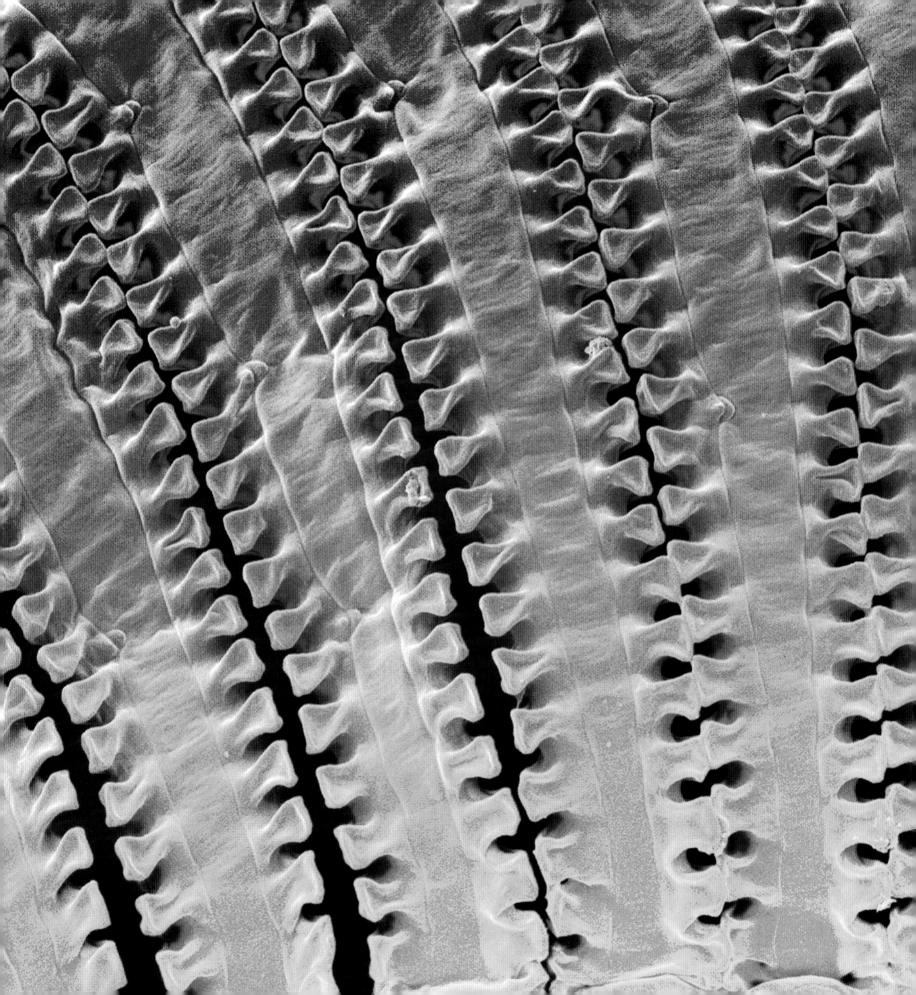

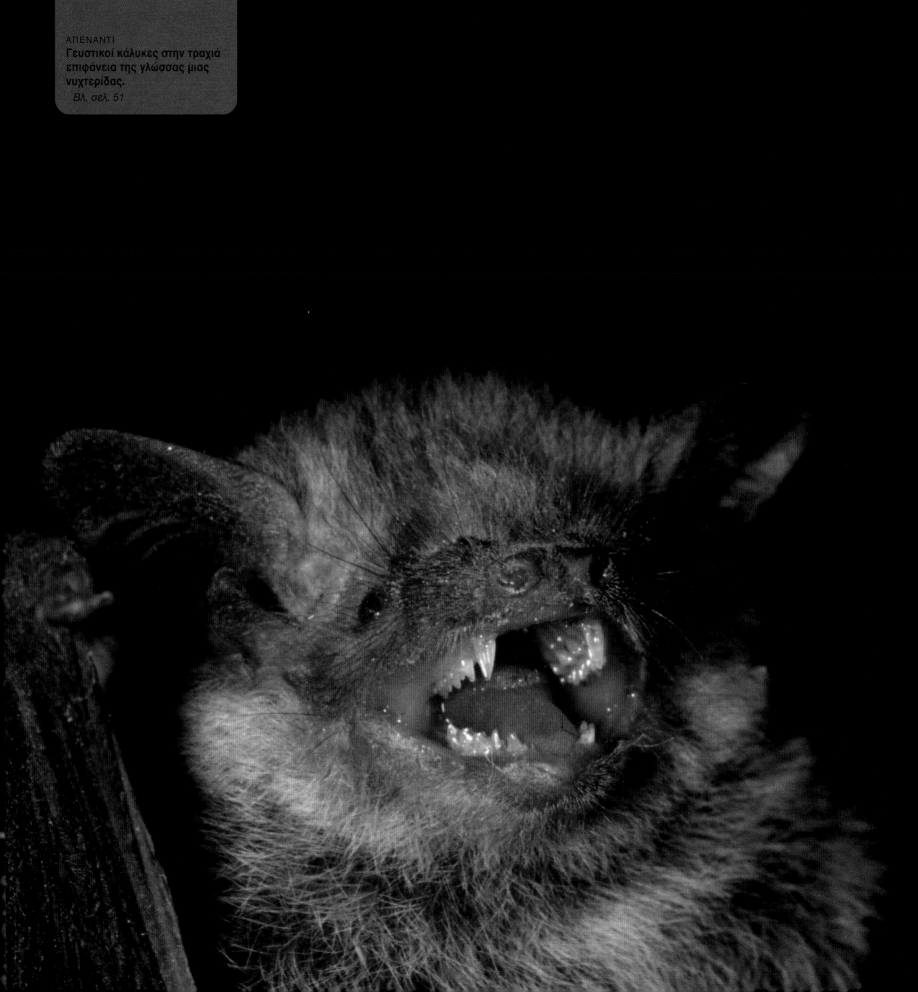

ΑΠΕΝΑΝΤΙ
Γευστικοί κάλυκες στην τραχιά
επιφάνεια της γλώσσας μιας
νυχτερίδας.
Βλ. σελ. 51

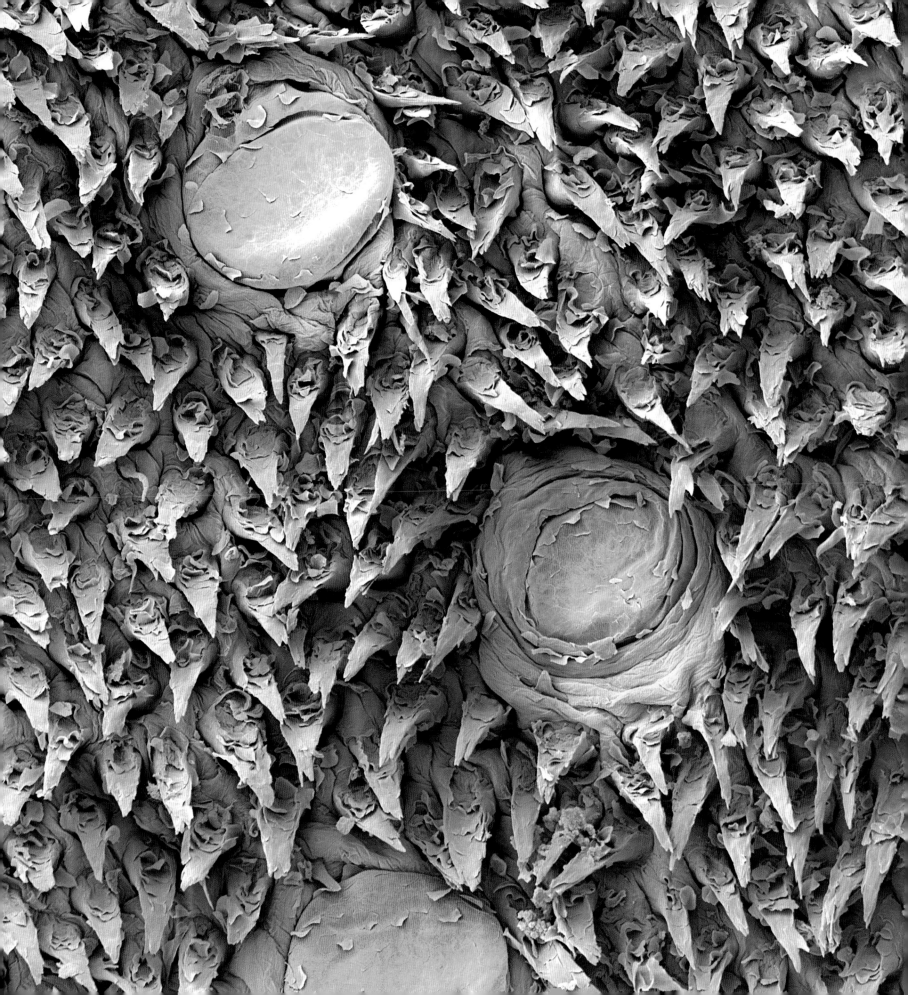

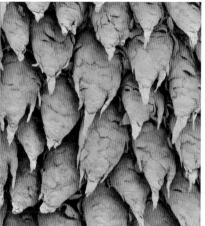
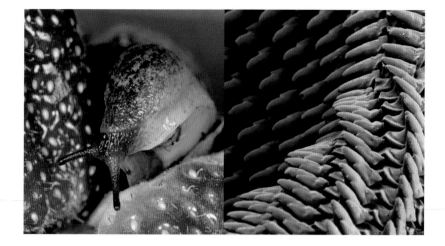

Αυτά τα φολιδωτά «μαξιλαράκια» με τα δάχτυλα είναι διατεταγμένα σε διαγώνιες περίπου σειρές. Δεν έχουν τέλειο γεωμετρικό σχήμα και ορισμένα μοιάζουν φαγωμένα. Και είναι φυσικό, καθώς πρόκειται για τη γλώσσα ενός θηλαστικού, για μία από τις πιο περίπλοκες μυικές δομές στο σώμα του κουνελιού, σχεδόν μονίμως εν χρήσει.

Οι γλώσσες των θηλαστικών επιτελούν πολλές λειτουργίες και είναι διαφόρων σχημάτων και μεγεθών. Στους ανθρώπους χρησιμεύουν στην ομιλία και, όπως και στα ανώτερα πιθηκοειδή, στην πέψη. Οι μυρμηγκοφάγοι έχουν μακριά, κολλώδη γλώσσα για να πιάνουν μυρμήγκια και τερμίτες. Οι αγελάδες και οι καμηλοπαρδάλεις έχουν συλληπτικές γλώσσες για να τραβούν χόρτα και φύλλα. Και σχεδόν όλα τα θηλαστικά με τη γλώσσα χειρίζονται την τροφή στο στόμα και την καταπίνουν.

Οι μικροδομές στην επιφάνειά της ποικίλλουν ανάλογα με τον ρόλο της γλώσσας ολόκληρης ή μέρους της, και παίρνουν τη μορφή μικρών εξογκωμάτων, των θηλών (papillae). Οι θηλές οι οποίες, ανάλογα με το σχήμα τους, διακρίνονται σε μυκητοειδείς, φυλλοειδείς και περιχαρακωμένες,

καλύπτονται συνήθως με γευστικούς κάλυκες. Οι περισσότερες όμως είναι οι νηματοειδείς, που προσδίδουν στην επιφάνεια της γλώσσας λίγο έως πολύ τραχιά υφή. Χρησιμεύουν στη συγκράτηση του βόλου της τροφής κατά τη μάσηση, καθώς και στη μετακίνησή του κατά μήκος των δοντιών και στο πίσω μέρος του στόματος κατά την κατάποση.

Στα κουνέλια, τις γάτες, τις αγελάδες και μερικά άλλα θηλαστικά οι νηματοειδείς θηλές είναι εξαιρετικά πολυάριθμες. Σχηματίζουν κανονικές σειρές σαν δόντια χτένας ή τρίχες βούρτσας, επειδή η γλώσσα δεν είναι μόνο όργανο γεύσης και θρέψης, αλλά και καλλωπισμού: βοηθούν τα ζώα να μαλακώνουν και να καθαρίζουν τις τρίχες τους, να τις ξεμπερδεύουν και να τις χτενίζουν, ώστε να είναι παράλληλες, και να διατηρεί το τρίχωμά τους την ιδιότητα του αδιάβροχου και μονωτικού μανδύα.

Το σάλιο που εκκρίνεται όταν χτενίζονται συμβάλλει στην καθαριότητα του τριχώματος, ταυτόχρονα όμως είναι και η αιτία αλλεργιών που εμφανίζονται όταν το σάλιο της γάτας ή του κουνελιού στεγνώνει και σωματίδιά του εισπνέονται μαζί με τον αέρα.

Αυτή η εικόνα θυμίζει τόσο πολύ μεταλλική ράσπα που δεν μπορεί παρά η δομή αυτή να έχει ανάλογη λειτουργία: και όντως πρόκειται για εργαλείο απόξεσης και κοπής. Τα δόντια αυτά είναι σαν γλύφανα τοποθετημένα υπό γωνία στην επιφάνεια τριβής και η ζημιά που προκαλούν δεν πρέπει να υποτιμάται. Το στόμα κάθε χερσαίου σαλιγκαριού ή γυμνοσάλιαγκα περιλαμβάνει ένα εργαλείο τριβής (μασητικό εξάρτημα), το ξέστρο (radula). Και μολονότι κάθε δοντάκι αυτού του ξέστρου έχει μήκος μόλις 40 μm ο αριθμός τους μπορεί να φτάνει τις 100.000 – και ένα τέτοιο πλήθος είναι καταστροφικό για τα φυτά.

Το ξέστρο είναι όργανο σαν γλώσσα στο εσωτερικό της στοματικής κοιλότητας του μαλακίου. Είναι μια ζώνη δοντιών που έχουν φορά προς τα πίσω και είναι τοποθετημένα σε σειρές. Επιφανειακά το ξέστρο κάνει ό,τι και η γλώσσα όταν γλείφει. Μύες κινούν μπρος πίσω τις σειρές των δοντιών, ενώ ταυτόχρονα ένα εξάρτημα από χόνδρο μπορεί και πετάγεται έξω από το στόμα του και έπειτα ξαναμαζεύεται μέσω συστολής

των μυών. Οι συνδυασμένες αυτές κινήσεις επιτρέπουν τη συνεχή απόξεση και μεταφορά σωματιδίων τροφής μέσα στο στόμα και στη συνέχεια μέσω του οισοφάγου στο στομάχι.

Αν και πολλά γαστερόποδα (σαλιγκάρια και γυμνοσάλιαγκες) είναι φυτοφάγα, η πλειονότητα είναι αποικοδομητές, δηλαδή τρέφονται με οργανικές ύλες σε αποσύνθεση, όπως πεσμένα φύλλα, σάπιο ξύλο, πτώματα και περιττώματα ζώων.

Συστατικό των δοντιών του ξέστρου είναι η χιτίνη, ένας σκληρός πολυσακχαρίτης προϊόν υδρογονανθράκων που απαντάται και στον εξωσκελετό των εντόμων, των καβουριών και άλλων γαστερόποδων. Η χημική τους σύνθεση διαφέρει εντελώς από αυτή των κυττάρων των μαλακίων, τα οποία σχηματίζονται κυρίως από ανθρακικό ασβέστιο. Παρότι ισχυρά, τα δόντια διαρκώς φθείρονται, ιδίως στο μπροστινό μέρος του ξέστρου, έτσι φυτρώνουν νέες σειρές στο πίσω μέρος της ζώνης αυτής που βαθμιαία μετακινούνται μπροστά αντικαθιστώντας τις φθαρμένες.

ΔΕΞΙΑ
Η γλώσσα του κουνελιού καλύπτεται με μικροσκοπικές προεξοχές, τις θηλές (papillae). Ορισμένες φέρουν γευστικούς κάλυκες, αλλά οι περισσότερες προορίζονται για τη μετατόπιση της τροφής στο στόμα και για την περιποίηση του ζώου.

ΑΡΙΣΤΕΡΑ
Το μαλακό τρίχωμά του ο λαγός το διατηρεί λείο και καθαρό χτενίζοντάς το με την τραχιά, όμοια με χτένα επιφάνεια της γλώσσας του.

ΔΕΞΙΑ
Η γλώσσα του γυμνοσάλιαγκα (ξέστρο, radula) φέρει χιλιάδες δοντάκια σαν λίμα με την οποία τρίβει και τρώει την τροφή του.

ΑΡΙΣΤΕΡΑ
Το μαλακό και εύκαμπτο σώμα του γυμνοσάλιαγκα έρχεται σε αντίθεση με τα πλήθος μυτερά δυνατά δόντια που στην εικόνα είναι κρυμμένα πίσω από το γλοιώδες πόδι του.

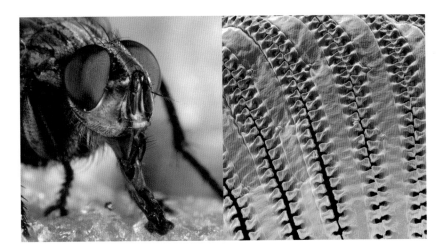

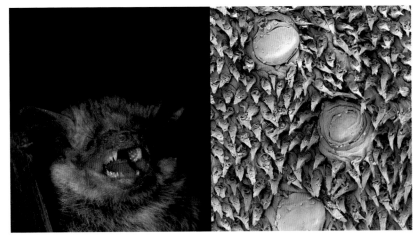

Aυτή η αρχιτεκτονική δομή θα μπορούσε να είναι η υψηλής τεχνολογίας οροφή ενός κτιρίου αεροδρομίου ή λεπτομέρεια πολυεδρικής επιφάνειας ενός τρυπανιού εξόρυξης πετρελαίου. Όπως στις προηγούμενες δομές αντανακλάται η λειτουργία που επιτελούν, έτσι και η γλώσσα της μύγας που εικονίζεται εδώ καθρεφτίζει τη λειτουργία που εξυπηρετεί.

Τα στοματικά μόρια των εντόμων χωρίζονται σε δύο μεγάλες κατηγορίες: σε αυτά με τεράστιες δηκτικές και μασητικές γνάθους και σε αυτά με μυζητικούς σωλήνες. Τα μυζητικά έντομα καλύπτουν ένα ευρύ φάσμα – από τα κουνούπια που πίνουν αίμα μέχρι τις συρφίδες που τρέφονται με νέκταρ. Εδώ εικονίζεται η πλατιά γλώσσα μιας οικιακής μύγας που η μορφή της σχετίζεται άμεσα με τη λειτουργία της, τη λειτουργία ενός σύνθετου μυζητικού εργαλείου.

Οι μύγες σκαλίζουν ό,τι απορρίμματα βρουν, από πτώματα και περιττώματα ζώων μέχρι πεσμένα φρούτα και ανθρώπινες τροφές. Τρέφονται χρησιμοποιώντας μια τεχνική εξωτερικής μερικής πέψης, η διάσπαση δηλαδή της τροφής σε θρεπτικές ουσίες ξεκινά μάλλον εκτός παρά εντός του

σώματος. Για να το πετύχουν αυτό, αποβάλλουν καταρχήν το υγρό περιεχόμενο του προσθεντέρου τους πάνω σε οτιδήποτε έχουν προσγειωθεί. Αυτό το υγρό περιέχει σύνθετα ένζυμα που αρχίζουν αμέσως να διαλύουν την τροφή.

Καθεμιά από τις παράλληλες σαν φερμουάρ ταινίες της εικόνας καλύπτει έναν κυλινδρικό σωλήνα και μέσω αυτών των σωλήνων η μύγα εκβάλλει το περιεχόμενο του προσθέντερου και ταυτόχρονα απομυζά τη μισοχωνεμένη, κολλώδη ουσία. Επομένως η γλώσσα, που μοιάζει με μυζητικό πλοκάμι εξωγήινου χταποδιού, συνδυάζει την τριχοειδή με τη μυζητική δράση των μυών και την απορρόφηση τελικά της τροφής στο σώμα του εντόμου.

Δυστυχώς για τους ανθρώπους, μαζί με τα πεπτικά ένζυμα που εκκρίνει η μύγα στη δυνάμει τροφή της, αποβάλλει, όπως είδαμε, και τα υπολείμματα του τελευταίου γεύματός της. Όταν λοιπόν κάθεται πάνω στο κυριακάτικο ψητό σας που το αφήσατε λίγο να κρυώσει, να θυμάστε ότι μόλις μπήκε από το παράθυρο, αφού ενδεχομένως απόλαυσε πρώτα ένα εξίσου γευστικό γεύμα πάνω στα περιττώματα σκύλου έξω στο δρόμο.

Με μια πρώτη ματιά η υφή της επιφάνειας αυτής θυμίζει ψάθινο χαλάκι ή σκληρή βούρτσα παπουτσιών, αλλά τα αυγά μάτια που την κοσμούν εδώ φαίνονται κάπως αταίριαστα. Η εντύπωση εντούτοις ψάθινου χαλιού είναι εύστοχη, γιατί η χρήση της ινώδους αυτής επιφάνειας είναι παρόμοια με χαλιού. Στο κατώφλι της πόρτας μας οι σκληρές ίνες σκοπό έχουν να συγκρατούν τη λάσπη και να την καθαρίζουν από τα παπούτσια μας. Μέσα στο στόμα του πιπιστρέλου, η τριχωτή γλώσσα τον βοηθά να πιάνει γερά τα έντομα που κυνηγά και τα οποία ίσως έχουν μισοπιαστεί ανάμεσα στις γνάθους του.

Οι μυτερές αυτές προεξοχές, παρόμοιες με αυτές στη γλώσσα του κουνελιού, είναι φυλλοειδείς και σκεπάζουν το μεγαλύτερο μέρος της γλώσσας της νυχτερίδας. Ευαίσθητες στην πίεση, της προσδίδουν την τραχύτητα γυαλόχαρτου, ώστε να συγκρατεί την τροφή στο στόμα και να την ωθεί στον οισοφάγο. Η ικανότητα συγκράτησης της λείας του έχει μεγάλη σημασία για ένα πλάσμα που όταν πετά είναι αναγκασμένο να έχει τα άκρα του τεντωμένα. Η ταχύτατη νυχτερίδα

προσπαθεί να κυνηγήσει ταχύτατα θηράματα και, παρά την ικανότητα ηχοεντοπισμού που τη διακρίνει, συχνά ίσα που πιάνει σκόρους και πεταλούδες από την άκρη του φτερού τους. Τότε όμως αναλαμβάνει δράση η σχεδόν συλληπτήρια γλώσσα της εμποδίζοντας τα έντομα που παλεύουν να διαφύγουν.

Τα μεγάλα ημισφαιρικά εξογκώματα που φαίνονται σαν καμωμένα από δέρμα λέγονται γευστικές μυκητοειδείς θηλές. Στις νυχτερίδες (και σε άλλα εντομοφάγα) η γεύση δεν αποσκοπεί τόσο στη γαστριμαργική απόλαυση όσο στην επιβίωση του ζώου. Οι νυχτερίδες δεν δοκιμάζουν το φαΐ τους για να βρουν μια νόστιμη τροφή ή για να διακρίνουν μεταξύ λεπτότατων γευστικών διαφορών, αλλά για να μην δηλητηριαστούν. Ένα από τα καλύτερα αμυντικά όπλα ενός εντόμου είναι να έχει γεύση αποσύνθεσης και αυτό το πετυχαίνει απομονώνοντας (μαζεύοντας και αποθηκεύοντας) ισχυρές και δηλητηριώδεις χημικές ουσίες από τα φυτά με τα οποία τρέφεται. Η απόφαση της νυχτερίδας να καταπιεί ή να φτύσει δεν είναι εύκολη υπόθεση.

ΔΕΞΙΑ
Το άκρο της προβοσκίδας της οικιακής μύγας είναι μια σύνθετη δομή από ελικοειδείς σίτες και αύλακες μέσω των οποίων απομυζά τη μισοχωνεμένη τροφή της.

ΑΡΙΣΤΕΡΑ
Μόλις η κρεατόμυγα προσγειωθεί στην τροφή της εκτείνει την αρθρωτή προβοσκίδα της και τη δοκιμάζει.

ΔΕΞΙΑ
Η τραχιά υφή του άκρου της γλώσσας του πιπιστρέλου τον βοηθά να συγκρατεί το έντομο που παλεύει να διαφύγει, ενώ οι μεγάλες γευστικές θηλές αποφαίνονται εάν είναι καλό να φαγωθεί ή όχι.

ΑΡΙΣΤΕΡΑ
Μυτερά δόντια χρησιμεύουν επίσης στη συγκράτηση των θηραμάτων της νυχτερίδας, κυρίως σκόρων και σκαθαριών που τα συλλαμβάνει εν πτήσει.

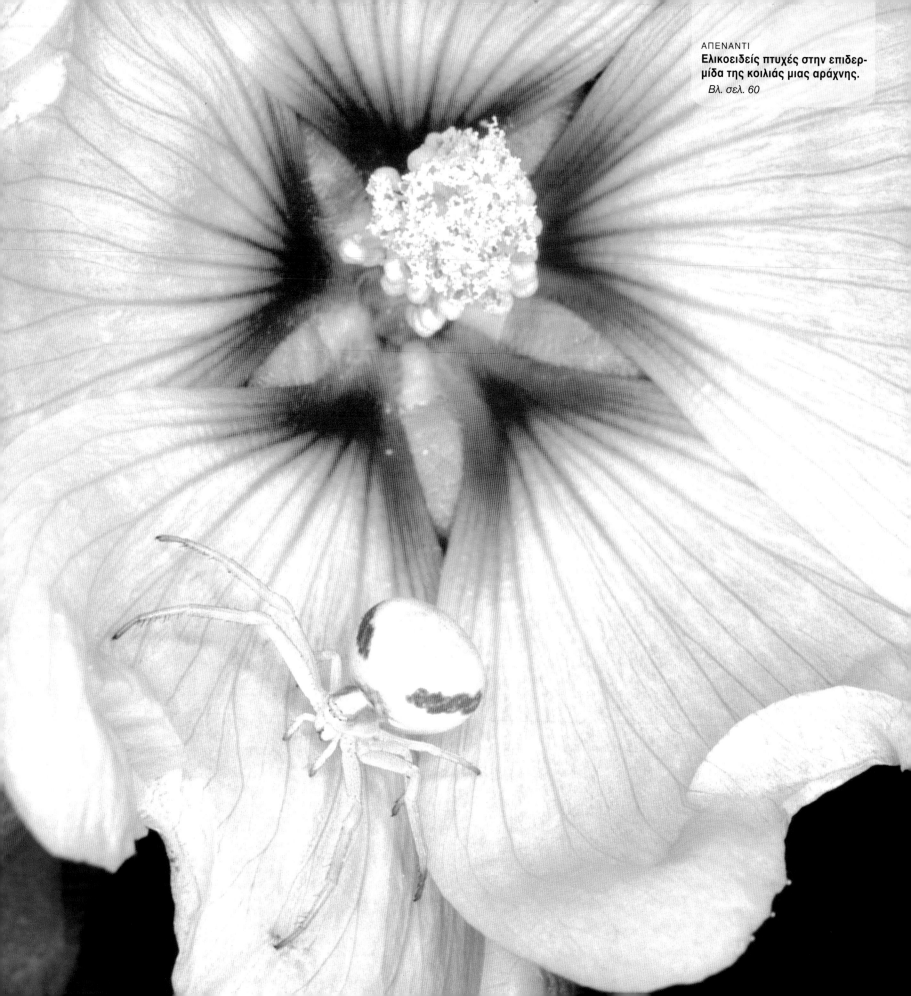

ΑΠΕΝΑΝΤΙ
**Ελικοειδείς πτυχές στην επιδερ-
μίδα της κοιλιάς μιας αράχνης.**
Βλ. σελ. 60

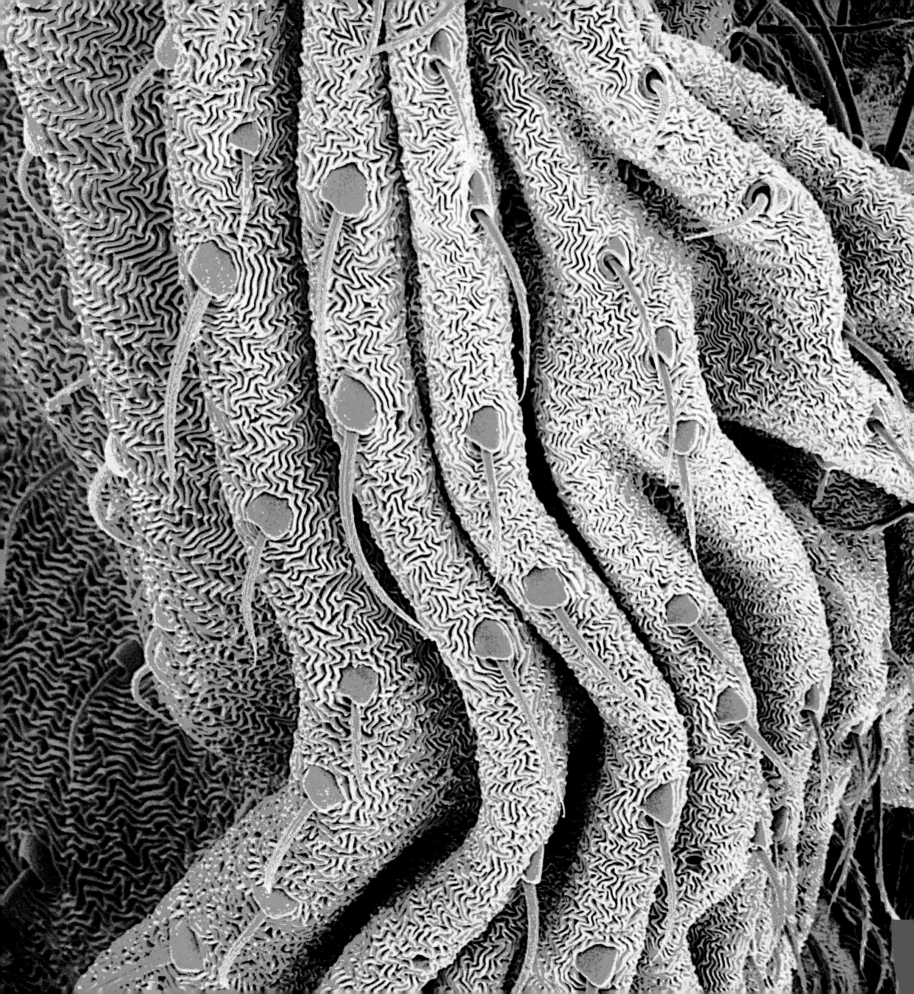

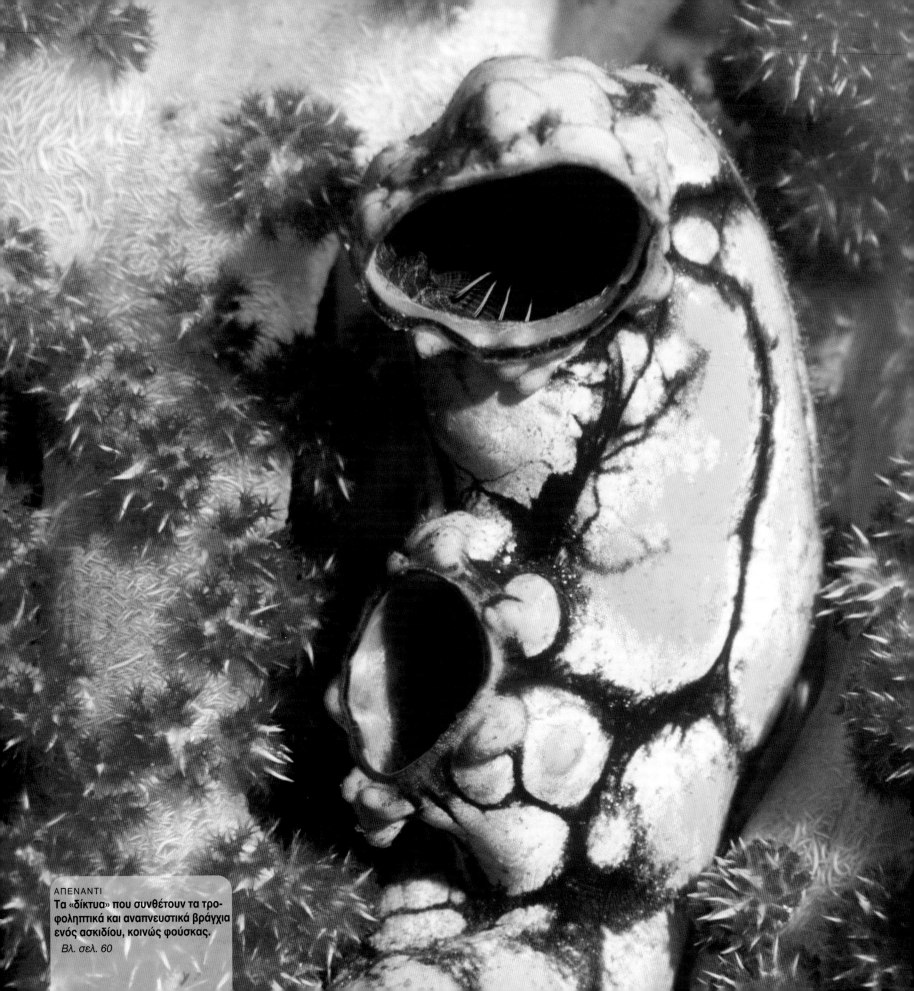

ΑΠΕΝΑΝΤΙ
Τα «δίκτυα» που συνθέτουν τα τρο-
φοληπτικά και αναπνευστικά βράγχια
ενός ασκιδίου, κοινώς φούσκας.
Βλ. σελ. 60

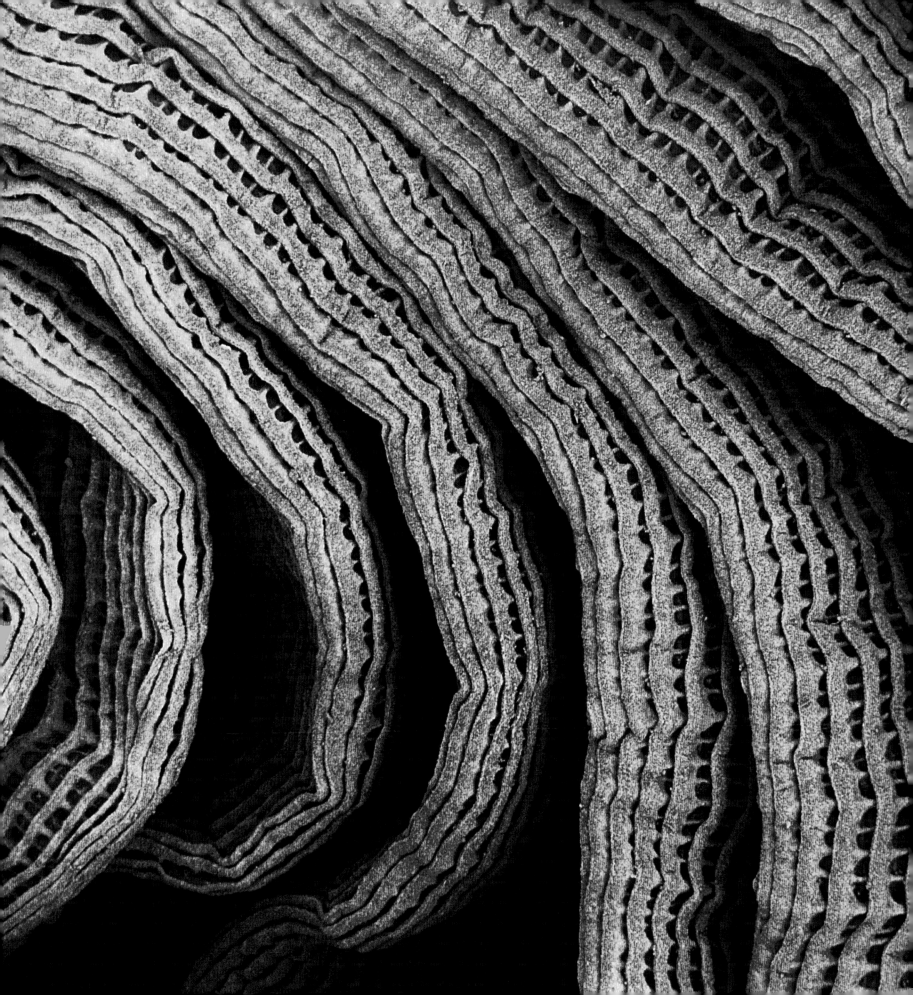

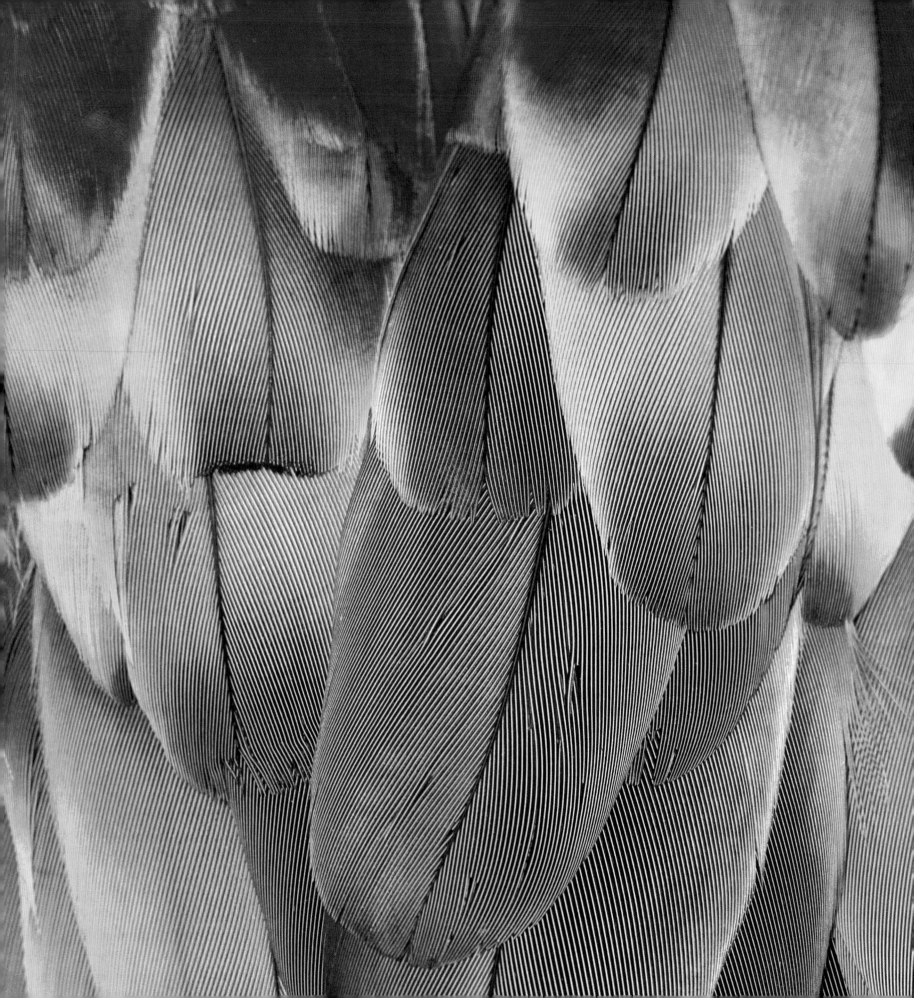

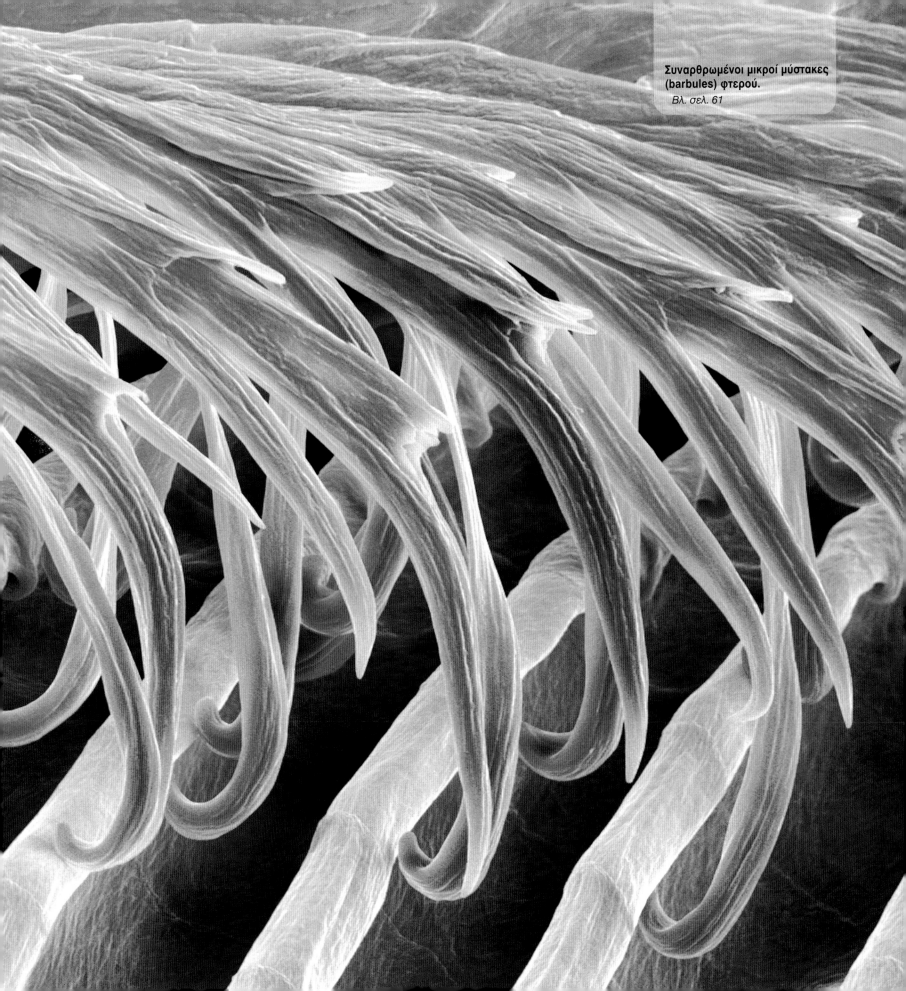

Συναρθρωμένοι μικροί μύστακες (barbules) φτερού.
Βλ. σελ. 61

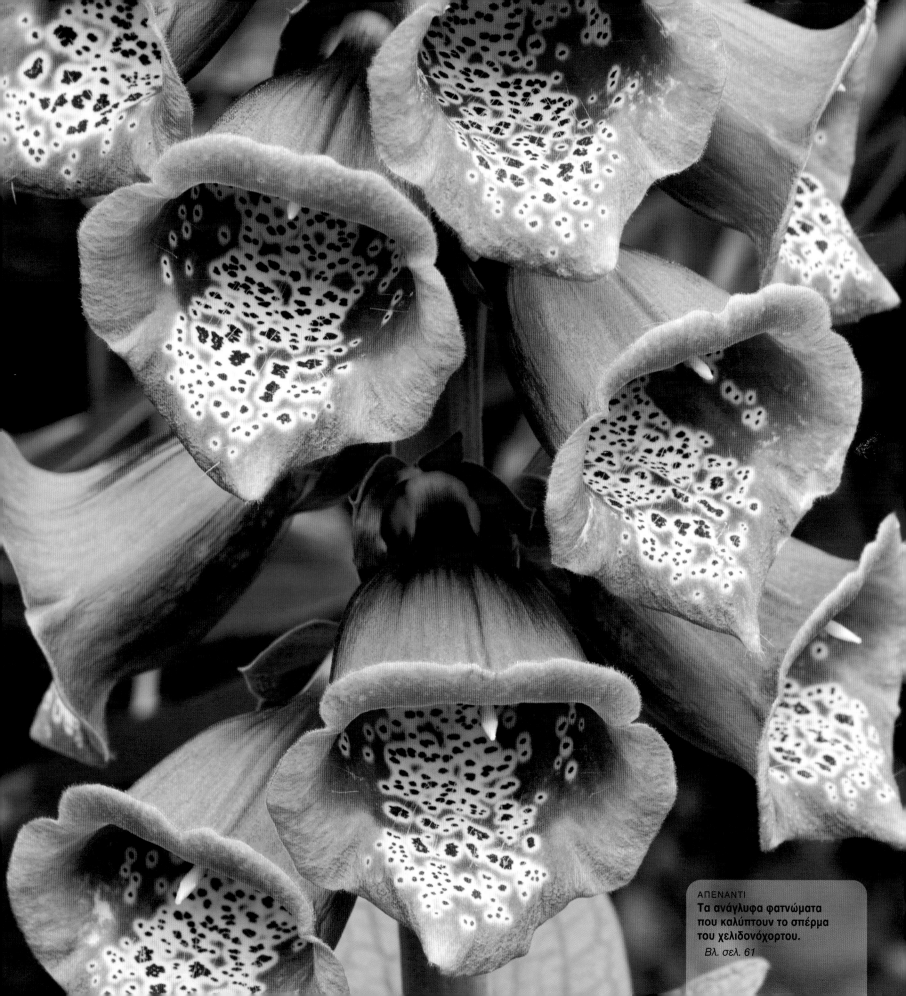

ΑΠΕΝΑΝΤΙ
**Τα ανάγλυφα φατνώματα
που καλύπτουν το σπέρμα
του χελιδονόχορτου.**
Βλ. σελ. 61

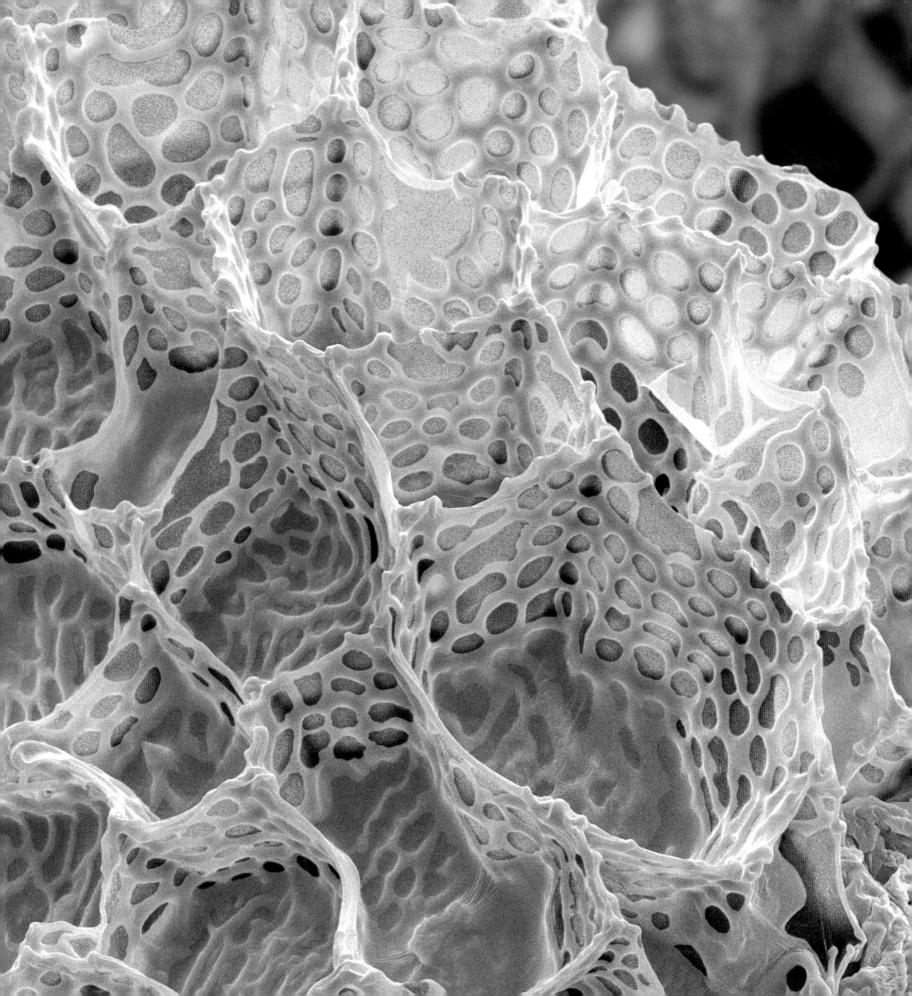

Οι ζαρωμένες πτυχές αυτού του υφάσματος μοιάζουν με πετσέτα του μπάνιου, αλλά η παρουσία πλήθους αγκαθιών σαν γάντζων μάλλον δεν υπόσχονται ένα ευχάριστο στέγνωμα, καθώς δεν πρόκειται για πετσέτα, αλλά την πτυχωτή, τραχιά δερμίδα (cuticula) του σώματος της αράχνης.

Συστατικό του δέρματος της αράχνης, όπως πολλών εντόμων, είναι ένας πολυσακχαρίτης ο οποίος συνδεδεμένος με πρωτεΐνες εναποτίθεται εν είδι στιβάδων, σχηματίζοντας μια σκληρή, ελασματική δομή. Στα έντομα σκληρές πλάκες δερμίδας αρκετού πάχους σχηματίζουν στρώσεις σαν πανοπλίας, που συνδέονται μεταξύ τους με λεπτότερους, πιο μεμβρανώδεις αρμούς. Οι αράχνες έχουν σκληρές πλάκες στον κεφαλοθώρακα ή πρόσωμα (όπου τα μάτια, τα στοματικά εξαρτήματα και οι αρθρώσεις των άκρων), καθώς και κυλινδρικές σωληνοειδείς πλάκες κατά μήκος των ποδιών, ωστόσο η κοιλιά είναι πολύ πιο μαλακή, εύκαμπτη και τείνει να σχηματίζει άχαρες πτυχές.

Από αυτή την άποψη οι αράχνες μοιάζουν με προνύμφες άλλων εντόμων που έχουν την τάση να είναι μαλακές και σαρκώδεις. Στις κάμπιες είναι απαραίτητη η μαλακή επιδερμίδα ώστε να αντέχει τη συνεχή ανάπτυξη του εντόμου κατά το λαρβικό στάδιο του βιολογικού του κύκλου. Παρ' όλα αυτά έρχεται κάποια στιγμή που η επιδερμίδα πρέπει να αποβληθεί για να δώσει τη θέση της σε ένα φαρδύτερο ένδυμα. Στον βιολογικό κύκλο των αραχνών δεν υπάρχει λαρβικό στάδιο, αλλά και αυτές έχουν στιγμές εκρηκτικής ανάπτυξης μετά κάθε γεύμα, και καθώς τα θύματά τους είναι συνήθως σχετικά μεγάλα βολεύουν τέτοιες μεγάλες ποσότητες διατηρώντας την κοιλιά τους πιο μαλακή και εύκαμπτη.

Αυτό όμως σημαίνει πως οι αραχνολόγοι πρέπει να φυλάσσουν τα αραχνοειδή σε αλκοόλη για να διατηρείται το μαλακό τους σώμα, διαδικασία πολύ πιο μπελαλίδικη από το καρφίτσωμα απλώς άλλων ειδών εντόμων που το χαίρονται τόσο οι εντομολόγοι.

Αυτές οι πτυχές θυμίζουν διπλωμένη πρόχειρα ψάθα μπάνιου από ίνες ράφιας ή λινό σεντόνι που μόλις έπεσε από την ντουλάπα. Διακρίνονται καθαρά το στημόνι και το υφάδι. Αλλά αυτή η δομή δεν είναι υφαντό, είναι το εσωτερικό του βραγχιακού μηχανισμού ενός θαλάσσιου οργανισμού, του ασκίδιου, που δεν είναι άλλο από τη γνωστή μας φούσκα.

Το αστείο είναι πως το επιστημονικό όνομα αυτού του υποφύλου των διηθηματοφάγων, δηλαδή το όνομα ασκίδια (λατ. Tunicatae), οφείλεται στο ότι μοιάζουν όντως τυλιγμένα σε σακί. Και ακόμα πιο αστείο είναι ότι τα ασκίδια είναι οι μόνοι οργανισμοί που συνθέτουν μια ουσία παρόμοια με την κυτταρίνη, το φυτικό προϊόν από το οποίο είναι φτιαγμένα το χαρτί, το βαμβάκι και το λινό. Η κυτταρίνη σχηματίζει το εξωτερικό περίβλημα του σώματος των ασκιδίων.

Ακμαία ασκίδια έχουν μορφή απλού σωλήνα ή σάκου με δύο ανοίγματα για να περνά το νερό. Το νερό που απομυζά μέσω ενός σίφωνα φιλτράρεται από τις δικτυωτές πτυχές των βράγχιων, που έχουν αυτή τη μορφή μάλλον για να

τρέφεται παρά για να αναπνέει το ζώο. Σωματίδια πλαγκτόν παγιδεύονται από τη βλέννα και μεταφέρονται στο στομάχι από μικρά τριχίδια (cilia) που κινούνται απαλά. Έπειτα, το νερό αποβάλλεται από τον άλλο σίφωνα, το άτριο (atrium).

Τα ενήλικα ασκίδια είναι μαλακά, ζελατινώδη ζώα σαν παχύρρευστες σταγόνες, που ζουν κολλημένα σε κοράλλια ή βράχια στον πυθμένα της θάλασσας. Η προνύμφη από την άλλη μεριά κολυμπά ελεύθερα και μοιάζει πολύ με γυρίνο. Η εξέτασή της με μικροσκόπιο δείχνει ότι διαθέτει άκαμπτη χορδή που διέρχεται μέσω της ουράς της και ονομάζεται νωτιαία χορδή. Η νωτιαία χορδή χάνεται όταν η προνύμφη προσγειώνεται με το κεφάλι σε μια επιφάνεια και μεταμορφώνεται σε ενήλικο άτομο. Σε άλλα ζώα η νωτιαία χορδή της προνύμφης ή του εμβρύου δεν χάνεται, αλλά εξελίσσεται σε νωτιαίο μυελό και σπονδυλική στήλη. Οι φούσκες αποδεικνύεται τελικά πως είναι η καλύτερη ένδειξη του κοινού προγόνου από τον οποίο εξελίχθηκαν όλα τα σπονδυλωτά, ψάρια, αμφίβια, ερπετά, πουλιά και θηλαστικά συμπεριλαμβανομένου και του ανθρώπου.

ΔΕΞΙΑ
Μαλακές, εύκαμπτες πτυχές στο δέρμα επιτρέπουν στο σώμα της αράχνης να αυξάνει απότομα το μέγεθός της μετά κάθε γεύμα. Το σώμα της καλύπτεται επίσης από τριχίδια αφής.

ΑΡΙΣΤΕΡΑ
Μια χλωμή, καμουφλαρισμένη αράχνη αναμένει σε ένα λουλούδι το θήραμά της που συχνά είναι πολύ μεγαλύτερο από την ίδια.

ΔΕΞΙΑ
Το περίπλοκο πτυχωτό δίκτυο των βράγχιων της φούσκας διυλίζει τα μικροσκοπικά σωματίδια του πλαγκτόν από το νερό που αντλεί στο σώμα της.

ΑΡΙΣΤΕΡΑ
Οι φούσκες έχουν σώμα απλό σαν ασκό με δύο ανοίγματα (σίφωνες), ένα για να απομυζά νερό και ένα για να το αποβάλλει.

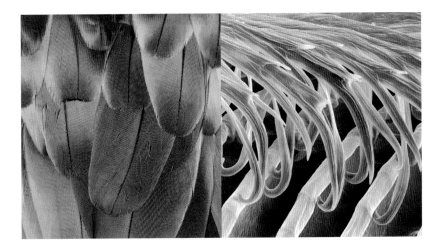

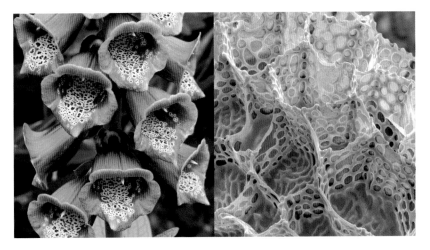

όντια γαμψά σαν τσουγκράνας, έτοιμα να γαντζωθούν στις ανοιχτόχρωμες νευρώσεις από κάτω. Οι απολήξεις τους δεν είναι αιχμηρές, αλλά προσκολλώνται απαλά σαν βέλκρο. Πρόκειται για τους μικροσκοπικούς θυσάνους που συνθέτουν το φτερό και που, συνδυάζοντας απαλό άγγιγμα και γερή αγκίστρωση, δίνουν στο φτερό το σχήμα και την αεροδυναμική του.

Μολονότι έχουν βρεθεί και σε απολιθώματα δεινόσαυρων, σήμερα φτερά έχουν μόνο τα πουλιά. Στα φτερά χρωστούν την ομορφιά και τα χρώματά τους, τα φτερά τα προστατεύουν από το κρύο, τη ζέστη και το νερό της βροχής, και τα διευκολύνουν στο κολύμπι αυξάνοντας τη δύναμη της άνωσης. Κυρίως όμως στα φτερά οφείλουν το κατεξοχήν χαρακτηριστικό τους – την ικανότητα να πετούν.

Τα φτερά είναι εξαιρετικά ελαφρά, αλλά πολύ δυνατά. Μέρος της δύναμής τους οφείλεται στη σύνθεσή τους από ανθεκτικές, πτυχωτές ίνες πρωτεΐνης, της βήτα κερατίνης. Ωστόσο, η πραγματική δύναμη του φτερού έγκειται στη μικροδομή του.

Τα φτερά προήλθαν από απλά τριχοειδή νημάτια που διακλαδώθηκαν, σχηματίζοντας τα επίπεδα ελάσματά τους. Το φτερό αποτελείται από ένα κεντρικό στέλεχος, τη ράχη, από το οποίο ξεκινούν παράλληλες διακλαδώσεις, οι κύριοι μύστακες, και από αυτούς μικρότερες, οι μικροί μύστακες· το επίπεδο σχήμα των φτερών οφείλεται στον τρόπο που αυτοί οι μικροί μύστακες συνδέονται μεταξύ τους. Οι παράλληλοι μικροί μύστακες που φυτρώνουν στην άνω πλευρά ενός από τους μεγαλύτερους ή κύριους μύστακες φέρουν μια σειρά αγκίστρων (hamuli) που γαντζώνονται στους μικρούς, θολωτής διατομής μύστακες στο κάτω μέρος του επόμενου κυρίου μύστακος. Καθ' όλο το μήκος του φτερού τα άγκιστρα της μιας σειράς μικρών μυστάκων γαντζώνονται στους αυλακωτούς μικρούς μύστακες από πάνω τους.

Μολονότι κάθε μικρός μύστακας ασκεί ελάχιστη πίεση, συνδυασμένη η δύναμη όλων μαζί συγκρατεί τους κυρίως μύστακες του φτερού στη θέση τους. Καθώς η πίεση που ασκούν είναι ελαφρά, το πτηνό μπορεί να περιποιείται το πτέρωμά του επαναφέροντας τη λεία, συνεκτική υφή του όταν σκιστεί.

Αυτές οι πτυχές, που μοιάζουν με κολλαρισμένη δαντελωτή τραχηλιά της Ελισαβετιανής εποχής, δεν είναι από ύφασμα, αλλά δομή που εξυπηρετεί τη μεταφορά διά του αέρος του σπέρματος του χελιδονόχορτου.

Το σπέρμα των φυτών αποτελείται από τρία μέρη: το έμβρυο, το ενδοσπέρμιο και το κέλυφος (testa). Πολύ συχνά το ανθεκτικό κέλυφος έχει σύνθετη διαμόρφωση και τα εξωτερικά του χαρακτηριστικά δίνουν στους βοτανολόγους τη δυνατότητα να ταυτίσουν είδη φυτών σε εξορυγμένα πετρώματα, τύρφη ή πάγο, σε αποθέσεις απολιθωμάτων και σε δείγματα του ιατροδικαστικού εργαστηρίου.

Η διαφορετική διαμόρφωση των σπερμάτων αντανακλά τις διαφορετικές στρατηγικές που ανέπτυξαν τα φυτά για να διασπαρούν. Ζώα και πουλιά παρασύρουν στα φτερά ή τη γούνα τους αγκιστρόκαρπους. Επίσης, τρώνε φρούτα που τα κουκούτσια τους τα αποβάλλουν αργότερα ή τα φτύνουν. Σκληρούς καρπούς, όπως καρύδια και βελανίδια, πολλές φορές τους παραχώνουν στη γη για αργότερα, που όταν τους ξεχνούν φυτρώνουν. Πολλά, ωστόσο, σπέρματα απλώς μένουν εκεί που πέφτουν από το φυτό ή μεταφέρονται από το νερό και τον αέρα.

Τα ελαφρότερα και μικρότερα, όπως ορισμένων ειδών ορχιδέας, είναι απλώς κονίδια που μεταφέρονται από τον άνεμο σαν αιθέριο πλαγκτόν. Άλλα πάλι έχουν μηχανικά μέσα για να πετούν: της συκομουριάς έχει πτεροειδή ελάσματα, ενώ του αγριοράδικου πτερώδη αλεξίπτωτα.

Τα σπέρματα του χελιδονόχορτου είναι κάτι το ενδιάμεσο: είναι όσο πρέπει μικρά για να μεταφέρονται από τον αέρα και συνάμα έχουν λεπτοδουλεμένη επιφάνεια με δαντελωτές προεξοχές σαν φατνώματα για να συλλαμβάνουν τον άνεμο. Όταν προσγειώνονται δεν είναι σίγουρο ότι θα φυτρώσουν αμέσως, έτσι λοιπόν τα περισσότερα πέφτουν σε λήθαργο περιμένοντας καλύτερες ημέρες. Η ζεστασιά του φθινοπωρινού ήλιου ή η υγρασία της βροχής μπορεί να είναι ένδειξη ότι οι συνθήκες για να αναπτυχθεί είναι οι σωστές, ωστόσο μια ψυχρή ριπή ανέμου προαναγγέλλει τον ερχομό του χειμώνα, προστατεύοντας το σπέρμα από τη λανθασμένη εκτίμηση του καιρού.

ΔΕΞΙΑ
Οι μικροί μύστακες του ελάσματος ενός φτερού φέρουν άγκιστρα και αυλακωτές προεξοχές που συνδέουν τους μεγαλύτερους μύστακες μεταξύ τους σχηματίζοντας το έλασμα του φτερού.

ΑΡΙΣΤΕΡΑ
Οι επικαλυπτόμενες δομές των φτερών τα καθιστούν ελαφρά αλλά ανθεκτικά. Εκτός από διαφορετικό χρωματισμό και εξωτερική διαμόρφωση, τα φτερά προσφέρουν προστασία από τη ζέστη, το κρύο και την υγρασία.

ΔΕΞΙΑ
Τα φατνώματα στο σπέρμα του χελιδονόχορτου συμβάλλουν στην εναέρια διασπορά του.

ΑΡΙΣΤΕΡΑ
Το χελιδονόχορτο είναι διετές φυτό, χρειάζεται δηλαδή δύο χρόνια για να ανθίσει: τον πρώτο χρόνο το σπέρμα παράγει τα θρεπτικά φύλλα και τον δεύτερο τον βότρυ των χαρακτηριστικών του ανθέων.

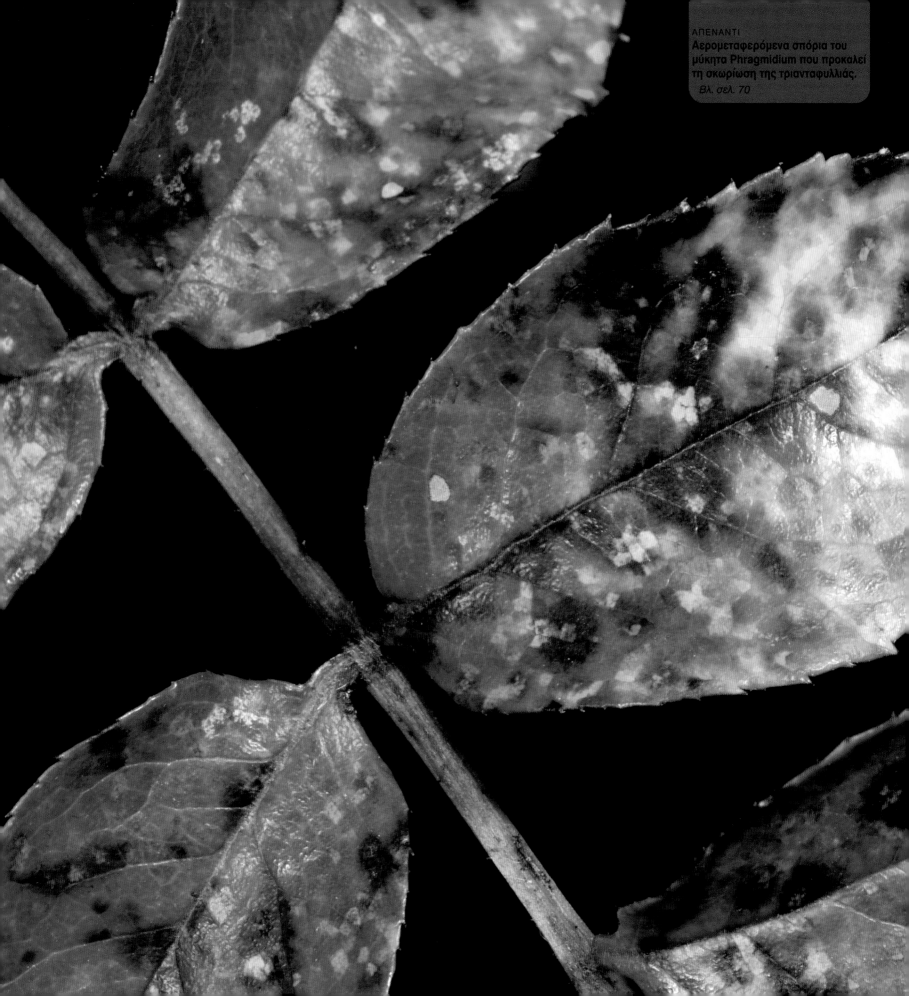

ΑΠΕΝΑΝΤΙ
Αερομεταφερόμενα σπόρια του
μύκητα **Phragmidium** που προκαλεί
τη σκωρίωση της τριανταφυλλιάς.
Βλ. σελ. 70

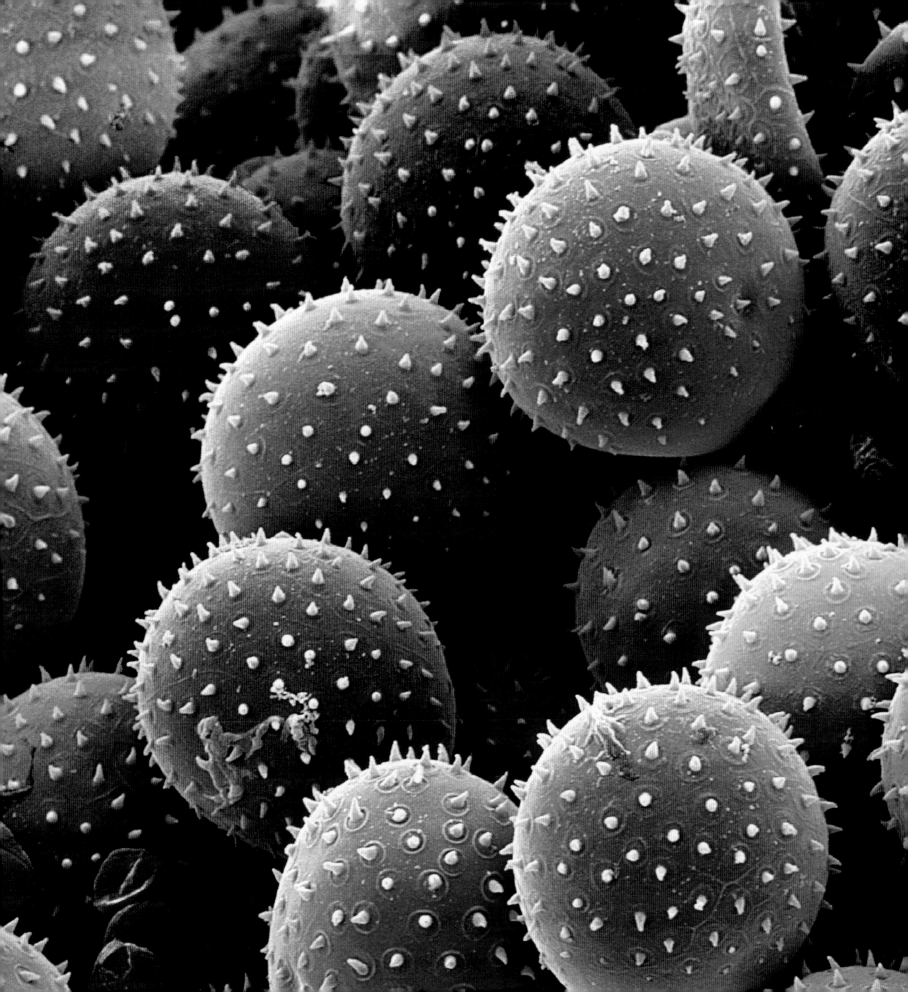

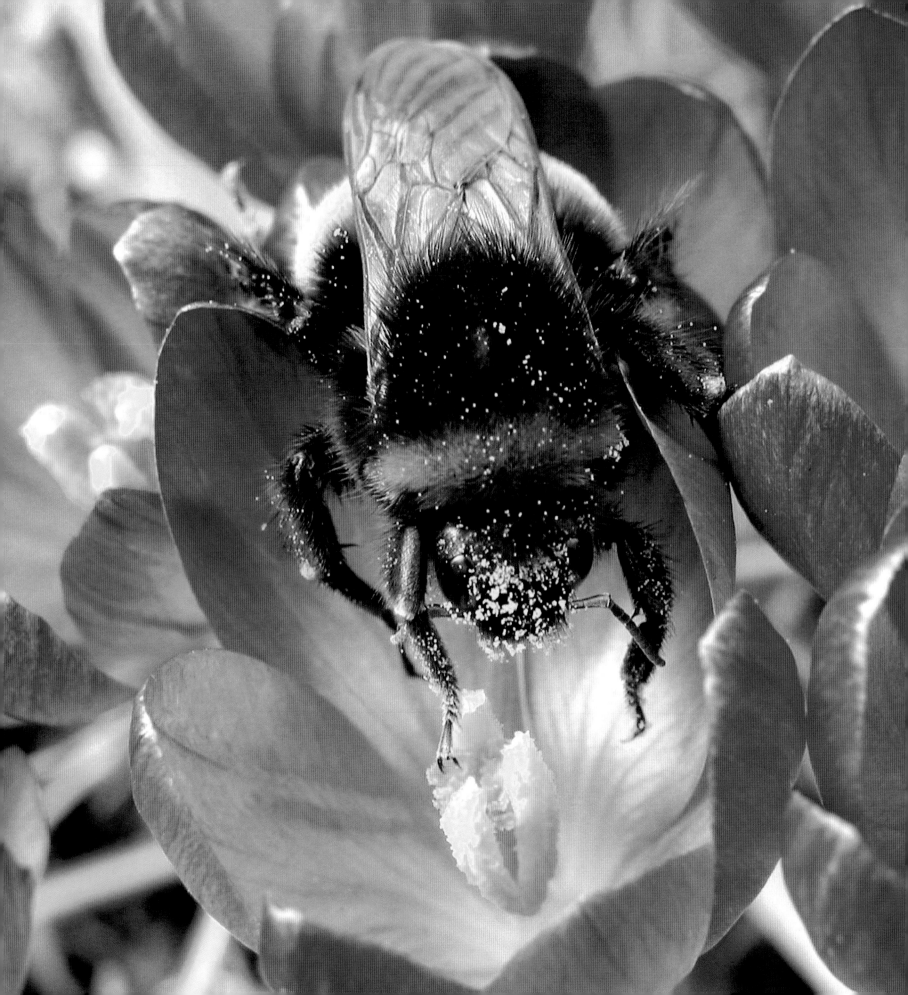

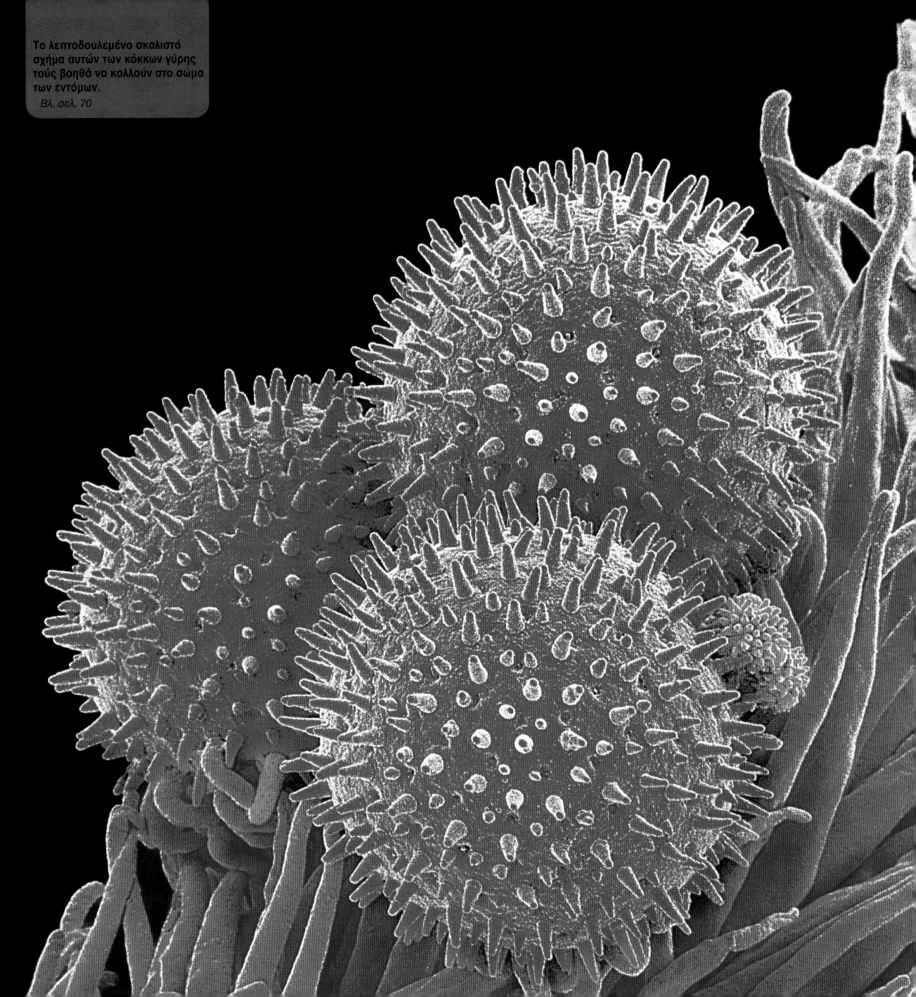

Το λεπτοδουλεμένο σκαλιστό
σχήμα αυτών των κόκκων γύρης
τούς βοηθά να κολλούν στο σώμα
των εντόμων.
Βλ. σελ. 70

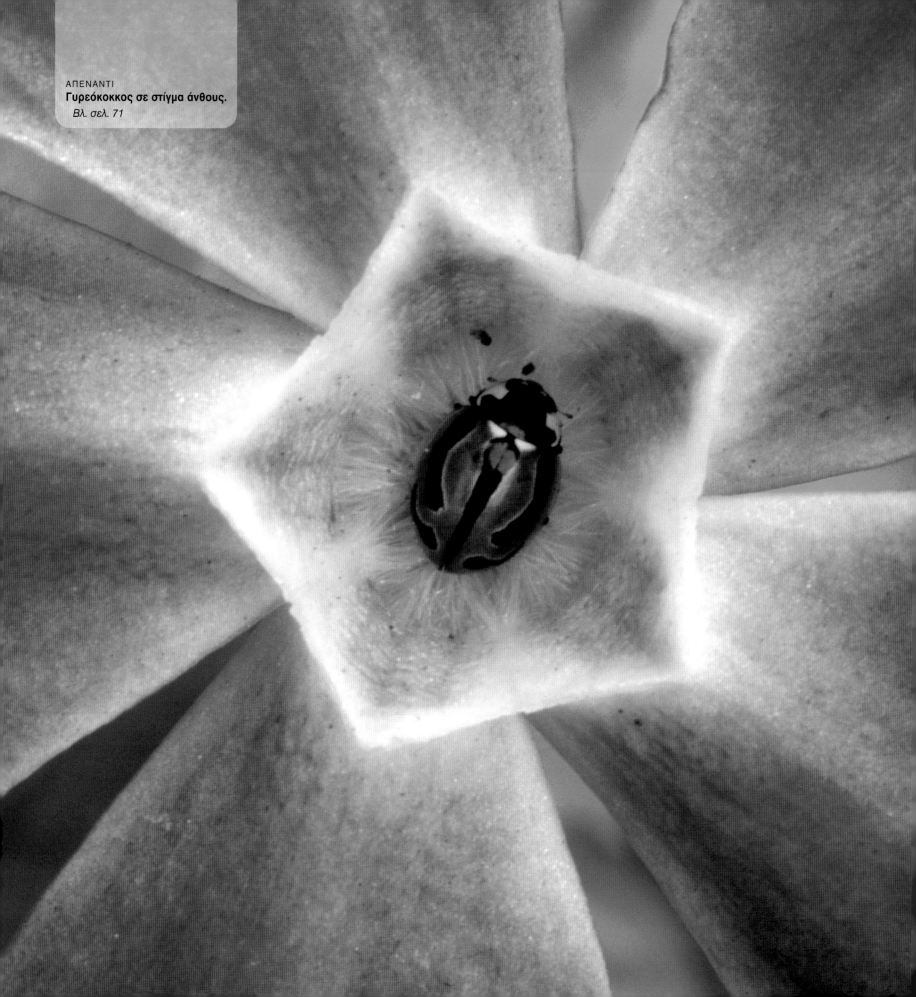

ΑΠΕΝΑΝΤΙ
Γυρεόκοκκος σε στίγμα άνθους.
Βλ. σελ. 71

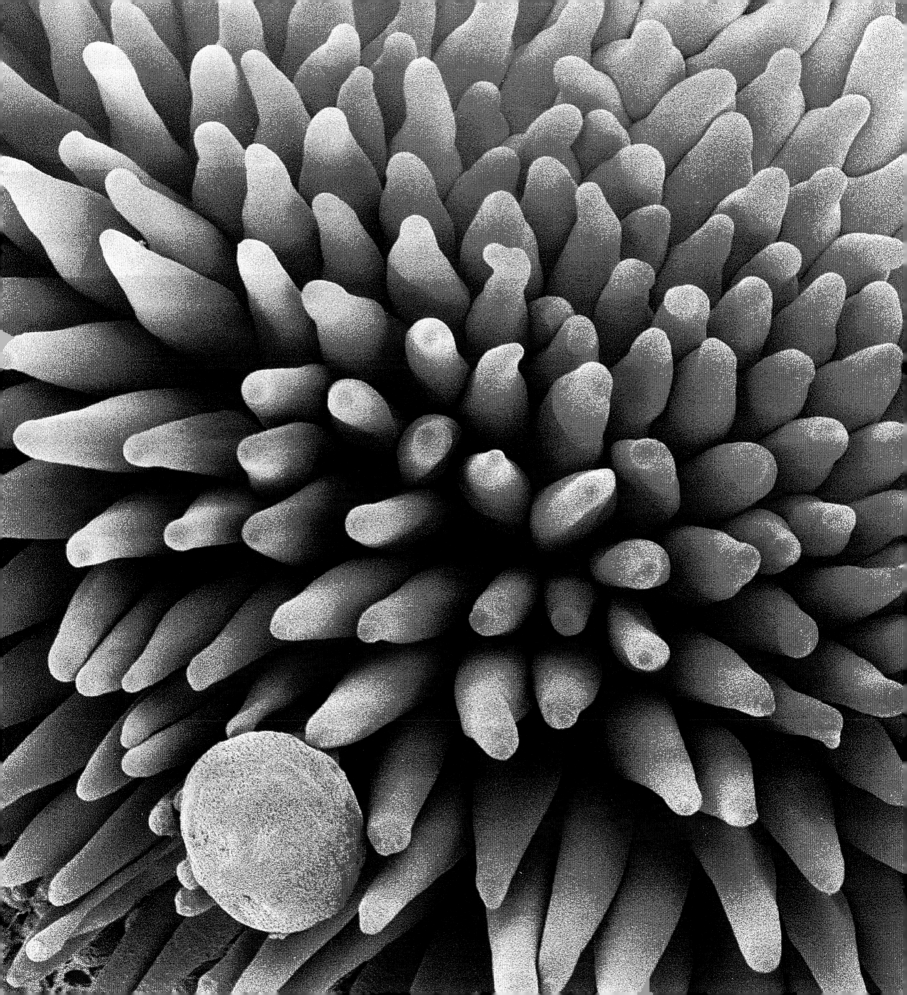

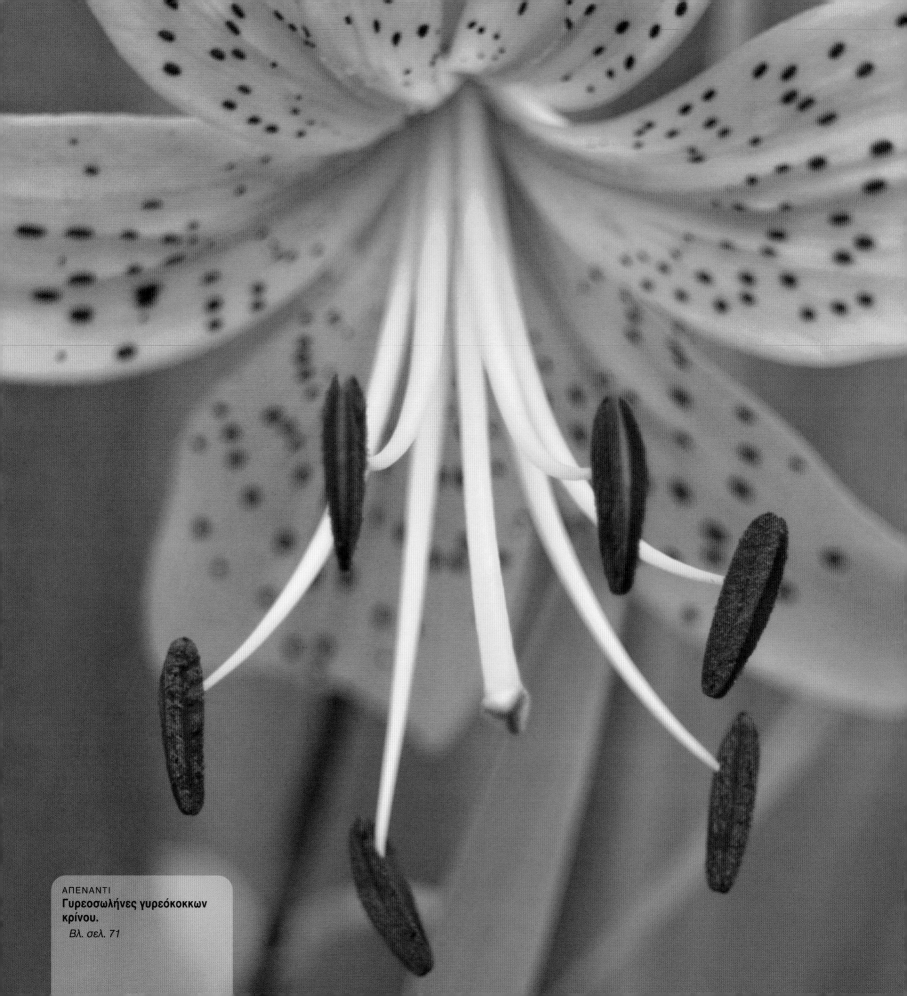

ΑΠΕΝΑΝΤΙ
Γυρεοσωλήνες γυρεόκοκκων κρίνου.
Βλ. σελ. 71

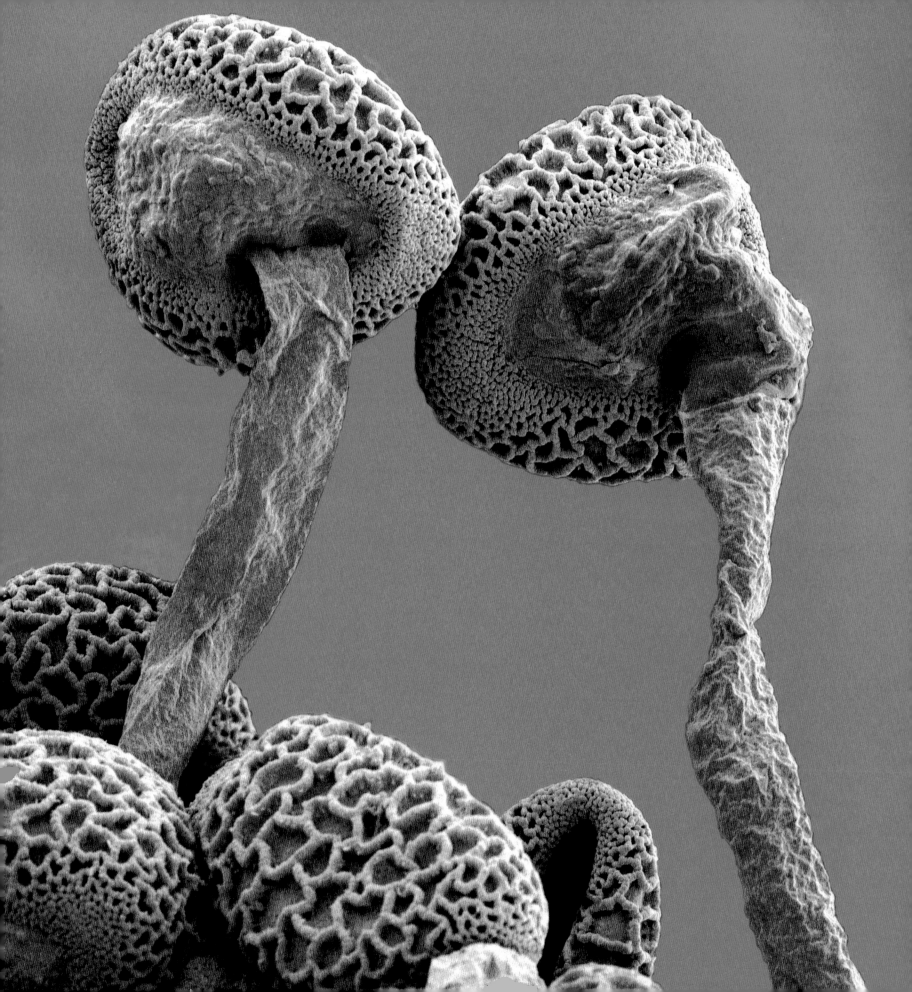

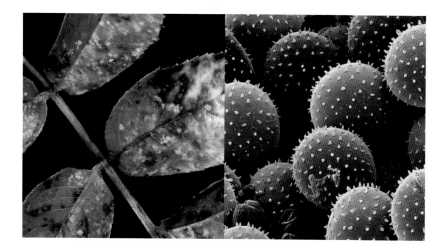

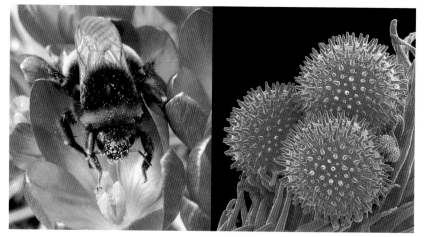

Αυτές οι καραμελίτσες μπορεί να σε προκαλούν να τις φας, αλλά στην πραγματικότητα είναι αυτές που τρώνε. Τα μικροσκοπικά αυτά σπόρια μύκητα, που λέγονται κονίδια, μόλις κάθονται στα φύλλα αρχίζουν και καταβροχθίζουν το φυτό από μέσα.

Σε αντίθεση με τα πράσινα φυτά, τα οποία επενδύουν σε σχετικά λίγα σπέρματα μεγάλου μεγέθους που το καθένα τους περιέχει αρκετή τροφή για το αναπτυσσόμενο έμβρυο και προστατεύεται από ανθεκτικό περίβλημα, οι μύκητες παράγουν πλήθος μικροσκοπικών, ελαφρότατων σπορίων που το καθένα περιέχει σχεδόν μόνο γενετικό υλικό. Η σχέση μεταξύ αριθμού και μεγέθους είναι υπέρ του μύκητα, καθώς ορισμένα από τα πολυάριθμα αυτά σπόρια είναι σχεδόν βέβαιο πως θα βρουν τον κατάλληλο τόπο να αναπτυχθούν.

Οι μύκητες αναπτύσσονται σε νεκρές και σε αποσύνθεση οργανικές ύλες, σε πεσμένα φύλλα, ξυλεία, πτώματα και περιττώματα ζώων, αλλά πολλοί προσβάλλουν επίσης ζωντανά φυτά. Όπως και άλλες ασθένειες, ενδέχεται να προσβάλλουν μόνο έναν ξενιστή, όπως οι σκωριομύκητες που προσβάλλουν την τριανταφυλλιά και ευθύνονται για τις κηλίδες στο χρώμα της σκουριάς που σχηματίζουν στα φύλλα της.

Μόλις το κονίδιο του σκωριομύκητα προσγειωθεί σε ένα φύλλο αναπτύσσει έναν μακρύ σωληνοειδή σχηματισμό, που λέγεται υφή, και ο οποίος πρέπει να διαρρήξει την επιδερμίδα του φύλλου για να αποκτήσει πρόσβαση στα κύτταρα του φυτού από τα οποία τρέφεται. Τελικά, η υφή προχωρεί ώσπου βρίσκει ένα στόμα (πόρο διαπνοής), εισχωρεί και αρχίζει να διακλαδώνεται και να απλώνεται στο εσωτερικό του φύλλου, αφομοιώνοντας τις θρεπτικές του ουσίες. Πολλές φορές σκοτώνει το φυτό είτε γιατί τρώει τα κύτταρα είτε γιατί φράζει τα αγγεία μέσω των οποίων μεταφέρονται νερό και θρεπτικές ουσίες από τις ρίζες στα φύλλα.

Όταν ο σκωριομύκητας έχει αναπτυχθεί αρκετά ώστε να παράγει σπόρια, αντί μεγάλους καρπούς, όπως το μανιτάρι αγαρικό, σχηματίζει στην επιφάνεια των φύλλων ριπίδια γεμάτα σπόρια, τα κονιδιοφόρα, που κάνουν το φυτό να φαίνεται σκονισμένο.

Αυτές οι σφαίρες με τις κατανεμημένες γεωμετρικά προεκβολές (η καθεμία είναι διάστικτη με πάνω από 350 τέτοιες ακίδες) μοιάζουν με απίθανα μαθηματικά μοντέλα ή με πολύπλοκα γρανάζια αλλόκοτης μηχανής. Ωστόσο, δεν είναι παρά τρεις κόκκοι γύρης.

Οι γυρεόκοκκοι είναι για τα φυτά ό,τι τα σπέρματα για τα ζώα: οι φορείς του αρσενικού γενετικού υλικού, οι γαμέτες που θα γονιμοποιήσουν τους σπερματοβλάστες του θηλυκού φυτού. Κάθε κόκκος είναι μόνο ένα ελάχιστο κλάσμα του χιλιοστού· το μικρότερο έχει διάμετρο μόλις 6 μm.

Συστατικό του σκληρού προστατευτικού τους τοιχώματος, της εξίνης, είναι η σποριοπολλενίνη. Το τοίχωμα αυτό είναι τόσο περίτεχνο και περίπλοκο ανάγλυφο, που πολλά είδη μπορούν να ταυτιστούν από έναν μοναδικό γυρεόκοκκο – χαρακτηριστικό ιδιαίτερα χρήσιμο για τους παλαιοντολόγους.

Μολονότι μερικά είδη φυτών αυτογονιμοποιούνται, τα περισσότερα ωφελούνται εξασφαλίζοντας τη διασταύρωσή τους με άλλα φυτά, που σημαίνει ότι γυρεόκοκκοι του ενός μεταφέρονται στο στίγμα του άλλου άνθους.

Οι γυρεόκοκκοι ταξιδεύουν με τρεις τρόπους. Πολλά δέντρα και αγρωστώδη παράγουν τόσο μικρούς κόκκους γύρης που αναρίθμητα δισεκατομμύρια κονιδίων μεταφέρονται όπου τύχει από τον αέρα. Και μόνο ο όγκος της παραγωγής εξασφαλίζει ότι τουλάχιστον μερικοί γαμέτες θα φτάσουν οπωσδήποτε σε κάθε θηλυκό άνθος. Αυτή είναι η γνωστή αερομεταφερόμενη γύρη της αλλεργίας. Ο δεύτερος τρόπος ή μάλλον δρόμος είναι ενάλιος: ορισμένα θαλάσσια φυτά διασπείρουν τη γύρη στο νερό, όπως τα άλλα στον αέρα.

Ο τρίτος είναι πιο περίπλοκος και σε αυτόν οφείλεται η ανάπτυξη ωραίων και περίτεχνων λουλουδιών, διότι τη γύρη μεταφέρουν άθελά τους ορισμένα ζώα, επομένως πρέπει τα άνθη να είναι όμορφα για να προσελκύουν τους επικονιαστές τους. Η γύρη αυτής της κατηγορίας είναι βαρύτερη και πιο κολλώδης και πρέπει να παραληφθεί και να μεταφερθεί με μεγάλη προσοχή και ακρίβεια. Οι συνηθισμένοι μεταφορείς είναι έντομα, αλλά στη διαδικασία αυτή συμμετέχουν επίσης πουλιά, νυχτερίδες και άλλα ζώα.

ΔΕΞΙΑ
Τα σπόρια του μύκητα αποτελούνται από μαλακούς ασκούς, που περιέχουν σχεδόν μόνο τα γονίδια του οργανισμού.

ΑΡΙΣΤΕΡΑ
Ο σκωριομύκητας προσβάλλει τα φύλλα της τριανταφυλλιάς μεταβάλλοντας το χρώμα τους στο χρώμα της σκουριάς.

ΔΕΞΙΑ
Η λεπτεπίλεπτη, ανάγλυφη επιφάνεια των γυρεόκοκκων βοηθά ώστε να κολλούν στο σώμα των εντόμων που τους μεταφέρουν.

ΑΡΙΣΤΕΡΑ
Τα σερσέγκια (bumblebees) είναι εξαιρετικοί επικονιαστές και, μολονότι μαζεύουν πολλή γύρη για να θρέψουν τα νεογνά τους, μεταφέρουν πάνω τους αρκετή ακόμα, ώστε να επικονιάσουν το επόμενο άνθος που θα επισκεφτούν.

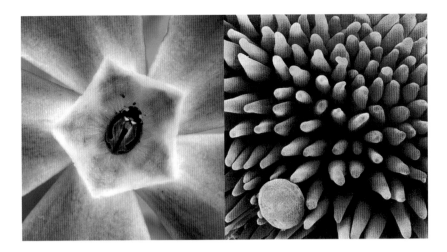

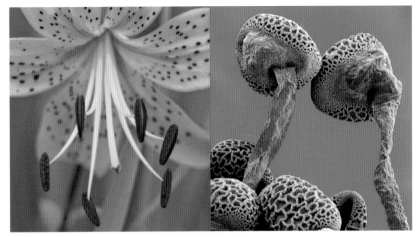

Αυτό το μεζεδάκι μοιάζει να έχει καταλύσει πάνω στα απαλά κυματίζοντα πλοκάμια του θαλλού μιας θαλάσσιας ανεμώνης. Έχει δηλητηριαστεί και σχεδόν παραδοθεί στην ανεμώνη, η οποία από στιγμή σε στιγμή θα αποφασίσει, εάν θα το φάει ή όχι. Η απόφαση αυτή έχει σημασία, γιατί αυτό το μεζεδάκι είναι ένας γυρεόκοκκος, ο αρσενικός γαμέτης, και έχει καταφτάσει στο θηλυκό άνθος που τα ωάριά του μέσα στον ύπερο περιμένουν τη γονιμοποίησή τους.

Για να ολοκληρωθεί ο γενετήσιος κύκλος ενός φυτού, οι κόκκοι της γύρης πρέπει να μεταφερθούν από τα όργανα αναπαραγωγής του άρρενος φυτού, από τον ανδρώνα ή ανθήρα, στα θηλυκά όργανα αναπαραγωγής, στον γυναικώνα ή ύπερο. Στο κατώτερο τμήμα του ύπερου, σε μία ή δύο ωοθήκες υπάρχουν ένας ή δύο σπερματοβλάστες, τα ωάρια των φυτών. Πάνω από τις ωοθήκες είναι ένας ψηλός στύλος που τον επιστεγάζει το στίγμα, το οποίο υποδέχεται τους γυρεόκοκκους. Η γύρη είναι πολύτιμη τόσο στο φυτό που την παράγει όσο και σε αυτό που την υποδέχεται. Και αυτό ισχύει ιδιαίτερα για τα φυτά που τα επικονιάζουν έντομα (και άλλα ζώα), όπου την ευθύνη μεταφοράς της γύρης

την έχουν περιπλανώμενοι διαμετακομιστές.

Για να εξασφαλιστεί η συλλογή, η παράδοση και η παραλαβή του άρρενος γενετικού υλικού λαμβάνονται όλα τα αναγκαία μέτρα. Η εξελικτική επένδυση στην παραγωγή λουλουδιών ικανών να προσελκύουν έντομα είναι εφάμιλλη της επένδυσης στον τεχνικό σχεδιασμό τους αφότου αφιχθεί το έντομο.

Για να εξασφαλιστεί ότι ο γυρεόκοκκος μετά την άφιξή του θα μείνει στη θέση του, τα στίγματα έχουν αναπτύξει διάφορα σχήματα και μορφές. Ορισμένα εκκρίνουν κολλώδη υγρά για να κολλούν οι κόκκοι της γύρης, ώσπου να ολοκληρωθεί η γονιμοποίηση. Άλλα, όπως η βίγκα η ελάσσων (κοινώς βίγκα, αγριολίτσα, αγριολίζα) καλύπτονται ολόκληρα με τις λεγόμενες θηλές (papillae), ανάμεσα στις οποίες σφηνώνονται οι γυρεόκοκκοι.

Τώρα, μετά την άφιξή τους οι γυρεόκοκκοι πρέπει να προστατευτούν, ώστε να μην σαρωθούν από τα έντομα που θα επισκεφτούν το στίγμα αργότερα. Η γονιμοποίηση των σπερματοβλαστών απαιτεί να παραμείνουν στο στίγμα, ώσπου να γλιστρήσουν μέσα από έναν σωληνίσκο στις ωοθήκες και να λάβει χώρα η τελική μεταφορά γενετικής πληροφορίας.

Εξωτικά μανιτάρια έτοιμα να μπουν στην κατσαρόλα δεν θα είχαν πιο παράξενη όψη από αυτά τα στριμμένα κοτσάνια και τους καρπούς με την τραχιά επιφάνεια. Δεν πρόκειται όμως για πόδια και κεφαλές μανιταριών με δικτυωτή διακόσμηση, αλλά για αδειανά, αφυδατωμένα κεφαλάκια που έχουν ρίξει ρίζες: κάθε τέτοιο κεφαλάκι μικρότερο από μύτη καρφίτσας είναι ένας γυρεόκοκκος, και το σαν πόδι μανιταριού στήριγμά του είναι ο γυρεοσωλήνας μέσα από τον οποίο θα παραδώσει το φορτίο του DNA στις ωοθήκες για να γονιμοποιηθούν τα ωάρια.

Όταν ο γυρεόκοκκος προσγειωθεί στο σωστό θηλυκό άνθος, πρέπει να μεταβιβάσει το αρσενικό γενετικό υλικό που μεταφέρει στο θηλυκό αναπαραγωγικό κύτταρο. Από τη συνένωση του αρσενικού με το θηλυκό DNA παράγεται το σπέρμα και, εάν οι συνθήκες είναι ευνοϊκές, φυτρώνει ένα νέο φυτό.

Μόλις ο γυρεόκοκκος προσγειωθεί στο στίγμα λαμβάνει χώρα μια διαδικασία χημικής αναγνώρισης, ώστε να διασφαλιστεί πως μόνο γυρεόκοκκοι του ίδιου είδους θα αναλάβουν τη γονιμοποίηση. Εάν ο

κόκκος αναγνωριστεί σωστά, αρχίζει να αναπτύσσεται σαν ρίζα ο λεγόμενος γυρεοσωλήνας. Ο γυρεοσωλήνας διατρυπά πρώτα το στίγμα στο σημείο που έχει προσγειωθεί ο γυρεόκοκκος, συνεχίζει μέσα στον στύλο, το υποστήριγμα του στίγματος, και φτάνει μέχρι τις ωοθήκες στη βάση του, όπου περιμένουν οι σπερματοβλάστες.

Καθώς αναπτύσσεται, αντλεί θρεπτικές ουσίες από το άνθος. Οι κρίνοι έχουν σχετικά μικρά άνθη και ο γυρεοσωλήνας μπορεί να έχει μήκος μόλις λίγα χιλιοστά. Ο αραβόσιτος έχει αναφερθεί συχνά ως το φυτό με τους μακρύτερους γυρεοσωλήνες που το μήκος τους φτάνει τα 300 χιλιοστά.

Μέσα στον γυρεοσωλήνα το αρσενικό DNA διαιρείται σε δύο σπερμοκύτταρα που όταν ο σωλήνας φτάσει στις ωοθήκες απελευθερώνονται. Το ένα γονιμοποιεί τον σπερματοβλάστη, από τον οποίο θα αναπτυχθεί το έμβρυο του νέου φυτού, το άλλο συμφύεται με δύο θηλυκά κύτταρα, τους πολικούς πυρήνες, που επίσης είναι μέσα στον εμβρυόσακο, και σχηματίζουν το ενδοσπέρμιο, τον αποταμιευτικό ιστό που τρέφει το έμβρυο και το νεαρό φυτό.

ΔΕΞΙΑ
Ένας γυρεόκοκκος παραδόθηκε επιτυχώς σε άνθος του σωστού είδους και γένους. Τα νημάτια στο θηλυκό όργανο αναπαραγωγής, το στίγμα, συγκρατούν τους γυρεόκοκκους στη θέση τους κατά τη γονιμοποίηση.

ΑΡΙΣΤΕΡΑ
Για να ανταμείψουν τους επικονιαστές τους τα άνθη προσφέρουν στα έντομα που τα επισκέπτονται το θρεπτικό τους νέκταρ.

ΔΕΞΙΑ
Μόλις προσγειωθεί στο στίγμα ενός άνθους, κάθε γιγαντιαίος γυρεόκοκκος κρίνου αναπτύσσει έναν μακρύ σωλήνα μέσα από τον οποίο θα μεταφερθεί το γενετικό υλικό στις ωοθήκες για να γονιμοποιήσει έναν σπερματοβλάστη.

ΑΡΙΣΤΕΡΑ
Ο γυρεοσωλήνας πρέπει να διαπεράσει τον μακρύ στύλο που εδώ περιβάλλεται από έξι στήμονες για να φτάσει στους σπερματοβλάστες βαθιά μέσα στον ύπερο του άνθους.

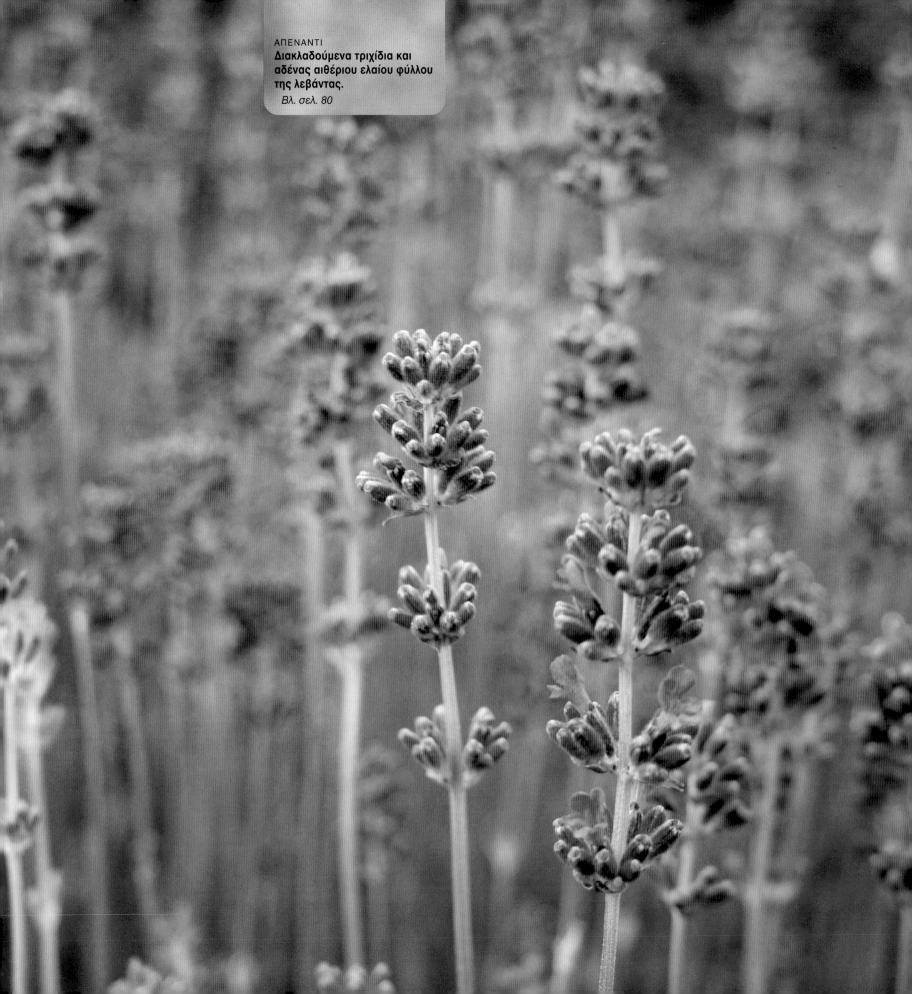

ΑΠΕΝΑΝΤΙ
Διακλαδούμενα τριχίδια και αδένας αιθέριου ελαίου φύλλου της λεβάντας.
Βλ. σελ. 80

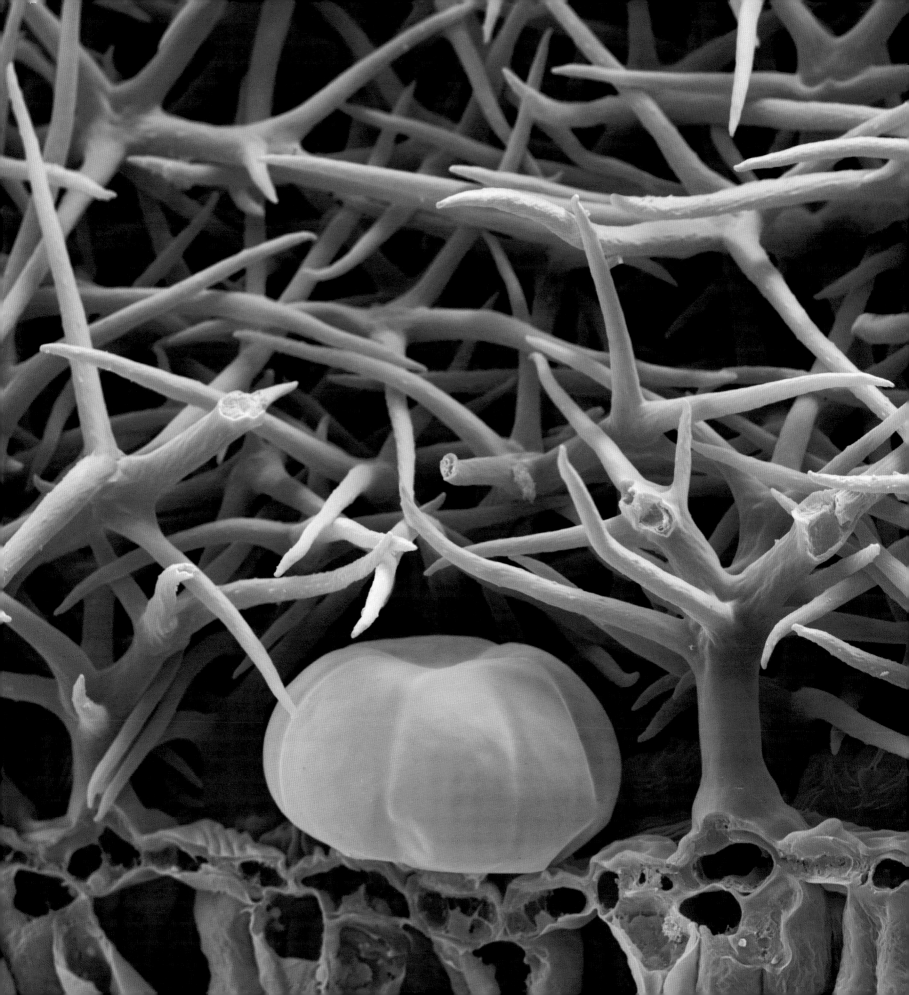

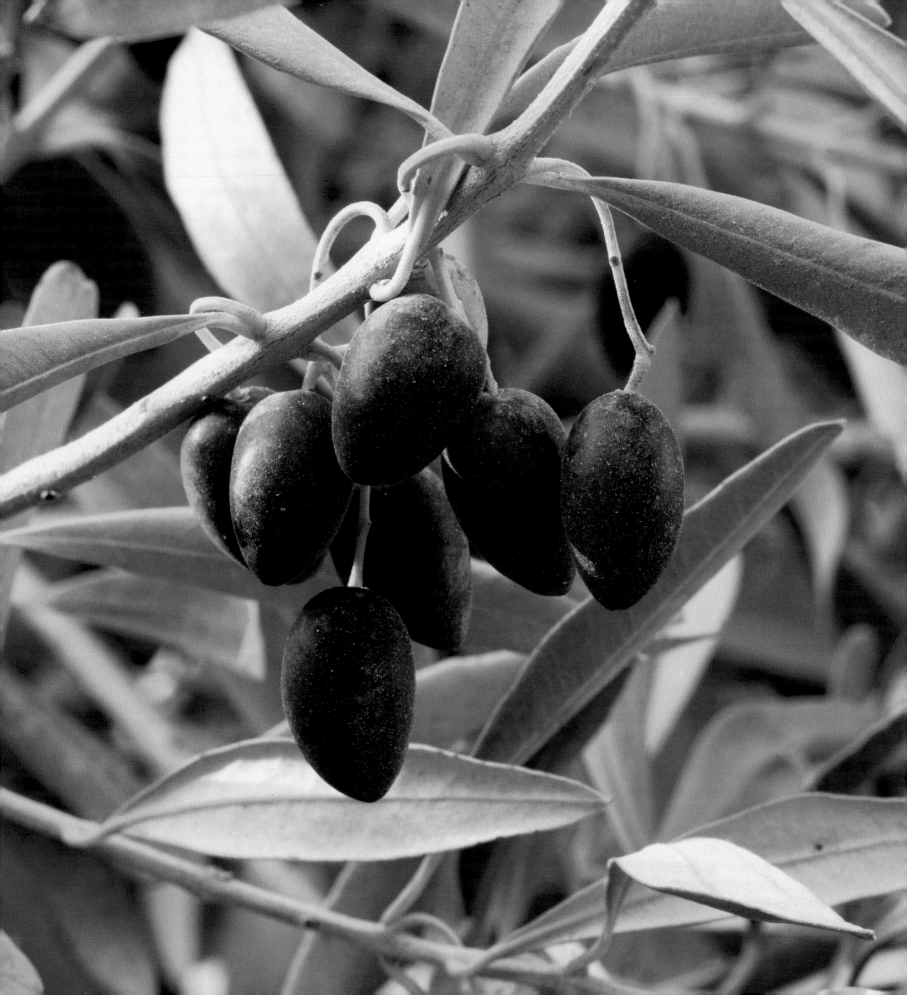

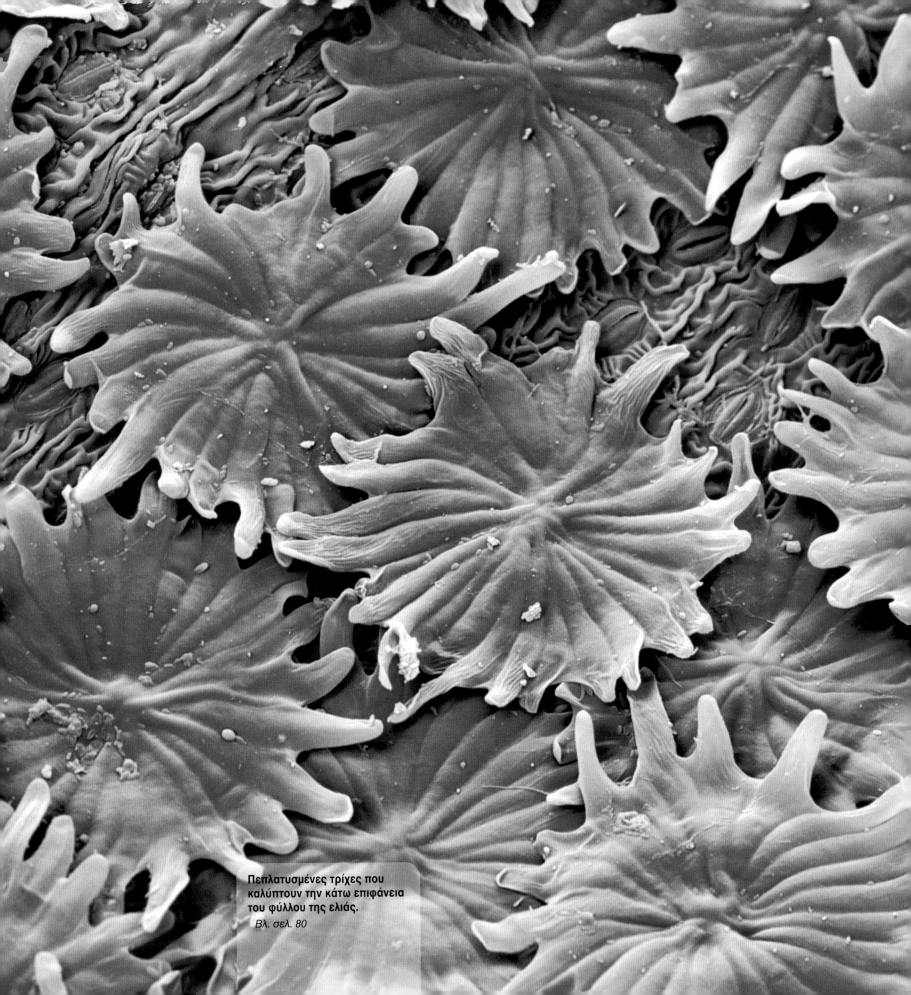

Πεπλατυσμένες τρίχες που καλύπτουν την κάτω επιφάνεια του φύλλου της ελιάς.

Βλ. σελ. 80

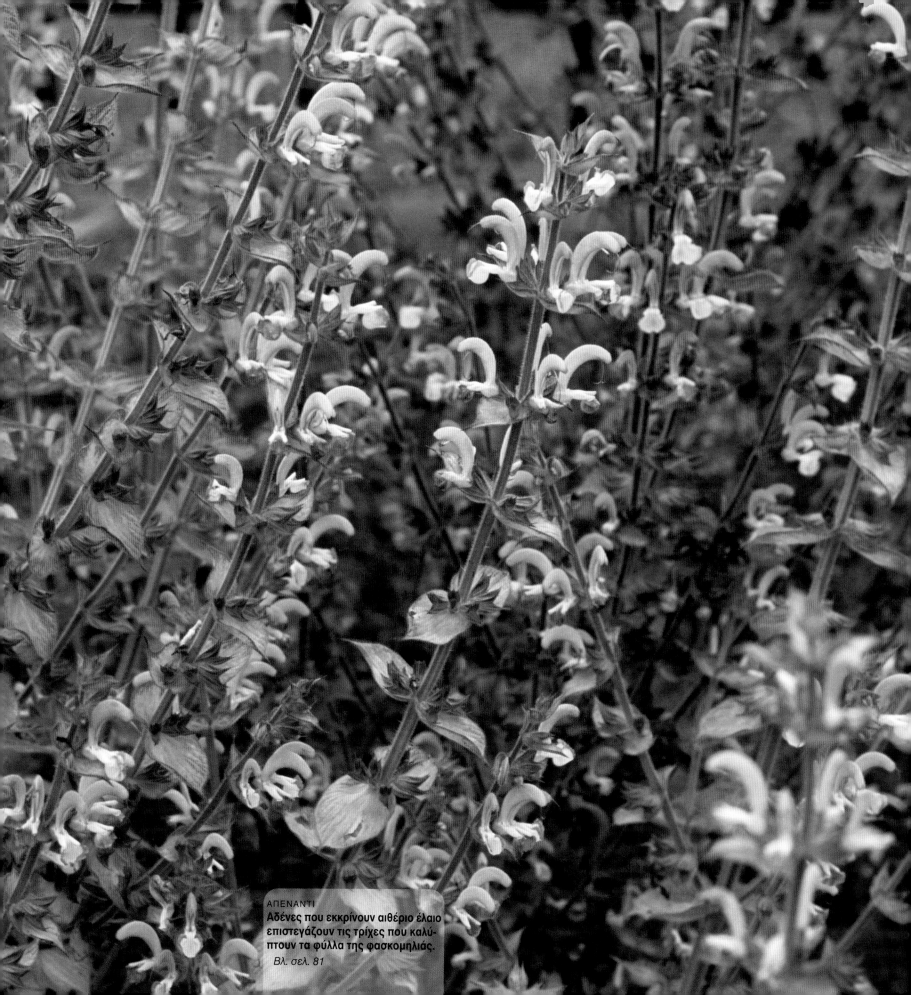

ΑΠΕΝΑΝΤΙ
Αδένες που εκκρίνουν αιθέριο έλαιο επιστεγάζουν τις τρίχες που καλύπτουν τα φύλλα της φασκομηλιάς.
Βλ. σελ. 81

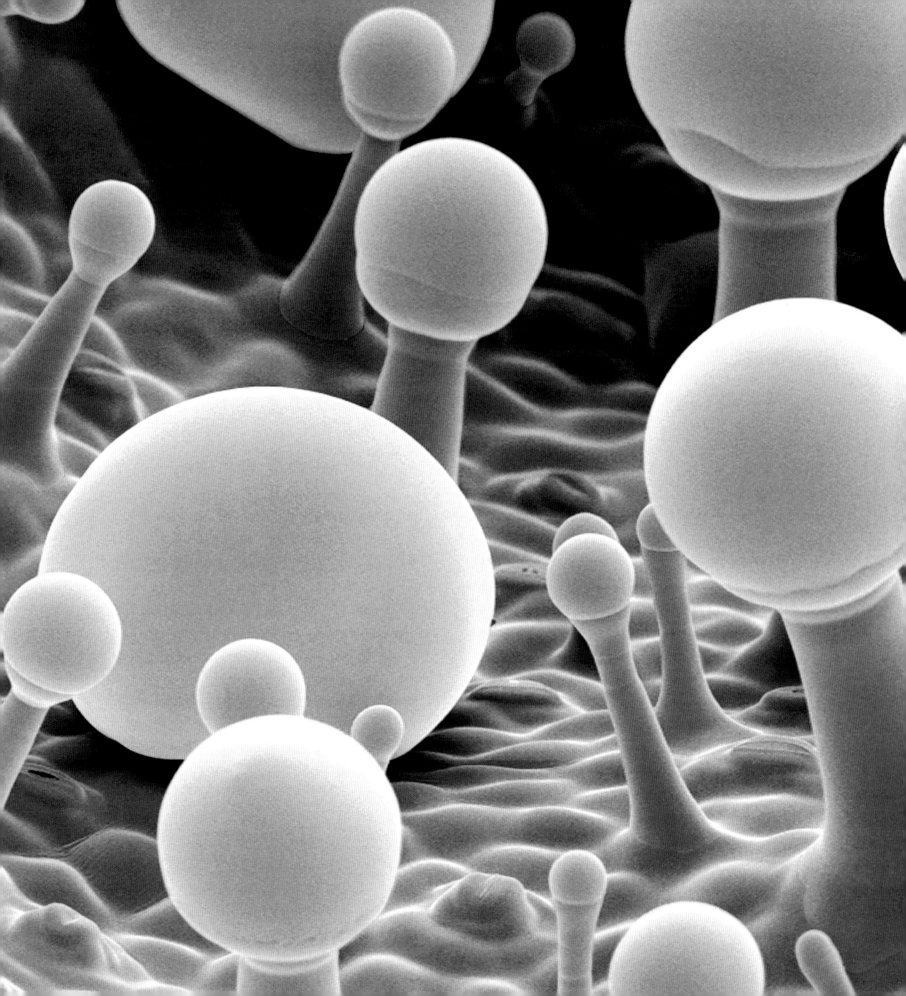

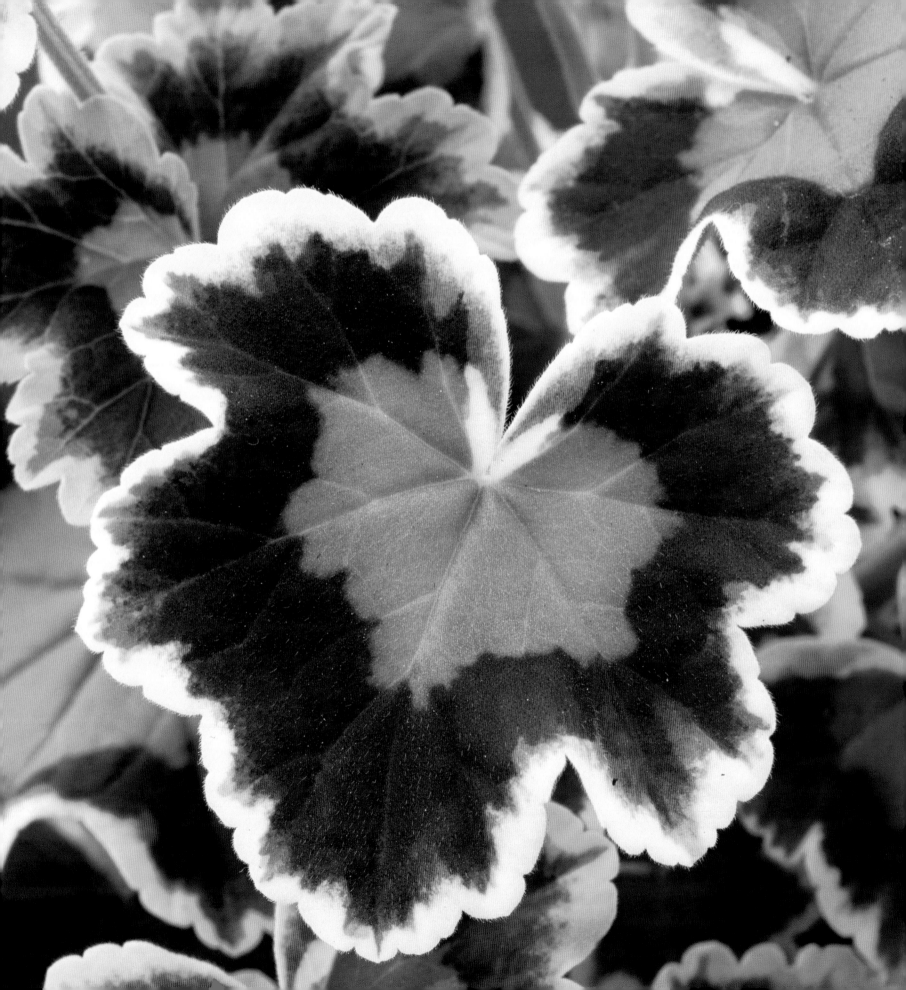

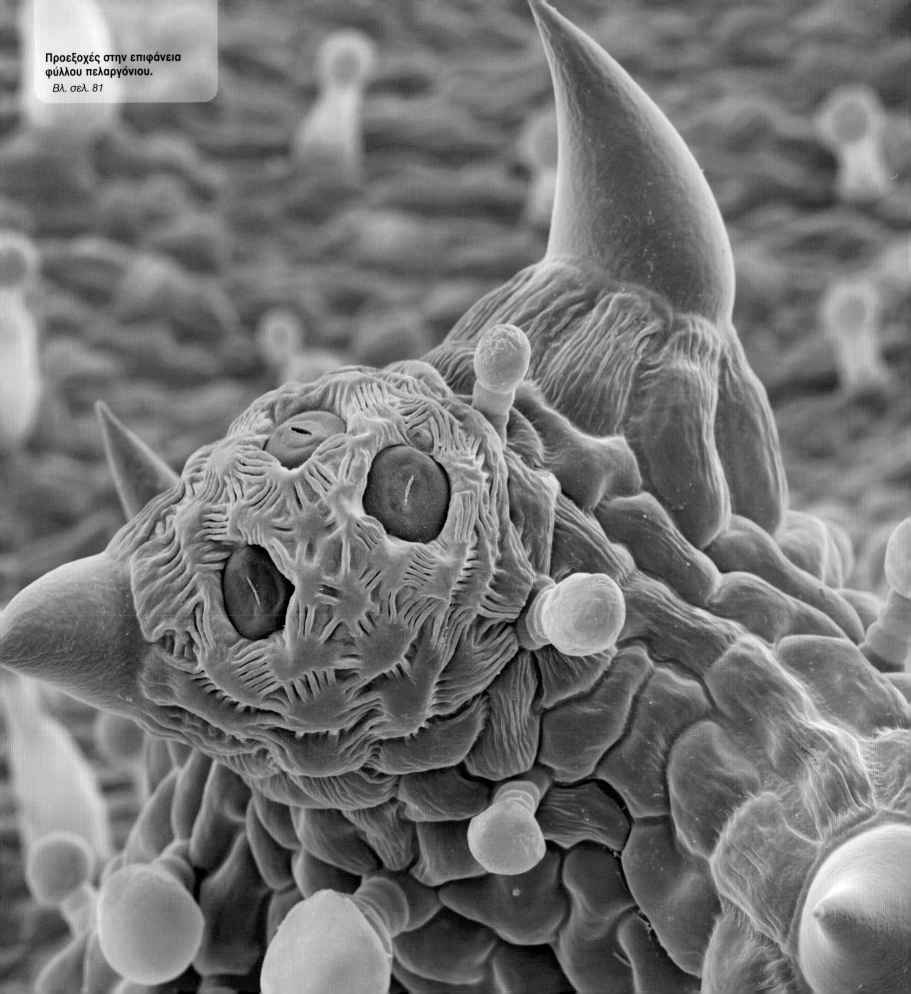

Προεξοχές στην επιφάνεια φύλλου πελαργόνιου.
Βλ. σελ. 81

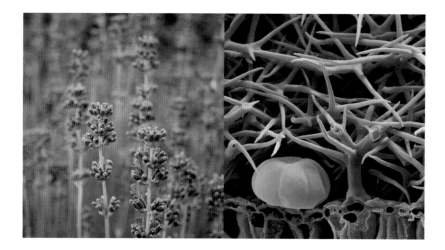

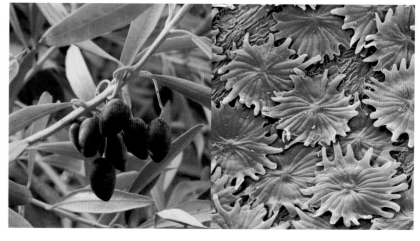

Αυτό το δασώδες τοπίο μοιάζει με τόπο εξωτικών και φαντασμάτων, όπου τα κλαδιά σχηματίζουν ένα πολύ πυκνό πλέγμα. Αλλά αυτό που μοιάζει με πυκνό δάσος στην πραγματικότητα είναι το πυκνό τρίχωμα, όπως λέγεται, που καλύπτει το φύλλο της λεβάντας. Αυτές οι τρίχες δίνουν στη λεβάντα την απαλή, χνουδωτή όψη της, έχουν δε τουλάχιστον τρεις διακριτές λειτουργίες.

Πρώτον, λειτουργούν ως φυσικό αποτρόπαιο φυτοφάγων εντόμων που μπλέκονται ανάμεσά τους ή αδυνατούν να διεισδύσουν μέχρι τις θρεπτικές ουσίες των κυττάρων στην επιφάνεια του φύλλου. Ορισμένα μεγαλύτερα φυτοφάγα θεωρούν τις τρίχες αυτές ενοχλητικές ή αηδιαστικές.

Το τρίχωμα λειτουργεί επίσης ως μονωτικό, περιορίζει την απώλεια του νερού παγιδεύοντας την υγρασία στις περιπεπλεγμένες τρίχες του και εμποδίζοντας την εξάτμισή του. Οι λεβάντες, καθώς και άλλα φυτά με τρίχωμα, ευδοκιμούν κατά κανόνα σε ζεστά ξηρά κλίματα, όπου άλλα φυτά μαραίνονται και πεθαίνουν.

Η όμοια με σάκο δομή στην εικόνα είναι αδένας που περιέχει μια δραστική χημική ουσία, το αιθέριο έλαιο που δίνει στη λεβάντα το έντονο άρωμά της. Το έλαιο αυτό είναι ένα σύνθετο κοκτέιλ μικρών, βιολογικά ενεργών μορίων (τερπένια και τερπινόλες).

Αρωματικά φυτά, όπως η λεβάντα, απωθούν τα φυτοφάγα με όπλο χημικές ουσίες με έντονη οσμή. Τα έντομα που τρώνε φύλλα πρέπει να ανταπεξέλθουν στις υψηλές συγκεντρώσεις τέτοιων ουσιών, που μπορεί να είναι και δηλητηριώδεις, εκτός εάν αναλώσουν μεγάλες ποσότητες ενέργειας, ώστε να τις μεταβολίσουν ή να τις αποβάλουν. Συγκεντρώνοντας τις χημικές ουσίες σε έναν αδένα σαν σάκο, η λεβάντα απωθεί με την πικρή γεύση της και μεγαλύτερα φυτοφάγα.

Αυτές οι όμοιες με φίνα πλεκτά πετσετάκια δομές στην κάτω επιφάνεια του φύλλου της ελιάς δεν είναι απλώς μια ωραίου χρώματος διακόσμηση. Δεν έχουν καμία σχέση με την εθιμοτυπία ενός επίσημου δείπνου ή με εργόχειρα. Αυτοί οι παράξενοι, πεπλατυσμένοι, δισκοειδείς πλόκαμοι είναι εξειδικευμένα τριχώματα, τέλεια προσαρμογή στις σκληρές κλιματικές συνθήκες που επικρατούν το καλοκαίρι στις ξηρές βουνοπλαγιές της Μεσογείου. Είναι τρίχες σαν λέπια που προστατεύουν την κάτω επιφάνεια του φύλλου και κατ' επέκταση ολόκληρο το φυτό από την ξήρανση.

Η απώλεια νερού είναι θέμα ζωής ή θανάτου για ένα φυτό. Ελεγχόμενη εξάτμιση του νερού από τα φύλλα είναι μία από τις βασικές αρχές που του επιτρέπουν να ζει και να αναπτύσσεται. Καθώς το φυτό εκλύει υδρατμούς από τους μικροσκοπικούς του πόρους, τα στόματα, στην κάτω επιφάνεια των φύλλων, δημιουργείται αρνητική πίεση στα αγγεία στον βλαστό του φυτού που μεταφέρουν το νερό, πράγμα που διευκολύνει την απορρόφηση νερού και ανόργανων θρεπτικών συστατικών από το έδαφος.

Τα φυτά είναι σε θέση να ελέγχουν έως έναν βαθμό την απώλεια νερού ανοιγοκλείνοντας τα στόματα. Αλλά, καθώς αυτοί οι πόροι επιτρέπουν και την είσοδο αερίων, ιδίως διοξειδίου του άνθρακα, το οποίο τα φυτά απορροφούν και μεταβολίζουν κατά τη διαδικασία της φωτοσύνθεσης, καμιά φορά ο μηχανισμός που βοηθά το φυτό να μην ξεραθεί έρχεται σε σύγκρουση με τον μηχανισμό θρέψης.

Η ελιά επιβιώνει κάτω από συνθήκες εποχικής ξηρασίας, που για άλλα φυτά θα ήταν μοιραίες. Το αποστραγγισμένο έδαφος σε συνδυασμό με τον άνεμο που επίσης απομακρύνει την υγρασία μαραίνει τα φυτά σε σημείο που αδυνατούν να συνέλθουν. Τα φύλλα της ελιάς, όμως, προστατεύονται από το τρίχωμα αυτό στην κάτω επιφάνειά τους, δηλαδή από έναν μανδύα κάτω από τον οποίο ένα υγρό στρώμα αέρα δεν παρασύρεται τόσο εύκολα από το φύσημα του ανέμου. Έτσι τα στόματα μπορούν να μένουν ανοιχτά, με συνέπεια αφενός να γίνεται ανταλλαγή αερίων, αφετέρου η απώλεια νερού να παραμένει σε χαμηλά επίπεδα.

ΔΕΞΙΑ
Διακλαδούμενες τριχούλες προστατεύουν τη λεβάντα από την εξάτμιση και την απώλεια νερού, ενώ ένας αδένας γεμάτος πικρό αιθέριο έλαιο απωθεί τα φυτοφάγα.

ΑΡΙΣΤΕΡΑ
Τα άνθη της λεβάντας εκκρίνουν και μια άλλη αρωματική ουσία, προσελκύοντας επικονιαστές (μέλισσες).

ΔΕΞΙΑ
Τα λεπιδωτά τριχώματα προστατεύουν την κάτω επιφάνεια των φύλλων της ελιάς ώστε να μην χάνει νερό από τα στόματα, μερικά από τα οποία φαίνονται στην εικόνα ακριβώς πάνω από το κέντρο.

ΑΡΙΣΤΕΡΑ
Οι ελιές ευδοκιμούν σε τόπους όπου το κλίμα είναι θερμό και ξηρό, και τα φύλλα τους έχουν προσαρμοστεί έτσι ώστε να μην κινδυνεύουν από την ξηρασία.

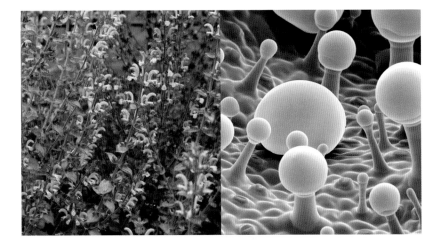

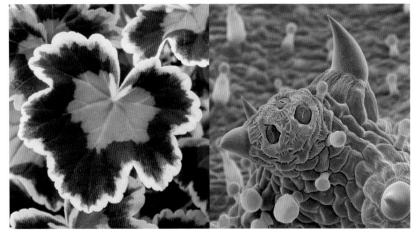

Αυτό το τοπίο των κορμών με τους υπόλευκους σφαιρικούς γλόμπους που μοιάζει παρμένο από έργο επιστημονικής φαντασίας θα μπέρδευε και τον πιο έμπειρο αστροναύτη. Κάθε βλαστός φαίνεται μαλακός και ζελατινώδης, ταυτόχρονα όμως τόσο ντελικάτος και εύθραυστος, που φαίνεται πως αν τον αγγίξεις θα διαλυθεί. Και όντως θα διαλυθεί, γιατί αυτό το δάσος σβόλων είναι το όπλο με το οποίο αμύνεται η φασκομηλιά (Salvia sclarea) στα φυτοφάγα.

Κάθε ανοιχτόχρωμος σβόλος πάνω στο κοντό στέλεχός του (ένα άλλο είδος τριχώματος από αυτό της ελιάς) είναι μια εξελιγμένη μορφή των τριχών στην επιφάνεια του φυτού. Η σφαιρική τους κορυφή είναι ένας εξειδικευμένος αδένας που εκκρίνει ένα αρωματικό έλαιο, αηδιαστικό σε μικρότερους μυζητικούς οργανισμούς, όπως π.χ. στις κάμπιες των εντόμων.

Η φασκομηλιά είναι φυτό ιθαγενές της Ευρώπης και της Κεντρικής Ασίας, γνωστό από παλιά για το άρωμά του. Τα φύλλα της τρώγονται ωμά στις σαλάτες ή χρησιμοποιούνται σαν αφέψημα, κυρίως όμως καλλιεργείται για το άρωμά της. Λέγεται πως βοηθά στην περίπτωση στομαχικών προβλημάτων, αερίων ή δυσπεψίας, και πως είναι τονωτικό και σπασμολυτικό φυτό που ανακουφίζει από τους πόνους της εμμηνόρροιας. Ενώ άλλοτε χρησιμοποιούσαν τη φασκομηλιά για να αρωματίσουν μπίρες και κρασιά, σήμερα καλλιεργείται για το αιθέριο άρωμά της που χρησιμοποιείται στην αρωματοποιία και την αρωματοθεραπεία, καθώς λένε πως προσθέτει ένα στοιχείο ευφορίας στα αρώματα.

Χημικά συστατικά του αιθέριου αυτού ελαίου είναι η σκλαρεόλη, μια σύνθετη ουσία που μοιάζει πολύ με τη χοληστερόλη. Όπως πολλές φυτικές αρωματικές ουσίες, έτσι και αυτή έχει φαρμακευτικές ιδιότητες που αποτελούν αντικείμενο μελέτης. Συγκεκριμένα, μελετάται η ιδιότητα της αναστολής της ανάπτυξης καρκινικών κυττάρων, καθώς και οι αντιβακτηριδιακές της ιδιότητες.

Ένα παράξενο πλάσμα, μια χίμαιρα, ένα πλάσμα μισό φυτό και μισό ζώο, μοιάζει να έχει ανασηκωθεί απειλώντας με τα τεράστια σαν νύχια κέρατά του. Κάτω από το ηλεκτρονικό μικροσκόπιο η φαινομενικά λεία επιφάνεια των φύλλων του πελαργόνιου (κοινώς αρμπαρόριζα), αποκαλύπτεται γεμάτη αγκάθια, προεκβολές όμοιες με κέρατα.

Αυτός ο τύπος προεκβολών προστατεύουν την αρμπαρόριζα από τις επιθέσεις των φυτοφάγων. Τα αγκάθια στα φύλλα της είναι σκληρά και ερεθίζουν τον ουρανίσκο των χορτοκόπων σπονδυλωτών, ενώ δεν χωνεύονται από τις κάμπιες ή καταστρέφουν τις άνω γνάθους (mandibulae) των εντόμων. Τα στελέχη που μοιάζουν με πόδια μανιταριών είναι τριχοειδείς αδένες που παράγουν την αρωματική ουσία για την οποία καλλιεργείται το πελαργόνιο.

Φυτά και φυτοφάγα (ιδίως έντομα) εξελίσσονται διεξάγοντας έναν διαρκή πόλεμο φθοράς το ένα εναντίον του άλλου. Η σύνθεση και συγκέντρωση χημικών ουσιών με έντονη οσμή από τα φυτά αποσκοπεί στην άμυνά τους εναντίον εχθρικών επιθέσεων.

Από την άλλη, φυτοφάγα ζώα πρέπει να ξοδέψουν πολλή ενέργεια για να αποτοξινώσουν ό,τι τρώνε.

Τα πελαργόνια (που μέχρι πρόσφατα κατατάσσονταν στα γεράνια) είναι διαδεδομένα φυτά κήπου. Τα περισσότερα είναι ιθαγενή της Νότιας Αφρικής, αλλά ορισμένα επίσης της Μέσης Ανατολής, της Μαδαγασκάρης, της Αυστραλίας και της Νέας Ζηλανδίας. Όπως πολλά εξωτικά φυτά κήπων, μακριά από το οικείο περιβάλλον τους, δεν ενοχλούνται πολύ από ασθένειες που προκαλούν τα έντομα, καθώς τα χημικά αμυντικά τους όπλα απωθούν επιτυχώς τους εχθρούς τους.

Παρ' όλα αυτά η πεταλούδα Geranium bronze της οικογένειας Lycaenidae έχει κάμπιες που όχι μόνο επιζούν του χημικού πολέμου, αλλά τρέφονται αποκλειστικά με αυτά τα φυτά. Παρότι είδος ιθαγενές της Νότιας Αφρικής, η πεταλούδα, μεταφέρθηκε σε όλο τον κόσμο μέσω της εξαγωγής πελαργόνιων, απειλώντας να εξελιχθεί σε σοβαρή ασθένεια των δημοφιλών αυτών φυτών.

ΔΕΞΙΑ
Τα χλωμά μανιτάρια που καλύπτουν την επιφάνεια αυτού του φύλλου είναι αδένες που εκκρίνουν ένα μίγμα σύνθετων χημικών ουσιών με έντονο άρωμα.

ΑΡΙΣΤΕΡΑ
Τα άνθη της φασκομηλιάς περιέχουν υψηλές συγκεντρώσεις αιθέριων ελαίων και συλλέγονται για τις φαρμακευτικές τους ιδιότητες και ως καρύκευμα.

ΔΕΞΙΑ
Αυτό το σαρκώδες εξόγκωμα που μοιάζει με κερασφόρο μυθικό πλάσμα είναι μια φλύκταινα στο φύλλο του πελαργόνιου.

ΑΡΙΣΤΕΡΑ
Παρότι φαίνονται μαλακά και χνουδωτά, τα φύλλα του πελαργόνιου είναι σκληρά και ινώδη στην αφή.

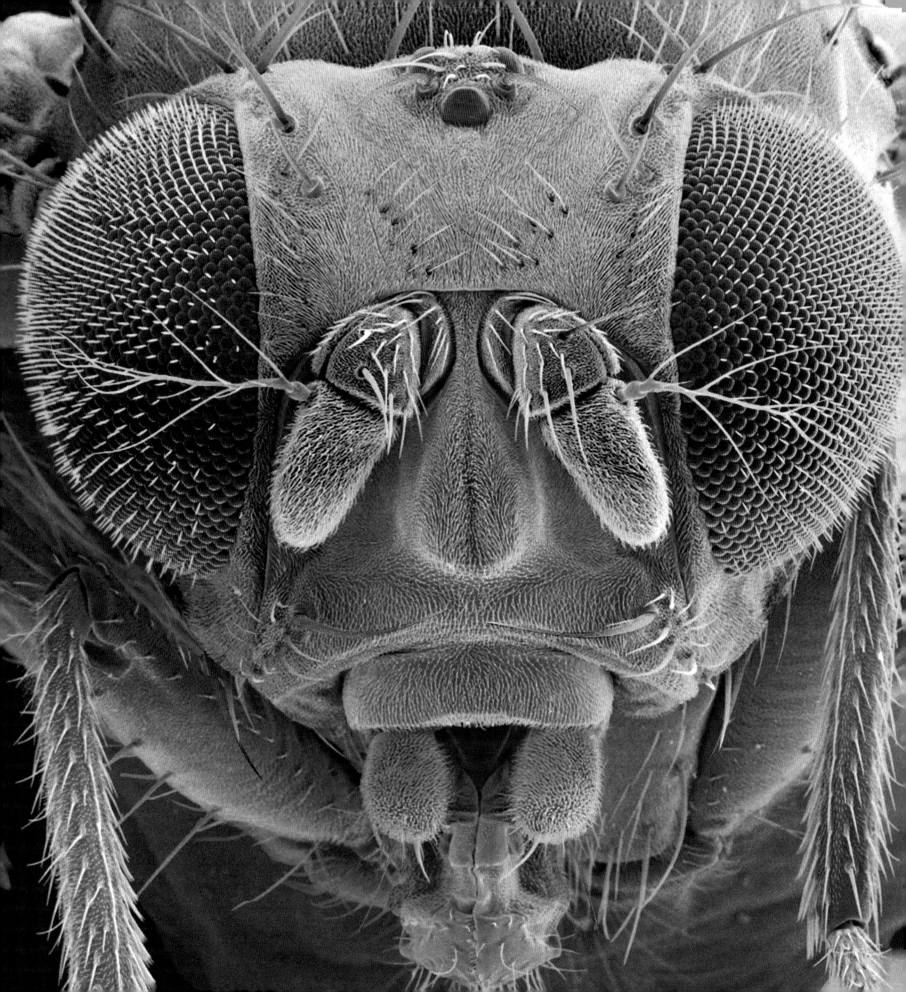

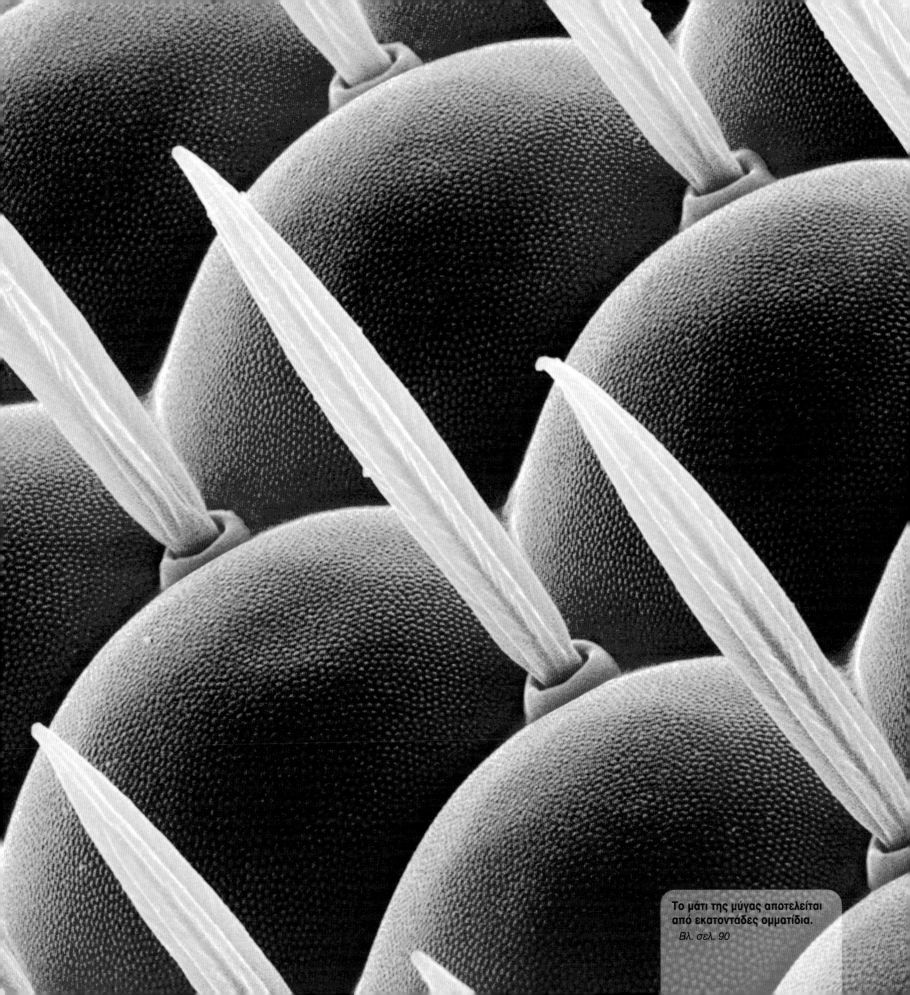

Το μάτι της μύγας αποτελείται
από εκατοντάδες ομματίδια.
Βλ. σελ. 90

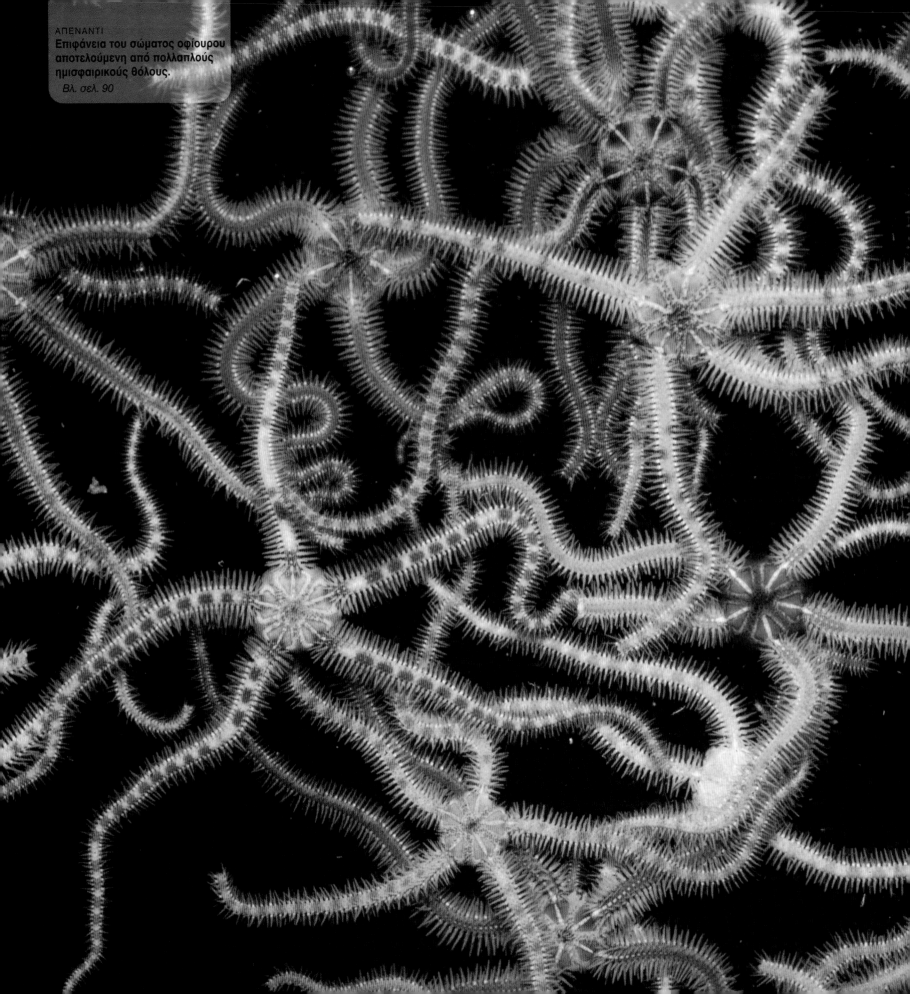

ΑΠΕΝΑΝΤΙ
Επιφάνεια του σώματος οφίουρου αποτελούμενη από πολλαπλούς ημισφαιρικούς θόλους.
Βλ. σελ. 90

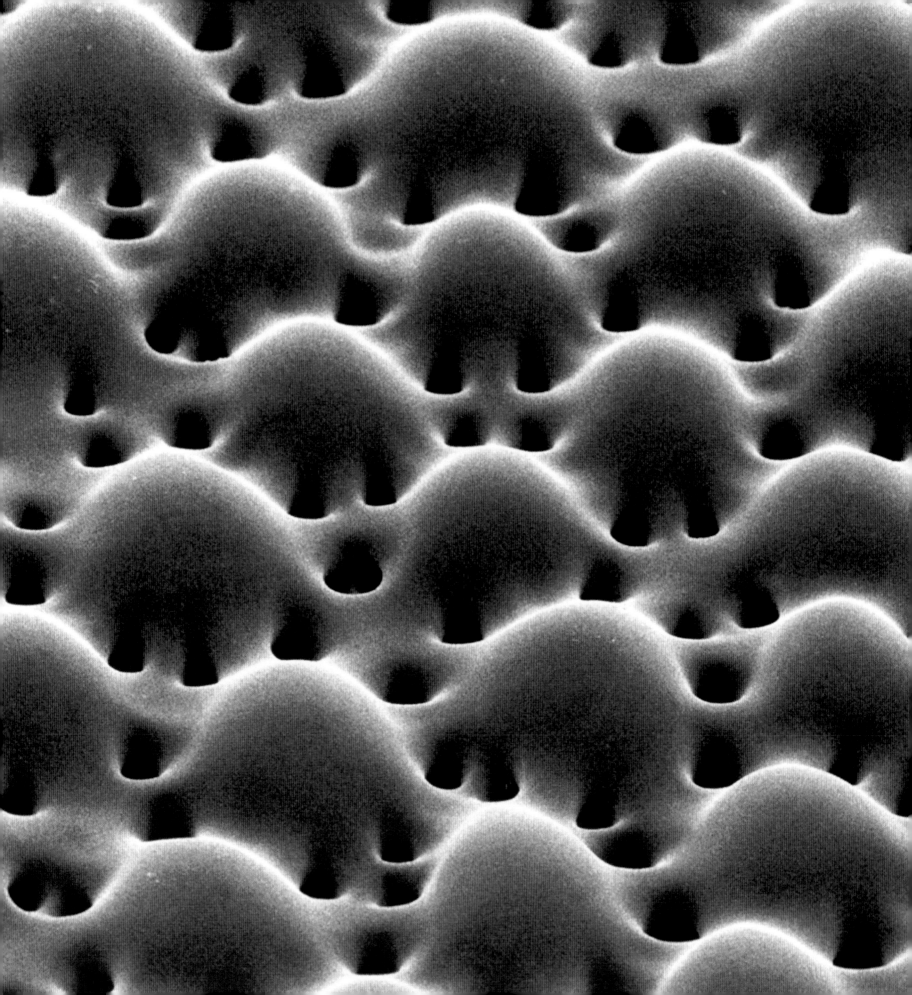

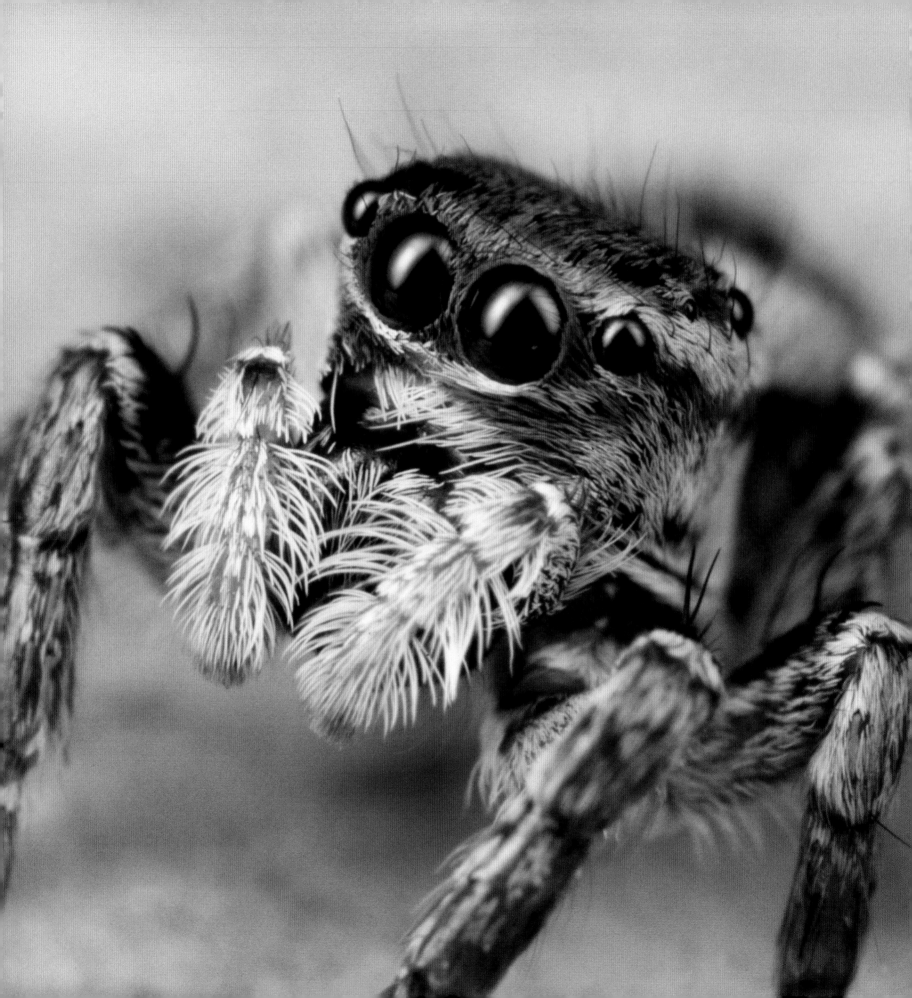

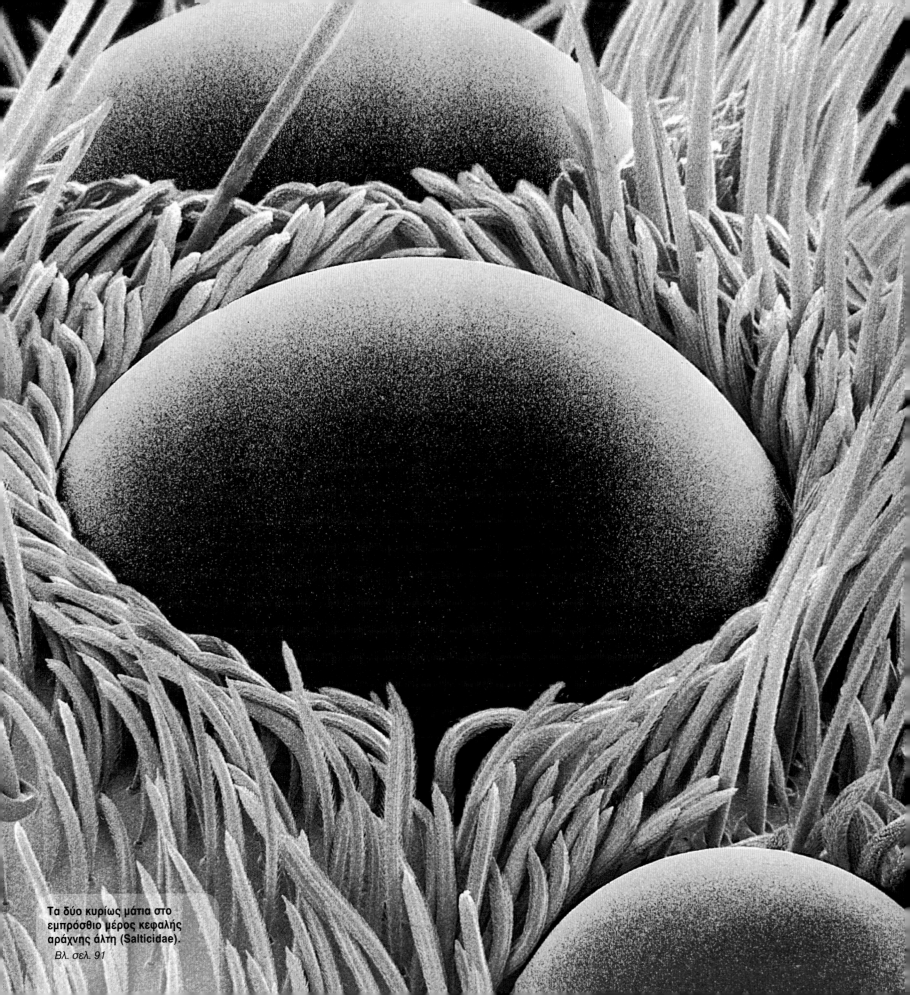

Τα δύο κυρίως μάτια στο εμπρόσθιο μέρος κεφαλής αράχνης άλτη (Salticidae).

Βλ. σελ. 91

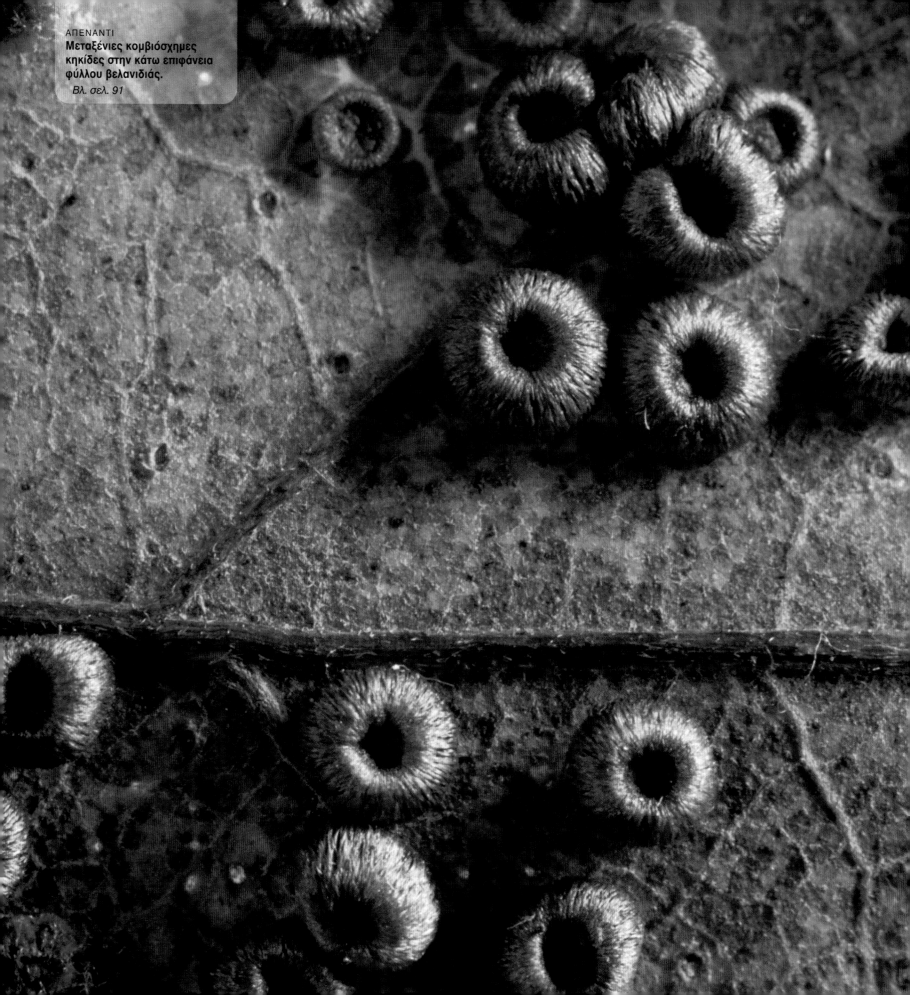

ΑΠΕΝΑΝΤΙ
**Μεταξένιες κομβιόσχημες
κηκίδες στην κάτω επιφάνεια
φύλλου βελανιδιάς.**
Βλ. σελ. 91

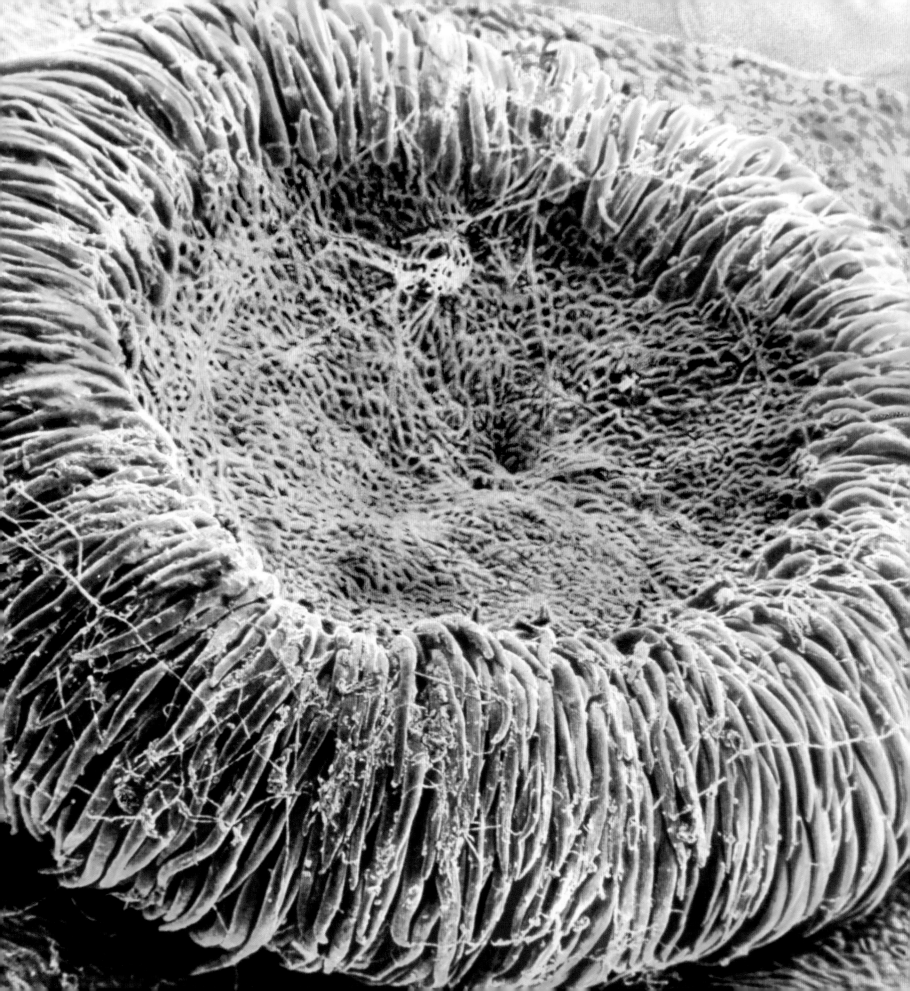

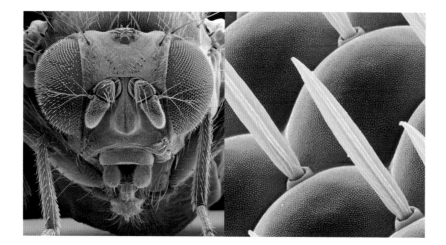

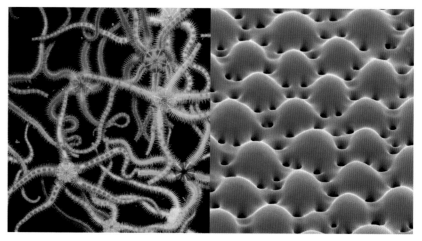

Οι σύνθετοι οφθαλμοί των εντόμων είναι ένα θαύμα συνδυασμού πλήθους λεπτομερειών. Κάθε οφθαλμός αποτελείται από πλήθος μονάδων, τα ομμάτιδια, που όλα μαζί σχηματίζουν θόλο. Κάθε ομμάτιδιο αποτελείται από την προστατευτική διάφανη δερμίδα (cuticula), έναν κυρτό φακό για να εστιάζει το φως, μια λεπτή στήλη φωτοευαίσθητων κυττάρων, το ράβδωμα, και τέλος από έναν ιστό οπτικών κυττάρων που μεταφέρουν τα ερεθίσματα στον εγκέφαλο του εντόμου.

Κάθε ομμάτιδιο λειτουργεί σαν αυτόνομη μονάδα. Το είδωλό τους είναι πολύ ασαφές απέχοντας κατά πολύ από το ακριβέστατο είδωλο στα πτηνά ή τα θηλαστικά. Το έντομο μπορεί να αποκτήσει μια εικόνα του κόσμου γύρω του μέσω αλληλεπικάλυψης των ειδώλων όλων των ομμάτιδίων. Αλλά ακόμα και αυτό το τελικό είδωλο δεν είναι και πολύ σπουδαίο. Είναι περισσότερο ένα είδος ιμπρεσιονιστικής ερμηνείας φωτεινών και σκοτεινών μορφωμάτων που θυμίζει μωσαϊκό, παρά σαφή και πλήρη εικόνα σαν φωτογραφία.

Παρότι αυτή η μικρής ανάλυσης άποψη ως καλλιτεχνική ερμηνεία του κόσμου δεν προσφέρει στο έντομο και πολλά, αυτού του τύπου ο μηχανισμός οπτικής ερμηνείας είναι εξαιρετικά ευαίσθητος στην κίνηση. Φτάνει να εισχωρήσει το φως που αντανακλά κάθε κινούμενο αντικείμενο σε ένα μόνο ομμάτιδιο, ώστε το νευρικό κύτταρο να εκπέμψει αμέσως σήμα κινδύνου με τη μορφή νευρικών παλμών.

Την εξωτερική, θολωτή επιφάνεια του ματιού συνθέτουν οι σχεδόν κανονικοί εξαγωνικοί φακοί των ομμάτιδίων. Αυτή η μύγα των φρούτων που εικονίζεται εδώ έχει περίπου 250 ομμάτιδια σε κάθε μάτι, αριθμό μάλλον μικρό, που παρ' όλα αυτά επιτρέπουν στο έντομο να διακρίνει αρκετά καλά φωτεινές και σκοτεινές περιοχές ώστε να εντοπίζει τα πεσμένα από το δέντρο φρούτα. Αντίθετα, οι λιβελούλες είναι εξαίρετοι ιπτάμενοι θηρευτές, και είναι φυσικό να χρειάζονται οπτική ακρίβεια για να πετύχουν τον στόχο τους – έτσι λοιπόν δεν εκπλήσσει το γεγονός ότι οι μεγαλύτερες έχουν έως και 30.000 ομμάτιδια σε κάθε μάτι.

Ο συνδυασμός κυματοειδούς επιφάνειας και μικροσκοπικών οπών, στην εικόνα δεξιά, σε κάνει να σκέφτεσαι πως πρόκειται για κάποιο αποστραγγιστικό σύστημα. Ή ίσως για τρυπητό. Ή για πορώδες αντικολλητικό τηγάνι. Όμως, αυτοί οι ελάχιστοι σε μέγεθος θόλοι απαντώνται στο οστέινο σώμα ενός οφίουρου και ο ακριβής λειτουργικός τους ρόλος παίδεψε χρόνια τους επιστήμονες. Μόνο όταν κάποιος ερευνητής γυάλισε μερικούς και εξέτασε τις διαθλαστικές τους ιδιότητες υπό άμεσο φωτισμό ανακάλυψε πως ήταν μικροσκοπικοί φακοί.

Οι οφίουροι, πλάσματα συγγενικά του αστερία, αλλά με λεπτά πλοκάμια, βγαίνουν από τις κρυψώνες τους τη νύχτα για να τραφούν με πλαγκτόν και άλλα σωματίδια. Το όνομά τους οφείλεται στα μακριά, λεπτά και οφιόσχημα πλοκάμια τους, που μοιάζουν πολύ εύθραυστα και συνδέονται με ένα δισκοειδές σώμα. Και, πράγματι, εύκολα χάνουν τα άκρα των πλοκαμιών τους που τα αποσπούν διάφορα άλλα αρπακτικά, αλλά αναγεννούνται.

Σε αντίθεση με τους δυσκίνητους αστερίες, οι οφίουροι χρησιμοποιούν τα κυματοειδή μέλη τους για να κινούνται με μεγάλη σχετικά ταχύτητα, ιδίως για να ξεφεύγουν από τα δυνάμει αρπακτικά. Είναι προ πολλού γνωστό ότι αντιλαμβάνονται σκιές που πέφτουν πάνω τους, γιατί απομακρύνονται γρήγορα όταν συμβαίνει αυτό. Εκείνο που μπέρδευε μέχρι πρόσφατα τους επιστήμονες ήταν το γεγονός ότι αυτά τα θαλάσσια ζώα δεν έχουν μάτια ή οποιονδήποτε άλλο φανερό οπτικό μηχανισμό. Η μικροσκοπία ηλεκτρονικής σάρωσης αποκάλυψε ότι η εξωτερική επιφάνειά τους καλύπτεται με θόλους σε σχήμα φακού, οπότε διατυπώθηκε η υπόθεση πως μάλλον αυτοί δίνουν στο ζώο μια κάποια πρωτόγονη αίσθηση του φωτός. Συστατικό των θόλων, όπως και του υπόλοιπου σκληρού περιβλήματος των οφίουρων, είναι μορφή του πολύμορφου ανθρακικού ασβεστίου, του ασβεστίτη. Εξετάζοντας τις οπτικές ιδιότητες αυτών των ημισφαιρικών προεξοχών από ασβεστίτη, οι επιστήμονες διαπίστωσαν ότι όντως λειτουργούν σαν φακοί, εστιάζοντας το φως στο σημείο κάτω από την εξωτερική επιφάνεια του οφίουρου όπου υπάρχουν νευρικοί υποδοχείς. Αυτό σημαίνει πως ουσιαστικά ολόκληρο το σώμα του οφίουρου είναι ένας σύνθετος οφθαλμός και πιθανόν να έχει οξύτερη όραση από πολλά άλλα ζώα που υποτίθεται πως είναι πιο εξελιγμένα.

ΔΕΞΙΑ
Παρά τον τεράστιο αριθμό τους, τα ομμάτιδια της μύγας τής προσφέρουν μια μάλλον αδρή και συγκεχυμένη εικόνα.

ΑΡΙΣΤΕΡΑ
Τα ημισφαιρικά, πολυεδρικά σύνθετα μάτια της μύγας των φρούτων δεσπόζουν στο στρογγυλό της κεφάλι.

ΔΕΞΙΑ
Το σώμα του οφίουρου Ophiocoma wendtii καλύπτουν 10.000 έως 20.000 μικροσκοπικοί θόλοι-φακοί που εστιάζουν το φως σε οπτικά κύτταρα κάτω από το εξωτερικό περίβλημα, μεταβάλλοντας ολόκληρο το σώμα του σε τεράστιο μάτι.

ΑΡΙΣΤΕΡΑ
Οι οφίουροι συγγενεύουν με τους αστερίες, αλλά είναι πιο ευλύγιστοι και γρήγοροι.

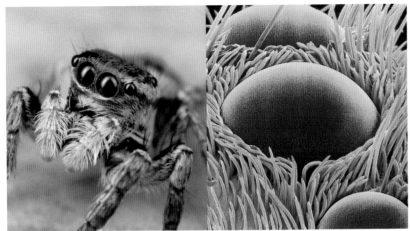

Αυτή η σειρά πορτοκαλιές μπάλες, μισοχωμένες στο γρασίδι εντυπωσιάζουν με την αψεγάδιαστη λάμψη και ομορφιά των σφαιρών. Καθώς είναι μάλλον απίθανο να σχηματίζουν τυχαία σειρά, η θέση τους μοιάζει απόρροια αισθητικής ακρίβειας και καλλιτεχνικής σκοπιμότητας.

Στην πραγματικότητα, όμως, η θέση τους εξυπηρετεί μια λειτουργία θεμελιώδους σημασίας για τις αράχνες άλτες, διότι πρόκειται για δύο από τα τέσσερα ωραία βαλμένα στη σειρά μπροστινά μάτια αυτής της οικογένειας αραχνών, στα οποία και χρωστούν τη θηρευτική τους δεινότητα.

Οι αράχνες άλτες δεν υφαίνουν μεταξωτούς ιστούς, παγίδες. Θηρεύουν χρησιμοποιώντας την όρασή τους, δηλαδή πηδώντας ξαφνικά πάνω στο θύμα τους, το δε άλμα τους συχνά είναι πολλαπλάσιο του μήκους του σώματός τους. Ένας τέτοιος άθλος απαιτεί ακριβή υπολογισμό της τροχιάς, καθώς και του μεγέθους και της απόστασης του θηράματος. Για να το κάνουν αυτό, οι αράχνες άλτες έχουν αποκτήσει τέτοια όραση που δεν έχει όμοιό της.

Οι αράχνες έχουν οκτώ (και σπανίως έξι) μάτια που είναι συνήθως κάτι παραπάνω από μικροί, φωτοευαίσθητοι θόλοι που αντιλαμβάνονται τη σκιά που πέφτει πάνω τους. Στις αράχνες άλτες, όμως, τα μπροστινά τέσσερα μάτια είναι μεγάλα και τα δύο στο μέσον τεράστια, συχνά 100 φορές μεγαλύτερα από τα μάτια ισομεγέθων αραχνών. Έτσι διαθέτουν ακριβή τηλεσκοπική όραση που τους επιτρέπει να προσδιορίζουν τριγωνομετρικά τη θέση (και κατ' αυτόν τον τρόπο την απόσταση) του αντικειμένου μπροστά τους. Έχουν εσωτερικό φακό, καθώς και τον σφαιρικό φακό που βλέπουμε στην εικόνα, που μετατρέπουν το μάτι σε τηλεφωτογραφική συσκευή, εστιάζοντας σε απόσταση από 2 εκατοστά έως το άπειρο. Επίσης, ελέγχουν μυικά τον ευαίσθητο στο φως αμφιβληστροειδή στο βάθος του ματιού, πράγμα που τους επιτρέπει να αλλάζουν την κατεύθυνση της ματιάς τους χωρίς να κινούνται. Τέλος, στον αμφιβληστροειδή υπάρχουν τέσσερα στρώματα ραβδομερών (φωτοευαίσθητων κυττάρων), διατεταγμένων με τρόπο ώστε να αντιλαμβάνονται χρώματα από διάφορες περιοχές του φάσματος του φωτός.

Αυτή η παράξενη στεφάνη θα μπορούσε να ανήκει σε ένα μαξιλάρι ή ψάθινο κάθισμα κήπου. Φτιαγμένη από χιλιάδες βρόχους φυτικού νήματος φαίνεται μαλακή και σπογγώδης, αλλά το ερώτημα είναι τι κρύβει μέσα της. Η περίτεχνη αυτή κατασκευή κρύβει την προνύμφη ενός μικροσκοπικού εντόμου σαν μυγάκι, μιας μικρής σφήκας που ανήκει στην οικογένεια των Cynipidae.

Οι σφήκες αυτές είναι συγγενείς με τις κοινές σφήκες, τις μέλισσες και τα μυρμήγκια, αλλά έχουν υιοθετήσει διαφορετικό τρόπο ζωής. Όταν εναποθέτουν το αυγό τους στο φυτό εκκρίνουν ταυτόχρονα και ένα κοκτέιλ χημικών ουσιών με συνέπεια το φύλλο, ο βλαστός ή ο οφθαλμός του φυτού να αναπτύσσεται αφύσικα. Όταν η προνύμφη εκκολάπτεται συνεχίζει να παράγει ουσίες που υπονομεύουν τη φυσιολογική ανάπτυξη του φυτού και προκαλούν τον σχηματισμό κηκίδων. Κάθε είδος της οικογένειας των Κυνιπίδων προκαλεί διαφορετικές κηκίδες, το καθένα συνήθως σε ένα είδος ξενιστή. Οι όζοι της εικόνας ονομάζονται μεταξένιες κομβιόσχημες κηκίδες.

Δεν υπάρχει αμφιβολία πως τα έντομα που προκαλούν τις κηκίδες σφετερίζονται την ενέργεια και τις θρεπτικές ουσίες του φυτού, αλλά ορισμένες κηκίδες μπορεί να είναι προϊόν μίμησης του φυτού, με την έννοια ότι δεν περιέχουν όντως σκωληκοειδείς προνύμφες. Έτσι το φυτό αποφεύγει την ολοκληρωτική καταστροφή του ιστού από τις κάμπιες, για παράδειγμα. Τέλος, μπορεί να υπάρχουν πλήθος κηκίδες σε ένα μόνο φύλλο και εκατομμύρια σε ένα δέντρο, χωρίς να βλάπτουν σοβαρά την ανάπτυξή του ή την παραγωγή σπερμάτων.

Οι μικρές σφήκες που προσβάλλουν τη βελανιδιά έχουν σύνθετο βιολογικό κύκλο. Την άνοιξη βγαίνουν από τα μεταξένια κουκούλια πάνω στα πεσμένα φύλλα του φθινόπωρου μόνο θηλυκά έντομα. Αυτά θα εναποθέσουν τα αυγά τους στα νεαρά, τρυφερά φύλλα, αλλά οι κηκίδες σε αυτό το στάδιο δεν είναι παρά δυσδιάκριτα εξογκώματα. Από τα αυγά του εντόμου εκκολάπτονται τόσο θηλυκά όσο και αρσενικά άτομα, και μετά τη σύζευξη τα αυγά που θα γεννηθούν θα δημιουργήσουν την επόμενη γενιά «κουμπιών ντυμένων με μετάξι».

ΔΕΞΙΑ
Η αράχνη άλτης έχει δύο τεράστια «κύρια» μάτια στο μέτωπο που της προσφέρουν εξαίρετη τηλεσκοπική όραση, ώστε να εκτιμά σωστά το μέγεθος και την απόσταση του θηράματος.

ΑΡΙΣΤΕΡΑ
Οι αράχνες άλτες πηδούν ψηλά για να αρπάξουν το θήραμα. Αν αποτύχουν, εκκρίνουν ένα μεταξωτό νήμα που το χειρίζονται όπως οι ορειβάτες τα σκοινιά για την ασφαλή κάθοδό τους.

ΔΕΞΙΑ
Μέσα στο προστατευτικό εξόγκωμα της μεταξένιας κομβιόσχημης κηκίδας αναπτύσσεται η μικροσκοπική προνύμφη της σφήκας που προσβάλλει τη βελανιδιά.

ΑΡΙΣΤΕΡΑ
Οι κηκίδες πέφτουν μαζί με τα φύλλα το φθινόπωρο, και την άνοιξη οι σφήκες που εκκολάπτονται αναζητούν νέα φύλλα βελανιδιάς.

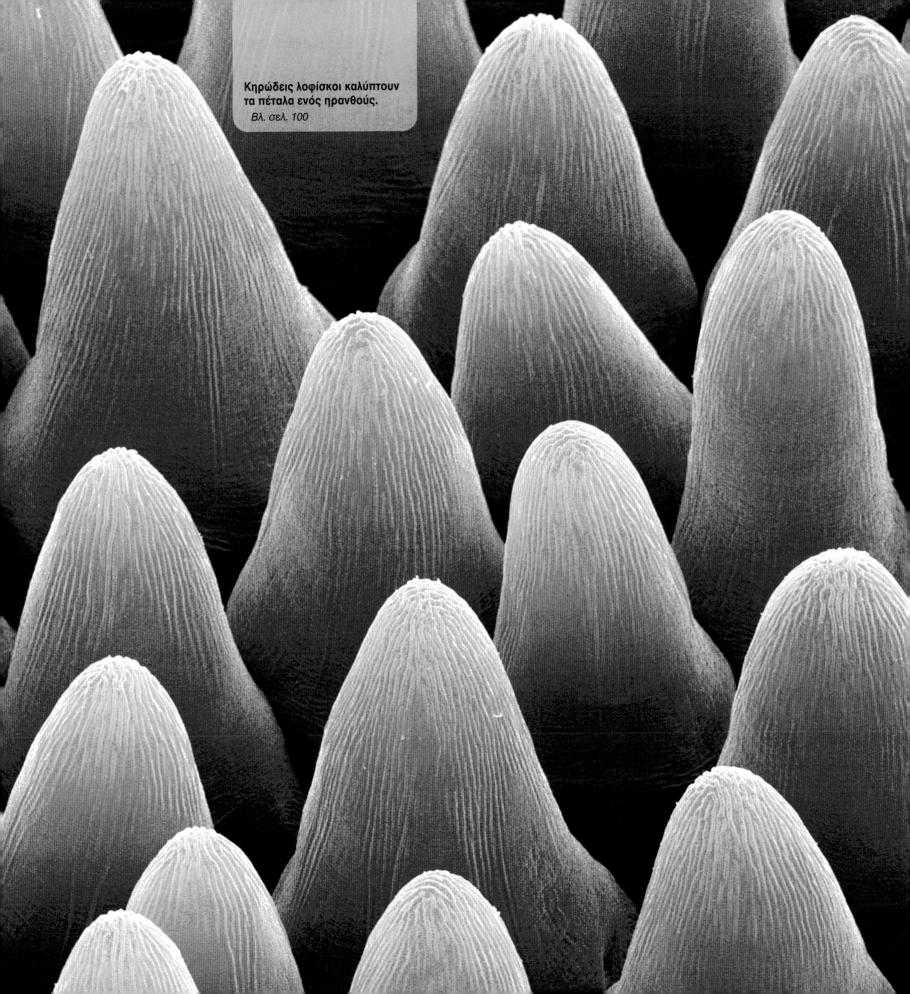

Κηρώδεις λοφίσκοι καλύπτουν τα πέταλα ενός ηρανθούς.

Βλ. σελ. 100

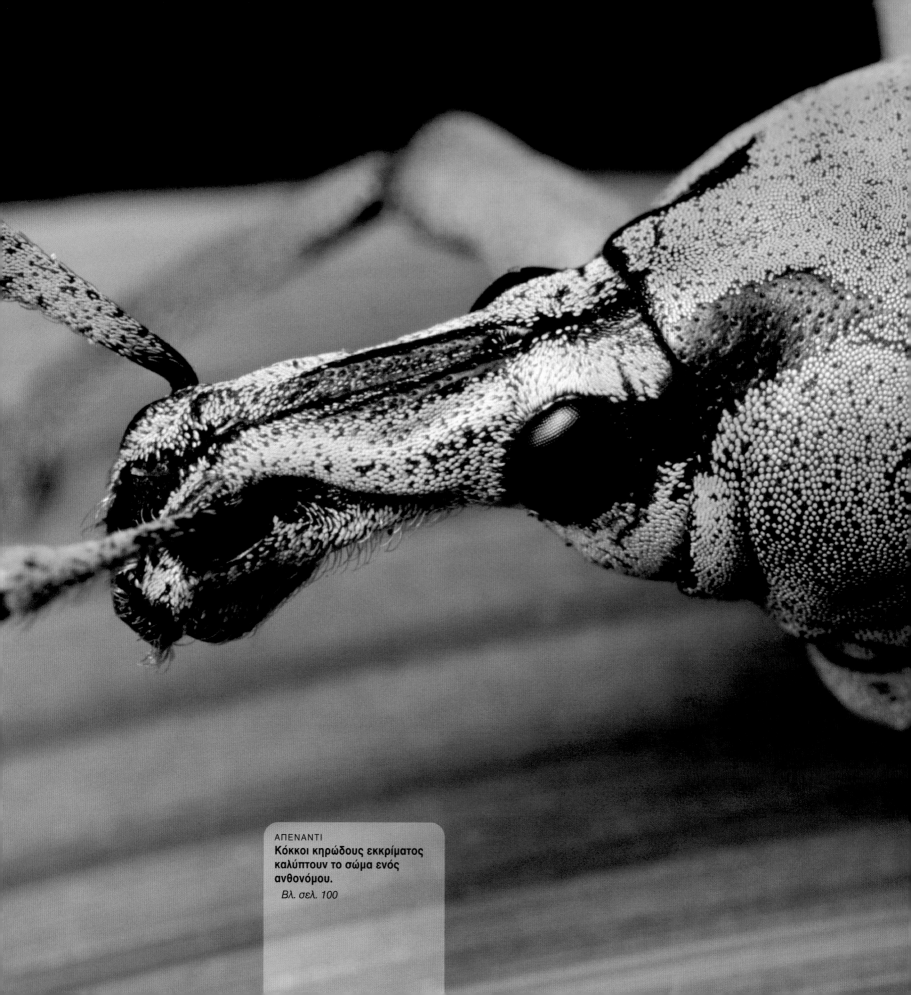

ΑΠΕΝΑΝΤΙ
**Κόκκοι κηρώδους εκκρίματος
καλύπτουν το σώμα ενός
ανθονόμου.**
Βλ. σελ. 100

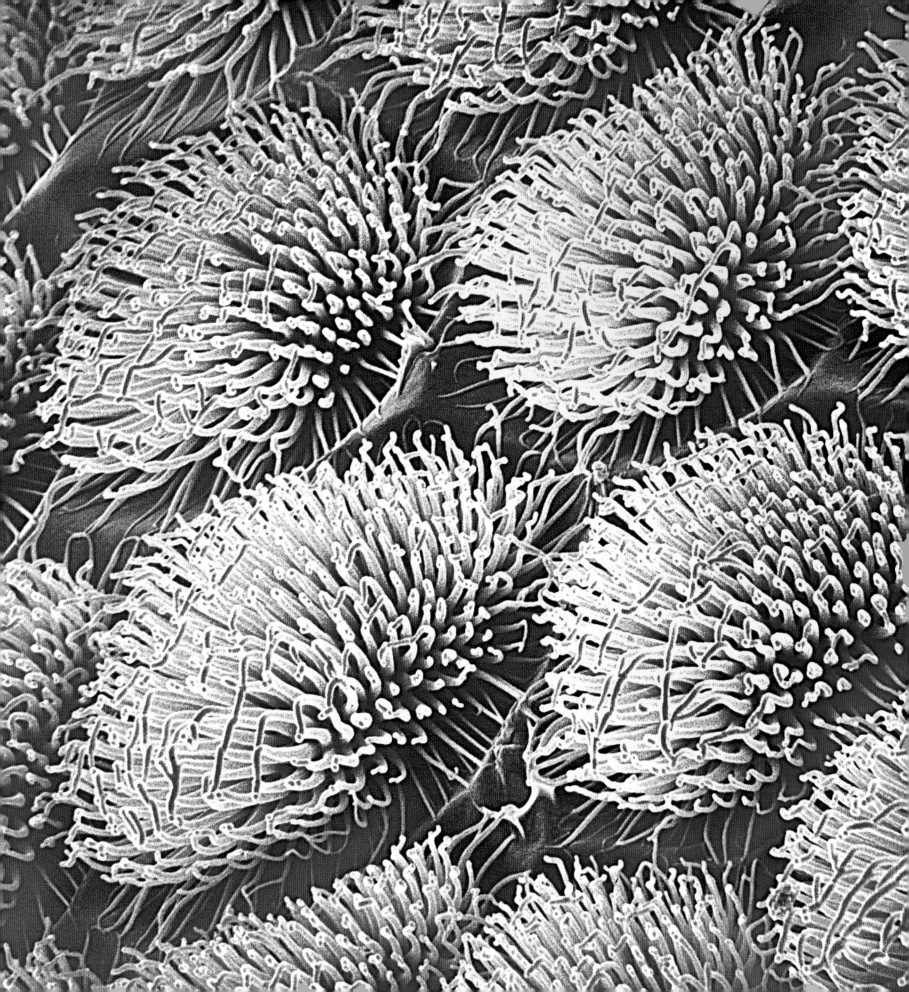

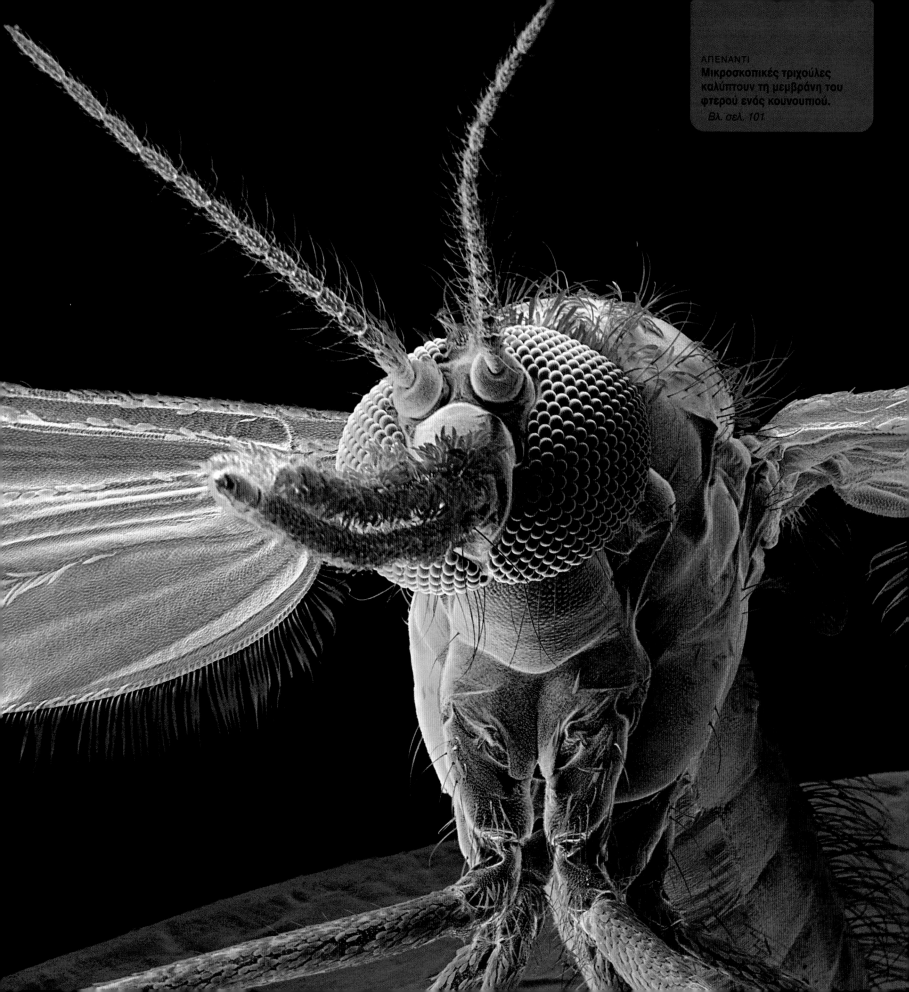

ΑΠΕΝΑΝΤΙ
**Μικροσκοπικές τριχούλες
καλύπτουν τη μεμβράνη του
φτερού ενός κουνουπιού.**
Βλ. σελ. 101

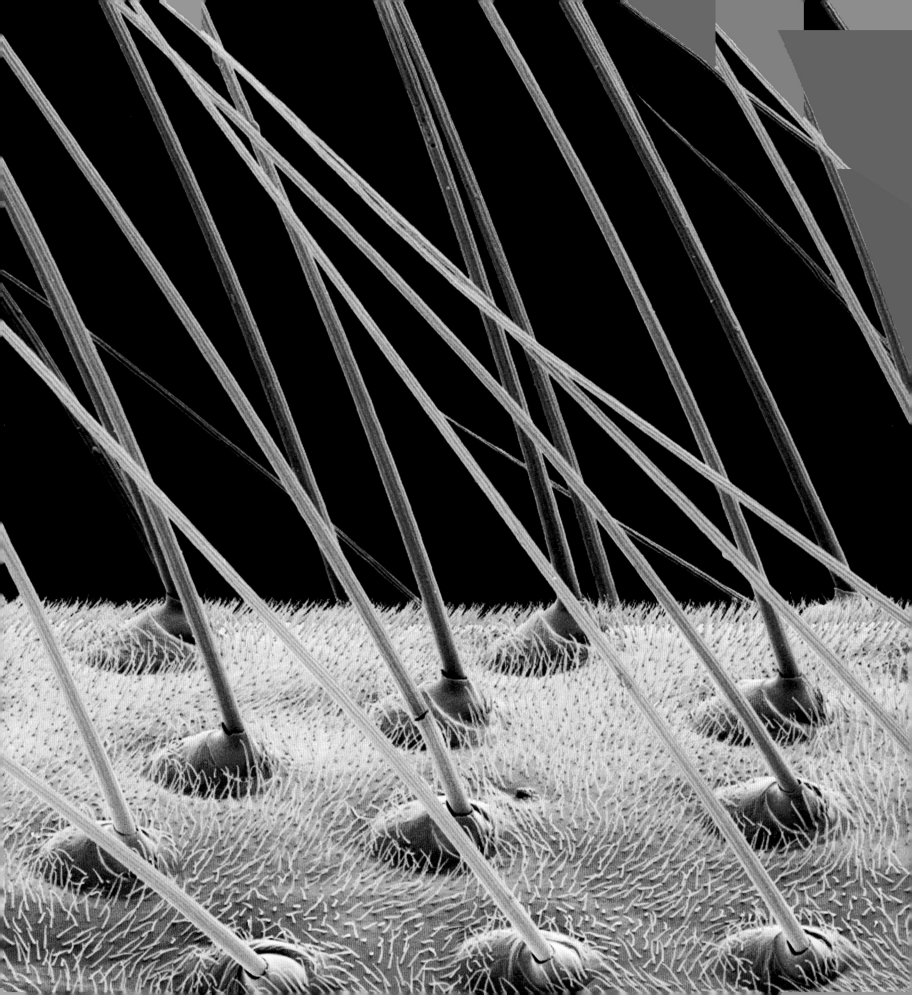

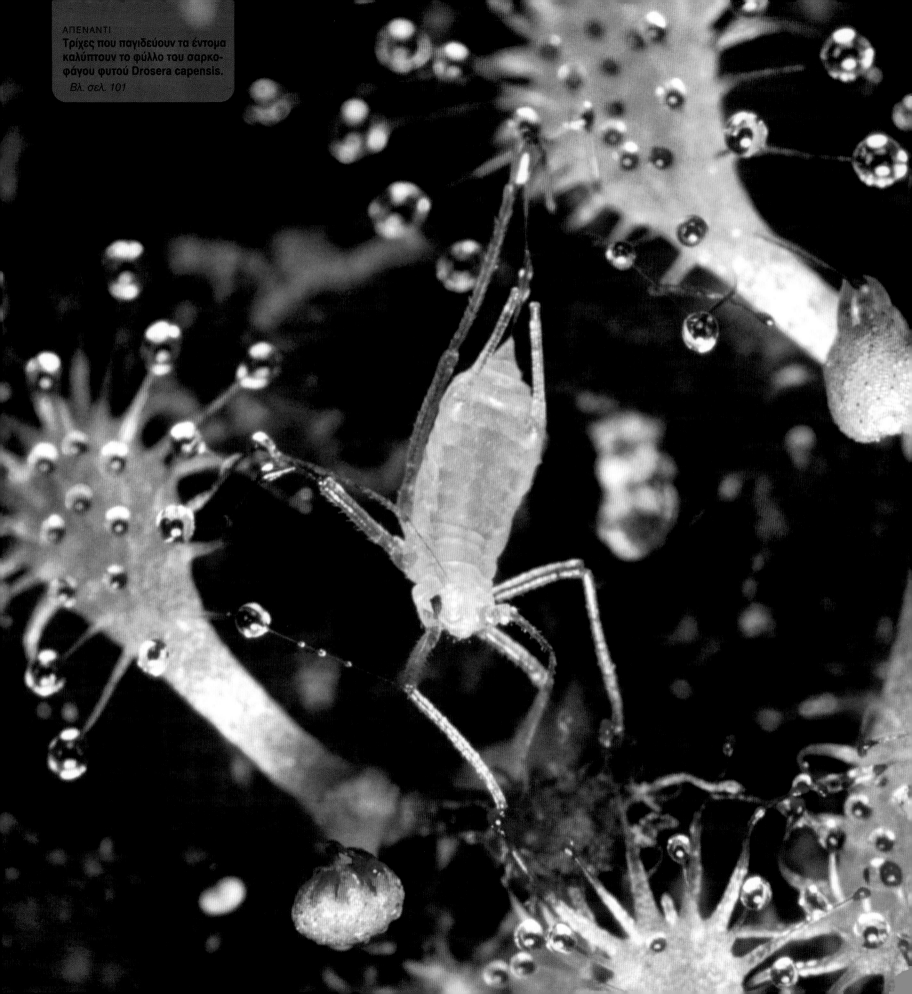

ΑΠΕΝΑΝΤΙ
Τρίχες που παγιδεύουν τα έντομα
καλύπτουν το φύλλο του σαρκο-
φάγου φυτού Drosera capensis.
Βλ. σελ. 101

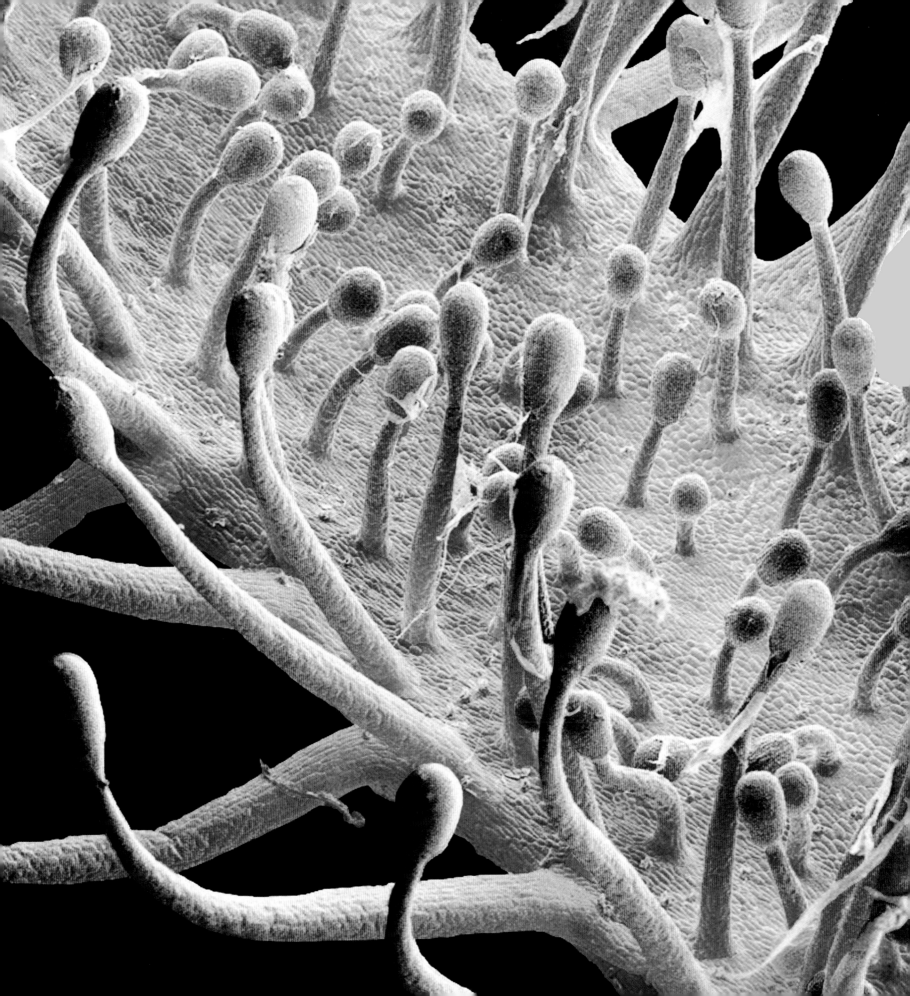

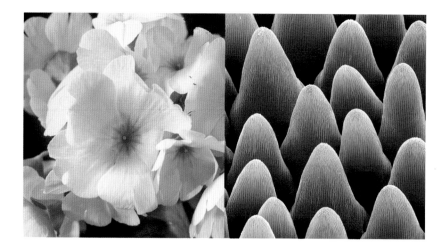

Αυτοί οι κωνικοί λοφίσκοι θυμίζουν επιφάνεια στρώματος από αφρώδες ελαστικό, αλλά τί είναι, άραγε, αυτό που θα ξαπλώσει πάνω του; Σίγουρα είναι μαλακοί, αλλά τα μόνα που μάλλον θα έρθουν σε επαφή μαζί τους είναι τα πόδια των εντόμων, καθώς πρόκειται για την επιφάνεια των λεπτών πετάλων ενός νηπενθούς.

Τα άνθη εξελίχθηκαν παράλληλα με τα έντομα που τα επικονιάζουν και έτσι ανέπτυξαν τα λαμπρά σχήματα και χρώματα που βλέπουμε να έχουν σήμερα. Τα πέταλα (και άλλα μέρη της ταξιανθίας) είναι άκρως τροποποιημένα φύλλα, τα οποία έχασαν τη χλωροφύλλη, τη χρωστική ουσία της φωτοσύνθεσης. Το χρώμα τους παίρνουν από άλλες χρωστικές αποθηκευμένες σε μια σειρά κηρώδεις λοφίσκους, τις θηλές (papillae).

Οι θηλές είναι λοβοί που αναπτύσσουν τα επιδερμικά κύτταρα του πετάλου στην επιφάνειά του. Το σχήμα τους διαφέρει από φυτό σε φυτό· μπορεί να είναι χαμηλοί, ήπιοι θόλοι, κωνικοί λοφίσκοι, όπως στο παράδειγμά μας, ή λάχνες που προεξέχουν σαν δάχτυλα, και τώρα πλέον οι βοτανολόγοι έχουν αρχίσει να τις συγκρίνουν όταν εξετάζουν τη σχέση των διαφόρων ειδών μεταξύ τους ή την εξέλιξη των φυτών.

Η κηρώδης υφή την προστατεύει από την απώλεια νερού στη ζέστη της ημέρας, διάστημα κατά το οποίο τα πέταλα κινδυνεύουν να μαραθούν. Ωστόσο, έχει διατυπωθεί η άποψη ότι οι θηλές αυτές ενίοτε εκκρίνουν επίσης ορισμένες ουσίες αντί για νέκταρ, με τις οποίες προσελκύουν τα φυτά, ή χημικές ουσίες που τροποποιούν τη συμπεριφορά των εντόμων για να εξασφαλίσουν ότι οι επικονιαστές θα χασομερήσουν λίγο παραπάνω στον ανθό.

Επίσης σημαντικές ίσως είναι οι αντανακλαστικές ιδιότητες των θηλών, γιατί σε αυτές οφείλεται η απαλή λάμψη των πετάλων, τα οποία έτσι έρχονται σε αντίθεση με τα πιο λαμπερά φύλλα του φυτού.

Στη φύση κυριαρχούν τα κόκκινα, τα πορτοκαλιά και τα κίτρινα έως λευκά άνθη, ενώ τα γαλάζια και τα μοβ είναι η μειονότητα. Ωστόσο, ομάδες φυτών που κίνησαν το ενδιαφέρον των κηπουρών μετά την επιλεκτική καλλιέργεια ορισμένων φυτών περιλαμβάνουν πλέον και νέες ποικιλίες διαφορετικών χρωμάτων.

Αυτές οι τούφες από λεπτά σωληνοειδή παρακλάδια σαν ψαλίδες κλήματος, που σχηματίζουν μαλακά μαξιλάρια, θα μπορούσαν να είναι άνθη γαϊδουράγκαθου ή του φυτού Armeria maritima ή θαλλοί θαλάσσιας ανεμώνας. Οι τούφες φυτρώνουν στην επιφάνεια ενός σκαθαριού, επειδή όμως μοιάζουν με άνθος αναφέρονται ως «άνθος».

Πέταλα αυτού του άνθους είναι νήματα κηρώδους ουσίας που εκκρίνεται από τη δερμίδα του σκαθαριού. Τα νήματα αυτά παίρνουν διάφορα χρώματα και, όπως τα λέπια στα φτερά της πεταλούδας, συνθέτουν πολύμορφα σχέδια. Πολλά σκαθάρια έχουν όντως λέπια, αλλά τα λέπια έχουν ένα μειονέκτημα: όταν τύχει και αποκολληθούν από κάποιον θηρευτή ή (το πιθανότερο) λόγω φθοράς ή επειδή πιάστηκαν κάπου, δεν αναγεννούνται και έτσι χάνονται χρώμα και σχέδια. Ενώ, εάν ξεκολλήσει ένα κηρώδες «άνθος» αντικαθίσταται μέσα σε ώρες ή λίγες ημέρες, οπότε επιστρέφουν τα χρώματα και μαζί με αυτά το καμουφλάζ του σκαθαριού.

Στις ερήμους, εξειδικευμένα σκαθάρια αποκτούν λευκά «άνθη» στη ράχη τους που αντανακλούν το φως του ήλιου και τα προστατεύουν από τη ζέστη. Το λευκό δεν είναι χρώμα εύκολο να παραχθεί με χρωστικές, γι' αυτό πολλές φορές τα σκαθάρια χρωστούν το λευκό τους χρώμα στις αντανακλαστικές ιδιότητες της δερμίδας.

Οι λόγοι ύπαρξης των κηρωδών αυτών εκκρίσεων είναι μάλλον λειτουργικής παρά διακοσμητικής φύσης, καθώς οι κηρώδεις ουσίες έχουν μια σημαντική ιδιότητα – είναι αδιάβροχες. Γενικά, τα έντομα παραμένουν στεγνά επειδή καλύπτονται από υδροαπωθητικές τρίχες, οι οποίες σε τόσο μικρή κλίμακα αντιστέκονται στην επιφανειακή ένταση του νερού και κατά συνέπεια το απωθούν. Επίσης, ένα κάλυμμα από υδρόφοβο κερί είναι σημαντικό για τα σκαθάρια που έχουν εν μέρει συνήθειες αμφίβιων, δηλαδή όσα τρέφονται με τη χλωρίδα που αναπτύσσεται στις άκρες λιμνών και στην παλιρροϊκή ζώνη των ακτών.

ΔΕΞΙΑ
Η φαινομενικά απαλή και λεία επιφάνεια των πετάλων του νηπενθούς αποκαλύφθηκε πως αποτελείται από μια σειρά κωνικών λοφίσκων, τις θηλές, και είναι προϊόν εκκρίσεων των κυττάρων της επιδερμίδας.

ΑΡΙΣΤΕΡΑ
Τα νηπενθή ή πρίμουλες είναι απλά ανοιχτά άνθη που πάνω στα πέταλά τους κάθονται τα έντομα.

ΔΕΞΙΑ
Δέσμες κηρωδών εκκρίσεων καλύπτουν τον εξωσκελετό ενός ανθονόμου, παράγοντας διάφορα χρώματα και σχηματίζοντας έναν αδιάβροχο μανδύα.

ΑΡΙΣΤΕΡΑ
Οι ρυγχωτοί κάνθαροι, που ζουν εκτεθειμένοι τρεφόμενοι με φυτά, συχνά παίρνουν εκπληκτικά χρώματα για να μην διακρίνονται.

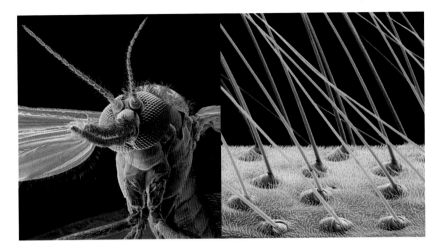
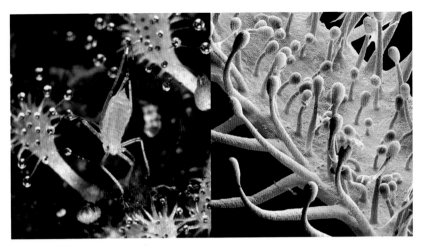

Αυτό το αλλόκοτο τοπίο με τα ψηλά πράσινα χόρτα που φυτρώνουν σε ροζ τύρφη, παρότι απέχει τόσο από την πραγματικότητα, δεν είναι απόρροια ψυχότροπων ουσιών. Κάθε χόρτο είναι ένα μικροτρίχιο (microtrichium), που φυτρώνει στα φτερά του κουνουπιού.

Τα φτερά της μύγας συνήθως τα αντιλαμβανόμαστε σαν λείες, διάφανες μεμβράνες τεντωμένες ανάμεσα σε ακτινωτά νεύρα. Αυτή είναι μια απολύτως θεμιτή απλούστευση, εάν τα συγκρίνουμε, λόγου χάρη, με τα φωτεινά πολύχρωμα λέπια που σκεπάζουν τα φτερά της πεταλούδας και του σκόρου ή τα σκληρά έλυτρα του σκαθαριού και της κατσαρίδας. Αλλά εάν τα βάλουμε στο ηλεκτρονικό μικροσκόπιο σάρωσης θα δούμε ότι δεν είναι λεία, αλλά καλύπτονται από τις μικροσκοπικές αυτές σμήριγγες.

Η ακριβής λειτουργία των μικροτριχίων δεν έχει ακόμα γίνει πλήρως κατανοητή. Διαφορετικά είδη μύγας παρουσιάζουν διαφορετική διάταξη και μορφή των μικροτριχίων· είναι μακρύτερα ή κοντύτερα, έχουν μεγαλύτερα ή μικρότερα κενά κομμάτια ανάμεσά τους, έχουν διαφορετική πυκνότητα και διαφορετικά σχέδια. Η χαρακτηριστική διάταξη αυτών των τριχών στα φτερά αποδείχτηκε χρήσιμο εργαλείο για τους εντομολόγους προκειμένου να ταυτίσουν ομάδες ειδών μύγας που μοιάζουν πολύ μεταξύ τους.

Όσο για τη λειτουργία τους η πιο διαδεδομένη θεωρία είναι ότι τα μικροτρίχια βοηθούν το έντομο να πετά. Το φτερό της μύγας δεν είναι απλώς ένα αεροδυναμικό σώμα, όπως ο χαρταετός που μεταφράζει την κίνηση του ανέμου κάτω από την επιφάνειά του σε ώση προς τα κάτω και κατ' αυτό τον τρόπο προκαλεί την ανύψωσή του. Όταν η μύγα πετά με κάθε κίνηση μπρος-πίσω της μεμβράνης του φτερού παράγει ώση προς τα κάτω. Αυτό το πετυχαίνει συστρέφοντας τα φτερά της, έτσι ώστε με κάθε κίνηση να συλλαμβάνει τον άνεμο και να προωθείται προς τα πάνω και προς τα μπρος. Αλλά, ανάμεσα στο τέλος κάθε κίνησης και την αρχή της επόμενης, καθώς το φτερό είναι λυγισμένο, μεσολαβεί ένα διάστημα απώλειας στήριξης, κατά το οποίο δεν παράγεται ενέργεια.

Τα μικροτρίχια, λοιπόν, λέγεται πως βοηθούν στην αποφυγή απώλειας της στήριξης παράγοντας οπισθέλκουσα – το έντομο συνεχίζει, δηλαδή, να πετά μέσω της τριβής που παράγεται μεταξύ μικροτριχίων και αέρα.

Αυτά που φαίνονται σαν μικρούτσικα γλειφιτσούρια που φυτρώνουν πάνω σε μια μακριά επίπεδη επιφάνεια έχουν όντως τη γλυκιά γεύση ειδών ζαχαροπλαστικής. Είναι όμως θανάσιμα, διότι αυτό που εικονίζεται εδώ είναι ένα φύλλο του σαρκοφάγου φυτού Drosera capensis, τα δε «γλειφιτσούρια» αποτελούν μέρος ενός άκρως αποτελεσματικού μηχανισμού θανάτωσης εντόμων.

Εν ζωή, το άκρο κάθε τέτοιου λοβού θα το σκέπαζε μια αστραφτερή σταγόνα, εξ ου και το όνομα του φυτού. Τα σταγονίδια αυτά περιέχουν γλυκά σάκχαρα για να προσελκύουν τα έντομα, είναι όμως και πολύ κολλώδη, οπότε παγιδεύουν αμέσως τους επισκέπτες τους. Για να μην δραπετεύσει το παγιδευμένο έντομο, το φύλλο της Drosera αρχίζει να κλείνει φυλακίζοντας το θύμα του (διαδικασία που διαρκεί περίπου μία ώρα), τυλίγοντάς το με βλέννα. Το έντομο πεθαίνει από ασφυξία, καθώς το παχύρρευστο υγρό κλείνει τα αναπνευστικά στίγματα, τα εξωτερικά ανοίγματα μέσα από τα οποία μπαίνει ο αέρας στις τραχείες. Ακολουθεί η πολύ πιο αργή και δόλια διαδικασία της χώνευσης: ένζυμα που εμπεριέχονται στο σταγονίδιο αρχίζουν να διαλύουν το έντομο μετατρέποντάς το σε θρεπτική σούπα που απορροφάται μέσω ειδικών πόρων στην επιφάνεια του φύλλου.

Αυτή η ασυνήθιστη συμπεριφορά επιτρέπει στις «δροσούλες» (και σε άλλα εντομοφάγα φυτά) να ζει σε τόπους φτωχούς σε θρεπτικές ουσίες και ειδικά σε όξινα πλημμυρισμένα εδάφη τελμάτων και αλιπέδων. Στη φύση το άζωτο, βασικό στοιχείο των πρωτεϊνών, είναι πηγή πολύτιμη. Παρότι άφθονο στην ατμόσφαιρα, κανονικά τα φυτά απορροφούν νιτρικά και νιτρώδη άλατα με τις ρίζες τους από το έδαφος. Όμως, τα φυτά του είδους αυτού παίρνουν το άζωτό τους από τις πρωτεΐνες των εντόμων.

Τα άνθη τους είναι απλά, συνήθως ανοιχτόχρωμα πάνω σε μακριά στελέχη που προεξέχουν από τα φύλλα. Παλαιότερα θεωρούσαν πως επρόκειτο για μηχανισμό που αποσκοπούσε στη μη παγίδευση και θανάτωση των εντόμων που τα επικονίαζαν. Στην πραγματικότητα, όμως, τα θηράματα και οι επικονιαστές συνήθως ανήκουν σε εντελώς διαφορετικές ομάδες εντόμων, και το ύψος των φυτών είναι μάλλον τόσο μεγάλο για να τραβούν την προσοχή των εντόμων και να αγνοούν τη συνήθως φτωχή σε λουλούδια χαμηλότερη βλάστηση.

ΔΕΞΙΑ
Το φτερό του κουνουπιού δεν είναι μια απολύτως λεία, διαφανής μεμβράνη, αλλά καλύπτεται από μικροσκοπικές τρίχες που θεωρείται ότι το βοηθούν να παραμένει εν πτήσει.

ΑΡΙΣΤΕΡΑ
Τα κουνούπια είναι σχετικά ισχνά έντομα. Μόνο το θηλυκό αναζητεί αίμα για τροφή ώστε να εξασφαλίσει αρκετή πρωτεΐνη για να ωριμάσουν τα αυγά του.

ΔΕΞΙΑ
Οι σαν γλειφιτσούρια ή σπίρτα τρίχες στα φύλλα του φυτού Drosera capensis εκκρίνουν ένα γλυκό, κολλώδες υγρό για να προσελκύουν έντομα και να τα παγιδεύουν.

ΑΡΙΣΤΕΡΑ
Η Drosera capensis, φυτό ιθαγενές της Νότιας Αφρικής, έχει παγιδεύσει μια αφίδα με τα λαμπερά σταγονίδιά της: αμέσως μετά τα φύλλα της θα περικλείσουν το παγιδευμένο θήραμα.

2

Ο αγώνας για την επιβίωση οδήγησε στην ανάπτυξη πλήθους όπλων και παράλληλα εργαλείων άμυνας, πρόσληψης τροφής, αναπνοής και διαπνοής, κίνησης και αναπαραγωγής. Αυτές οι σύνθετες και συχνά σουρεαλιστικές δομές αναπτύχθηκαν για να αντιμετωπιστούν ειδικές ανάγκες, έτσι λοιπόν καθεμιά εξυπηρετεί κάποια ειδική λειτουργία. Αόρατες στον γυμνό οφθαλμό μέχρι τη χρήση των ισχυρών μικροσκοπίων, οι αλλόκοτες αυτές δομές είναι πλέον ορατές και επιτρέπουν να τις εξετάσουμε αποκαλύπτοντας όλη τους την πολυπλοκότητα και την εκθαμβωτική ομορφιά ενός άλλου κόσμου. Στο δεύτερο μέρος του βιβλίου οι δομές του νανόκοσμου έχουν ταξινομηθεί με κριτήριο τη λειτουργία τους.

ΝΑΝΟΛΕ

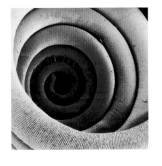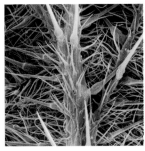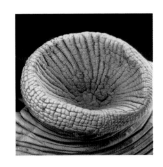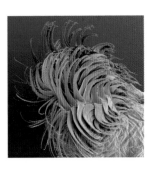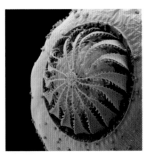

όπλα · σωλήνες · όνυχες · μυζητήρες · αισθήσεις ουρές · αναπαραγωγή · αναπνοή · άγκιστρα σποριόφυτα

ΤΟΥΡΓΙΕΣ

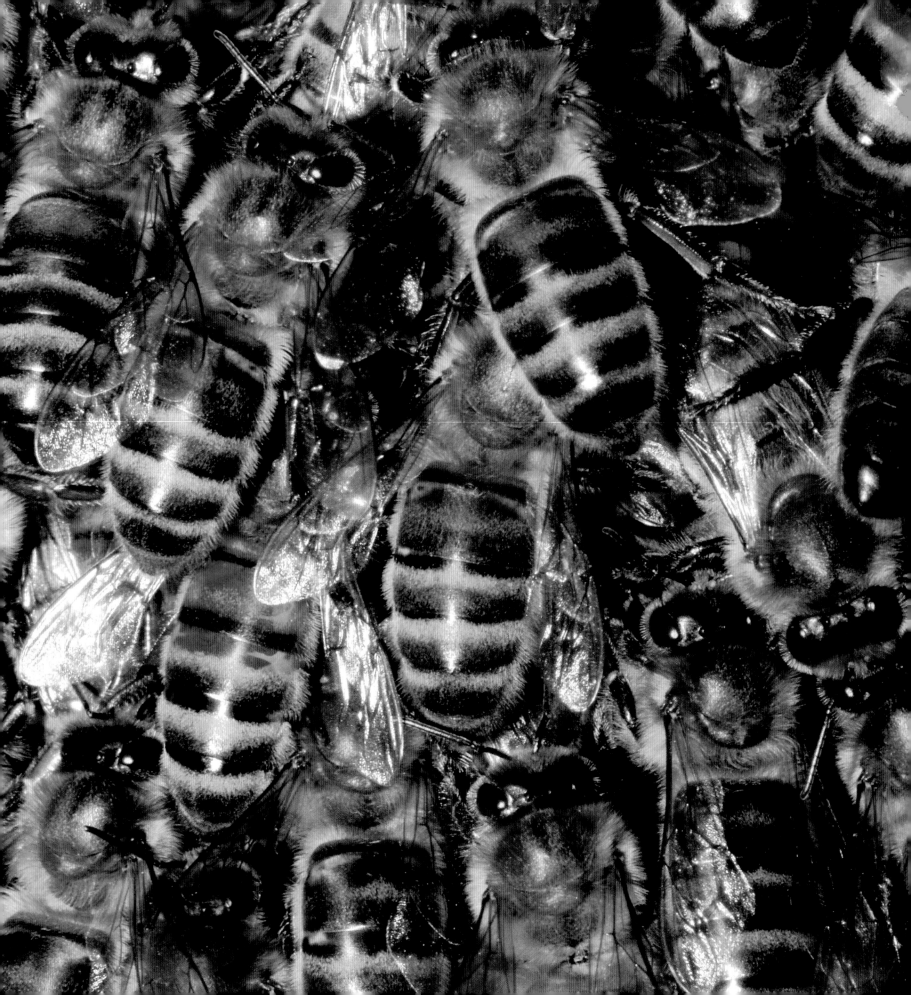

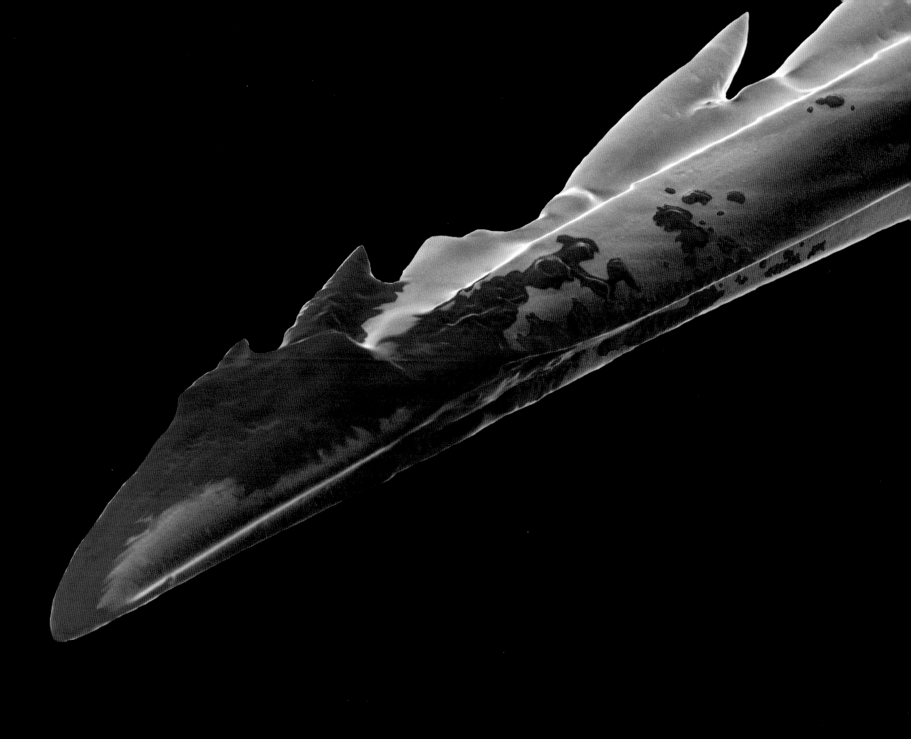

Το κεντρί της μέλισσας είναι
αγκαθωτό για να γαντζώνεται
γερά στο δέρμα του θύματος.
Βλ. σελ. 112

ΑΠΕΝΑΝΤΙ
Τα δηλητηριώδη αγκάθια που καλύπτουν τα φύλλα της τσουκνίδας.
Βλ. σελ. 112

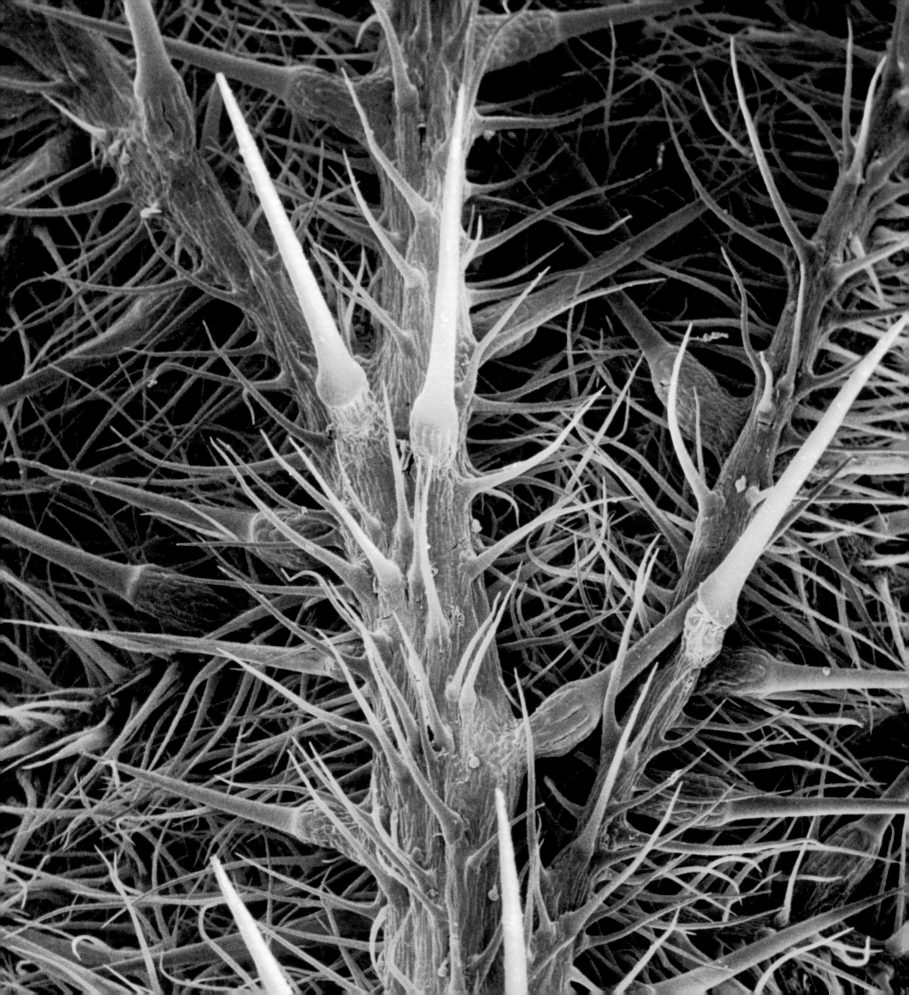

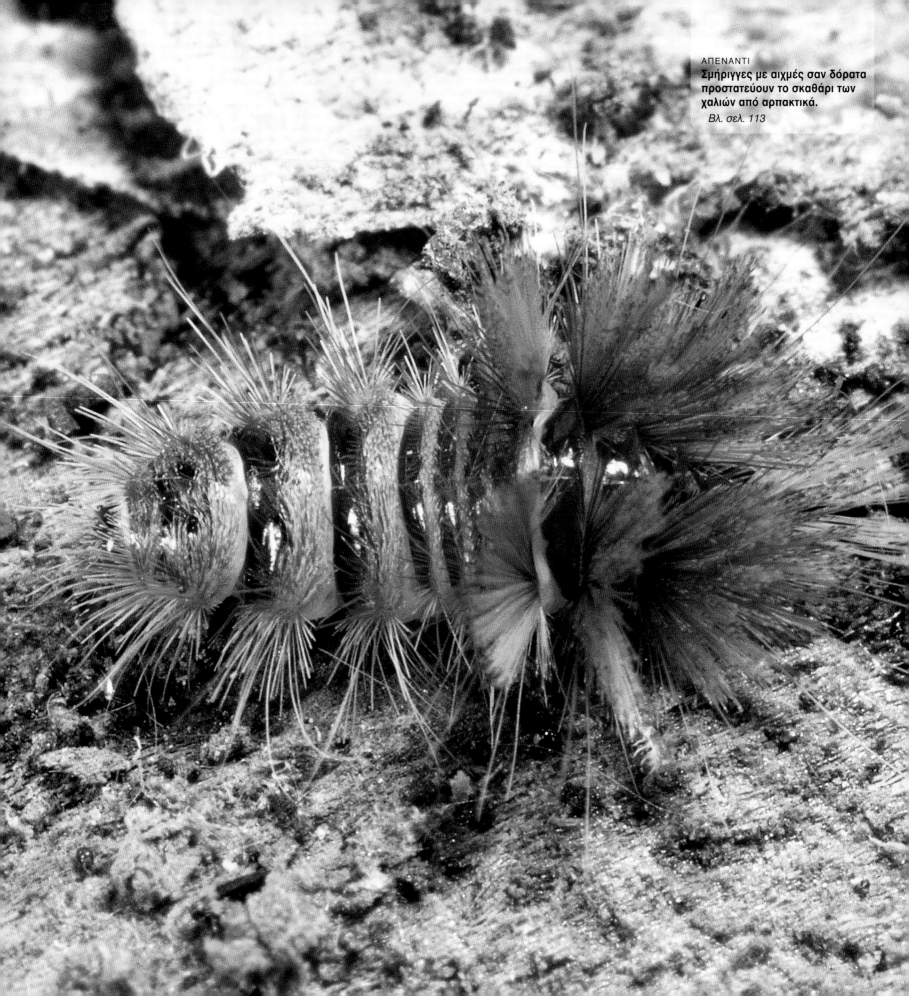

ΑΠΕΝΑΝΤΙ
Σμήριγγες με αιχμές σαν δόρατα προστατεύουν το σκαθάρι των χαλιών από αρπακτικά.
Βλ. σελ. 113

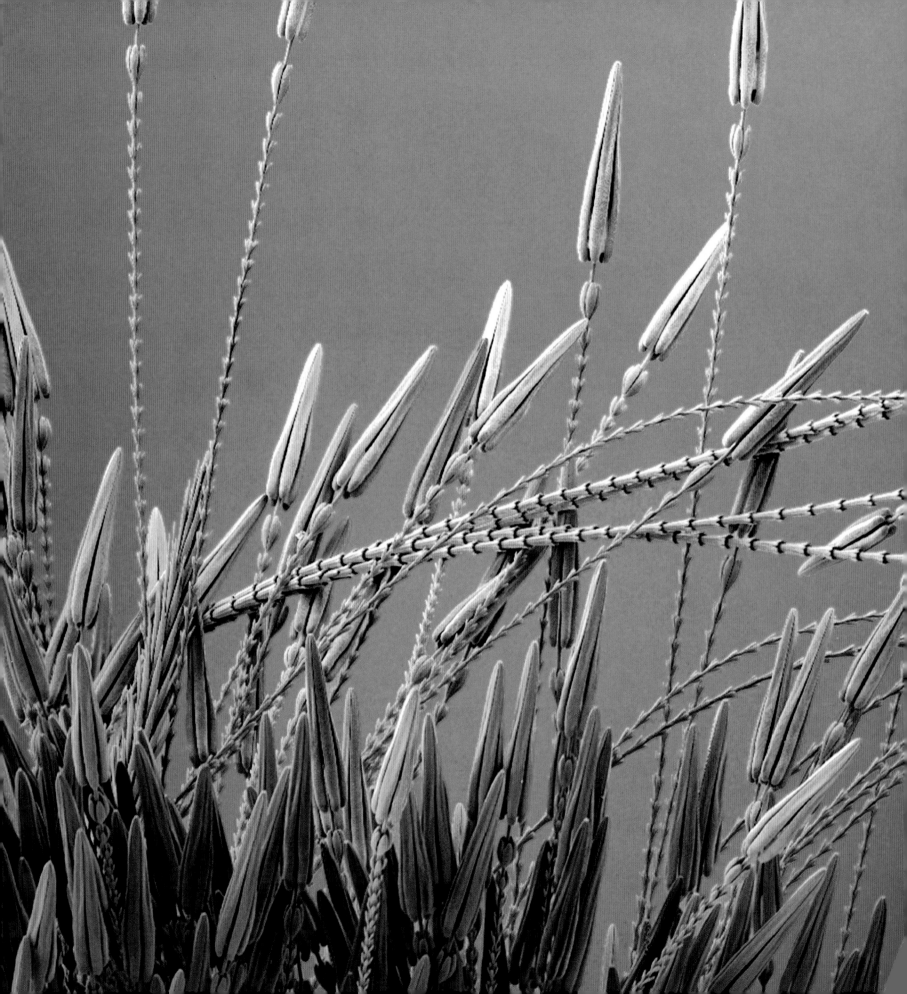

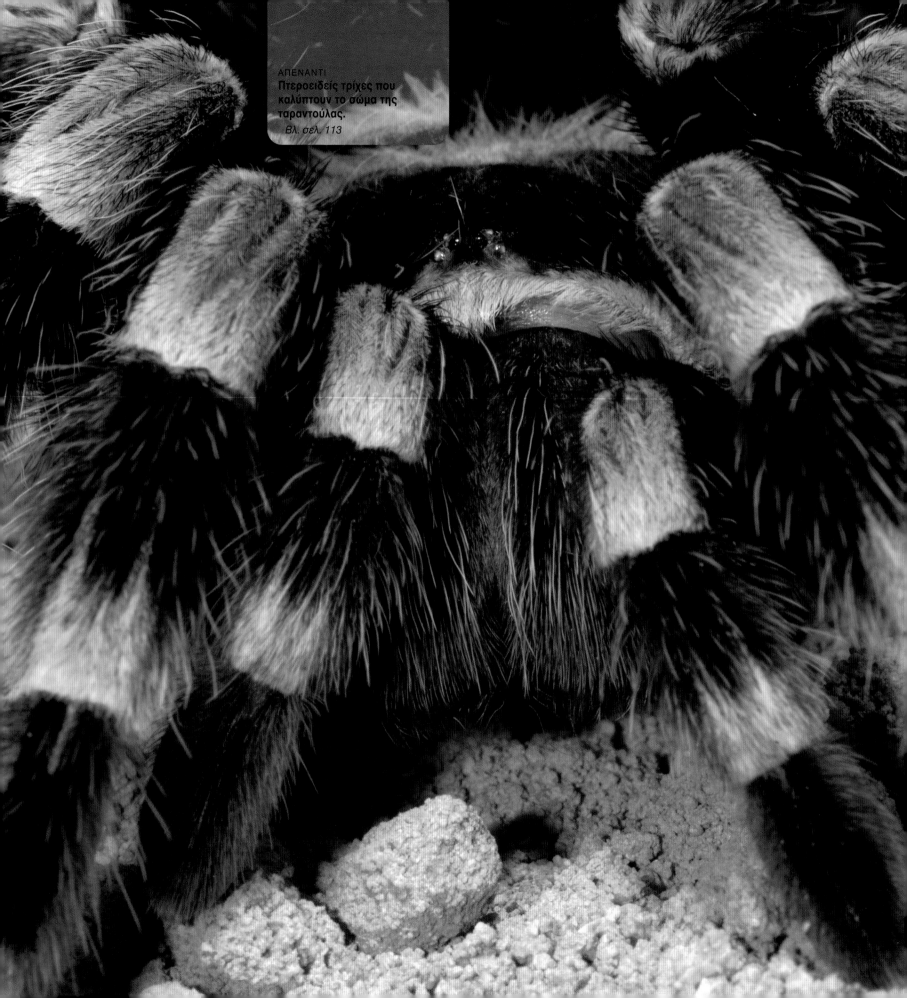

ΑΠΕΝΑΝΤΙ
**Πτεροειδείς τρίχες που
καλύπτουν το σώμα της
ταραντούλας.**
Βλ. σελ. 113

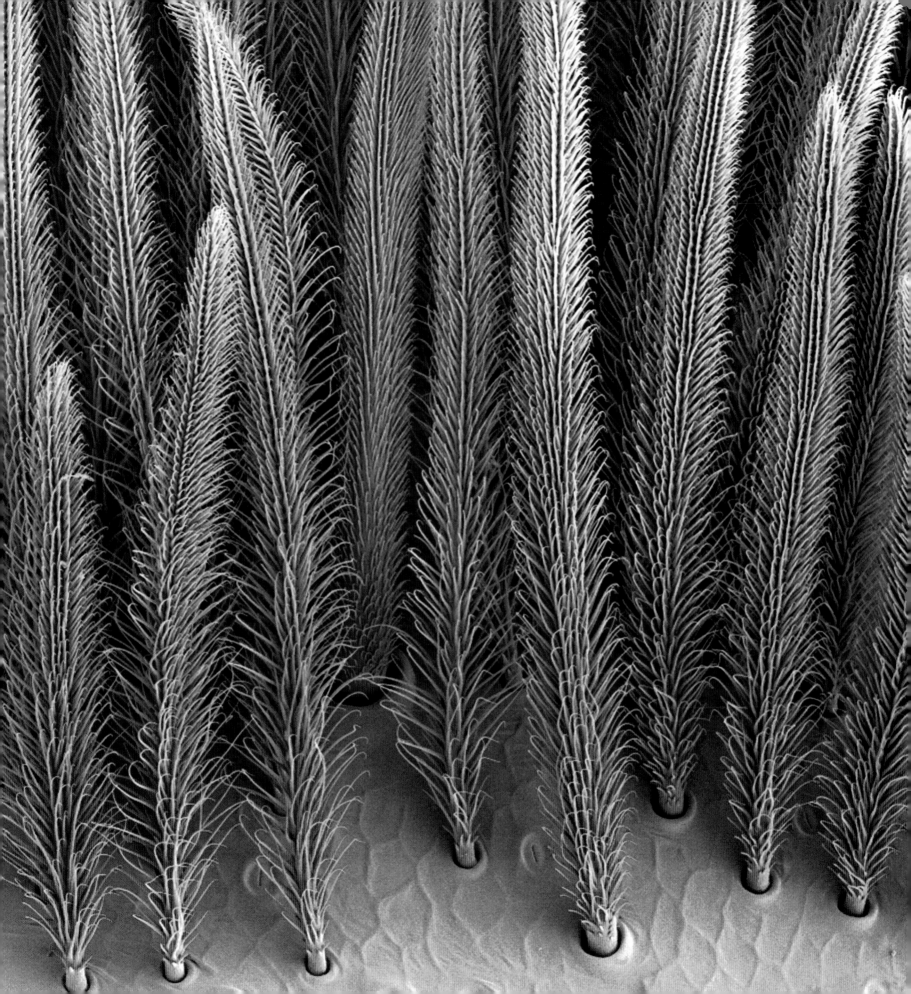

Όπλο κοφτερό, αγκαθωτό, με απειλητική αιμοσταγή αιχμή, το κεντρί της μέλισσας είναι ένα τρομακτικό εργαλείο, και σε αυτό οφείλεται ο δυσανάλογος προς το μικροσκοπικό του μέγεθος σεβασμός που απέκτησε το έντομο αυτό. Ως όπλο το κεντρί είναι ανυπέρβλητο και το γεγονός ότι το διαθέτουν οι μέλισσες εξηγεί εν μέρει τη βαθιά δυσφορία με την οποία αντιδρά τόσο πολύς κόσμος στα έντομα.

Το πιο εμφανές αλλά και σημαντικό δομικό χαρακτηριστικό του κεντριού είναι η οπλισμένη με ακίδες αιχμή του. Διότι καθώς τσιμπούν οι μέλισσες, το κεντρί μπαίνει στο δέρμα πριονίζοντάς το με γρήγορες παλινδρομικές κινήσεις και οι ακίδες του διευρύνουν την πληγή ώστε να διεισδύσει βαθύτερα. Έπειτα, μετά την έκκριση του δηλητηρίου από τον σωλήνα του κεντριού, όταν το θύμα αρχίζει να νιώθει το γνωστό έντονο, οδυνηρό τσούξιμο, τα αγκάθια του γαντζώνονται στη σάρκα και έτσι δεν κινδυνεύει να αποκολληθεί. Απελπισμένος ο στόχος της επίθεσης, μπορεί να απομακρύνει τη μέλισσα, αλλά το κεντρί,

παρότι το σώμα έχει αποσπαστεί, παραμένει γαντζωμένο γερά στο δέρμα, και ο μυς της κύστης με το δηλητήριο εξακολουθεί να συστέλλεται διοχετεύοντας σαν τρόμπα το οδυνηρό δηλητήριο στην πληγή.

Η θυμωμένη μέλισσα, άοπλη πλέον, πεθαίνει, αλλά η επίθεσή της δεν έχει τελειώσει. Ο ακρωτηριασμός της προκαλεί την έκκριση φερομονών (χημικών οσμών) από τους αδένες του κεντριού που είναι ακόμα μπηγμένο στο δέρμα. Το σινιάλο αυτό επιθετικότητας και συναγερμού ειδοποιεί τις άλλες μέλισσες στην κυψέλη να βρουν τον «εχθρό» που έχει «μαρκαριστεί» με αυτές και να εξαπολύσουν ευρείας κλίμακας επίθεση εναντίον του. Παρότι κάθε μέλισσα εκκρίνει το πολύ ένα μικρογραμμάριο δηλητηρίου, ο πόνος που προκαλεί είναι ασφαλής ένδειξη πως πρόκειται για επικίνδυνη τοξική ουσία. Κύριο ενεργό συστατικό της είναι η μελιτίνη που καταστρέφει τα ερυθρά αιμοσφαίρια, ενεργοποιεί την αλλεργική αντίδραση και μειώνει την πίεση του αίματος. Δεν χρειάζονται παρά το πολύ 20 κεντρίσματα για να θανατωθεί ένας ενήλικος.

Αυτή η άγρια δέσμη επικίνδυνων αγκαθιών δεν προστατεύει κάποιον κάκτο που τα τσιμπήματά του είναι επιφανειακά. Κάθε αγκάθι της είναι μια δηλητηριώδης βελόνα σύριγγας και το άλγος που προκαλεί είναι έντονο και διαρκεί ώρα. Πρόκειται για τις τρίχες της τσουκνίδας.

Η τσουκνίδα είναι φυτό ιθαγενές όλης της Ευρώπης, της Ασίας, της Βόρειας Αφρικής και της Βόρειας Αμερικής, και είναι πασίγνωστη ως φυτό που καλό είναι να αποφεύγεται. Με γυμνό οφθαλμό τα φύλλα της φαίνονται χνουδωτά, με απαλά τριχίδια, αλλά ανάμεσά τους κρύβουν αιχμηρές, κοίλες τρίχες. Αυτές οι τρίχες είναι σκληρές και εύθραυστες λόγω της περιεκτικότητάς τους σε πυριτικά άλατα, με συνέπεια όταν τις αγγίζουμε να διεισδύουν στο δέρμα και να σπάζουν. Ο πόνος όμως δεν οφείλεται σε αυτό καθαυτό το κέντρισμα, αλλά στο ισχυρό δηλητήριο που είναι αποθηκευμένο στη διογκωμένη βάση των τριχών, το οποίο αμέσως διοχετεύεται μέσα από αυτές τις βελόνες στην πληγή.

Το δηλητήριο της τσουκνίδας περιέχει τους χημικούς νευροδιαβιβαστές ακετυλοχο-

λίνη και σεροτονίνη, καθώς επίσης και ισταμίνη, η οποία ευθύνεται για τις αλλεργικές αντιδράσεις. Ο πόνος που προκαλείται είναι άμεσος και έντονος, αλλά σύντομα μεταβάλλεται σε αίσθημα φαγούρας και θέρμης. Λίγες μόνο μυτερές τρίχες προκαλούν μικρά χλωμά εξανθήματα, αλλά εάν την πιάσουμε, μπορεί να προκληθεί μεγάλος ερεθισμός.

Επειδή η τσουκνίδα είναι πολύ διαδεδομένη, υπάρχουν πλήθος λαϊκά γιατροσόφια για την καταπολέμηση του ερεθισμού που προκαλεί. Συνήθως συνιστάται τρίψιμο της ερεθισμένης περιοχής με κάτι δροσερό, όπως με σάλιο, με φύλλα μολόχας ή άλλων φυτών, και η χρήση μαγειρικής σόδας που θεωρείται πως καταπολεμά το μυρμηκικό οξύ, επίσης συστατικό του δηλητήριου.

Η αίσθηση της θέρμης είναι γνωστή από παλιά: οι Ρωμαίοι λέγεται πως ενίοτε αυτομαστιγώνονταν με τσουκνίδες για να ζεστάνουν το σώμα τους στο βόρειο, κρύο κλίμα της Βρετανίας. Μερικοί πάσχοντες από ρευματισμούς και αρθρίτιδα ακόμα χρησιμοποιούν τσουκνίδες που τις τρίβουν στα πονεμένα μέρη του σώματός τους για να μειώσουν τον πόνο.

ΔΕΞΙΑ
Η αιχμή του κεντριού της μέλισσας φέρει ακίδες για να γαντζώνεται γερά στο δέρμα του θύματος. Το κεντρί αποτελεί μετεξέλιξη μέρους του μηχανισμού ωοτοκίας, γι' αυτό κεντρί έχουν μόνο οι θηλυκές μέλισσες.

ΑΡΙΣΤΕΡΑ
Ένα μελίσσι περιλαμβάνει βασικά μόνο θηλυκές μέλισσες, οπότε τα συνδυασμένα κεντρίσματα χιλιάδων εργατριών είναι μια καλή άμυνα εναντίον των αρπακτικών που τις απειλούν.

ΔΕΞΙΑ
Τα αιχμηρά αγκάθια στα φύλλα της τσουκνίδας είναι εύθρυπτα και κοίλα, και καθώς σπάζουν τρυπώντας το δέρμα εκκρίνουν ένα οδυνηρό δηλητήριο αποθηκευμένο στις ελαφρώς διογκωμένες βάσεις τους.

ΑΡΙΣΤΕΡΑ
Τα ιδιαίτερα πριονωτά φύλλα είναι ένα οικείο θέαμα στις άκρες των δρόμων και σε αλάνες, παντού όπου το έδαφος είναι σκαμμένο αλλά πλούσιο σε θρεπτικές ουσίες.

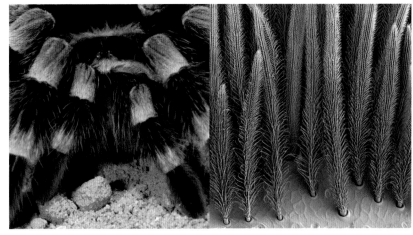

Ζυγοί παρατεταγμένων δοράτων που σχηματίζουν μια αδιαπέραστη λόχμη είναι ο συνηθισμένος παλαιόθεν τρόπος άμυνας στο πεδίο της μάχης. Οι κοφτερές, επικίνδυνες αιχμές των δοράτων αποκρούουν και τις πιο άγριες, τις πιο φρενήρεις επιθέσεις. Το ίδιο ισχύει και για τις σαν δόρατα σμήριγγες που όλες μαζί αποτελούν το αμυντικό όπλο της προνύμφης του σκαθαριού χαλιών.

Όπως υποδηλώνει το όνομά του, το σκαθάρι αυτό τρώει χαλιά, αλλά μόνο όσα είναι κατασκευασμένα με ζωικές ίνες, όπως μαλλί και μετάξι. Εντούτοις δεν περιφρονεί και άλλες τροφές, όπως μάλλινα και μεταξωτά ρούχα, γούνες, δέρματα, παστά, καπνιστά και εν γένει διατηρημένα είδη κρεάτων και ψαριών, ακόμα και ταριχευμένα ζώα σε μουσεία. Πριν οι άνθρωποι αρχίσουν να στρώνουν τα σπίτια τους με χαλιά και κιλίμια, τα σκαθάρια αυτά ζούσαν σε φωλιές ζώων και πτηνών τρεφόμενα με απορρίμματα, πεσμένα φτερά και τρίχες, ίσως κάποτε και με νεκρές ζωικές ύλες. Έτσι ήρθαν σε επαφή με μεγάλους επικίνδυνους ξενιστές που το πιθανότερο ήταν πως θα

δοκίμαζαν να τα φάνε. Οι μακριές σκληρές τρίχες της προνύμφης τους είναι εύθρυπτες και σπάζουν, αφήνοντας τις σαν δόρατα αιχμές τους μπηγμένες στο στόμα του ζώου ή του πτηνού.

Οι τρίχες είναι καλό αμυντικό όπλο και εναντίον μικρότερων αρπακτικών. Το φυσικό ενδιαίτημα ορισμένων ειδών των κολεόπτερων αυτών είναι οι περίπλοκοι και μπερδεμένοι ιστοί αραχνών κάτω από τον χαλαρό φλοιό μεγάλων νεκρών δέντρων. Εδώ επιβιώνουν τρεφόμενα με τα υπολείμματα νεκρών εντόμων που έχουν αφήσει οι αράχνες. Εάν η αράχνη πλησιάσει την προνύμφη, έρχεται αντιμέτωπη με έναν πυκνό φραγμό αγκαθιών που σπάζουν μες στο στόμα της.

Τα σκαθάρια χαλιών είναι οικόσιτα από τον καιρό που οι άνθρωποι έφτιαξαν κατοικίες ώστε να εισβάλουν σε αυτές, και μολονότι τα ενήλικα αποκαλούνται περιφρονητικά σκαθάρια χαλιών, λαρδιού, μπέικον, κοκάλων ή δερμάτων, οι μαλλιαρές προνύμφες τους είναι γνωστές με το μάλλον τρυφερό όνομα «μαλλιαρά αρκουδάκια».

Αυτό το δάσος δίνει την εντύπωση σχεδόν αδιαπέραστης λόχμης. Ωστόσο, τα κωνοφόρα του έχουν ύψος μικρότερο από μισό χιλιοστό και η πυκνή λόχμη που σχηματίζουν είναι το παχύ τρίχωμα που καλύπτει σαν μανδύας το σώμα της μεξικάνικης ερυθρόποδης ταραντούλας.

Οι ταραντούλες είναι μεγάλες τριχωτές αράχνες που το άνοιγμα των ποδιών τους φτάνει μέχρι τα 15 εκατοστά. Όπως όλες οι αράχνες, είναι δηλητηριώδεις θηρευτές εντόμων που τα σκοτώνουν με το δηλητήριο, το οποίο εκχύουν από τις χηληκεραίες που έχουν στην περιοχή του στόματος. Είναι γνωστές ως αράχνες που δαγκώνουν τον άνθρωπο, αλλά παρά τον ευρέως διαδεδομένο φόβο που προκαλούν τα δαγκώματά τους είναι σπάνια και συνήθως δεν πονούν περισσότερο από το τσίμπημα σφίγγας. Οι ταραντούλες απεχθάνονται να δαγκώνουν τον άνθρωπο και καθώς είναι αξιοσημείωτα υπάκουες είναι πολύ δημοφιλή οικόσιτα.

Το δάγκωμά της είναι ένας καλός τρόπος επίθεσης, αλλά όχι και τόσο καλός

τρόπος άμυνας, όπως θα νόμιζε κανείς. Πρώτα απ' όλα γιατί είναι μάλλον πολύ αργά να αμυνθεί όταν την έχει ήδη διαλέξει κάποιος επιθετικός εχθρός με σκοπό να τη φάει. Έτσι λοιπόν έχει ένα άλλο, πιο εκλεπτυσμένο όπλο – τις σμήριγγες. Όταν η ταραντούλα αισθανθεί κίνδυνο οπισθοχωρεί απειλητικά, κινώντας τα μπροστινά της πόδια. Ταυτόχρονα ξύνεται με τα πίσω πόδια της και οι τρίχες που κατ' αυτό τον τρόπο πέφτουν μένουν πάνω της ή σκορπίζονται στον αέρα. Οτιδήποτε πλησιάσει την αράχνη σε αυτή την κατάσταση ή την αρπάξει θα μολυνθεί από τις σμήριγγές της.

Οι τρίχες της είναι αιχμηρές σαν βελόνες. Στο στόμα του επίδοξου αρπακτικού ζώου ή πτηνού προκαλούν έντονο πόνο και κάψιμο. Εάν μπουν στο μάτι ή στη βλεννογόνο των αναπνευστικών οδών, μπορεί να διεισδύσουν βαθιά προκαλώντας φλεγμονή και ερεθισμό. Όσοι έχουν ταραντούλες, πρέπει να πλένουν τα χέρια τους όταν έρχονται σε επαφή μαζί τους και να μην τρίβουν τα μάτια τους.

ΔΕΞΙΑ
Οι αιχμηρές σαν δόρατα σμήριγγες της προνύμφης ενός σκαθαριού χαλιών που σπάζουν στο στόμα του επίδοξου αρπακτικού, προκαλώντας επώδυνη ενόχληση.

ΑΡΙΣΤΕΡΑ
Οι σμήριγγες λειτουργούν ως φραγμός ή, όπως του είδους αυτού που τρέφεται από οργανικά απορρίμματα μέσα σε ιστούς αραχνών, πάλλονται προκαλώντας σύγχυση στην αράχνη που νομίζει ότι πάλλεται ο ιστός.

ΔΕΞΙΑ
Αυτές οι τρίχες, που μοιάζουν με φτερά και που οι μυτερές σαν βελόνα άκρες τους είναι μπηγμένες στο δέρμα της ερυθρόποδης ταραντούλας, πετάγονται από το αμυνόμενο ζώο και εισχωρούν στα μάτια, τη μύτη και το στόμα κάθε επίδοξου αρπακτικού.

ΑΡΙΣΤΕΡΑ
Οι ταραντούλες είναι υπάκουα οικόσιτα, αλλά η αδέξια μεταχείρισή τους μπορεί να έχει ως συνέπεια αλλεργικές αντιδράσεις από τις αερομεταφερόμενες σμήριγγες.

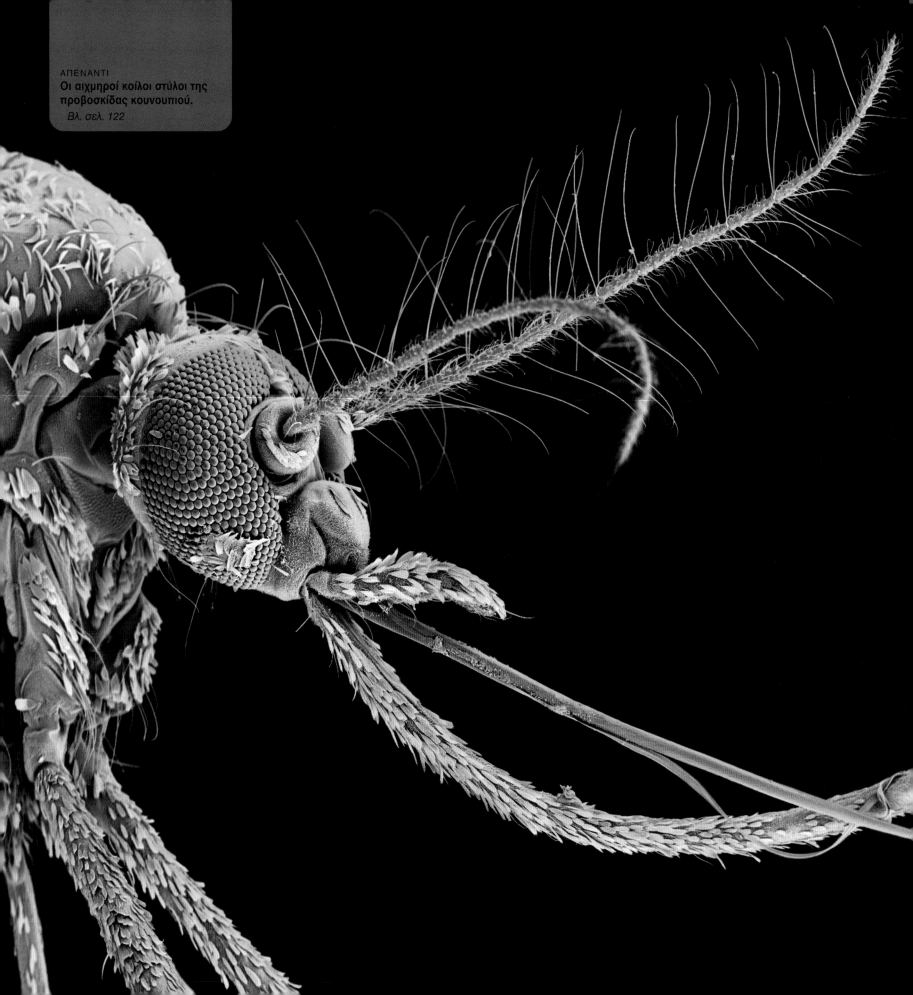

ΑΠΕΝΑΝΤΙ
Οι αιχμηροί κοίλοι στύλοι της προβοσκίδας κουνουπιού.
Βλ. σελ. 122

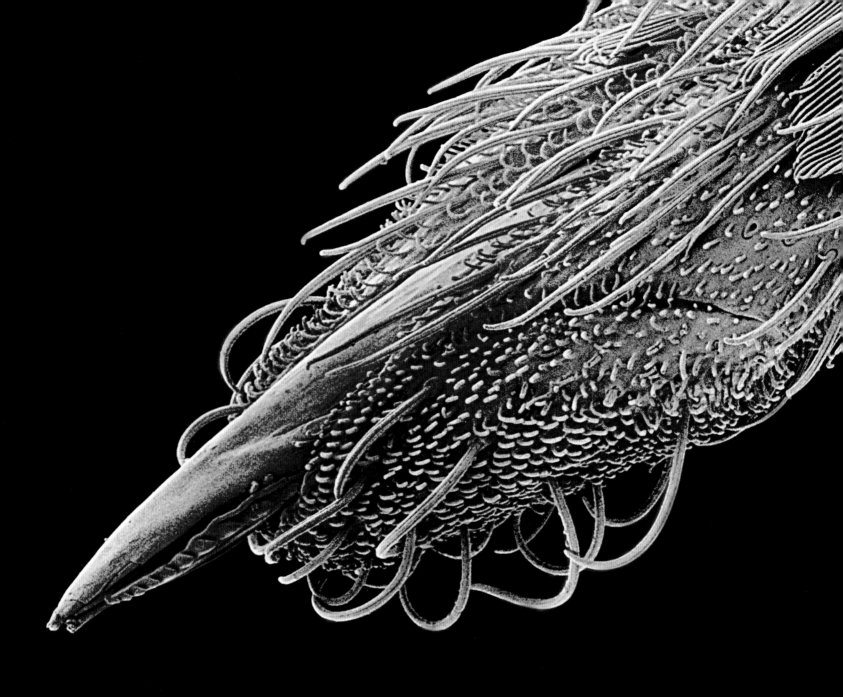

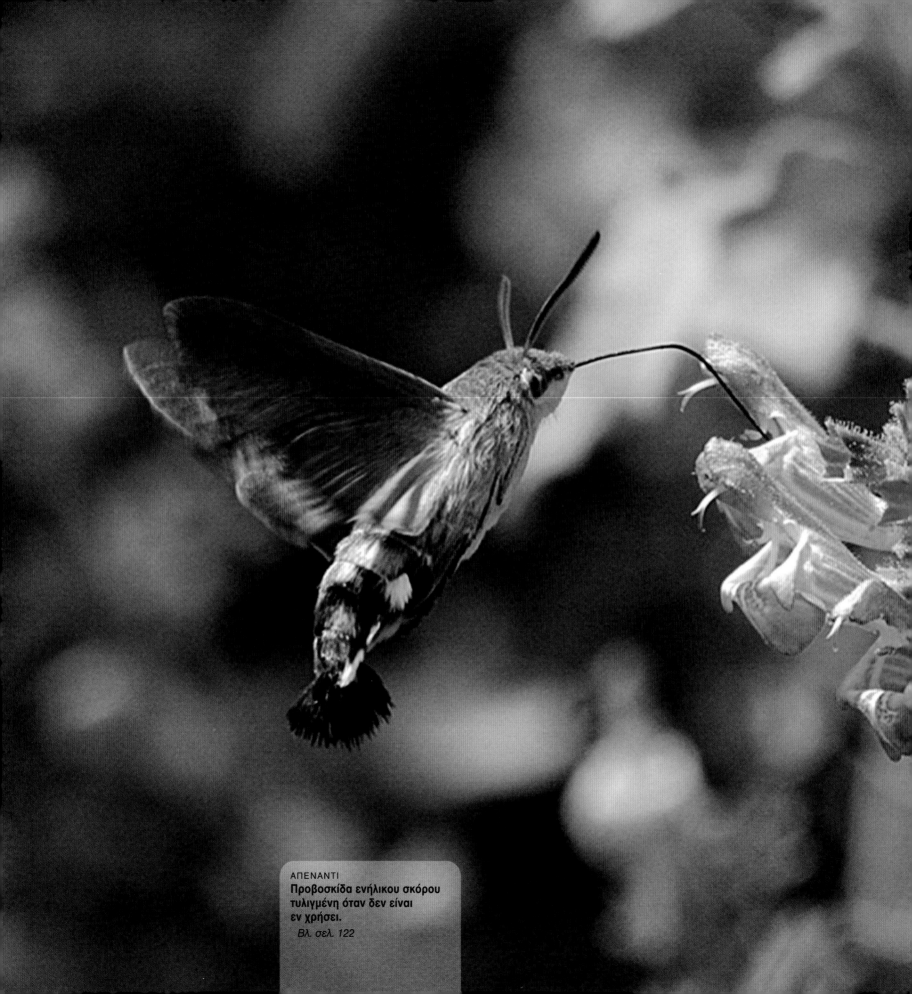

ΑΠΕΝΑΝΤΙ
**Προβοσκίδα ενήλικου σκόρου
τυλιγμένη όταν δεν είναι
εν χρήσει.**
Βλ. σελ. 122

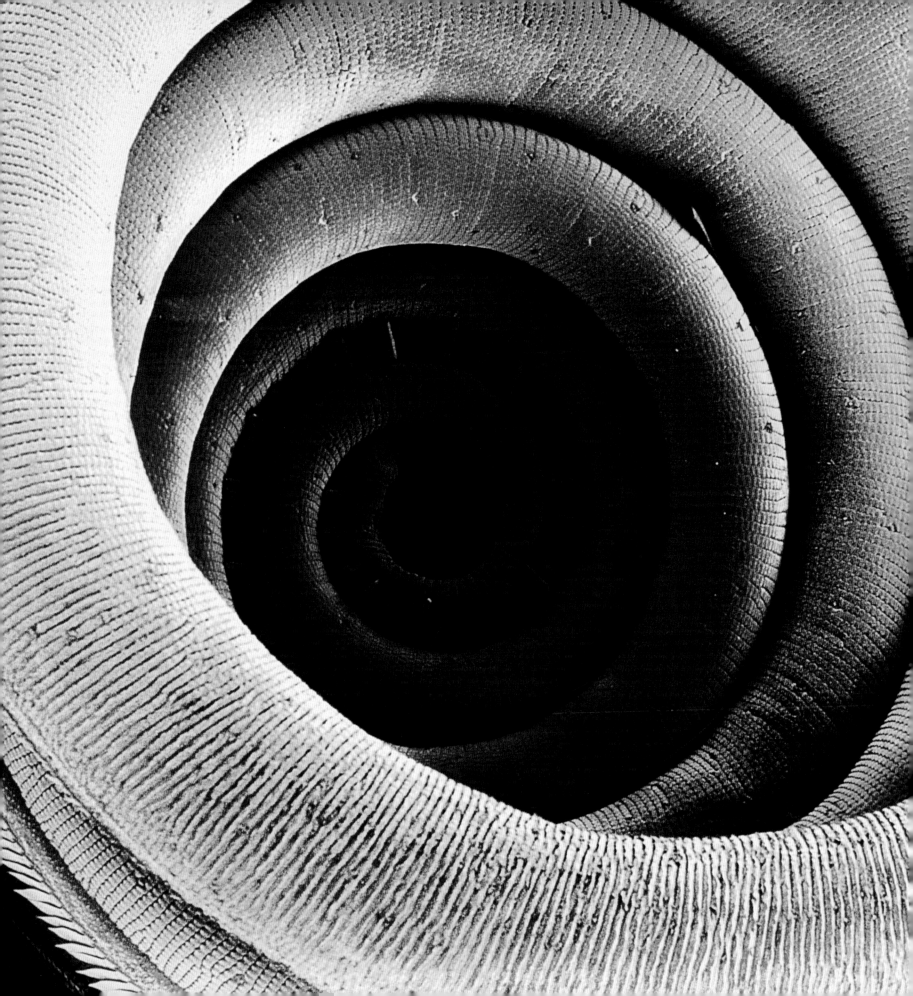

ΑΠΕΝΑΝΤΙ
Τομή σε βλαστό μπαμπού με τα αγγεία μέσω των οποίων μεταφέρονται υγρά και θρεπτικές ουσίες.

Βλ. σελ. 123

ΑΠΕΝΑΝΤΙ
Τομή τριχών εξωτερικού μανδύα πολικής αρκούδας.

Βλ. σελ. 123

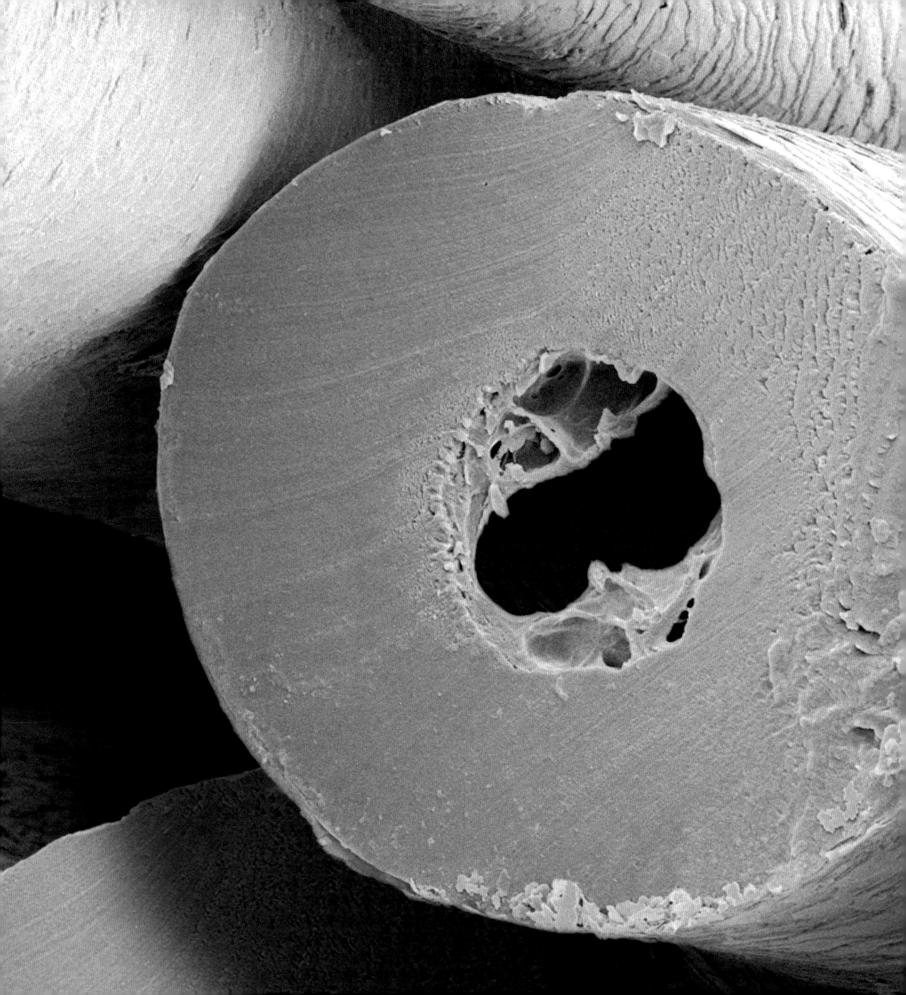

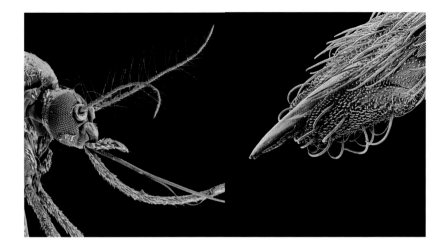

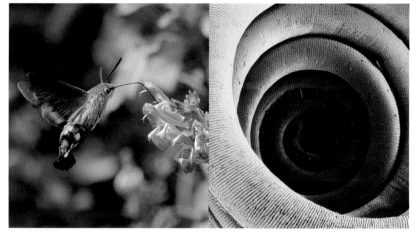

Επικίνδυνο όπλο σπανίως στη θήκη του, με όψη από την ελαφρώς καμπύλη προβοσκίδα μέχρι την απαλή λαμπερή άνω επιφάνειά του, τρομάζει. Θέμα αυτής της εικόνας είναι ένα αντικείμενο που δεν θα μπορούσε να έχει παρά μόνο μία σκοπιμότητα – να σε μαχαιρώσει και να απολαύσει στη συνέχεια το αίμα που τρέχει από την πληγή. Η προβοσκίδα του κουνουπιού εξυπηρετεί θαυμάσια αυτό τον στόχο.

Όπως σε όλα τα έντομα έτσι και στο κουνούπι το στοματικό μόριο αποτελείται από ζεύγη εξαρτημάτων, αριστερό και δεξί, τα οποία ανάγονται στο απώτερο παρελθόν της εξέλιξης, σε αποφύσεις εν είδει άκρων, που στα άλλα μέρη του σώματός του έχουν εξελιχθεί σε φτερά, πόδια και κεραίες. Αποτελείται δηλαδή από έξι νύσσοντα και μυζητικά στοιχεία που όλα μαζί λέγονται δέσμη (fascicle) και περικλείονται από το κάτω χείλος (labium), από το καλυμμένο με σμήριγγες, κεκαμμένο στοιχείο στην εικόνα μας. Όταν το κουνούπι προσγειώνεται στην επιδερμίδα του ανθρώπου ή άλλου ζώου και πιέζει πάνω του τα έξι αυτά μέρη του

στόματός του, το κάτω χείλος κάμπτεται για να τους κάνει τόπο. Οι άνω γνάθοι, τα επιμήκη, λεία στοιχεία που μοιάζουν με άνω και κάτω ράμφος, είναι τα ισχυρά διεισδυτικά όργανα, που χρησιμοποιούνται για να διαρρήξουν το πρώτο εμπόδιο της επιδερμίδας. Οι κάτω γνάθοι, η καθεμιά τους πιο κοντή, περισσότερο καμπύλη και ανώμαλη εξωτερικά, είναι τα εργαλεία διείσδυσης. Κόβουν εναλλάξ, πριονίζοντας την πληγή όλο και βαθύτερα και χρησιμοποιώντας τις αγκιστροειδείς προεκβολές τους για να αγκυρώνονται στη σάρκα.

Κρυμμένα στα στοιχεία κοπής υπάρχουν και άλλα μέρη του στόματος: δύο στύλοι, ενσωματωμένοι μέσα σε έναν αγωγό σιέλου, εκκρίνουν ένζυμα για να ξεκινήσει η πέψη και αντιπηκτικά για την αποφυγή θρόμβων. Δύο ακόμα στύλοι ενσωματωμένοι στον τροφικό αγωγό αναρροφούν το αίμα.

Μόνο τα θηλυκά κουνούπια απομυζούν αίμα, χρησιμοποιώντας την πλούσια πρωτεΐνη για να ωριμάσουν τα αυγά τους. Το αρσενικό χρησιμοποιεί τους στύλους του για να ρουφά νέκταρ και φυτικούς χυμούς.

Το ιλιγγιώδες πηγάδι στο κέντρο μιας ελικοειδούς σκάλας ή μήπως οι σπείρες μιας κουλουριασμένης πυροσβεστικής μάνικας; Ούτε το ένα ούτε το άλλο, η εικόνα όμως της μάνικας πλησιάζει περισσότερο στην πραγματική λειτουργία αυτής της έλικας, γιατί είναι οι βρόχοι που σχηματίζει η συσπειρωμένη προβοσκίδα ενός σκόρου.

Νυχτοπεταλούδες και πεταλούδες τρέφονται με υγρό νέκταρ των λουλουδιών και χρησιμοποιούν τη μακριά μυζητική τους προβοσκίδα για να δοκιμάσουν το νέκταρ που συχνά είναι θαμμένο μέσα στον προστατευτικό κάλυκα. Αντί να κουβαλά έναν δύσχρηστο, δύσκαμπτο σωλήνα σαν καλαμάκι, ο σκόρος μαζεύει την προβοσκίδα του και την αποθηκεύει διακριτικά κάτω από το κεφάλι του μέχρι να την ξαναχρειαστεί.

Η προβοσκίδα δεν είναι απλώς ένας επιμήκης κοίλος κύλινδρος, αλλά ένα σύνθετο εργαλείο που απαιτεί ειδική κατασκευή. Τον αποτελούν δύο μακριές ράβδοι που λέγονται λοβοί (galeae). Αυτές οι ράβδοι αποτελούν μετεξέλιξη αρχικά διακεκριμένων αποφύσεων στο κάτω μέρος του κεφαλιού. Κάθε ράβδος φέρει αύλακα στο εσωτερικό της, οπότε εκεί όπου οι δύο λοβοί ενώνονται κατά μήκος της

προβοσκίδας σχηματίζουν τον τροφικό αγωγό που είναι περίπου κυκλικός σε τομή. Στο άνω άκρο του τροφικού αγωγού υπάρχει μυϊκή αντλία που δημιουργεί κενό για την αναρρόφηση του νέκταρος.

Οι λοβοί (galeae) έχουν φυσική ελαστικότητα και για να ξετυλιχθούν και να αποκτήσουν όλο τους το μήκος ο ενήλικος σκόρος αυξάνει την πίεση της αιμολέμφου (το ανάλογο του αίματος στα έντομα) στο εσωτερικό της προβοσκίδας την οποία σχηματίζουν προκαλώντας υδραυλικά τη σκλήρυνσή της. Για να ξαναμαζέψει την προβοσκίδα του την αποσυμπιέζει, τυλίγοντάς την σφιχτά.

Αυτή η ικανότητα δραματικής αύξησης του μήκους της γλώσσας τους σημαίνει πως οι σκόροι ρουφούν νέκταρ ακόμα και από τους βαθύτερους ύπερους, στους οποίους μόνο αυτοί φτάνουν. Σε μερικές περιπτώσεις η γλώσσα τους έχει μήκος πολλαπλάσιο του σώματός τους, χαρακτηριστικό που ανέπτυξαν παράλληλα με την εμφάνιση ενός τεράστια επιμηκυσμένου άνθους, έτσι ώστε ένα ιδιαίτερο είδος σκόρου είναι το μόνο έντομο που επικονιάζει το συγκεκριμένο φυτό.

ΔΕΞΙΑ
Όταν τσιμπούν, τα κουνούπια εκχέουν και μέρος του τελευταίου γεύματός τους, μεταξύ άλλων και το παράσιτο πλασμώδιο, είδος πρωτόζωου που προκαλεί ελονοσία.

ΑΡΙΣΤΕΡΑ
Καθώς η εύκαμπτη προστατευτική θήκη κάμπτεται, αποκαλύπτει τα μυζητικά μέρη του στοματικού μορίου του κουνουπιού.

ΔΕΞΙΑ
Η ικανότητα να συσπειρώνει τη γλώσσα επιτρέπει στον ακμαίο σκόρο να έχει ένα μυζητικό όργανο που πολλές φορές είναι πολλαπλάσιο του σώματός του σε μήκος.

ΑΡΙΣΤΕΡΑ
Το λεπιδόπτερο Macroglossum stellatarum ζυγιάζεται πάνω από το άνθος σαν το μικροσκοπικό κολίμπρι, ενώ ταυτόχρονα εκτείνει την εξαιρετικά μακριά προβοσκίδα του βαθιά μέσα στο άνθος.

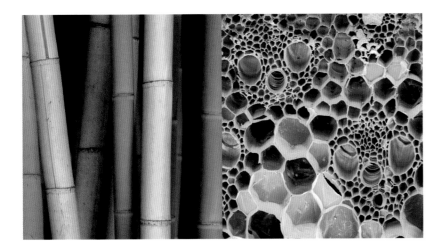

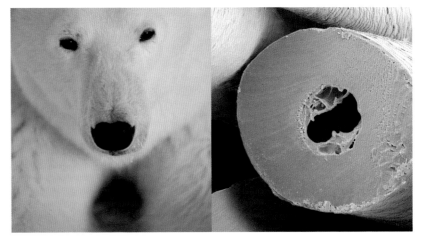

Αυτά θα μπορούσαν να είναι μια δέσμη από καλαμάκια που χρησιμοποιούμε για να πίνουμε. Η ομοιότητα δεν είναι τυχαία, διότι πρόκειται για κατακόρυφους σωλήνες στο εσωτερικό των βλαστών του μπαμπού, οι οποίοι φέρουν σε πέρας την ίδια ακριβώς υδραυλική λειτουργία με τα καλαμάκια – δηλαδή την ελεγχόμενη μεταφορά υγρών υπό πίεση.

Κάθε ομάδα αγγείων που εδώ απεικονίζονται με πράσινο χρώμα ονομάζεται αγγειακή δέσμη, εξ ου και το όνομα της συνομοταξίας. Αυτή η τεράστια συνομοταξία περιλαμβάνει πτεριδόφυτα, αγγειόσπερμα και γυμνόσπερμα – με άλλα λόγια την πλειονότητα των πράσινων φυτών. Στα φυτά που δεν ανήκουν σε αυτή τη συνομοταξία περιλαμβάνονται πολύ απλούστερες φυτικές μορφές, όπως βρύα, λειχήνες και πράσινα φύκη.

Μια αγγειακή δέσμη περιλαμβάνει δύο τύπους σωληνίσκων. Τα μεγαλύτερα κύτταρα της δέσμης, τα ξυλώματα, είναι αυτά που μεταφέρουν νερό και θρεπτικές ουσίες από τις ρίζες στα φύλλα. Εδώ δεν υπάρχει ανάλωση ενέργειας, γιατί το φυτό μεταφέρει το νερό συνδυάζοντας την πίεση που δημιουργείται στις ρίζες λόγω της όσμωσης και της εξάτμισης από τα φύλλα. Τα ξυλώματα είναι σκληρά και ινώδη· συνήθως δεν αναπτύσσονται άλλο, καθώς δεν περιέχουν ενεργά μέρη κυττάρου, όπως πυρήνα ή κυτόπλασμα, και είναι τα κύρια συστατικά του ξύλου.

Τα μικρότερα κύτταρα σχηματίζουν τα φλοιώματα που μεταφέρουν θρεπτικές ουσίες με μορφή οπού σακχάρων από τα φύλλα σε άλλα αναπτυσσόμενα μέρη του φυτού ή τις αποθηκεύουν στις ρίζες, τους βολβούς ή τους κονδύλους του φυτού. Τα φλοιώματα είναι κοντύτερα από τα ξυλώματα, αλλά είναι ενωμένα μεταξύ τους σχηματίζοντας σωληνίσκους με πλακίδια εν είδει ηθμού σε κάθε τους άκρο.

Σε ολόκληρο το φυτικό βασίλειο τα ξυλώδη και φλοιώδη αυτά αγγεία είναι διατεταγμένα με τον ίδιο τρόπο: τα ξυλώδη πλησιέστερα στο κέντρο των βλαστών και των ριζών, τα φλοιώδη στην εξωτερική πλευρά. Στα φύλλα τα ξυλώδη είναι πλησιέστερα στην άνω, τα φλοιώδη στην κάτω επιφάνειά τους. Αυτό το χαρακτηριστικό εκμεταλλεύονται οι αφίδες, οι οποίες συνήθως τρέφονται απομυζώντας τον γλυκό οπό από την κάτω επιφάνεια των φύλλων.

Αυτό θα μπορούσε να είναι αντικείμενο οικιακής χρήσης, όπως ένα ρολό χαρτί τουαλέτας ή κουζίνας. Ακόμα και η τομή δίνει την εντύπωση πορώδους μαλακού χαρτιού που κόπηκε με λάμα. Αλλά αυτή η εικόνα απέχει κατά πολύ από τα αντικείμενα του νοικοκυριού, καθώς αυτοί οι σωλήνες είναι οι τρίχες μιας πολικής αρκούδας.

Πρόκειται για τις προστατευτικές τρίχες του ζώου, τον εξωτερικό τραχύ μανδύα που προστατεύει το κοντύτερο και λεπτότερο τρίχωμα του υπομανδύα από τα στοιχεία της φύσης. Μολονότι η γούνα της πολικής αρκούδας με γυμνό οφθαλμό φαίνεται λευκή, στην πραγματικότητα είναι διαφανής. Κάποτε υπέθεταν πως τα κοίλα αυτά στελέχη λειτουργούσαν σαν καλώδια οπτικών ινών μεταφέροντας φως στο σκουρόχρωμο δέρμα της αρκούδας, σήμερα όμως θεωρείται πιθανότερο πως η γεμάτη αέρα κοιλότητα απλούστατα συμβάλλει στη μόνωση. Η αρκούδα χρειάζεται ό,τι μπορεί να αποτρέψει την απώλεια θερμότητας, γιατί έχει διαλέξει για κατοικία έναν από τους πιο αφιλόξενους τόπους της γης – την παγωμένη Αρκτική.

Εξωτερικό μανδύα με κούφιες τρίχες έχει και ένα άλλο θηλαστικό της Αρκτικής, ο τάρανδος.

Η αρκούδα ζει ουσιαστικά όλη της τη ζωή πάνω στους πάγους ή εάν όχι στους πάγους πάντως στις παρυφές του παγωμένου ωκεανού, όπου ψαρεύει φώκιες και άλλα θηράματα σε σχισμές και μέσα στη θάλασσα. Οποιαδήποτε άλλη γούνα θα έκανε πιο φανερή την παρουσία της, έτσι λοιπόν μολονότι το καλοκαίρι μαδά, ποτέ δεν αποκτά σκουρότερο χρώμα όπως πολλά άλλα πλάσματα της Αρκτικής. Υπό συνθήκες αιχμαλωσίας, εάν το περιβάλλον στο οποίο ζουν είναι ζεστό και υγρό, οι πολικές αρκούδες μερικές φορές αποκτούν ανοιχτό πράσινο χρώμα, επειδή στις κούφιες τρίχες αναπτύσσονται φύκη.

Το μήκος τους σχεδόν σε όλο το σώμα κυμαίνεται από 5 έως 15 εκατοστά με εξαίρεση τα μπροστινά πόδια των αρσενικών. Εδώ οι τρίχες αυτές φτάνουν μέχρι τα 35 εκατοστά μήκος σχηματίζοντας πυκνή, μακριά χαίτη που θεωρείται ότι είναι σεξουαλικό σήμα που απευθύνεται στα θηλυκά.

ΔΕΞΙΑ
Το μπαμπού είναι ψηλό φυτό ταχείας ανάπτυξης και γι' αυτό χρειάζεται να μεταφέρει ταχύτατα και εύκολα υγρά μέσω των βλαστών.

ΑΡΙΣΤΕΡΑ
Μια εγκάρσια τομή στελέχους μπαμπού αποκαλύπτει τους σωληνίσκους (tubules) μεταφοράς του νερού από τις ρίζες στα φύλλα, και τις φωτοσυντεθειμένες θρεπτικές ουσίες από τα φύλλα στον αναπτυσσόμενο κάλαμο.

ΔΕΞΙΑ
Κοίλες τρίχες συμβάλλουν στη θερμομονωτική προστασία της πολικής αρκούδας.

ΑΡΙΣΤΕΡΑ
Η αρκούδα μοιάζει κατάλευκη με γυμνό οφθαλμό, αλλά το χρώμα είναι συνέπεια της περίθλασης του φωτός, καθώς το ίδιο το τρίχωμα είναι διαφανές.

ΑΠΕΝΑΝΤΙ
**Ζεύγος νυχιών στο πόδι ενός
ψύλλου σκαντζόχοιρου.**
Βλ. σελ. 132

ΑΠΕΝΑΝΤΙ
Νύχια στο πόδι ενός σκαθαριού του είδους Ηρακλής.

Βλ. σελ. 132

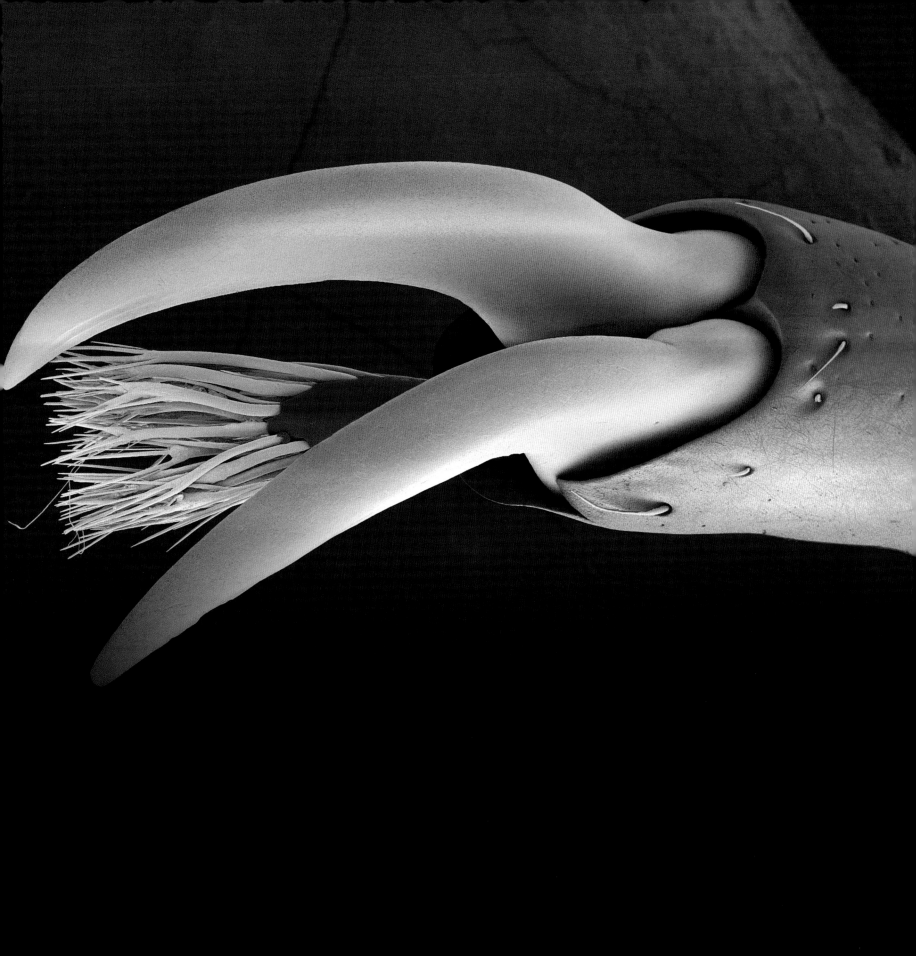

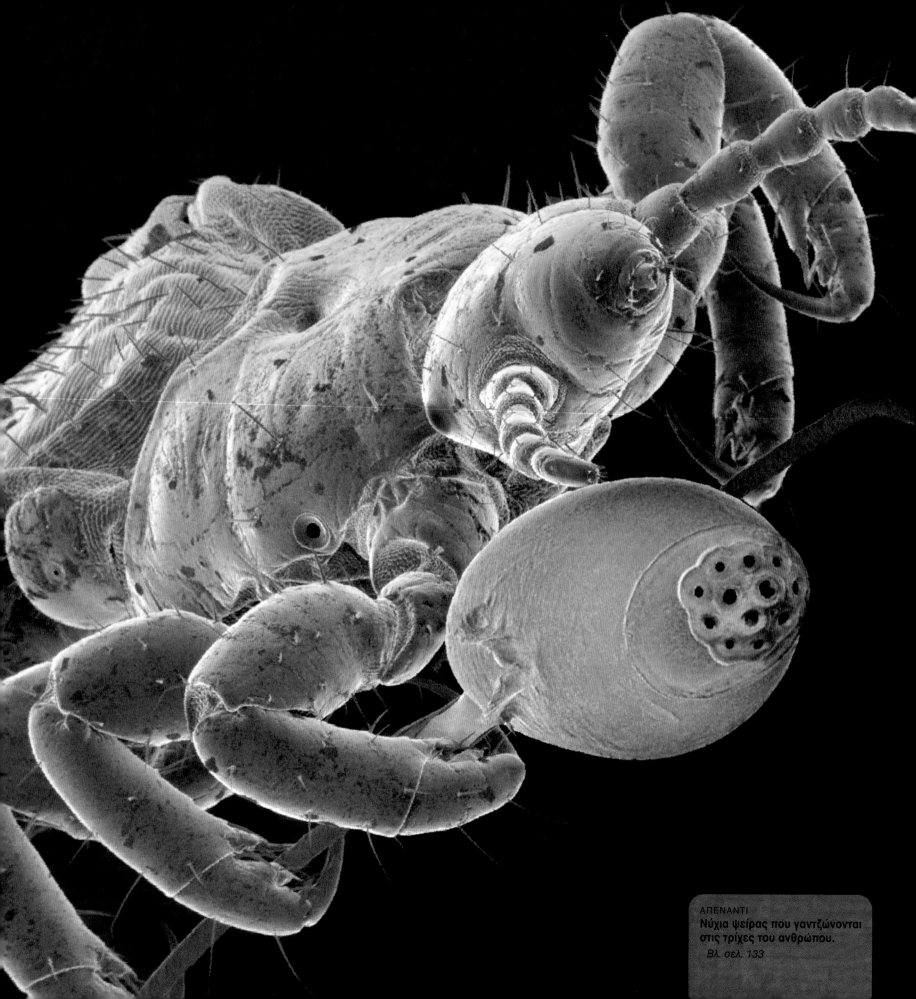

ΑΠΕΝΑΝΤΙ
Νύχια ψείρας που γαντζώνονται στις τρίχες του ανθρώπου.
Βλ. σελ. 133

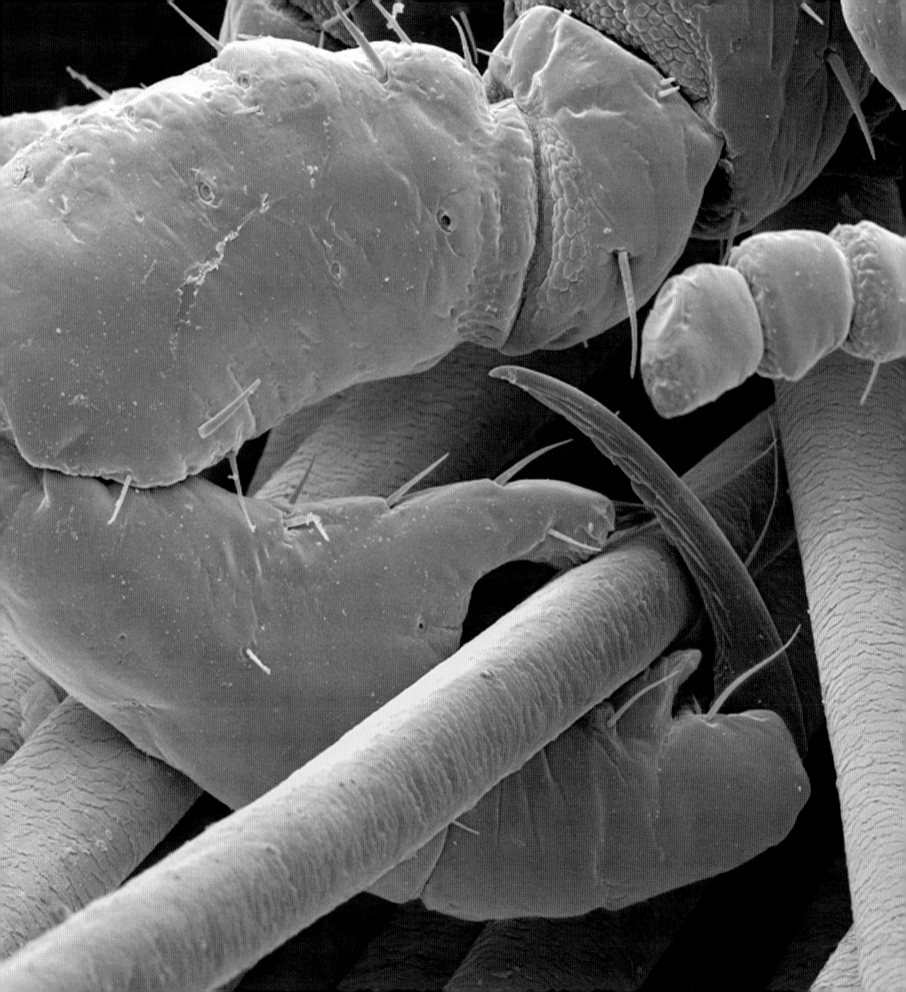

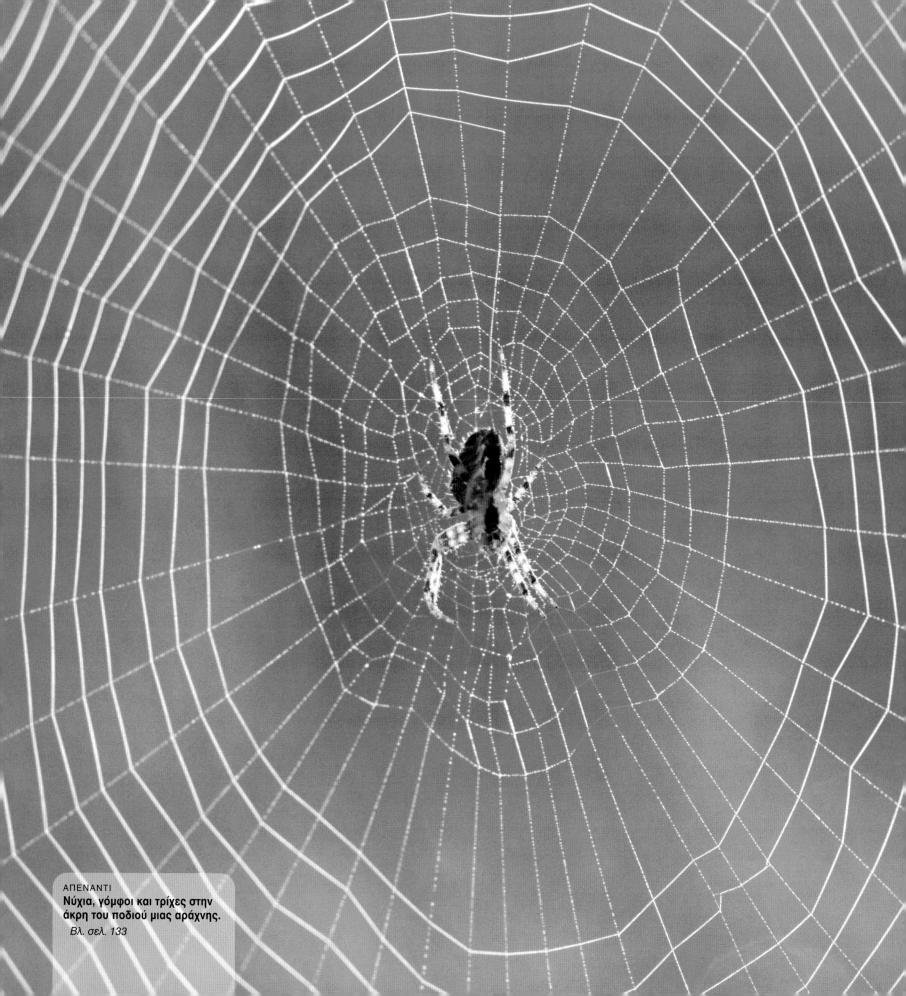

ΑΠΕΝΑΝΤΙ
Νύχια, γόμφοι και τρίχες στην άκρη του ποδιού μιας αράχνης.
Βλ. σελ. 133

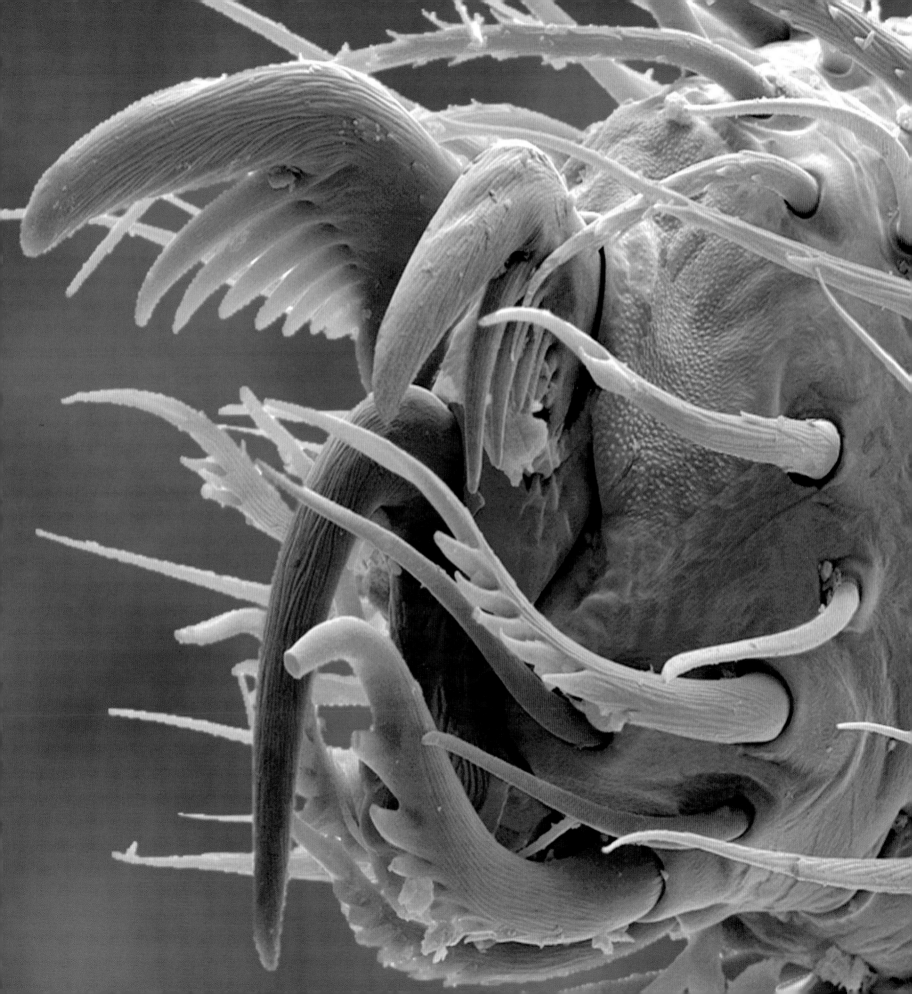

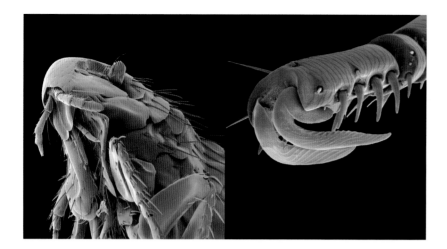

Αυτή η ισχυρή σιδερένια αρπάγη έχει διπλό γάντζο για να σηκώνει μεγάλο βάρος, καθώς και δόντια ασφαλείας που συγκρατούν το σκοινί, εντούτοις δεν ανύψωσε ποτέ φορτίο ως μέρος γερανού σε κάποιον ντόκο. Ούτε είναι ένας νέος τύπος καραμπίνερ για την αναρρίχηση σε βράχο, αν και φαίνεται ικανό να ασφαλίσει μια ολόκληρη παρέα ορειβατών μαζί με τις σκηνές τους σε συνθήκες μαινόμενης ανεμοθύελλας. Αυτά τα γαντζάκια χρησιμοποιούνται για ένα πολύ λεπτότερο πιάσιμο, αλλά εξίσου μεγάλης σημασίας για τον ιδιοκτήτη τους – για τον ψύλλο του σκαντζόχοιρου.

Οι σκαντζόχοιροι είναι γνωστοί για τα μυτερά αγκάθια τους, δηλαδή για τις κοίλες τρίχες τους που έχουν σκληρυνθεί και αποτελούν το αμυντικό τους όπλο. Αλλά κάτω από αυτούς τους καλάμους υπάρχει μια παχιά γούνα κανονικών τριχών, και εδώ ζει ο ψύλλος απομυζώντας το αίμα του άτυχου ξενιστή του. Οι ψύλλοι, όπως και άλλα παράσιτα που ζουν στο τρίχωμα ζώων ή στο πτέρωμα πτηνών, κινδυνεύουν διαρκώς να απομακρυνθούν από τον ξενιστή τους όταν αυτός περιποιείται τον εαυτό του, ξύνεται ή μαδά, έτσι λοιπόν ανέπτυξαν νύχια και μάλιστα γαμψά για να πιάνονται γερά. Τα

σαν πιάστρες μαλλιών αυτά νύχια στον ταρσό του ψύλλου όταν κλείνουν εφάπτονται σε μια σειρά τεσσάρων μυτερών δοντιών παγιδεύοντας τις τρίχες ανάμεσά τους.

Τα νύχια του ψύλλου όμως επιτελούν και μια άλλη λειτουργία: καθώς τα πόδια συσπώνται σαν ελατήριο σπρώχνοντάς τον, τα νύχια του γαντζώνουν στο έδαφος και τον συγκρατούν. Οι ψύλλοι πηδούν ψηλά χρησιμοποιώντας την τεράστια ελαστικότητα των μυών στα γερά πίσω πόδια τους που τους τεντώνουν στο έπακρο και έπειτα τους χαλαρώνουν απότομα εντελώς. Έτσι το έντομο τινάζεται στον αέρα κάνοντας ένα τεράστιο άλμα εκατονταπλάσιο του μήκους του σώματός του, εάν όχι παραπάνω.

Οι ψύλλοι έχουν και ένα άλλο χαρακτηριστικό που τους επιτρέπει να κινούνται πάνω στους ξενιστές τους άνετα σαν να κολυμπούν ανάμεσα στις τρίχες. Είναι πολύ πεπλατυσμένοι και το κεφάλι, ο θώρακας και κάθε μεταμερές της κοιλιάς είναι όλα εξοπλισμένα με χτένια που τα δόντια τους διευθύνονται προς τα πίσω. Αυτό επιτρέπει την κίνησή τους προς τα μπρος, ενώ δυσκολεύει τον ξενιστή να τους ξεκολλήσει τραβώντας τους προς τα πίσω.

Αυτή η επιφάνεια με τη λεία υφή δίνει σε αυτές τις δύο εκφύσεις όψη καμπύλων χαυλιόδοντων από ελεφαντοστό, αλλά δεν είναι ούτε δόντια ούτε όπλα, είναι νύχια και η δουλειά τους είναι να αρπάζουν. Πρόκειται για τα νύχια στο άκρο του ποδιού ενός σκαθαριού που ονομάζεται Ηρακλής (Herakles dynastes).

Το σκαθάρι Ηρακλής είναι ένας τεράστιος και γεροδεμένος σκαραβαίος. Ζει στα τροπικά δάση της Κεντρικής και της Νότιας Αμερικής και εδώ και καιρό αποτελεί το καύχημα συλλεκτών και μουσείων λόγω της ομορφιάς και της παράξενης όψης του. Είναι ένα από τα μεγαλύτερα είδη των ρινόκερων κανθάρων (Oryctes nasicornis), μέχρι 17 εκατοστά μήκος, και το αρσενικό έχει δύο μακριά, λεπτά κέρατα. Το ένα φυτρώνει προς τα μπρος και κάτω από το κέντρο του θώρακά του και το άλλο προς τα έξω και πάνω από το κέντρο του κεφαλιού του. Αυτά τα δύο κέρατα συναντιούνται σχεδόν σαν σκέλη τσιμπίδας και είναι τα όπλα των αρσενικών όταν κονταροχτυπιούνται μεταξύ τους με έπαθλο τα θηλυκά.

Το σώμα αυτού του σκαθαριού είναι κοντόχοντρο και τα πόδια του κοντά.

Έτσι λοιπόν οι αγώνες κρίνονται από τα αποτελέσματα της προσπάθειας ανύψωσης, διότι νικητής στέφεται ο Ηρακλής που αρπάζει και αναποδογυρίζει τον αντίπαλό του. Καθώς τα σκαθάρια αυτά πολλαπλασιάζονται σε νεκρούς και αποσυντεθειμένους ιστούς, οι μάχες συνήθως λαμβάνουν χώρα σε κλαδιά και κορμούς δέντρων, όπου είναι υψίστης σημασίας η δυνατότητα να πιάνονται γερά από τον εύθρυπτο φλοιό. Τα δύο νύχια στον κάθε ταρσό του είναι αρκετά μεγάλα και ισχυρά, ώστε να γαντζώνεται όταν μάχεται για την επικράτειά του.

Όλα σχεδόν τα έντομα έχουν δύο νύχια στα πόδια τους, κοινό χαρακτηριστικό που δείχνει την κοινή εξελικτική καταγωγή τους, από τον ίδιο κοινό πρόγονο που έζησε πριν από εκατοντάδες εκατομμύρια χρόνια. Ο θύσανος τριχών ανάμεσα στα νύχια ονομάζεται αρόλειο. Σε έντομα όπως οι μύγες αυτός ο λοβός είναι πεπλατυσμένος και αρκετά μεγάλος, και αποτελεί μέσον προσκόλλησης του εντόμου σε σκληρές, λείες επιφάνειες (βλ. πόδι μύγας σελ. 37). Το σκαθάρι Ηρακλής δεν βρίσκεται ποτέ σε τέτοια θέση, αντίθετα βασίζεται στα γερά νύχια του ταρσού για να κρατιέται στη θέση του.

ΔΕΞΙΑ
Όλα σχεδόν τα έντομα έχουν δύο γαμψά νύχια στο άκρο του ταρσού για διάφορους λόγους στρατηγικής· ο ψύλλος έχει δύο νύχια σε κάθε πόδι σαν τσιμπιδάκι για να πιάνει γερά τις τρίχες του ξενιστή του.

ΑΡΙΣΤΕΡΑ
Οι ψύλλοι έχουν προσαρμοστεί στην κίνηση μέσα στο τρίχωμα, αποκτώντας πεπλατυσμένο σώμα και σειρές τριχών που κλίνουν προς τα πίσω.

ΔΕΞΙΑ
Τα δύο νύχια στην άκρη του ταρσού του σκαθαριού γαντζώνονται γερά στα κλαδιά και τους κορμούς των δέντρων, καθώς το έντομο μεταφέρει το τεράστιο κορμί του μέσα στο τροπικό δάσος.

ΑΡΙΣΤΕΡΑ
Το σκαθάρι Ηρακλής ονομάστηκε έτσι επειδή είναι τεράστιο και πολύ δυνατό έντομο.

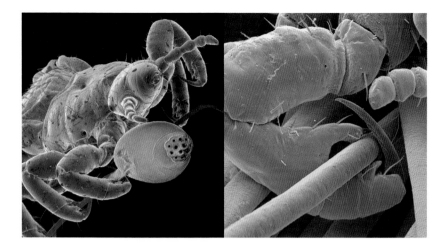

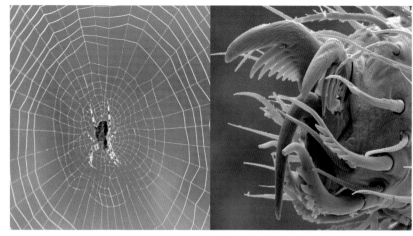

Αυτό πρέπει να συγκαταλέγεται ανάμεσα στα καλύτερα όργανα αρπαγής του ζωικού βασιλείου. Το μέγεθος του γιγαντιαίου μυός του χεριού, η εσοχή υποδοχής του σωληνοειδούς φορτίου του και το τεράστιο λυγισμένο δάχτυλο που κλείνει τη δαγκάνα, όλα αυτά μαρτυρούν την τεράστια δύναμη και αποτελεσματικότητά του. Και πράγματι μπορεί και πιάνει γερά, γιατί το να κρατιέται γερά είναι ζήτημα ζωής και θανάτου για μια ψείρα του τριχωτού του ανθρώπου.

Οι ψείρες του τριχωτού είναι πεισματάρικα απομυζητικά παράσιτα που βασανίζουν τους ανθρώπους από τους προϊστορικούς χρόνους. Μετακινούνται ανάμεσα στις τρίχες του κεφαλιού με αξιοσημείωτη ευκολία και ταχύτητα, εάν λάβουμε υπόψη μας το δύσχρηστο μέγεθος των ποδιών τους. Όταν ένα κεφάλι αγγίξει ένα άλλο, η ψείρα είναι ικανή να πεταχτεί στον νέο της ξενιστή μέσα σε δευτερόλεπτα. Δεν μπορεί να πηδά ή να πετά, αλλά είναι ικανή να μετακινείται ταχύτατα περπατώντας με τα τέσσερα.

Μόνο ο θάνατος ο δικός της ή του ξενιστή της κάνει την ψείρα στο κεφάλι του ανθρώπου να χαλαρώσει τη λαβή της. Ειδάλλως δεν έχει κανένα λόγο να τον εγκαταλείψει, καθώς έχει το τέλειο ενδιαίτημα και εύκολη ζωή. Το ανθρώπινο κεφάλι είναι ζεστό, υγρό και ασφαλές. Το αίμα, η τροφή της ψείρας, είναι διαθέσιμο όποτε το χρειαστεί (συνήθως πέντε φορές την ημέρα) και αν είναι τυχερή, ο ξενιστής της θα διατηρήσει το ενδιαίτημά της καθαρό λούζοντας τα μαλλιά του τακτικά και απομακρύνοντας τα δυσάρεστα περιττώματά της.

Οι ψείρες πολλαπλασιάζονται ταχύτατα προσκολλώντας τα σκληρά γκρίζα αυγά τους, τη λεγόμενη κόνιδα, στη βάση των τριχών πολύ κοντά στην επιδερμίδα. Όταν βγαίνει από το αυγό, η μικροσκοπική νύμφη αφήνει πίσω της ένα κατάλευκο τσόφλι αυγού ξεγελώντας τον ξενιστή της να κυνηγά τα άδεια αυγά.

Εάν τη βγάλουμε με τη χτένα, η ψείρα είναι καταδικασμένη. Μακριά από το υγρό δέρμα του ξενιστή της σύντομα θα αφυδατωθεί και θα πεθάνει μέσα σε λίγες ώρες. Δεν είναι λοιπόν απορίας άξιο που κρατιέται με νύχια και με δόντια πάνω του.

Επιλέγοντας αυτές τις ποικιλόμορφα οδοντωτές λάμες και τα άγκιστρα, οπλίζεται κανείς με ένα τρομακτικό σετ εργαλείων που θα μπορούσε κάλλιστα να αποτελεί μέρος ενός σουγιά του ελβετικού στρατού. Ίσως αυτό δεν εκπλήσσει και πολύ, δεδομένου ότι στην προκειμένη περίπτωση έχουμε να κάνουμε με έναν σύνθετο μηχανισμό προορισμένο να επιτελεί ένα εξίσου σύνθετο έργο. Αυτές οι τρίχες, οι γόμφοι και τα χτένια δεν είναι ωστόσο επιθετικά αλλά αμυντικά όπλα – είναι η άμυνα της αράχνης όταν μπλεχτεί στον ίδιο της τον ιστό, καθώς πρόκειται για τα νύχια στην άκρη του ταρσού της.

Στην πραγματικότητα οι αράχνες δεν έχουν πόδι, δηλαδή το τελευταίο λυγισμένο ταρσομερές όπως των εντόμων με τον επίπεδο λοβό για να πατούν στο έδαφος. Αντ' αυτού έχουν χηλές (ungulate), που σημαίνει ότι περπατούν ακροποδητί περίπου όπως και τα θηλαστικά που έχουν οπλές. Όταν μια αράχνη περπατά σε ένα φύλλο ή σκαρφαλώνει σε ένα κλαδί, χρησιμοποιεί τα τελευταία μεγάλα νύχια με τα μακριά δόντια (αποδίδονται με

ανοιχτό πράσινο στην εικόνα) για να κρατιέται. Αυτή είναι μια αράχνη κήπου (Argiope aurantia) που υφαίνει ιστούς κυκλοτερείς και ξοδεύει πολύ χρόνο σεργιανώντας πάνω στην κολλώδη παγίδα της. Τα υπόλοιπα νύχια τα έχει για να σκοινοβατεί στον ιστό της.

Όταν η άκρη του ποδιού μιας αράχνης πιέζει μια ίνα του ιστού, το μεγαλύτερο αγκιστροειδές νύχι (καστανόχρωμο στην εικόνα) λυγίζει, επιτρέποντας στο νήμα να στηριχτεί πάνω στις λυγισμένες στην άκρη τρίχες με τα κοντά δόντια. Αυτές οι τρίχες είναι ελαστικές και κάμπτονται προς τα πίσω, επιτρέποντας στο μεγαλύτερο νύχι να αγκιστρώσει το νήμα και να το κλείσει με τη βοήθεια των μικρότερων τριχών. Αντί να κρατιέται όπως οι άνθρωποι που αρπάζουν ένα χοντρό σκοινί, η αράχνη κρατιέται χρησιμοποιώντας τα εξαρτήματα του ποδιού της σαν λεπτό τσιμπιδάκι, δηλαδή αγκιστρώνεται σε ένα πολύ μικρό σημείο του κολλώδους νήματος. Όταν θέλει να το αφήσει, το νύχι ανασηκώνεται και οι ελαστικές τρίχες τινάζονται πίσω, αφήνοντας ελεύθερο το νήμα.

ΔΕΞΙΑ
Το οπλισμένο με νύχια κεφάλι μιας ψείρας είναι θαυμάσια προσαρμοσμένο στην ανάγκη να προσκολλάται στις τρίχες. Γερό χτένισμα είναι ο καλύτερος τρόπος να απαλλαγεί κανείς από τα ενοχλητικά αυτά παράσιτα.

ΑΡΙΣΤΕΡΑ
Μια ψείρα του τριχωτού της κεφαλής προσκολλάται πεισματικά στις τρίχες του ανθρώπου μαζί και το αυγό της (κόνιδα), του οποίου εδώ βλέπουμε τους πόρους αναπνοής.

ΔΕΞΙΑ
Τα άγκιστρα και τα νύχια στην άκρη του ποδιού μιας αράχνης τής επιτρέπουν να κινείται σε σκληρές επιφάνειες, όπως φύλλα και τοίχους, αλλά και να πιάνεται προσεκτικά από τα νήματα του ιστού της δίχως να παγιδεύεται.

ΑΡΙΣΤΕΡΑ
Ο ιστός που υφαίνει η αράχνη είναι μια σύνθετη σπείρα αποτελούμενη από κολλώδη νήματα συνδεόμενα με άλλα ακτινοειδώς διατεταγμένα που την υποβαστάζουν.

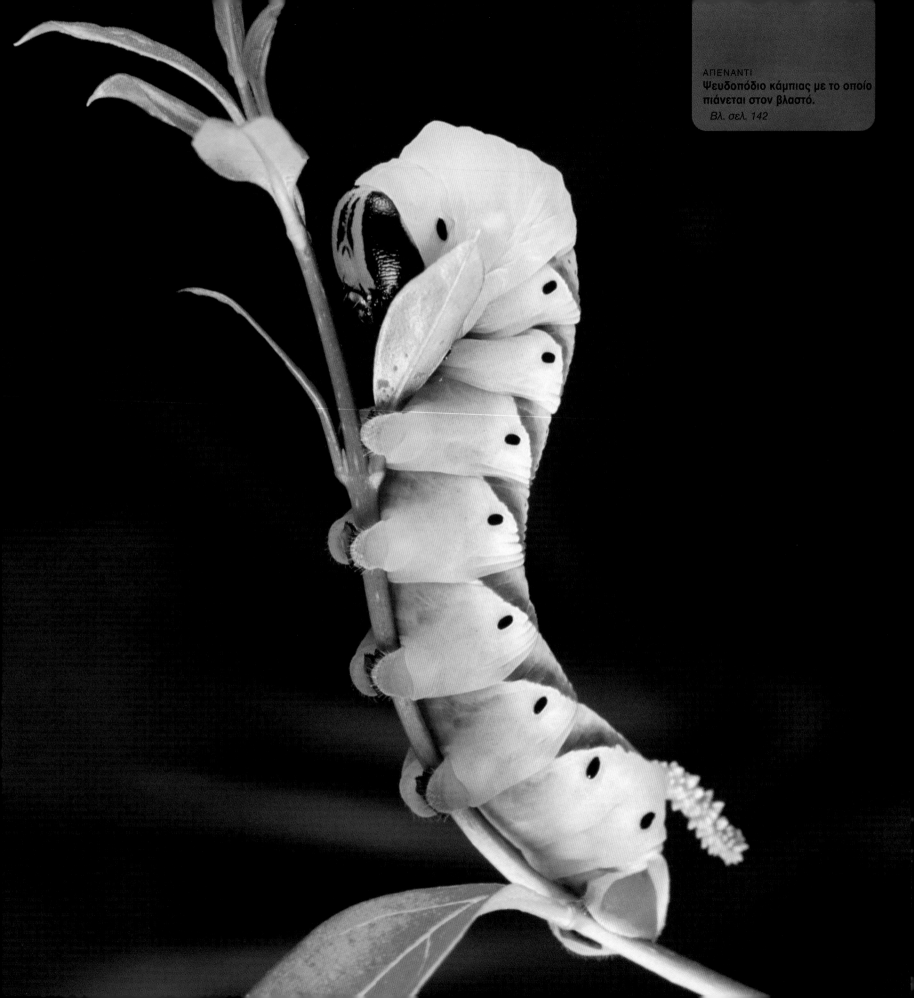

ΑΠΕΝΑΝΤΙ
Ψευδοπόδιο κάμπιας με το οποίο πιάνεται στον βλαστό.
Βλ. σελ. 142

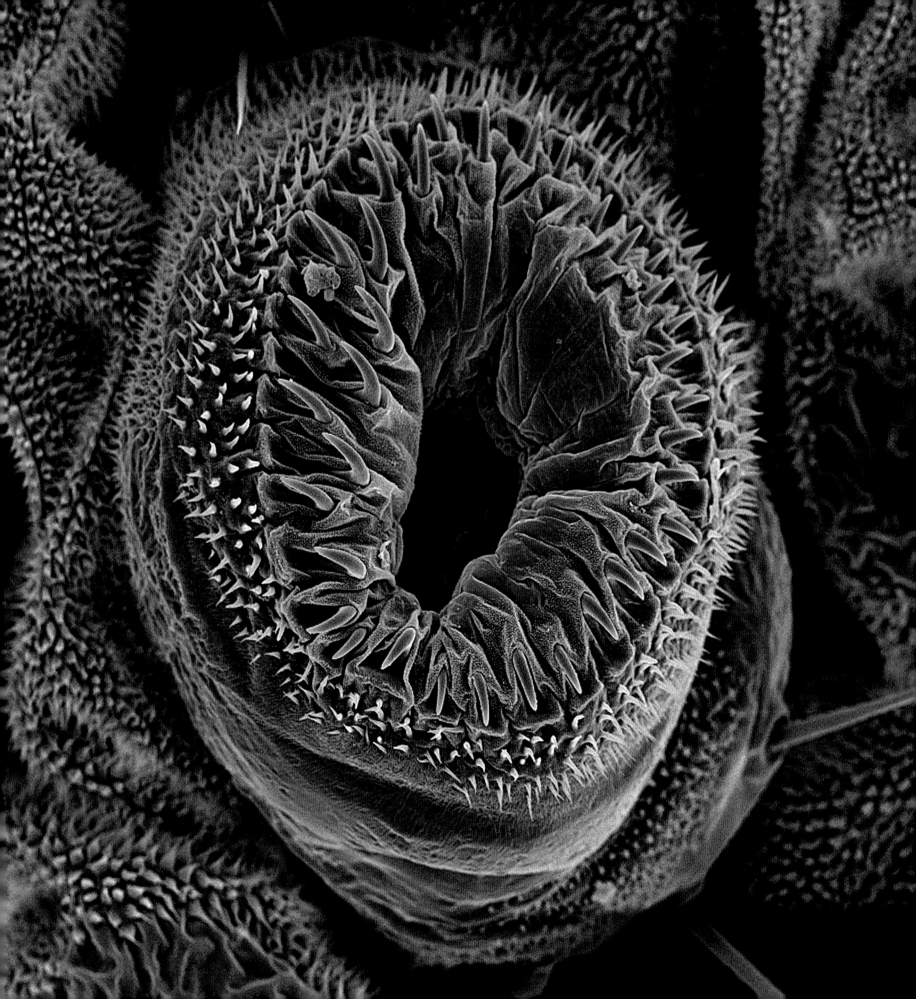

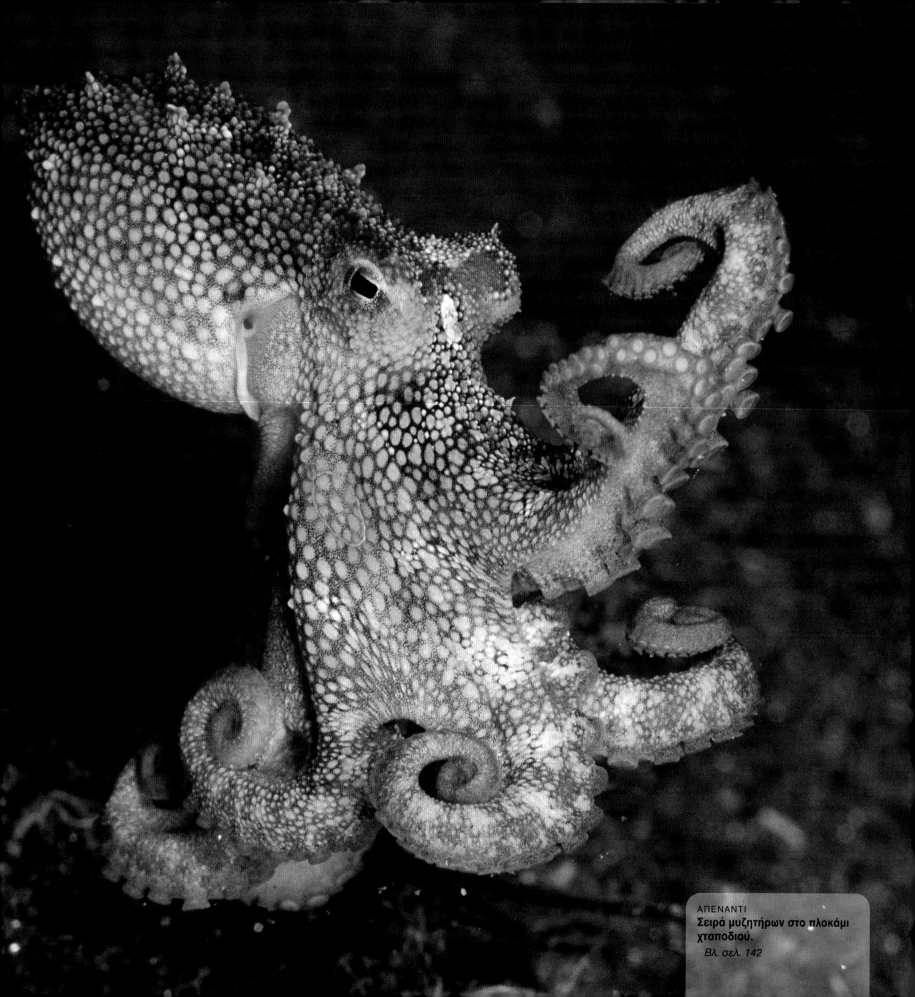

ΑΠΕΝΑΝΤΙ
Σειρά μυζητήρων στο πλοκάμι χταποδιού.
Βλ. σελ. 142

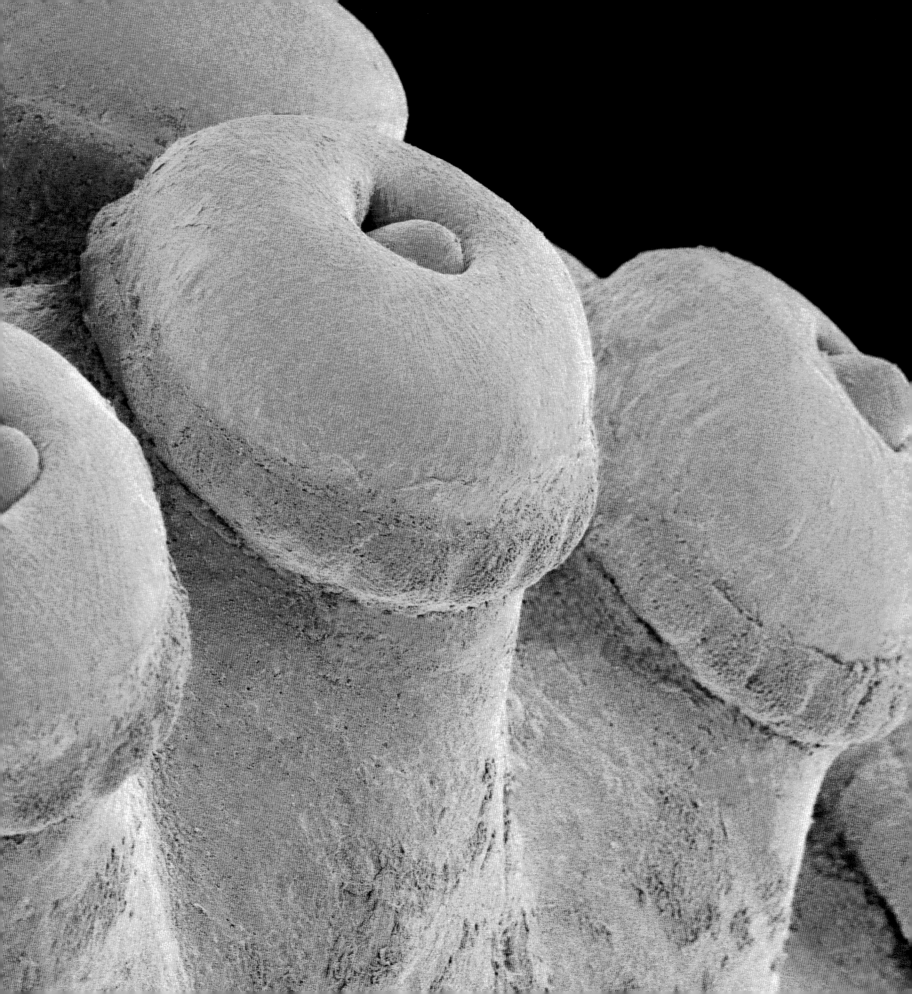

ΑΠΕΝΑΝΤΙ
**Κεφάλι και μυζητήρας
αρσενικού δίστομου
σχιστοσώματος.**
Βλ. σελ. 143

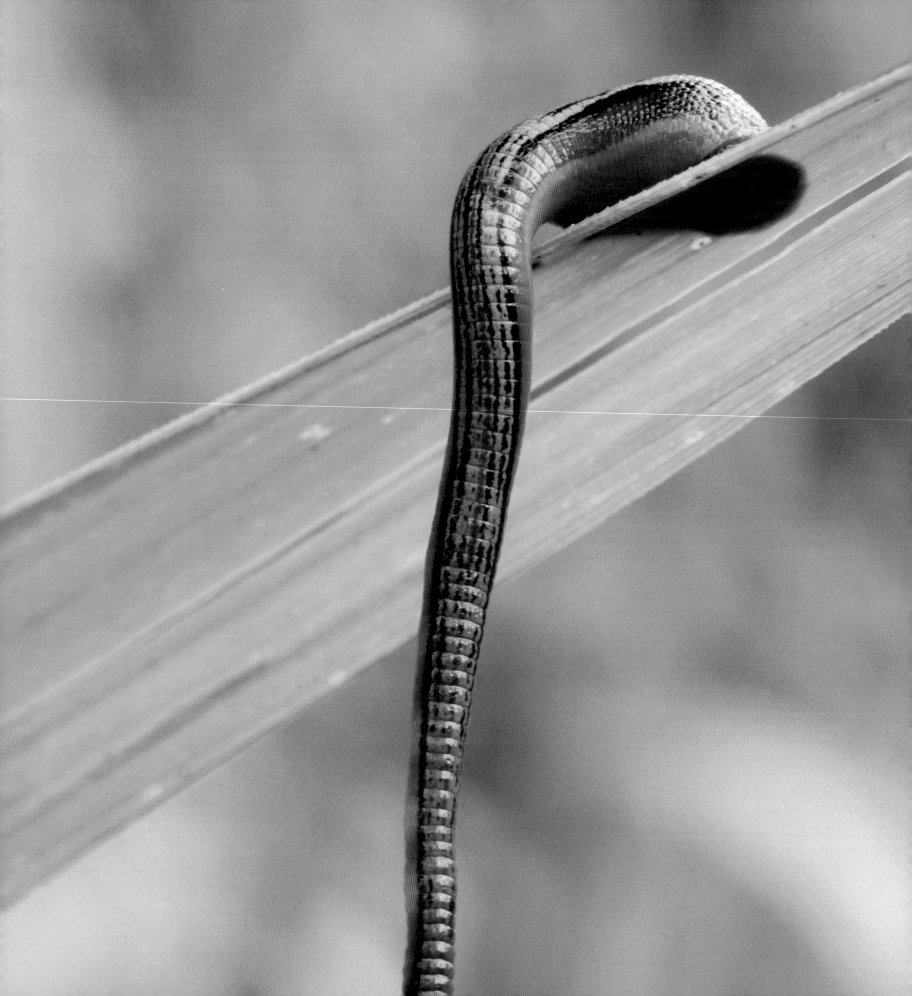

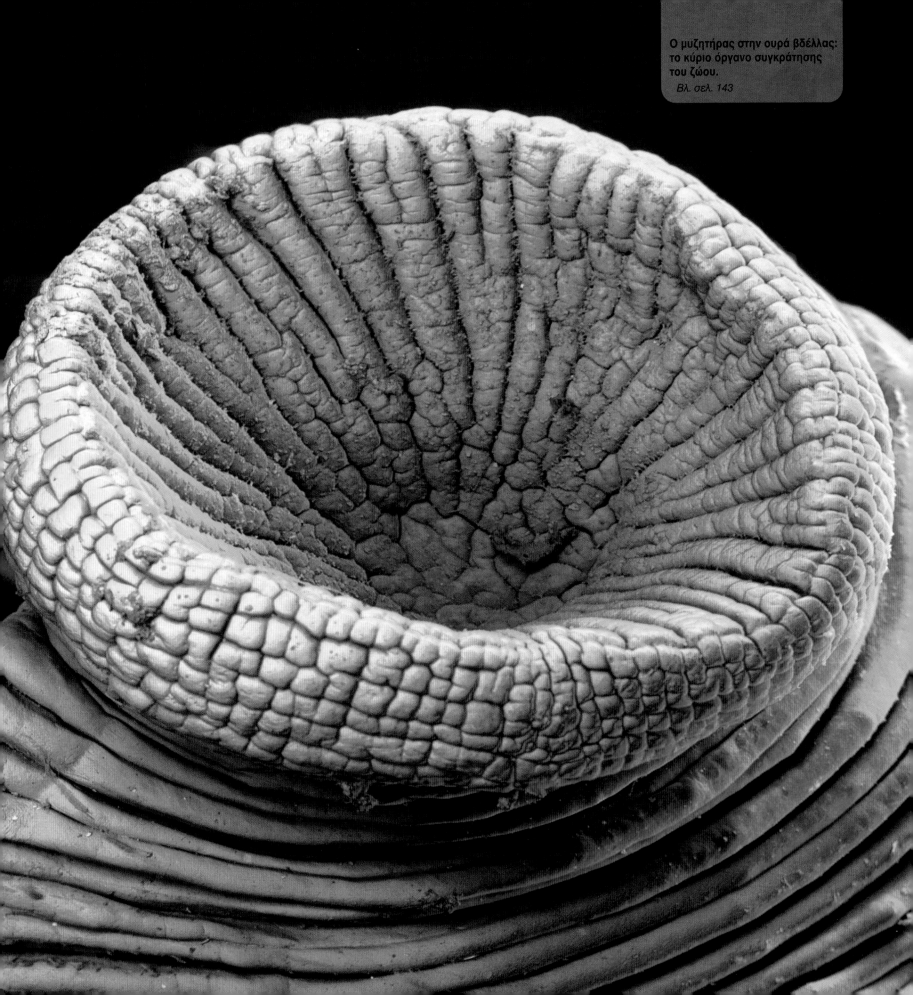

Ο μυζητήρας στην ουρά βδέλλας:
το κύριο όργανο συγκράτησης
του ζώου.
Βλ. σελ. 143

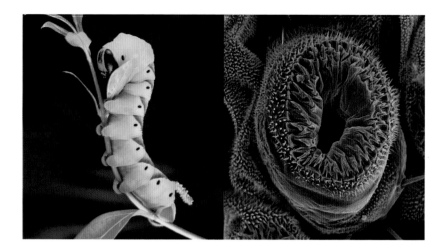

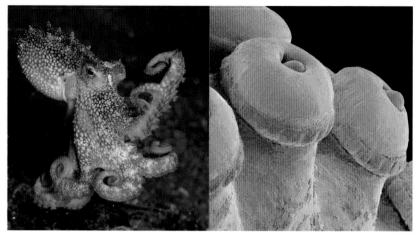

Το μυζητικό, οπλισμένο με δόντια σαν αγκίστρια στόμα κάποιου εξωγήινου σκουληκιού ανοίγει πεινασμένο, έτοιμο να πάρει το επόμενο γεύμα του. Και όμως, αυτό το τρήμα είναι απλώς το άδειο εσωτερικό ενός στρογγυλού ποδιού κάμπιας και τα νύχια το εργαλείο για να κρατιέται πάνω στα φύλλα.

Οι κάμπιες των σκόρων και των πεταλού- δων έχουν ποικίλα άκρα με τα οποία προσκολ- λώνται στα φύλλα. Παρότι η κάμπια φαίνεται πως είναι μια απλή κυλινδρική, τροφοληπτική μηχανή, εμφανίζει ήδη τα συνήθη μέρη του σώματος του εντόμου: κεφάλι, θώρακα και κοιλιά. Κάθε ένας από τους τρεις θωρακικούς σωμίτες (τα μέρη του θώρακα) φέρει ένα ζεύγος κοντών, άκαμπτων, πραγματικών ποδιών που μοιάζουν με αρπάγες. Αργότερα, τα πόδια αυτά μεταμορφώνονται στα αρθρωτά πόδια του ακμαίου εντόμου, αλλά στο στάδιο της κάμπιας χρησιμοποιούνται κυρίως για να προσκολλώνται στο φύλλο, έτσι ώστε να διευκολύνεται η λειτουργία των μασητικών τους γνάθων. Από τα δέκα κοιλια- κά μεταμερή της κάμπιας, μόνο τα τρία ή τα τέσσερα έχουν ζεύγη ποδιών όμοιων με μαλακούς μυζητήρες, τα ψευδοπόδια.

Υπάρχει επίσης ένα ζεύγος στο τελευταίο μεταμερές που λέγονται λαβίδες. Αυτά τα κοντόχοντρα πόδια είναι τα κύρια άκρα του εντόμου στο στάδιο της προνύμφης, διότι στηρίζουν τον κορμό της κάμπιας και την αγκιστρώνουν στον βλαστό ή στο φύλλο με το οποίο τρέφεται. Η σχετικά απλή δομή των ψευδοποδίων σε συνδυασμό με το εύκαμπτο σαν σκουληκιού σώμα της προνύμφης (στην εικόνα φαίνεται καθαρά το πτυχωτό της δέρμα) αρκεί για να ελίσσεται το ζώο πάνω στο φυτό. Παρά τον σημαντικό τους ρόλο, κατά τη μεταμόρφωση της νύμφης σε ακμαίο έντομο τα ψευδοπόδια εξαφανίζονται.

Κάποια στιγμή κατά τη διάρκεια της μακράς εξελικτικής ιστορίας των έμβιων οργανισμών, απλά ζώα έγιναν πιο σύνθετα, επαναλαμβάνοντας τον εαυτό τους και αναπτύσσοντας πολλαπλά μέρη του σώματος. Με τον καιρό μερικά από αυτά παρέμειναν πόδια, άλλα εξελίχθηκαν σε δομές κεραιών, οργάνων αφής, πτερύγων και κέρκων, άλλα εξαφανίστηκαν εντελώς. Τα ψευδοπόδια της κάμπιας είναι εμβρυϊκός απόηχος μιας εποχής κατά την οποία τα μεταμερή του σώματος είχαν αποφύσεις.

Αυτή η σειρά μαλακών ανοιχτόχρωμων λοφίσκων βαλμένων στη σειρά πάνω σε κοντά στελέχη μοιάζουν με γλυκά φούρνου. Και πράγματι είναι κάτι το φαγώσιμο, αλλά δεν έχουν γλυκιά γεύση, αφού εδώ εικονίζονται οι μυζητήρες στα πλοκάμια του χταποδιού.

Μια διπλή σειρά μυζητήρων κοσμεί καθένα από τα οκτώ πλοκάμια του χταποδιού, τα οποία όμως διαφέρουν από τα συλληπτήρια πλοκάμια (tentacles) του καλαμαριού ή της σουπιάς που είναι μακρύτερα και έχουν μυζητήρες μόνο στα άκρα τους. Ο μυζητήρας του χταποδιού είναι ένα μαλακό, εύκαμπτο, μυώδες εξάρτημα που σε αντίθεση με τους πριονοειδείς μυζητήρες του καλαμαριού δεν είναι εξοπλισμένος με άγκιστρα, αλλά δίνουν στο χταπόδι τη δυνατότητα να κινείται πολύ επιδέξια στα βράχια και ανάμεσα στα θαλάσσια φυτά, καθώς και να συλλαμβάνει τη λεία του.

Ο μηχανισμός κάθε μυζητήρα είναι πολύ πιο περίπλοκος από της βεντούζας που έχουν στην άκρη τους τα παιδικά βελάκια. Κάθε μυζητήρας μπορεί και ασκεί τη δική του δύναμη αναρρόφησης ή να αδρανεί, ούτως ώστε το ζώο να προσαρμόζεται σε άπειρα είδη αντικειμένων ή επιφανειών.

Ο μυζητήρας αποτελείται από δύο κυρίως μέρη, έναν μαλακό δακτύλιο μυϊκού ιστού που λέγεται χωνί (infundibulum) και την κοτύλη ή κάλυκα (acetabulum). Ο δακτύλιος αυτός είναι τόσο εύκαμπτος που εφάπτεται απόλυτα σε κάθε επιφάνεια, τα δε τοιχώματα της κοτύλης ή του κάλυκα στο εσωτερικό του είναι επίσης από μυικό ιστό. Όταν ο μυζητήρας αγγίζει μια επιφάνεια, οι ακτινωτοί μύες στο εσωτερικό του «χωνιού» συστέλλονται, διευρύνοντας την εσωτερική κοιλότητα με αποτέλεσμα τη μείωση της πίεσης του νερού μέσα σε αυτό τον χώρο, την εμφάνιση αναρροφητικής δύναμης και την προσκόλληση του μυζητήρα σε οποιαδήποτε επιφάνεια. Κυκλικοί μύες εντός του μυζητήρα συστέλλονται για να επαναφέρουν την αρχική πίεση και ο μυζητήρας ξεκολλά.

Τα χταπόδια είναι τα πιο έξυπνα ασπόνδυ- λα που γνωρίζουμε, ικανά να μάθουν περίπλο- κες λειτουργίες, όπως να κινούνται σε λαβύρινθους ή να ανοίγουν βάζα με βιδωτό καπάκι. Παρ' όλα αυτά ο εγκέφαλός τους δεν είναι αρκετά σύνθετος ώστε να διατηρεί μια νοητική εικόνα του κόσμου που τα περιβάλλει ή αυτού που έχει πιαστεί στα πλοκάμια τους με την άκρως ανεπτυγμένη αίσθηση αφής.

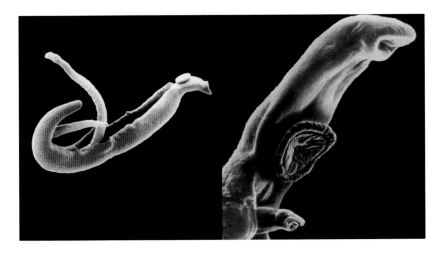

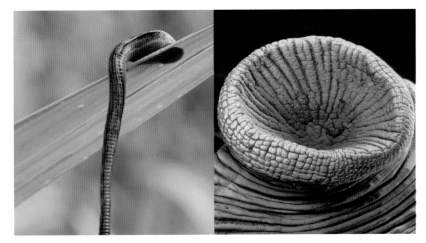

Εδώ έχουμε την ενσάρκωση του πιο αλλόκοτου ζευγαριού της θάλασσας: δύο τρηματώδεις σκώληκες (δίστομα) που ζουν κυριολεκτικά ο ένας μέσα στο άλλον σε όλη τη διάρκεια της ενήλικης ζωής τους. Η μικρότερη προεξοχή (η πορτοκαλιά στη δεξιά εικόνα) είναι το κεφάλι ενός σχιστοσώματος που προβάλλει έξω από τη λεγόμενη γυναικοφόρο αύλακα στο κάτω μέρος του μεγαλύτερου σε μέγεθος αρσενικού. Η στενή αυτή επαφή επιτρέπει τη γονιμοποίηση των πολυάριθμων αυγών που εναποτίθενται κατά τη διάρκεια του παρασιτικού βίου αυτού του ζώου στο ανθρώπινο ήπαρ, προκαλώντας τη λεγόμενη σχιστοσωμίαση.

Η σχιστοσωμίαση είναι συνήθης λοίμωξη στην Αφρική, την Ασία και τη Νότια Αμερική, ενδιάμεσος δε ξενιστής των παράσιτων που την προκαλούν είναι υδρόβια σαλιγκάρια. Αυγά τα οποία αποβάλλονται μαζί με τα ανθρώπινα ούρα ή με την κοπριά ζώων εκκολάπτονται στο νερό και μεταμορφώνονται σε μικροσκοπικές νύμφες, τα μειράκια, που στη συνέχεια ψάχνουν και χρησιμοποιούν σαν ενδιάμεσο ξενιστή ένα είδος σαλιγκαριού. Εδώ ζουν κατά το πρώτο στάδιο του βιολογικού τους κύκλου τρεφόμενα από αυτά και

παράγοντας νέες προνύμφες του παράσιτου, τα κερκάρια. Τα κερκάρια αντιδρούν σε αναταράξεις ή στη σκιά που ρίχνει κάποιο ζώο ή άνθρωπος που περπατά ή κολυμπά στα πέριξ, βγαίνοντας από τους δευτερεύοντες ξενιστές τους, τα σαλιγκάρια. Όπως τα μειράκια, έτσι και τα κερκάρια είναι κολυμβητές που ψάχνουν να διεισδύσουν σε ανθρώπινο δέρμα. Διεισδύουν συνήθως από το πόδι και αποβάλλουν τον διχαλωτό κέρκο τους. Ο μικροσκοπικός οργανισμός εισχωρεί στα επιφανειακά αγγεία του δέρματος και μέσα από αυτά, μετά περίπου δέκα ημέρας, φτάνει στην ουροδόχο κύστη, τη χολή, τα έντερα ή το ορθό. Με τους μυζητήρες του προσκολλάται στα τοιχώματα ενός αγγείου και αρχίζει να τρέφεται με αιμοσφαίρια. Τα παράσιτα αυτά σε 45 περίπου ημέρες είναι πλέον ενήλικα οπότε αρχίζουν να γεννούν 300 έως 3.000 αυγά την ημέρα.

Από σχιστοσωμίαση υποφέρουν 200 εκατομμύρια άτομα στον κόσμο. Τα συμπτώματα (πόνοι στο πεπτικό σύστημα, διάρροια, κόπωση, πυρετός) δεν προκαλούνται από το παράσιτο αλλά από τη χρόνια αντίδραση του ανοσοποιητικού συστήματος στα αυγά που δεν αποβάλλονται και τα οποία εγκαθίστανται στα πεπτικά όργανα.

Είναι προφανές πως αυτή η συνεστραμμένη, συρρικνωμένη κοτύλη δεν μπορεί παρά να εξυπηρετεί μόνο μία λειτουργία: αμέσως διακρίνουμε πως πρόκειται για μυζητήρα και όργανο προσκόλλησης. Η δυνατότητα προσκόλλησης είναι ζωτικής σημασίας για τη βδέλλα, διότι μόνο έτσι μπορεί να μένει σταθερά πάνω στη λεία της.

Οι βδέλλες ανήκουν στους δακτυλιοσκώληκες, ζώα συγγενή με τους γεωσκώληκες που έχουν σώμα μακρουλό αποτελούμενο από πολλούς δακτύλιους (μεταμερή). Πολλά είδη έχουν προσαρμοστεί στη ζωή στο γλυκό νερό, αλλά στα υγρά τροπικά δάση ζουν στα φύλλα των δέντρων και σε πιο ξηρά ενδιαιτήματα στο υγρό έδαφος. Όλες οι βδέλλες αποτελούνται από 34 πανομοιότυπα μεταμερή, με εξαίρεση τους μυζητήρες στα δύο άκρα τους. Ο μικρός στο κεφάλι συγκρατεί το στοματικό μόριο στη θέση του όσο οι γνάθοι (ή σε ορισμένα άλλα είδη ένας αιχμηρός στύλος) διατρυπούν το δέρμα και απομυζούν το αίμα· ο δεύτερος μυζητήρας στο πίσω άκρο του σώματός της είναι πολύ μεγαλύτερος και ισχυρότερος, διότι με αυτόν

αγκιστρώνεται ολόκληρη η βδέλλα στο θύμα της ακόμα και όταν το αίμα που απομυζά μεγαλώνει το σώμα της κάμποσες φορές.

Διαφορετικές βδέλλες επιτίθενται σε διαφορετικά θηράματα: ασπόνδυλα (σκουλήκια και άλλες βδέλλες), ψάρια, πουλιά, αμφίβια και θηλαστικά. Η ιατρική βδέλλα που εικονίζεται εδώ ειδικεύεται στα θηλαστικά και ιδίως στα ζώα που εκτρέφει ο άνθρωπος, και έτσι ήρθε σε επαφή και με τον άνθρωπο.

Παρά τη βδελυγμία που προκαλεί συχνά η ιδέα του αιμοβόρου, οι βδέλλες χρησιμοποιούνται στην ιατρική ως μέσον αφαίμαξης εδώ και τουλάχιστον δύο χιλιετίες. Αρχικά, η πρακτική αυτή αποσκοπούσε στην εξασθένιση των συμπτωμάτων με την αφαίρεση του «κακού» αίματος. Η επιθυμία του κόσμου να θεραπευτεί με αυτόν τον τρόπο είχε πάρει τέτοιες διαστάσεις ώστε στο αποκορύφωμα αυτής της πρακτικής στα μέσα του 19ου αιώνα οι βδέλλες ήταν είδος σε ανεπάρκεια. Κατά περίεργο τρόπο η αφαίμαξη με βδέλλες επέστρεψε: τα περίεργα αυτά ζώα εξακολουθούν να χρησιμοποιούνται από τη σύγχρονη ιατρική, ειδικά στην αποκατάσταση τραυμάτων πλαστικής χειρουργικής, καθώς περιορίζουν τα οιδήματα και τους μώλωπες.

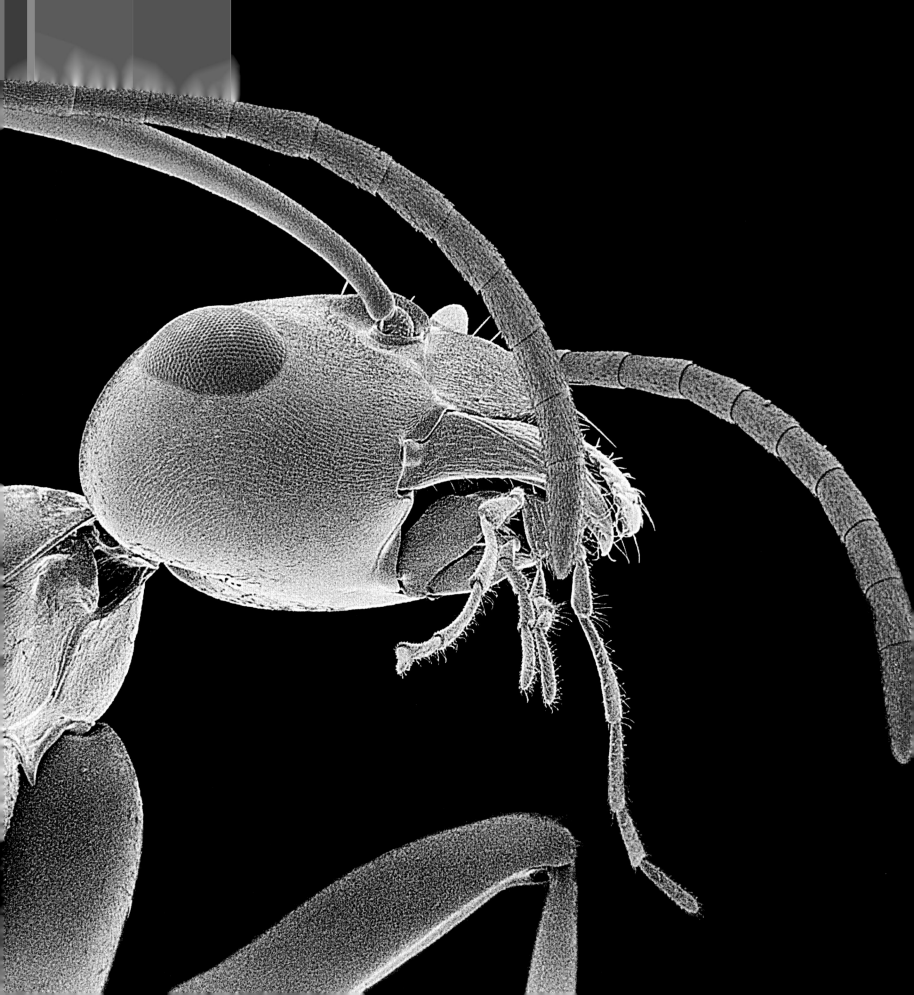

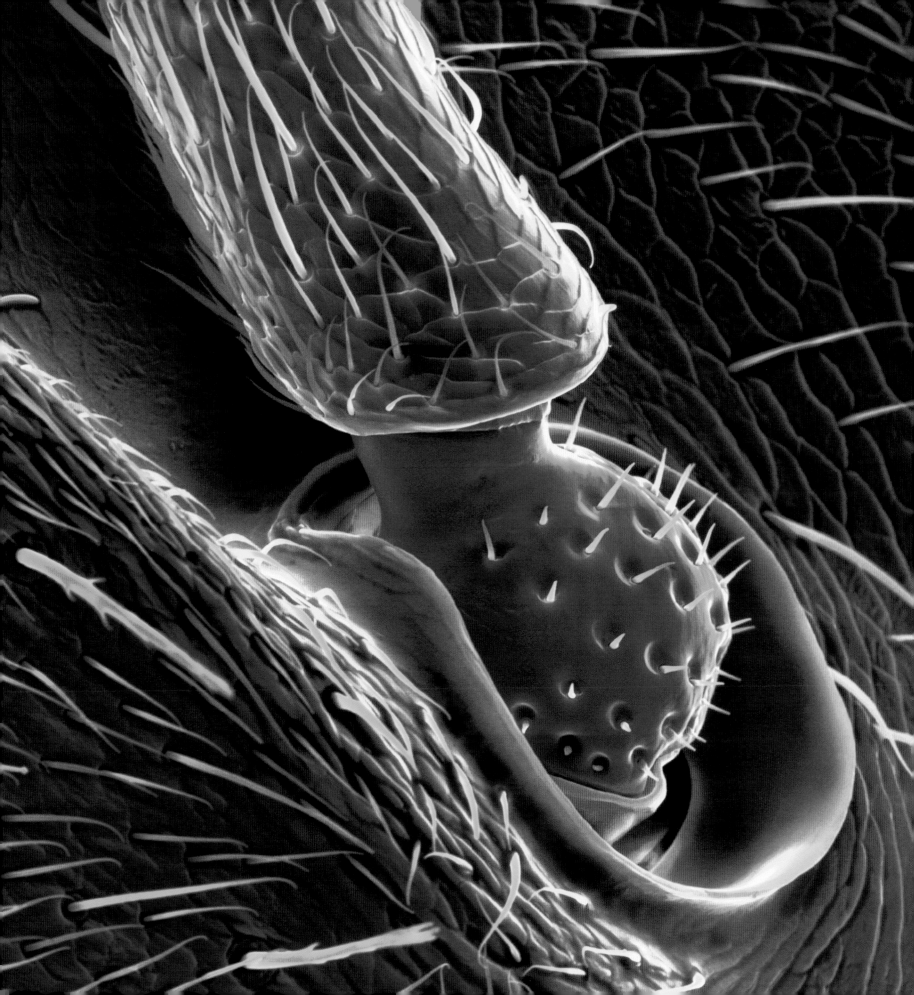

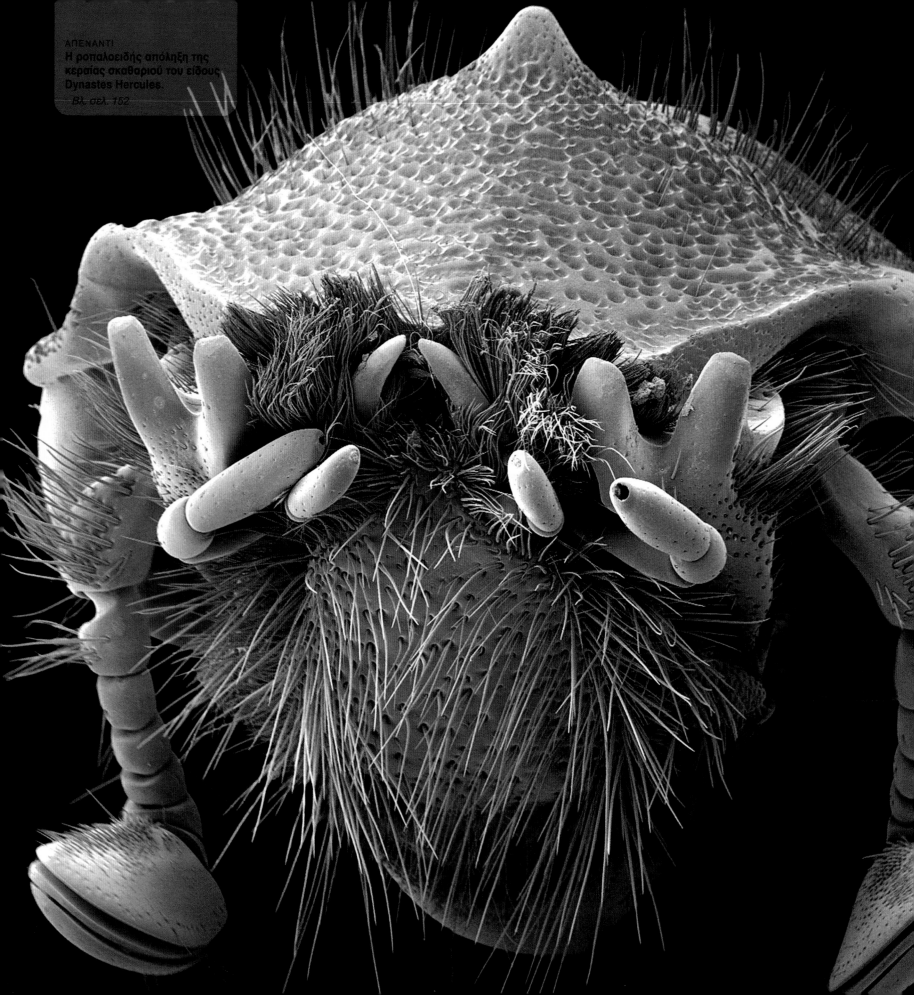

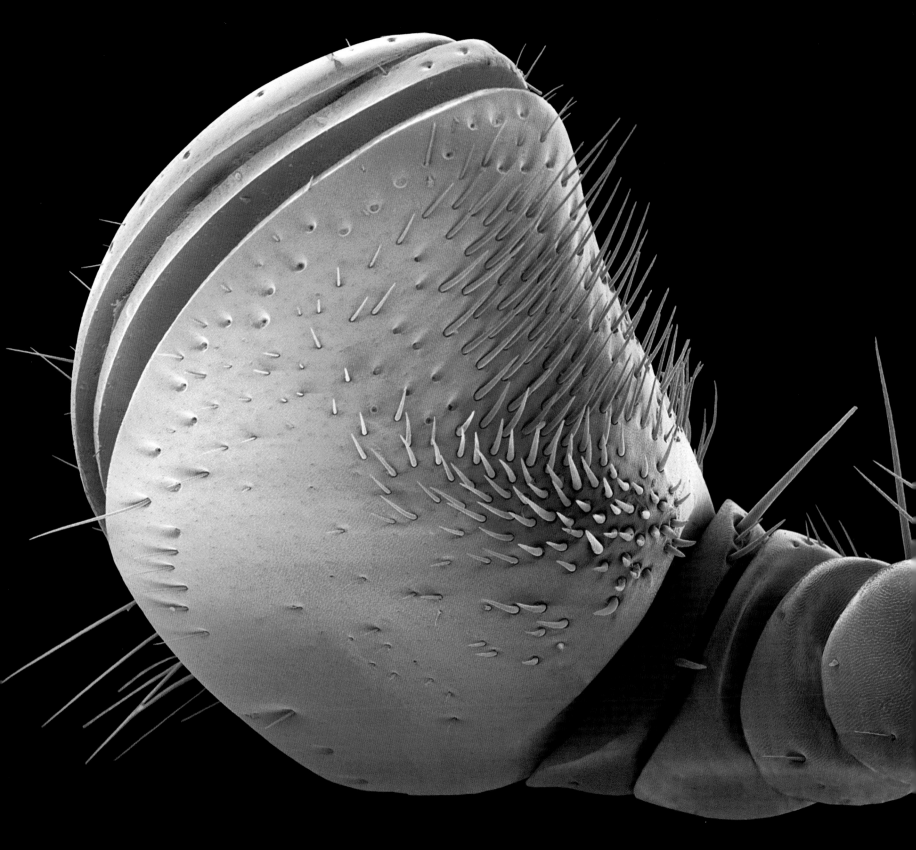

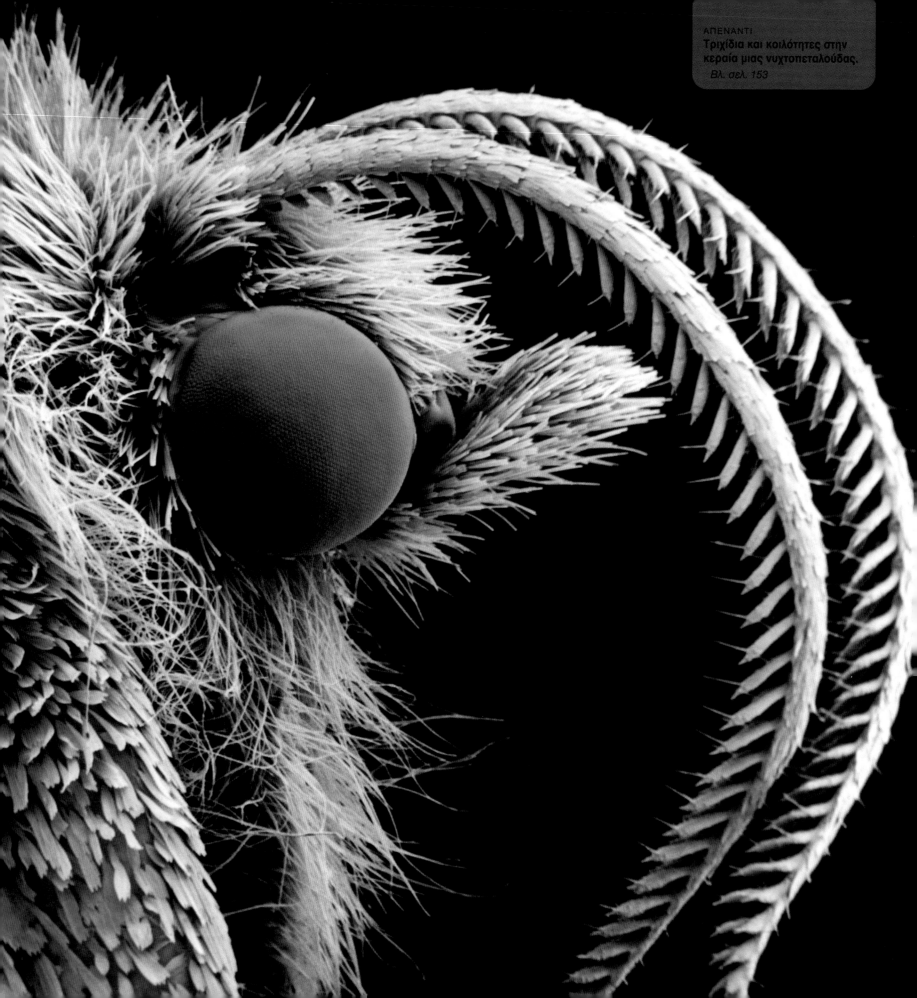

ΑΠΕΝΑΝΤΙ
Τριχίδια και κοιλότητες στην κεραία μιας νυχτοπεταλούδας.
Βλ. σελ. 153

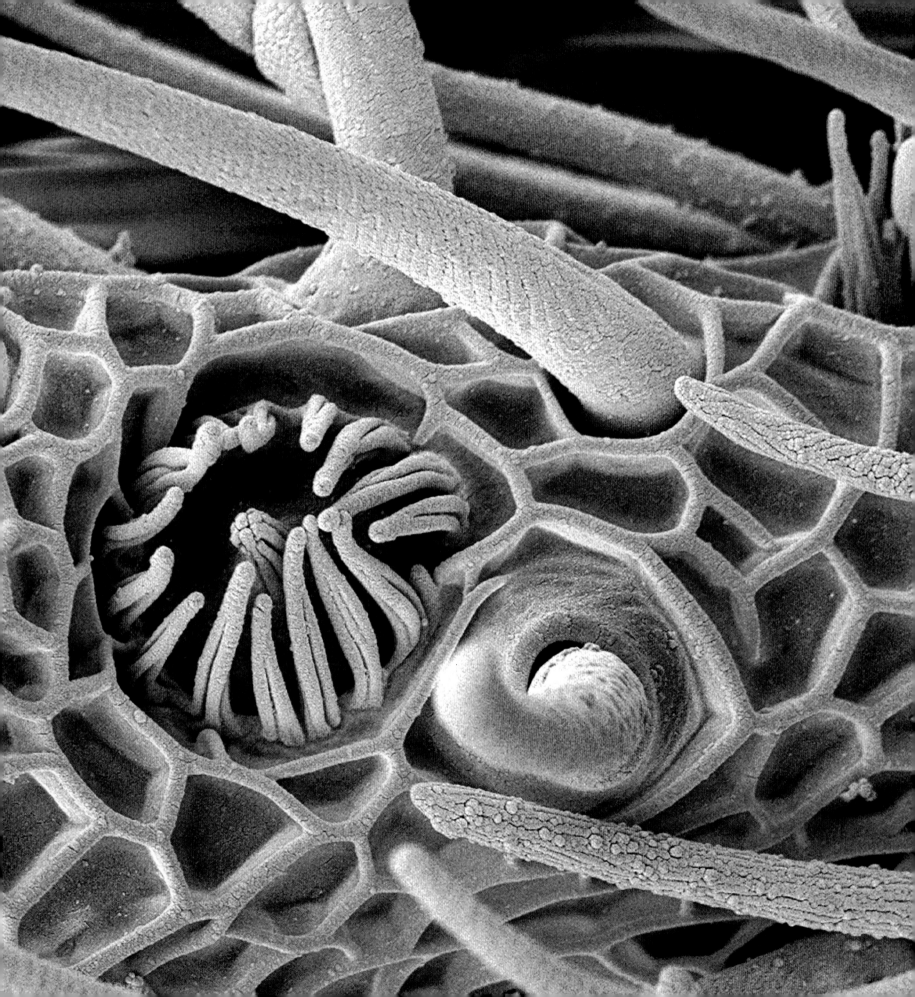

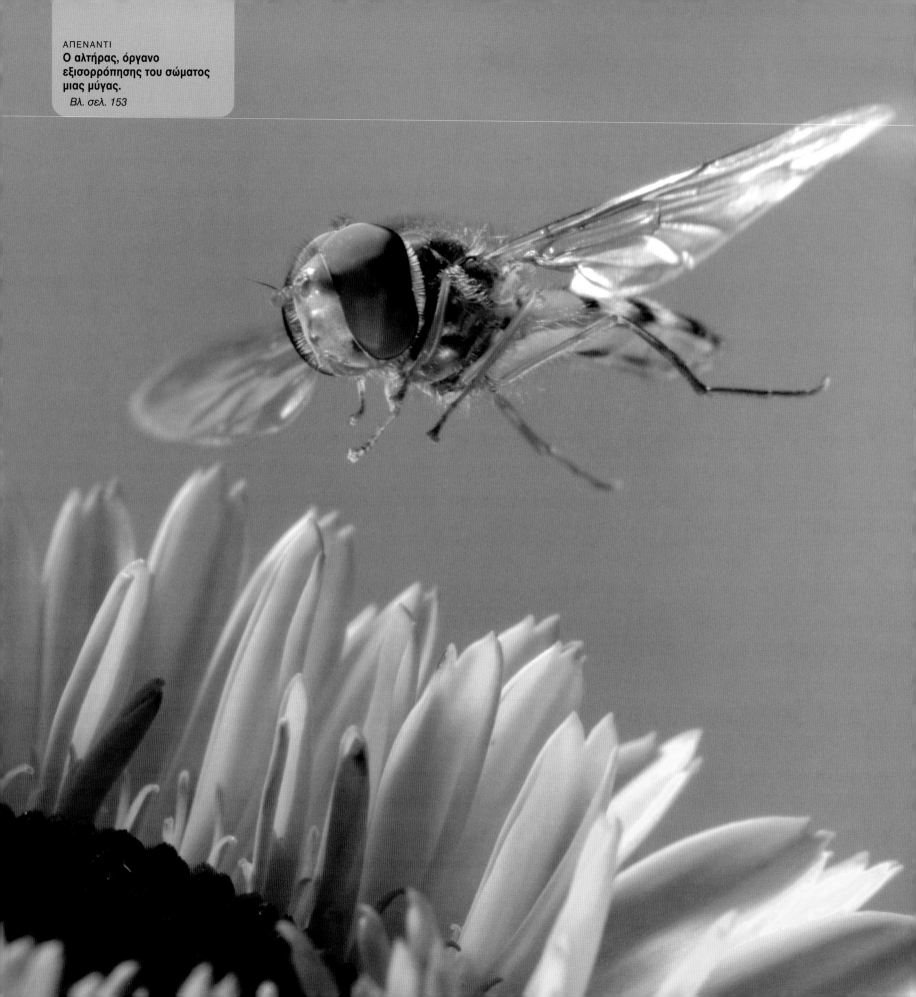

ΑΠΕΝΑΝΤΙ
Ο αλτήρας, όργανο εξισορρόπησης του σώματος μιας μύγας.
Βλ. σελ. 153

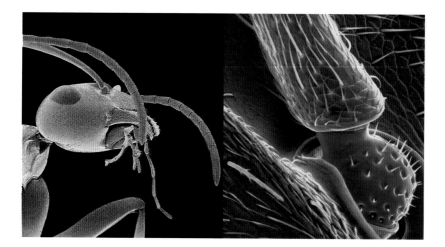

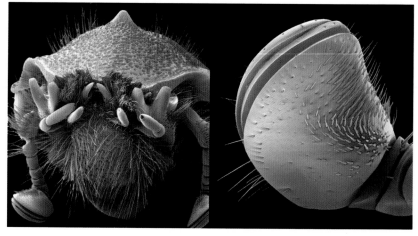

Ο τύπος της άρθρωσης που περιλαμβάνει κεφαλή (σφαιρικό στην άκρη οστό) και κοτύλη έχει εμφανιστεί πολλές φορές στη φύση. Ίσως οι πιο γνωστές τέτοιες αρθρώσεις είναι των ισχίων και των ώμων στα θηλαστικά, που στα πουλιά έχουν μετασχηματιστεί σε αρθρώσεις των ποδιών και των φτερών. Η επιτυχία αυτής της άρθρωσης οφείλεται στην ελεύθερη περιστροφική κίνηση που επιτρέπει στο άκρο να περιστρέφεται ανεμπόδιστα γύρω από κάθε άξονα. Στον κόσμο των ασπόνδυλων οργανισμών αυτού του είδους οι αρθρώσεις απαντώνται εκεί όπου συνδέονται τα πόδια με τον κορμό και, ακόμα πιο σημαντικό, οι κεραίες με το κεφάλι.

Οι κεραίες των εντόμων είναι άκρως σημαντικά αισθητήρια, που χρησιμοποιούνται για την ανίχνευση οσμών χημικών ουσιών, παλμών και κινήσεων του αέρα. Στα μυρμήγκια είναι επίσης όργανα επικοινωνίας μέσω της αφής: τα μέλη μιας αποικίας αγγίζονται και χαϊδεύονται με τις κεραίες για να αντιληφθούν διά της αφής και της οσμής με ποιον έχουν να κάνουν,

Οι κεραίες των αρσενικών μυρμηγκιών (κηφήνων) έχουν συνήθως 12 άρθρα, ενώ των θηλυκών (της βασίλισσας και των εργατριών) 13 άρθρα. Το πρώτο άρθρο, το σκήπος ή σκάπος, είναι μακρύ και κυλινδρικό έχοντας συχνά μήκος όσο όλα τα άλλα άρθρα μαζί. Τη σφαίρα στη βάση του σκάπου υποδέχεται η κοτύλη στο μέτωπο της κεφαλής. Ο σκάπος συνδέεται με κωνικό τμήμα που αποκαλείται μίσχος ή ποδίσκος (pedicel) και ακολουθούν τα βραχύτερα άρθρα που όλα μαζί αποτελούν το εύκαμπτο τμήμα της κεραίας, το μαστίγιο (flagellum). Όπως σε όλα τα έντομα έτσι και στα μυρμήγκια μόνο τα δύο πρώτα άρθρα, ο σκήπος και ο ποδίσκος, έχουν μύες που ελέγχουν την κίνηση τους.

Στα μυρμήγκια ο μακρύς σκήπος σχηματίζει με τα υπόλοιπα άρθρα γωνία περίπου 90 μοιρών που δίνει στην κεραία τη χαρακτηριστική τοξωτή μορφή και τη δυνατότητα πλήθους επιδέξιων ελιγμών.

Δεν θα μπορούσε αυτό το αντικείμενο με το στέλεχος που αρθρώνεται τόσο εύκαμπτα με μια τόσο εντυπωσιακή κεφαλή, αποτελούμενη από ελάσματα και από αεροδυναμικές καρφίτσες να είναι ένα νέο, υψηλής τεχνολογίας μπαστούνι του γκολφ; Η λάμψη του μοιάζει σχεδόν μεταλλική, ενώ καθώς συνδυάζει οξείες γωνίες και βολβώδεις λοβούς θυμίζει ρομπότ. Η λιτή και γερή κατασκευή του όμως μεταμφιέζει τη λεπτεπίλεπτη λειτουργία του, διότι εδώ έχουμε να κάνουμε με την κεραία ενός σκαθαριού.

Το σκαθάρι του είδους Δυνάστης Ηρακλής (Dynastes Hercules) ανήκει σε μια πολυπληθή κατηγορία, τα Κολεόπτερα, που απαντώνται σε όλο τον κόσμο. Τρέφονται με φυτικές ύλες και, μολονότι ορισμένα είναι βλαβερά για τη φυτοκομία, καθώς μασουλάνε κηπευτικά, τα περισσότερα τρέφονται με φυτικές ουσίες σε αποσύνθεση, σάπιο ξύλο ή φυτά που έχουν ήδη φαγωθεί και αποβληθεί από χορτοφάγα.

Χαρακτηριστικές είναι οι όμοιες με μπαστούνια κεραίες τους, των οποίων τα τελευταία τρία έως πέντε άρθρα έχουν προεκταθεί σχηματίζοντας πεπλατυσμένα ελάσματα (ελασματοειδείς κεραίες). Το μέγεθος των ελασμάτων αυτών διαφέρει από είδος σε είδος, συνήθως όμως είναι μεγαλύτερο στα αρσενικά, πράγμα που σημαίνει πως μία από τις λειτουργίες των κεραιών είναι η ανίχνευση θηλυκών μέσω της οσμής των φερομονών που αυτά αναδίδουν.

Αυτό ήταν και το πόρισμα μελετών των «αισθητιδίων» (sensillae), δηλαδή μικροσκοπικών προεκβολών αισθητήριων οργάνων, χημιϋποδοχέων που καλύπτουν τα άρθρα των κεραιών. Ειδικοί τύποι χημιϋποδοχέων απαντώνται μόνο σε ελαφρές εντόμες στην εσωτερική πλευρά των ελασμάτων, είναι δε πολύ περισσότεροι στα αρσενικά από ό,τι στα θηλυκά. Ο ηλεκτρονικός έλεγχος μεμονωμένων αισθητιδίων απέδειξε επίσης ότι, αν και ορισμένα προσλαμβάνουν ερεθίσματα προερχόμενα από φυτικές χημικές ουσίες (τα σκαθάρια μυρίζουν την τροφή τους), άλλα προσλαμβάνουν μόνο τις πολύ ειδικές αερομεταφερόμενες χημικές ουσίες που παράγουν τα θηλυκά έντομα του είδους, αντιδρώντας σε απειροελάχιστες συγκεντρώσεις: λίγα μόνο μόρια αρκούν για να πυροδοτήσουν την αντίδραση του αρσενικού στο νευρικό ερέθισμα.

ΔΕΞΙΑ
Το μακρύ πρώτο άρθρο σε συνδυασμό με το πολυαρθρωτό μαστίγιο καθιστά την κεραία το σημαντικότερο όργανο αφής του εντόμου.

ΑΡΙΣΤΕΡΑ
Η κεραία του μυρμηγκιού συνδέεται με το κεφάλι μέσω μιας άρθρωσης του τύπου κεφαλή-κοτύλη που της εξασφαλίζει ευρύτητα κινήσεων.

ΔΕΞΙΑ
Το μπαστούνι της κεραίας ενός Ηρακλή περιέχει χημιϋποδοχείς που βοηθούν το τεράστιο αυτό σκαθάρι να εντοπίζει την τροφή του και τα θηλυκά του είδους του με την οσμή.

ΑΡΙΣΤΕΡΑ
Μολονότι σημαντικά αισθητήρια όργανα, οι κεραίες μπορεί να μαζευτούν κάτω από το κεφάλι όταν το σκαθάρι σκαλίζει το χώμα ψάχνοντας ρίζες και σάπια φύλλα.

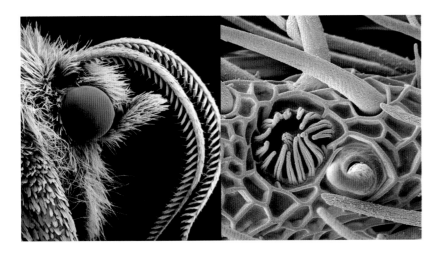

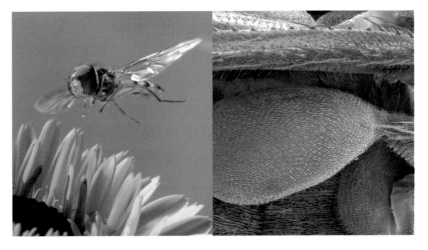

Οι μαλακοί στην όψη αυτοί βλαστοί που σχηματίζουν δακτύλιο γύρω από μια σκοτεινή οπή θα μπορούσε να είναι μια θαλάσσια ανεμώνη εγκατεστημένη πάνω σε ένα δαντελωτό κοράλλι. Είναι όμως απλώς η επιφάνεια του κυλινδρικού άρθρου της κεραίας μιας νυχτοπεταλούδας, όπου οι τρίχες, τα σύνθετα φύλλα και τα λακκάκια αποτελούν μέρος του περίπλοκου αισθητήριου συστήματος που χρησιμοποιεί ο σκόρος για να χαράζει την πορεία του στον κόσμο.

Οι σκόροι έχουν άκρως ανεπτυγμένες κεραίες που είναι κάθε άλλο παρά απλώς μηχανικά αισθητήρια όργανα αφής. Οι τρίχες, οι σκληρές ίνες, οι κοιλότητες και οι οπές είναι διαφορετικά αισθητήρια νεύρα, κάθε δε είδος σκόρου έχει τον ιδιαίτερο, μοναδικό συνδυασμό τέτοιων δομών, ανάλογα με τις ιδιαίτερες ανάγκες του.

Έξι ή επτά διαφορετικοί τύποι αισθητήριων δομών (sensillae) έχουν εντοπιστεί σχεδόν σε όλες τις κεραίες σκόρων που έχουν μελετηθεί. Κάθε τέτοια δομή έχει το χαρακτηριστικό της εξωτερικό σχήμα και το εσωτερικό νευρικό σύστημα. Η διάταξη της εικόνας είναι ένας φράχτης από προεκβολές που περιβάλλουν το σημείο από όπου φύονται τα τριχίδια που χρησιμεύουν στην ανίχνευση οσμών, δηλαδή νέκταρος και φυτικών θρεπτικών ουσιών για τις προνύμφες. Ο πασσαλόπηκτος αυτός δακτύλιος μετριάζει την κίνηση του αέρα πάνω από τους χημιϋποδοχείς, επιτρέποντας λεπτομερέστερη ανάλυση.

Οι συνηθέστερες προεκβολές είναι αυτές που μοιάζουν με τούφες μακριών μαλλιών (οι ροζ της εικόνας) και καλύπτουν το μεγαλύτερο μέρος της επιφάνειας των κεραιών. Κάθε τέτοιο τριχίδιο ή τριχοειδές αισθητήριο (sensillum trichodeum) καλύπτεται από πλήθος μικροσκοπικούς πόρους διατεταγμένους μέσα σε σπειροειδή αύλακα.

Αυτά είναι οι χημιϋποδοχείς που ανιχνεύουν απειροελάχιστες ποσότητες φερομόνης, την οποία εκκρίνει το θηλυκό για να προσελκύσει το αρσενικό. Ένα μόνο μόριο αυτής της σύνθετης χημικής ουσίας αρκεί για να ερεθίσει τους χημιϋποδοχείς στις κεραίες του αρσενικού. Για να αυξήσουν την ευαισθησία στη φερομόνη, οι αρσενικοί σκόροι συχνά έχουν μεγάλες πτεροειδείς κεραίες και συνεπώς μεγαλύτερο αριθμό τριχοειδών αισθητήριων.

Αυτό το απλό τριχωτό μάτι φυτού σε σχήμα φασολιού είναι σχεδόν πεσμένο πάνω στο σώμα του φυτού στο οποίο ανήκει, κρυμμένο ντροπαλά κάτω από μια αγκαθωτή προεξοχή. Η απουσία στολιδιών ή λεπτομερειών υποδηλώνει πως το έργο που επιτελεί είναι μάλλον απλό. Και όμως η λειτουργία του ουδεμία σχέση έχει με την απλή του μορφή, καθώς πρόκειται για δύο ζωτικής σημασίας όργανα εξισορρόπησης που επιτρέπουν στις μύγες να πετούν τόσο καλά.

Σχεδόν κάθε έντομο φέρει τέσσερα φτερά, ανά δύο στο μεσαίο και το πίσω θωρακικό μεταμερές. Έντομα της τάξης των Οδοντόγναθων, όπως η λιβελούλα, έχουν φτερά παρόμοιου σχήματος. Στις πεταλούδες και τους σκόρους τα οπίσθια φτερά είναι ελαφρώς μικρότερα και πιο στρογγυλεμένα από τα εμπρόσθια, αλλά και τα τέσσερα είναι ορατά. Στις μέλισσες και τις σφήκες τα οπίσθια είναι πολύ μικρότερα από τα εμπρόσθια, εντούτοις εξακολουθούν να είναι τέσσερα. Στα σκαθάρια τα εμπρόσθια έχουν σκληρύνει και μεταμορφωθεί σε έλυτρα, αλλά και πάλι τα φτερά είναι συνολικά τέσσερα. Οι μύγες όμως έχουν μόνο δύο φτερά, εξ ου και το επιστημονικό όνομα της τάξης τους (Δίπτερα). Στα δίπτερα τα οπίσθια φτερά έχουν μεταμορφωθεί σε εξαρτήματα που ονομάζονται αλτήρες και βοηθούν τη μύγα να κρατά την ισορροπία της όταν πετά.

Συχνά έχουν σχήμα κορύνης ή ρόπαλου, δηλαδή είναι προεκβολές αποτελούμενες από στέλεχος άλλοτε μακρύτερο και άλλοτε κοντύτερο, πάντα όμως με διογκωμένο άκρο. Όταν η μύγα είναι στον αέρα οι αλτήρες δονούνται στον ίδιο ρυθμό με τα φτερά. Λόγω του μικρού τους μεγέθους και της μεγαλύτερης πυκνότητάς τους σε σύγκριση με τα μεγαλύτερα δύο φτερά, λειτουργούν σαν γυροσκόπιο. Σε αντίθεση με τα δύο φτερά, τα οποία κινούνται πάνω-κάτω και μπρος-πίσω, οι αλτήρες κινούνται ελεύθερα μόνο στο κάθετο επίπεδο. Αισθητήρια τριχίδια γύρω από τη βάση των αλτήρων προσλαμβάνουν και την πιο ανεπαίσθητη αλλαγή διεύθυνσης της μύγας και αναπληρώνουν κάθε σκαμπανέβασμα και εκτροπή κατά την πτήση, ακόμα και όταν επικρατούν ισχυρά ρεύματα αέρα, δίνοντας στη μύγα την εκπληκτική δεινότητά της στο πέταγμα.

ΔΕΞΙΑ
Η επιφάνεια των κεραιών του σκόρου καλύπτεται από ένα ευρύ φάσμα αισθητήριων δομών που ανιχνεύουν αερομεταφερόμενες χημικές ουσίες.

ΑΡΙΣΤΕΡΑ
Οι κεραίες των αρσενικών σκόρων συχνά είναι πτεροειδείς, πράγμα που αυξάνει την επιφάνεια και συνεπώς τον αριθμό των αισθητήριων που προσλαμβάνουν την οσμή χημικών ουσιών που εκκρίνουν οι θηλυκοί σκόροι.

ΔΕΞΙΑ
Τα οπίσθια φτερά της μύγας έχουν μετασχηματιστεί στα εξαρτήματα που ονομάζονται αλτήρες και λειτουργούν ως γυροσκοπικά όργανα εξισορρόπησης κατά την πτήση του εντόμου.

ΑΡΙΣΤΕΡΑ
Οι μύγες της οικογένειας των Συρφίδων είναι εξαιρετικοί αστροναύτες μένοντας μετέωρες μέσα σε μια δέσμη ακτίνων του ήλιου ή πάνω από ένα άνθος.

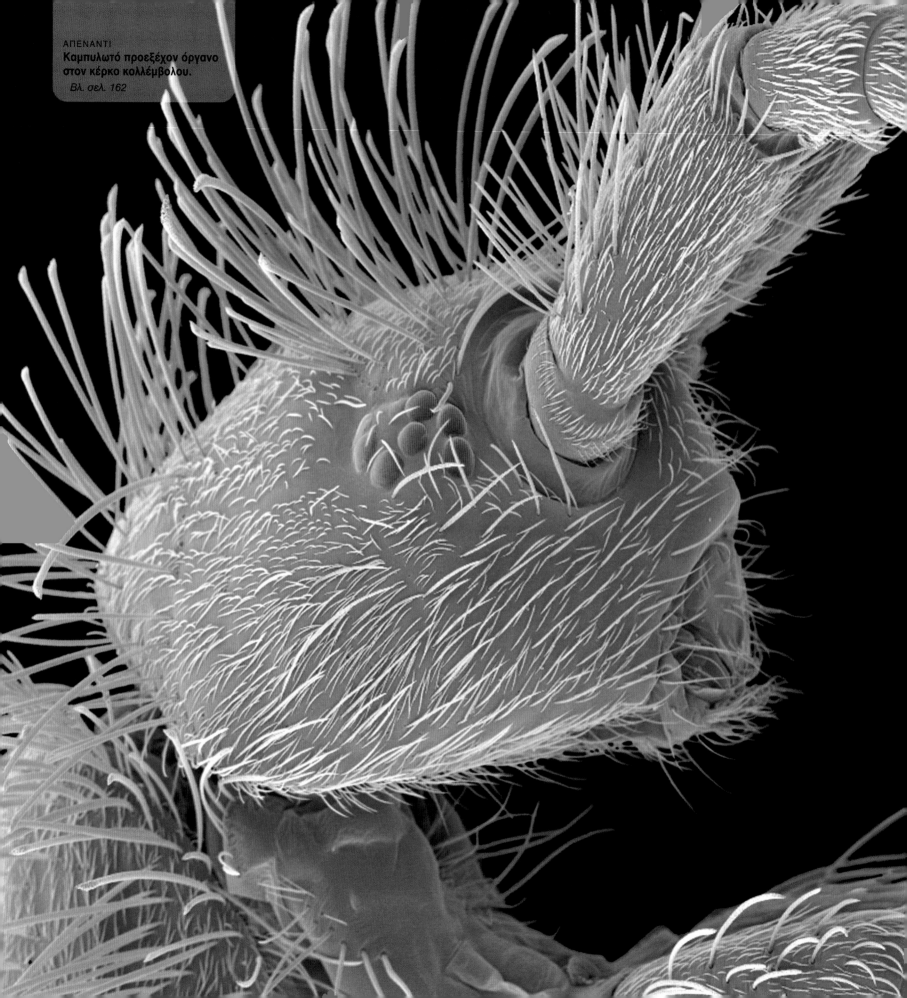

ΑΠΕΝΑΝΤΙ
Καμπυλωτό προεξέχον όργανο στον κέρκο κολλέμβολου.
Βλ. σελ. 162

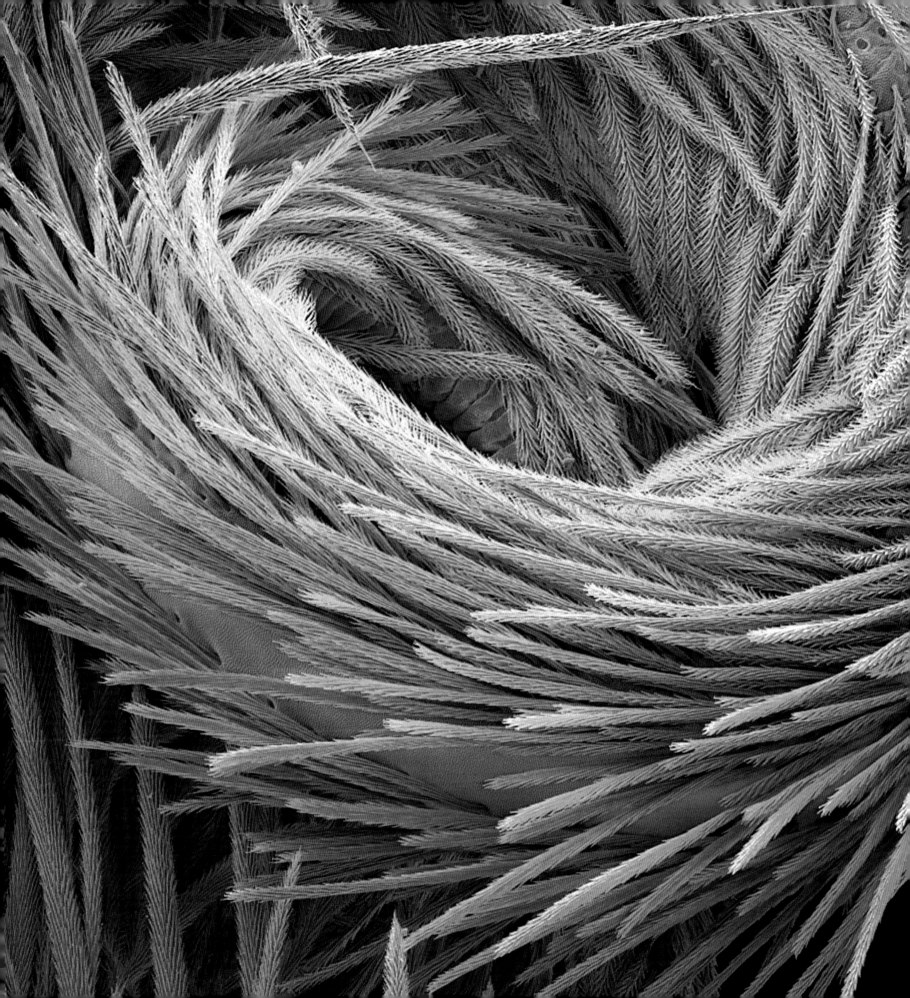

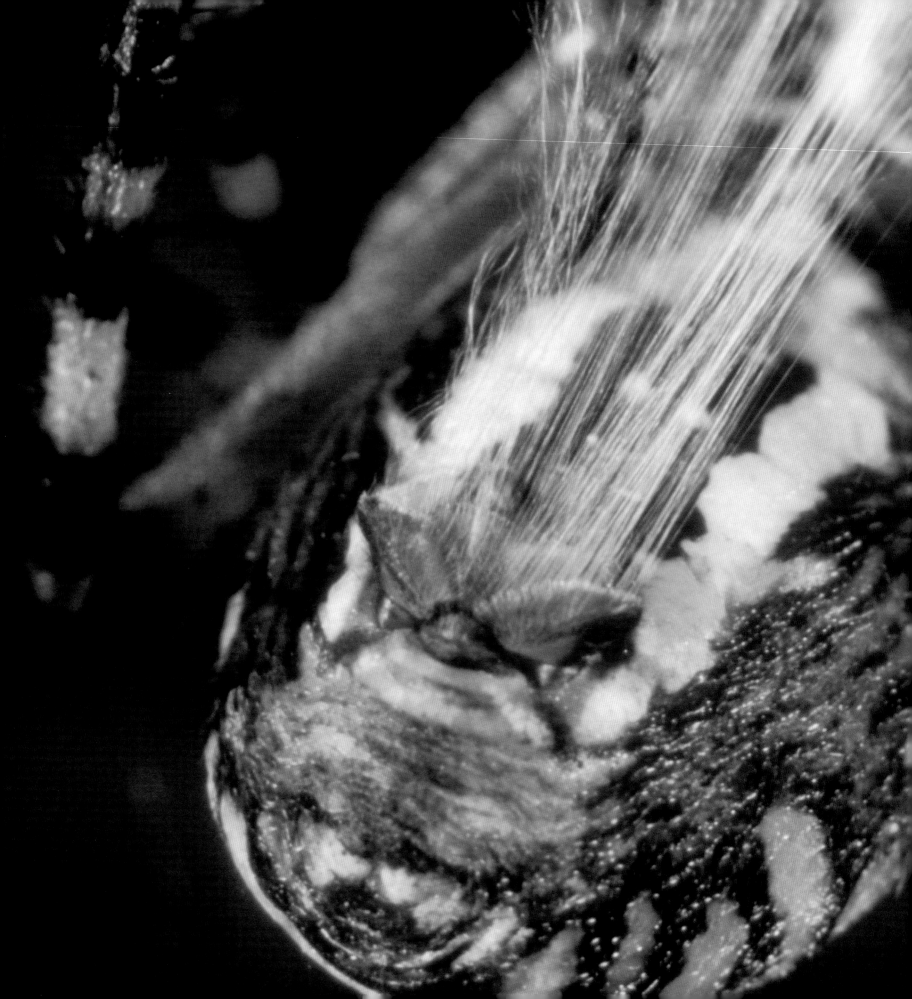

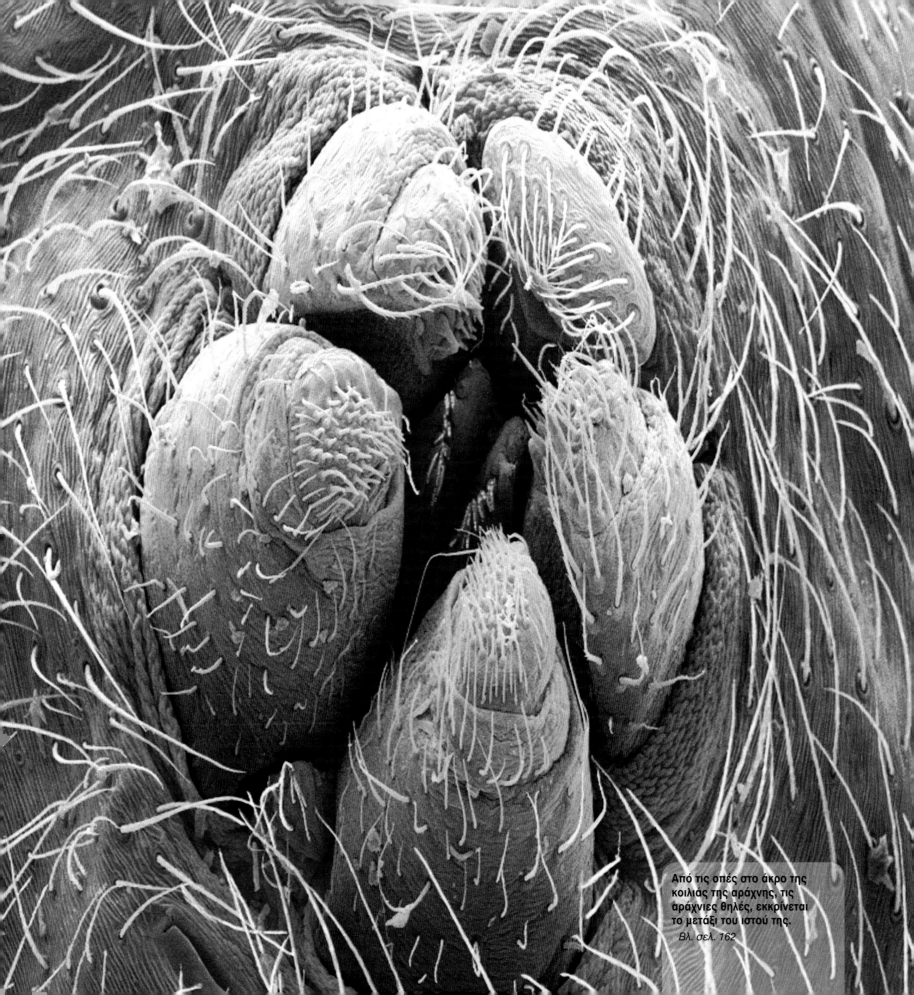

Από τις οπές στο άκρο της κοιλιάς της αράχνης, τις αράχνιες θηλές, εκκρίνεται το μετάξι του ιστού της.

Βλ. σελ. 162

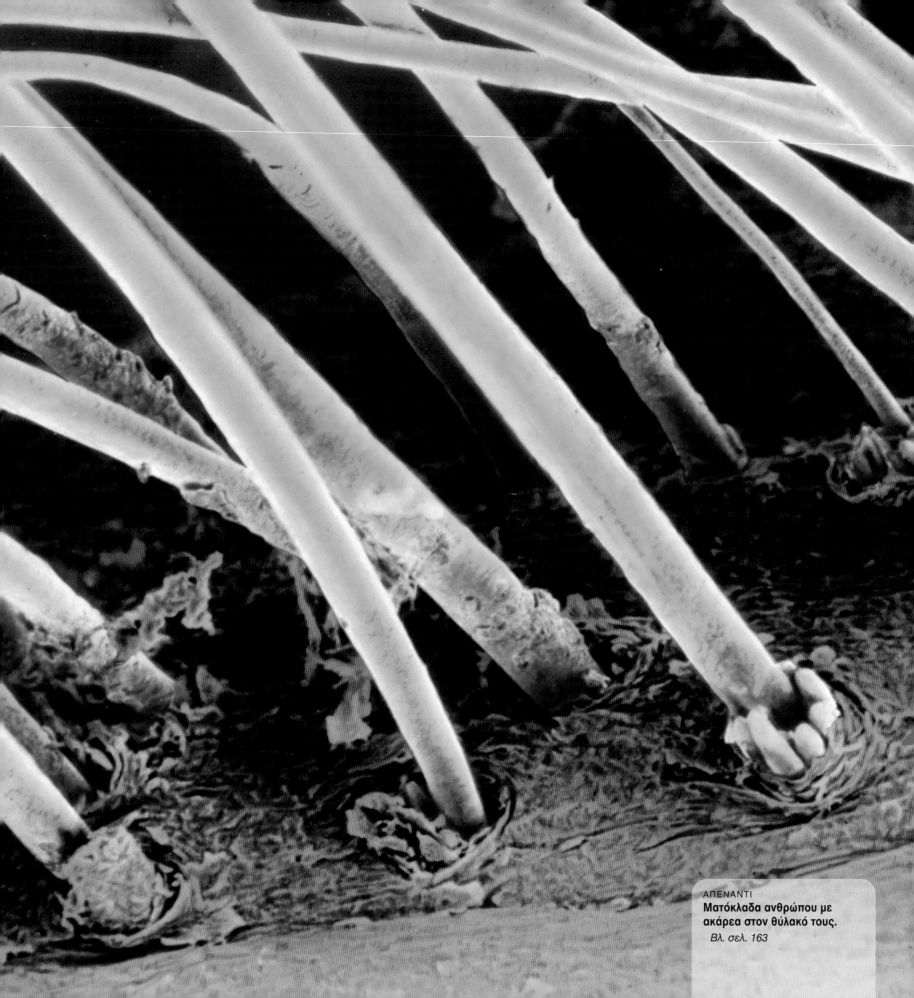

ΑΠΕΝΑΝΤΙ
**Ματόκλαδα ανθρώπου με
ακάρεα στον θύλακό τους.**
Βλ. σελ. 163

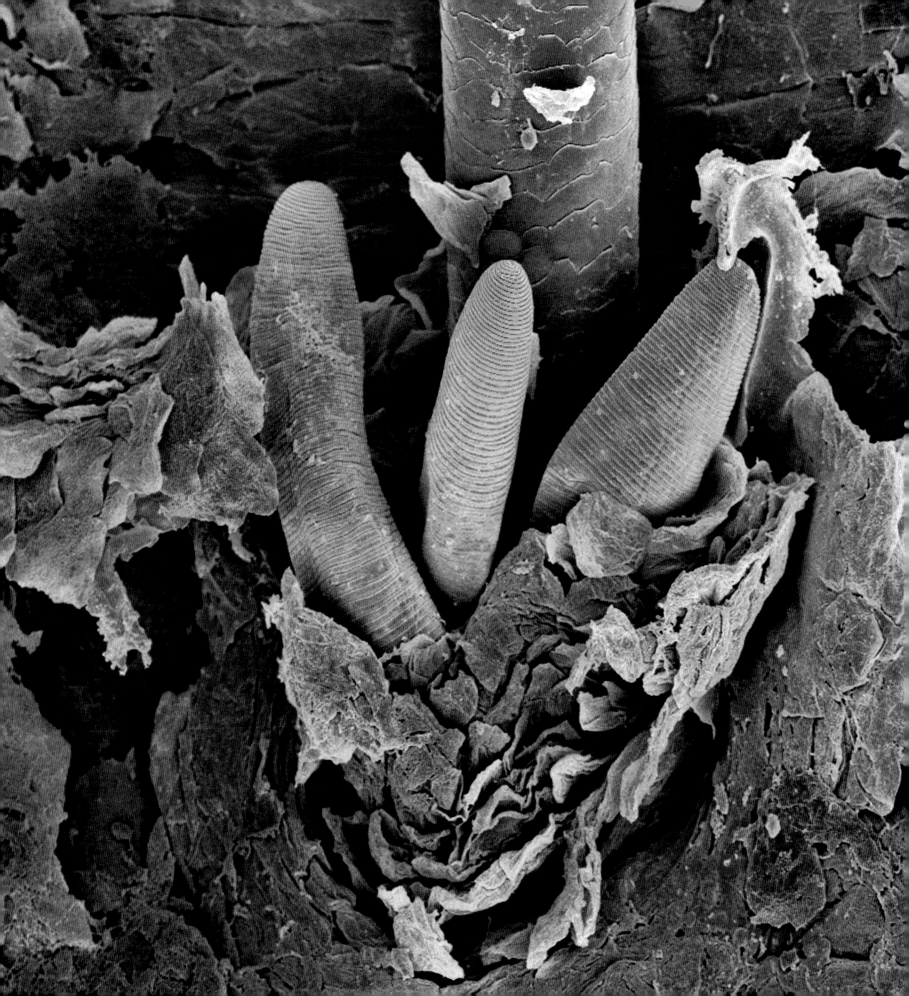

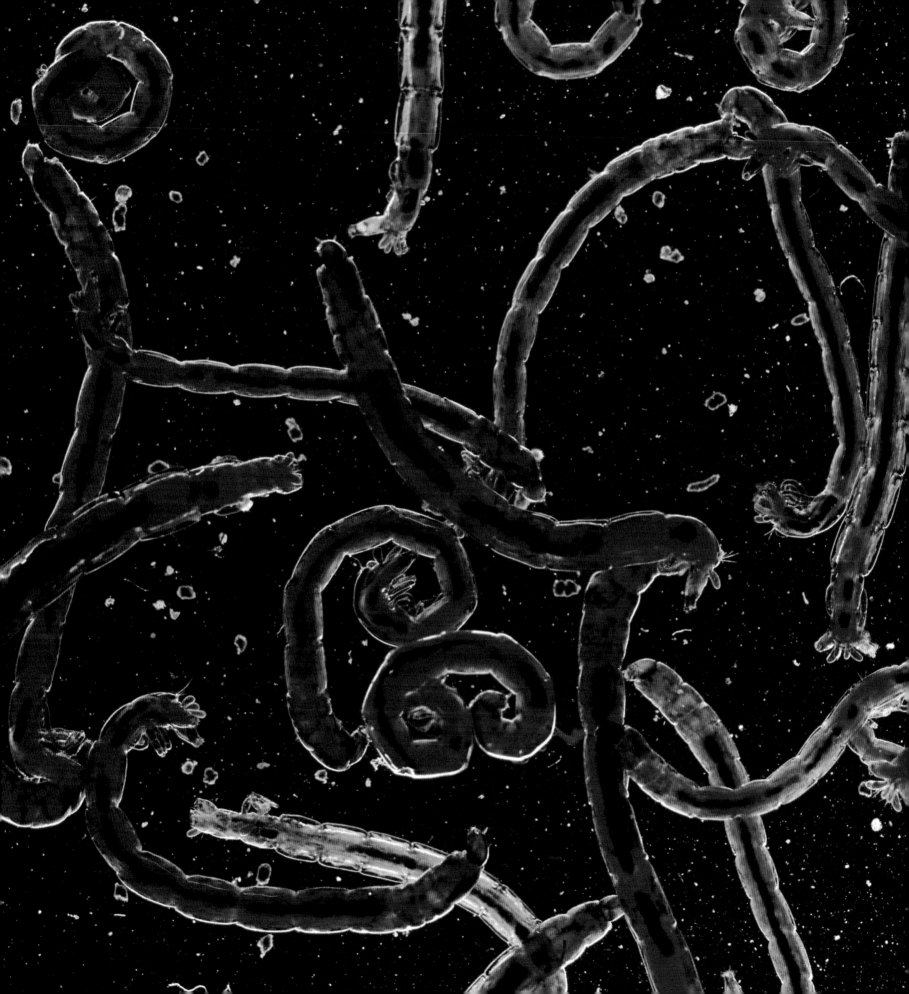

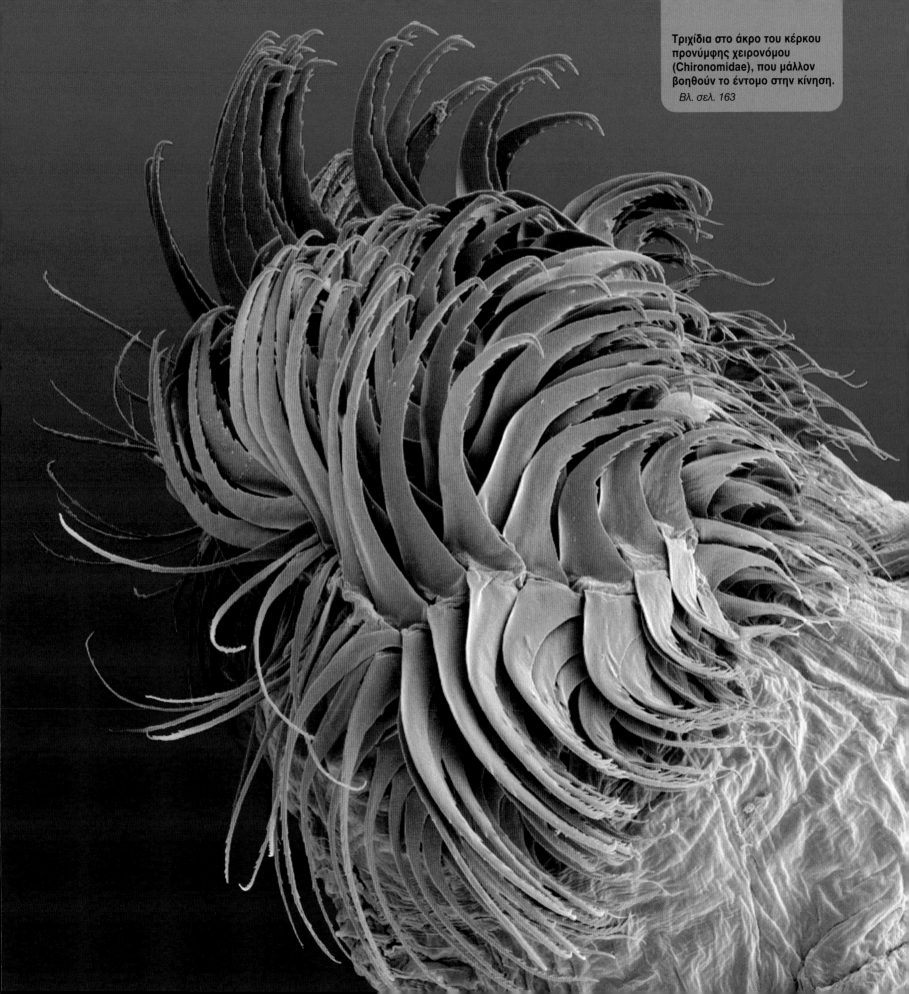

Τριχίδια στο άκρο του κέρκου προνύμφης χειρονόμου (Chironomidae), που μάλλον βοηθούν το έντομο στην κίνηση.
Βλ. σελ. 163

Εδώ δεν πρόκειται για μαλακά, καμπυλωτά φτερά ενός μποά τυλιγμένου απαλά γύρω από έναν γυναικείο λαιμό. Τα μακριά, στενά φτερά της εικόνας είναι οι χνουδωτές σκληρές τρίχες που διακοσμούν τον κέρκο ενός μικροσκοπικού ζώου.

Σωστά ονομάζεται κοινώς springtail (ουρά ελατήριο), διότι το ελατήριο στην ουρά του είναι τέλειο μέσον διαφυγής για ένα μικροσκοπικό, άφτερο αρθρόποδο σαν κι αυτό. Μολονότι τα κολλέμβολα έχουν τα συνήθη έξι πόδια των εντόμων, θεωρούνται πλέον πιο πρωτόγονα πλάσματα, που εξελίχθηκαν ξεχωριστά. Όπως τα έντομα έτσι και αυτά διαθέτουν μάτια και κεραίες αλλά δεν έχουν ίχνη φτερών. Κάτω από το τέταρτο μεταμερές της κοιλιάς έχουν διχαλωτή ουρά, το λεγόμενο έμβολο (furcula) και προήλθε από τη συγχώνευση δύο αποφύσεων. Υπό κανονικές συνθήκες το έμβολο είναι διπλωμένο κάτω από το σώμα του κολλέμβολου μέσα σε μια μικρή εσοχή στο τρίτο μεταμερές της κοιλιάς. Σε περίπτωση, όμως, ενόχλησης ή επίθεσης το κολλέμβολο ανοίγει απότομα το έμβολό

του, χτυπά με αυτό σαν μαστίγιο το έδαφος και εκτινάσσεται σπειροειδώς στον αέρα. Μολονότι το μήκος τους είναι ένα έως δύο χιλιοστά, τα κολλέμβολα μπορούν και «πετούν» 30-50 εκατοστά μακριά διαφεύγοντας πάραυτα τον κίνδυνο και αφήνοντας έκπληκτο τον θηρευτή τους.

Η εξέλιξη της πτήσης είναι ένας από τους σπουδαιότερους λόγους για τους οποίους τα έντομα είναι τόσο πολυάριθμα και τόσο διαφορετικά. Το γεγονός, ωστόσο, ότι στερούνται φτερών δεν εμπόδισε τα κολλέμβολα να σημειώσουν μια παρόμοια επιτυχία.

Είναι διαδεδομένη η άποψη ότι τα έντομα είναι τα πιο πολυάριθμα πλάσματα του πλανήτη. Στα τροπικά δάση για παράδειγμα έχουν αναφερθεί πυκνότητες μέχρι και 200.000 άτομα ανά τετραγωνικό μέτρο. Γνωρίζουμε 6.000 είδη αλλά τα κολλέμβολα έχουν παραμεληθεί από τους εντομολόγους, γι' αυτό και τα ήδη γνωστά αυξάνουν διαρκώς. Θεωρείται ότι υπάρχουν 50.000 περίπου είδη που περιμένουν την ανακάλυψή τους.

Είτε μοιάζουν με κοντά γαντοφορεμένα τριχωτά δάχτυλα είτε με τον μηχανισμό στερέωσης των εξαρτημάτων ενός ηλεκτρικού δράπανου, αυτές οι προεκβολές ασφαλώς φαίνεται πως συνεργάζονται φέροντας σε πέρας μια συγκεκριμένη λειτουργία. Και πράγματι αυτό κάνουν, διότι πρόκειται για το κλωστοϋφαντουργικό εργαλείο της αράχνης, τις θηλές στο τελευταίο μεταμερές της κοιλιάς της (spinnerets, κλωστικά εργαλεία), από όπου εξέρχονται οι ίνες με τις οποίες κλώθουν το νήμα του ιστού τους.

Ο ακριβής αριθμός και η διάταξη των θηλών αυτών διαφέρει από είδος σε είδος, αλλά συνήθως είναι τρία ζεύγη. Παρότι στην εικόνα φαίνονται πέντε ευμεγέθεις θηλές, πραγματικά είναι μόνο τέσσερις, αυτές με το σαφώς μεταμερισμένο άκρο. Δύο ακόμα είναι σχεδόν κρυμμένες στο κέντρο της ομάδας.

Το μετάξι είναι το μυστικό της επιτυχίας των αραχνών: τους χρησιμεύει για να ταξιδεύουν, για την κάθοδό τους από ψηλά και τα τεράστια άλματα τους, για να παγιδεύουν και να τυλίγουν τη λεία τους, να τυλίγουν τα αυγά τους, να προστατεύουν τους εαυτούς τους. Για όλες αυτές τις χρήσεις οι αράχνες ανέπτυξαν

τουλάχιστον επτά διαφορετικά είδη μεταξιού.

Το μετάξι τους είναι πρωτεϊνικές εκκρίσεις που βασίζονται σε μια σειρά ειδικών βιοχημικών μορίων (spidroins). Διαφορετικοί συνδυασμοί αυτών των μορίων δίνουν νήματα μεταξιού που οι φυσικές τους ιδιότητες διαφέρουν, μολονότι όλα παράγονται με τον ίδιο τρόπο και αποτελούνται από ένα εσωτερικό μέρος και ένα εξωτερικό περίβλημα. Οι εκκρίσεις παράγονται από ειδικούς αδένες μέσα στην κοιλιά της αράχνης και ρέουν μέσω σωληνίσκων προοδευτικά μειούμενης διατομής. Καθώς το μετάξι πλησιάζει τις μικροσκοπικές οπές στο άκρο των θηλών, εξειδικευμένα κύτταρα στα τοιχώματα των σωληνίσκων αφαιρούν νερό από τις πρωτεΐνες με συνέπεια να γίνονται πιο ιξώδεις. Τέλος, ένα ήπιο όξινο μπάνιο και η ελκτική τάση των ποδιών της αράχνης μετατρέπουν τις ίνες του μεταξιού σε στέρεο ελαστικό νήμα.

Το νήμα αυτό έχει πάχος συνήθως 1-4 μm, αλλά η ελαστικότητά του είναι απίστευτη. Ένας τυπικός, κυκλοτερής ιστός για να υφανθεί απαιτεί νήμα μήκους τουλάχιστον 20 μέτρων και πάνω από 1.000 ενώσεις, και παρότι ζυγίζει μόλις μισό γραμμάριο, μπορεί να σηκώσει μια αράχνη 4.000 φορές βαρύτερη.

ΔΕΞΙΑ
Τα πτεροειδή τριχίδια στο διχαλωτό πίσω άκρο ενός κολλέμβολου είναι μεγάλο πλεονέκτημα για το μικροσκοπικό ζώο, καθώς το βοηθούν να εκτιναχθεί ψηλά, όταν κινδυνεύει.

ΑΡΙΣΤΕΡΑ
Τα κολλέμβολα είναι απλά, άφτερα, εξάποδα πλάσματα που συγγενεύουν στενά με τα έντομα.

ΔΕΞΙΑ
Οι θηλές στο πίσω άκρο της κοιλιάς της αράχνης εκκρίνουν ίνες μεταξιού από εκατοντάδες μικροσκοπικές οπές (spigots), που η αράχνη στη συνέχεια γνέθει, παράγοντας το ισχυρό ελαστικό νήμα του ιστού της.

ΑΡΙΣΤΕΡΑ
Οι αράχνες γνέθουν χνουδωτό μετάξι για να μεταμφιέσουν τον ιστό τους και να τυλίξουν το θύμα τους που παλεύει να ελευθερωθεί.

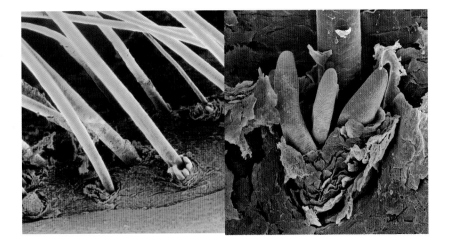

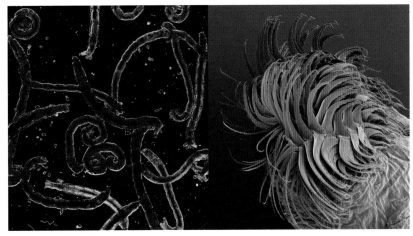

Αυτοί οι τρεις νεαροί βλαστοί φαίνονται έτοιμοι να αναπτυχθούν σαν τους βλαστούς του σπαραγγιού την άνοιξη. Ένα τέταρτο στέλεχος έχει πάρει κιόλας μπόι, ενώ όμως αυτό το τελευταίο λεπτό και φολιδωτό στέλεχος είναι ευθυτενές σαν κυπαρίσσι, η τριάδα των χαμηλότερων κοντόχοντρων με τις ραβδώσεις γέρνουν προς τα κάτω και προς τα μέσα. Το στέλεχος είναι τρίχα ανθρώπινη, ενώ τα τρία «βλαστάρια» στη βάση της είναι τα πίσω άκρα μικροσκοπικών οργανισμών που ζουν στους θυλάκους των τριχών, τα ακάρεα του γένους Demodex.

Όσο ενοχλητικά και αν φαίνονται με πρώτη ματιά, τα ακάρεα αυτά είναι στην πλειονότητά τους αβλαβή, ενώ οι περισσότεροι άνθρωποι-ξενιστές τους αγνοούν παντελώς την ύπαρξή τους. Είναι τόσο διαδεδομένα και τόσο διακριτικά (δεν προξενούν συμπτώματα), ώστε είναι δύσκολη η εκτίμηση του ποσοστού των ατόμων που προσβάλλονται από αυτά. Εκείνο που ξέρουμε σαφώς είναι ότι με την ηλικία συσσωρεύουμε όλο και περισσότερα ακάρεα.

Τα θυλακόβια ακάρεα έχουν μήκος 1,1 - 0,4 μm και κατατάσσονται έτσι στα πιο μικροσκοπικά αρθρόποδα που γνωρίζουμε. Έχουν ανοιχτόχρωμο, ημιδιαφανές σώμα σε σχήμα πούρου και οχτώ κοντόχοντρα πόδια κοντά στο κεφάλι. Ζουν όλη σχεδόν τη ζωή τους μέσα ή μισοχωμένα στον θύλακο της τρίχας, όπου τρέφονται με κύτταρα του δέρματος και τις ελαιώδεις ουσίες που εκκρίνει η ρίζα της. Η διατροφή τους είναι τόσο τέλεια για την ανάπτυξη και την εξέλιξή τους, ώστε δεν έχουν έδρα και δεν αποβάλλουν άχρηστα υλικά.

Τα ακάρεα απαντώνται στους θυλάκους των τριχών του προσώπου, κυρίως γύρω από τη μύτη, τα αυτιά και τα ματόκλαδα, γι' αυτό και μερικές φορές ονομάζονται ακάρεα ματόκλαδων. Ζευγαρώνουν, γεννούν αυγά και πεθαίνουν μέσα στον θύλακο. Ένα θηλυκό γεννά περίπου 25 αυγά, από τα οποία τρεις τέσσερις ημέρες αργότερα εκκολάπτονται εξάποδες προνύμφες, οι οποίες μετά τρεις εβδομάδες μεταμορφώνονται σε ενήλικα άτομα αποκτώντας και το τελευταίο ζεύγος ποδιών. Όταν εγκαταλείπουν κάποτε τον θύλακό τους (πράγμα που το κάνουν για να εξαπλωθούν σε έναν νέο ξενιστή κατά την επαφή πρόσωπο με πρόσωπο δύο ανθρώπων) μπουσουλάνε με ταχύτητα 14 εκατοστά την ώρα. Τα ακάρεα σπεύδουν βραδέως αλλά ασφαλώς.

Αυτή η εκκεντρική κόμμωση δεν στολίζει το κεφάλι κάποιου ζώου, αλλά την ουρά του. Τα καμπυλωτά και πεπλατυσμένα αυτά τριχίδια σχηματίζουν έναν θύσανο στο πίσω μεταμερές του χειρονόμου, ενός δίπτερου νηματοκέρατος εντόμου που το ακμαίο του μοιάζει με κουνούπι, αλλά ούτε τσιμπά ούτε απομυζά αίμα.

Οι προνύμφες του λέγονται κοινώς «αιμασκούληκα» (bloodworms), επειδή είναι κόκκινες, εξαιτίας της χρωστικής που υπάρχει και στο αίμα των σπονδυλωτών, δηλαδή της αιμοσφαιρίνης.

Οι αιμοσφαιρίνες είναι πολύ σύνθετα μακρομόρια που το καθένα αποτελείται από μικρότερες πρωτεϊνικές αλυσίδες που οργανώνονται στον χώρο σε σφαιρικούς σπειροειδείς σχηματισμούς (σφαιρίνες) με προσθετικές ομάδες που ονομάζονται αίμη και κάθε μία περιέχει ένα άτομο σιδήρου. Ο σίδηρος, στον οποίο οφείλεται και το κόκκινο χρώμα του αίματος, έχει μεγαλύτερη τάση σύνδεσης με το οξυγόνο και μικρότερη με το διοξείδιο του άνθρακα. Έτσι το οξυγόνο που απορροφάται από τους πνεύμονες (ή τα βράγχια) μεταφέρεται με το αίμα σε όλα τα μέρη του σώματος, ενώ παράλληλα απομακρύνεται το διοξείδιο του άνθρακα. Στα σπονδυλωτά η λειτουργία αυτή επέτρεψε την ανάπτυξη μεγάλου μεγέθους οργανισμών.

Παρότι η αιμοσφαιρίνη στον χειρονόμο είναι πολύ διαφορετική από την αιμοσφαιρίνη των σπονδυλωτών, εντούτοις και αυτή είναι μια σύνθετη δομή αλυσίδων πρωτεΐνης και προσθετικών ομάδων αίμης. Η προνύμφη του χειρονόμου, αντί να χρησιμοποιεί αιμοσφαιρίνη για να μεταφέρει οξυγόνο σε μεγάλες αποστάσεις μέσα στο σώμα της, χρησιμοποιεί την επαρκή τάση σύνδεσης του σιδήρου με το οξυγόνο για να αντλεί όσο οξυγόνο χρειάζεται σε ύδατα ανεπαρκώς οξυγονωμένα (συνήθως μολυσμένα), όπου άλλοι οργανισμοί δεν θα επιβίωναν.

Σε αντίθεση με τις προνύμφες του κουνουπιού, οι οποίες επιπλέουν και αναπνέουν αέρα μέσω μικρών σωλήνων (σιφώνων), οι χειρονόμοι είναι εγκατεστημένοι στον πυθμένα. Κολυμπούν με ζωηρές, κυματιστές κινήσεις του μακριού σώματός τους, ωθώντας έναν στρόβιλο νερού προς το πίσω τάγμα τους. Οι τούφες του μάλλον χρησιμεύουν στον έλεγχο της κατεύθυνσης και της ροής του στροβίλου καθώς κολυμπούν.

ΑΠΕΝΑΝΤΙ
Φαλλός ζυγόπτερου.
Βλ. σελ. 172

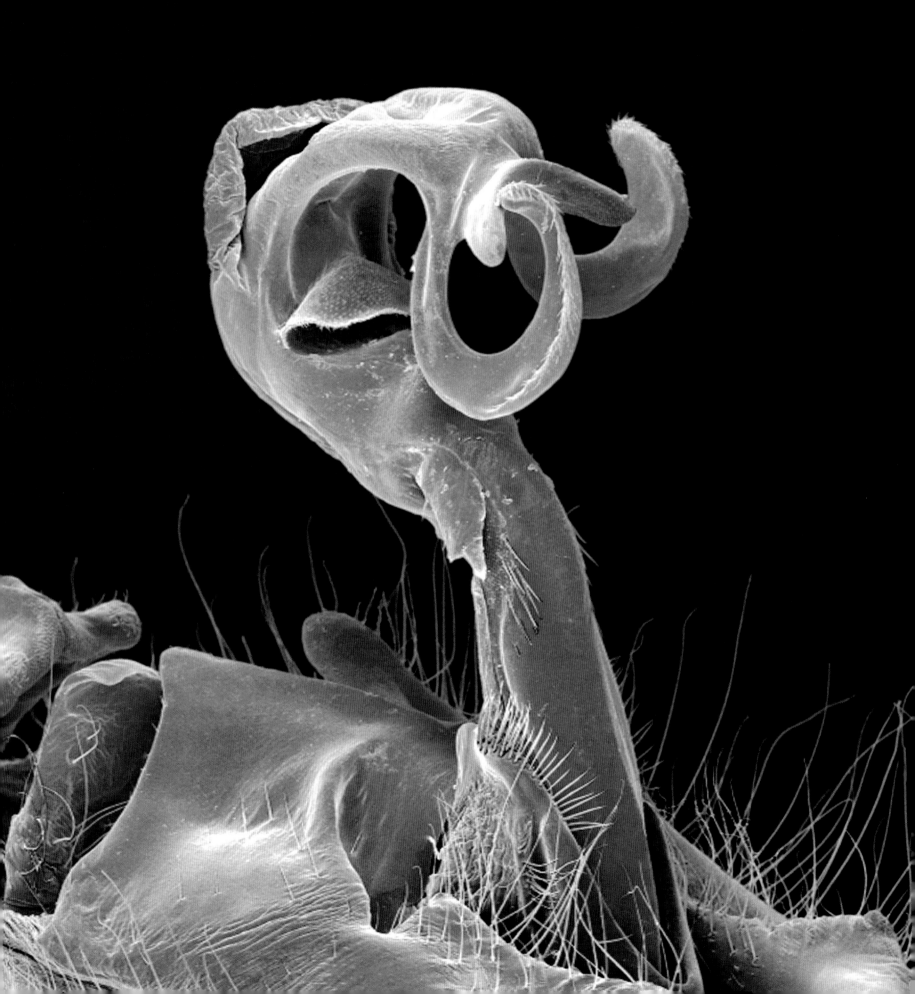

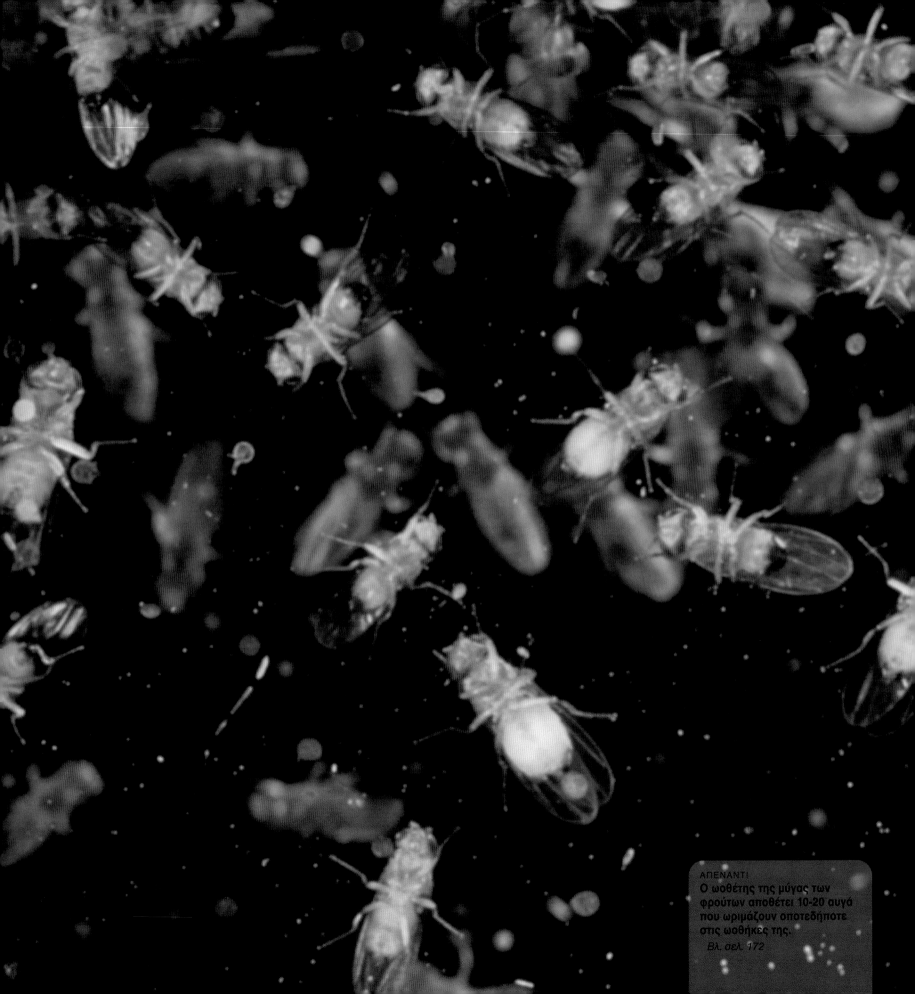

ΑΠΕΝΑΝΤΙ
Ο ωοθέτης της μύγας των φρούτων αποθέτει 10-20 αυγά που ωριμάζουν οποτεδήποτε στις ωοθήκες της.
Βλ. σελ. 172

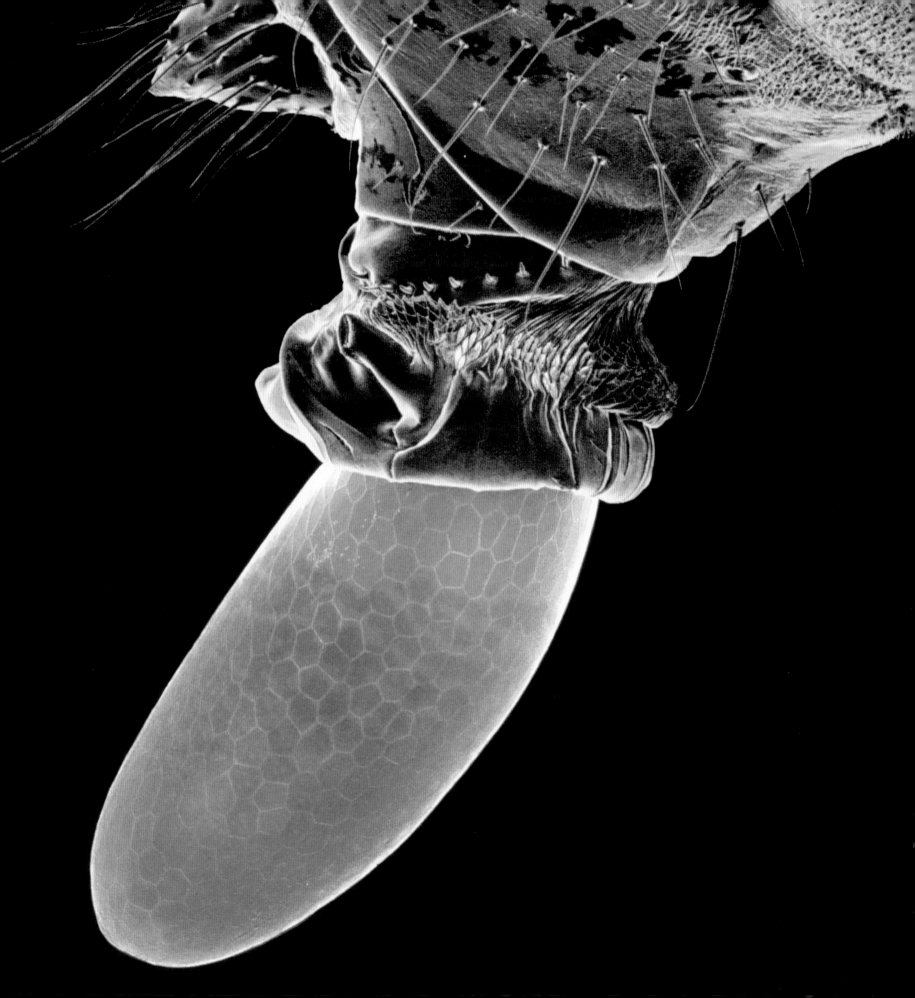

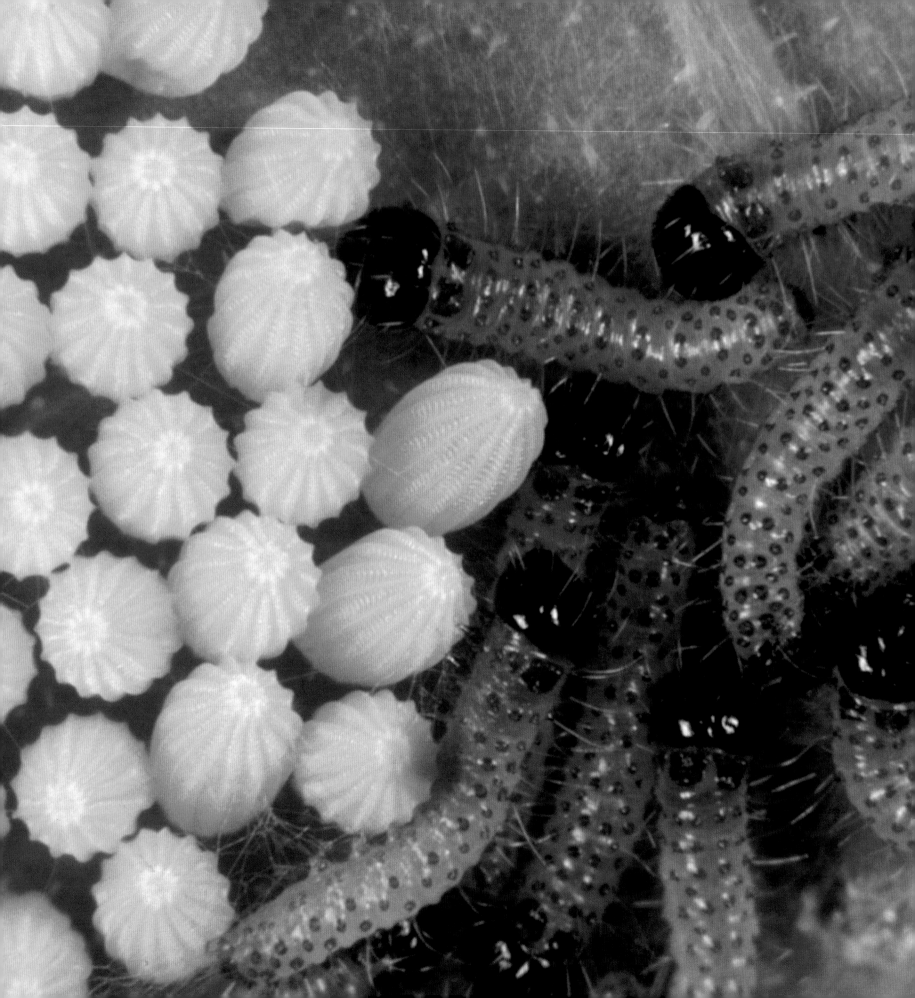

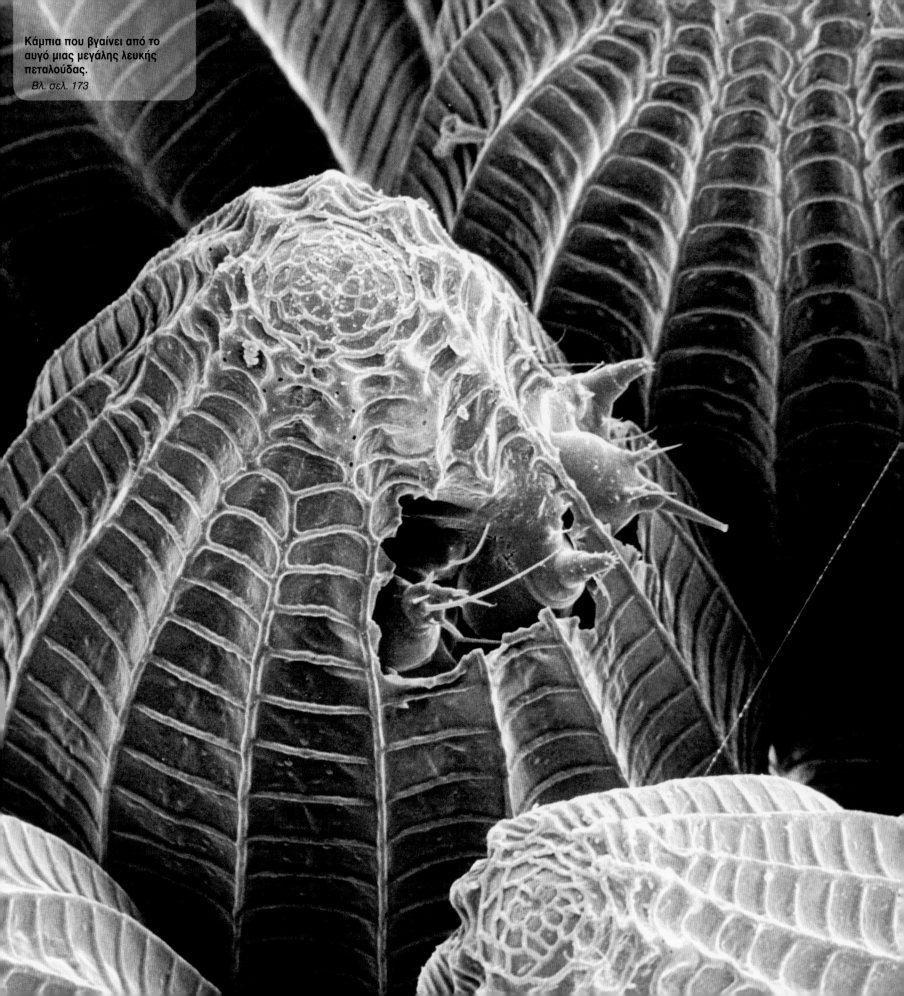

Κάμπια που βγαίνει από το αυγό μιας μεγάλης λευκής πεταλούδας.

Βλ. σελ. 173

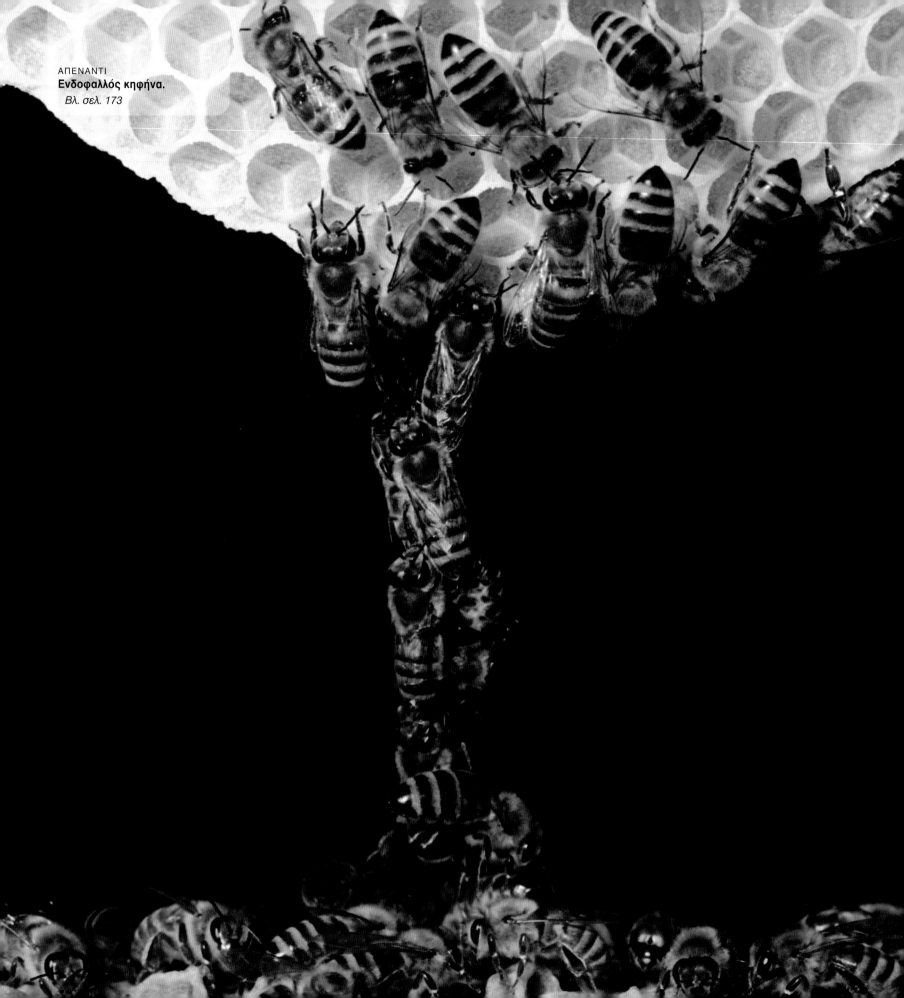

ΑΠΕΝΑΝΤΙ
Ενδοφαλλός κηφήνα.
Βλ. σελ. 173

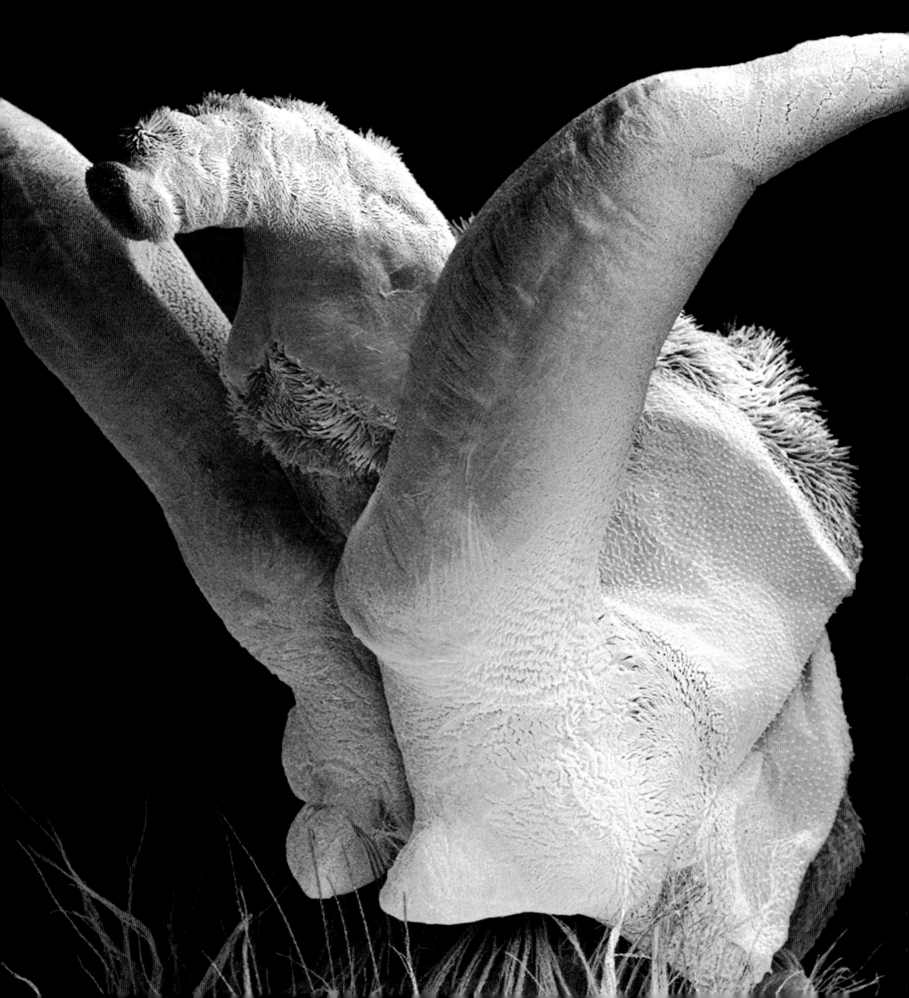

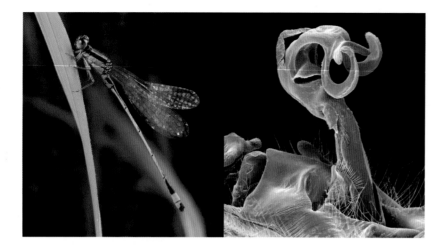

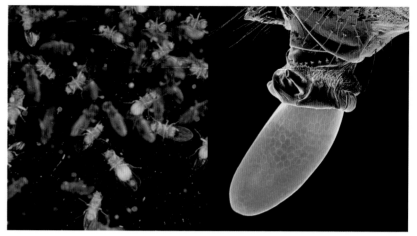

Αυτού του είδους η κατασκευή ταιριάζει μάλλον με κεραία κινητής τηλεφωνίας ή με εγκατάσταση ραντάρ. Με τις παράξενες, γυριστές ουρές της και το συσπασμένο στέλεχος που προβάλλει μέσα από διπλωμένες φολίδες θωράκισης, ο φαλλός ενός ζυγόπτερου μοιάζει περισσότερο με όπλο παρά με όργανο αναπαραγωγής.

Τα συστήματα ζευγαρώματος στα έντομα είναι σύνθετα και πολλές φορές αλλόκοτα, όλα όμως βασίζονται σε εσωτερική γονιμοποίηση των ωών του θηλυκού από το σπέρμα του αρσενικού. Το σκληρό όργανο οχείας του αρσενικού που διεισδύει στο θηλυκό ονομάζεται αιδοιαγός ή φαλλός και πολλοί έχουν εξαιρετικά περίπλοκα σχήματα και διαφέρουν ακόμα και αν ανήκουν σε πολύ συγγενικά είδη. Εικάζεται ότι αυτές οι εκκεντρικές μορφές αιδοιαγών έχουν εξελιχθεί όπως τα κλειδιά, έτσι ώστε να ταιριάζουν στις σωστές «κλειδαριές» των θηλυκών του αυτού είδους. Κατ' αυτόν τον τρόπο αποφεύγονται οι διασταυρώσεις που το πιθανότερο είναι να αποβούν ανεπιτυχείς, επειδή το προϊόν σπέρματος/ωού είναι συνήθως στείρο.

Στα ανισόπτερα (λιβελούλες) και στα ζυγόπτερα οδοντόγναθα, καθώς και σε άλλα έντομα, όπως αποδεικνύεται, η έγχυση σπέρματος είναι μόνο μία από τις λειτουργίες του φαλλού. Η άλλη είναι η αφαίρεση από το θηλυκό του σπέρματος προηγούμενων συζεύξεων με άλλα αρσενικά, διαδικασία που δίνει στο τελευταίο αρσενικό μια τεράστια ευκαιρία να ζευγαρώσει, επειδή έτσι έχει πολύ περισσότερες πιθανότητες να γονιμοποιήσει όλους τους γόνους του θηλυκού. Έτσι προέκυψαν συμπεριφορές διαφύλαξης του ζευγαρώματος, διαδεδομένες σε όλα τα είδη ανισόπτερων: το αρσενικό προσκολλάται στο θηλυκό όσο αυτό εναποθέτει τα αυγά του ή μετεωρίζεται κοντά του επιτιθέμενο σε κάθε επίδοξο μνηστήρα. Στα ζυγόπτερα είθισται το αρσενικό να παραμένει προσκολλημένο στο θηλυκό το οποίο έχει συλλάβει στον αέρα από τον λαιμό με τις λαβίδες του στο άκρο της κοιλιάς του, ενώ και τα δύο βυθίζονται στο νερό για την εναπόθεση των αυγών στα στελέχη υδρόβιων φυτών.

Το ζαρωμένο, τραχύ και τριχωτό στόμιο δημιουργεί έντονο κοντράστ με τη λεία, στιλπνή καραμέλα που αποβάλλει. Το αμυδρό φιλιγκράν που διαγράφει ένα άυλο πλέγμα εξαγώνων πάνω στη σαν γυαλί επιφάνεια εντείνει την αντίθεση αυτή. Μπορεί να φαίνεται παράξενο με την πρώτη ματιά, αλλά εδώ έχει απαθανατιστεί μια πράξη που σπάνια έχει υπάρξει αντικείμενο παρατήρησης, αν και είναι συνηθισμένη και απολύτως εγκόσμια: η εναπόθεση ενός αυγού.

Το αυγό, ένα από τα 10 έως 20 ώριμα ανά πάσα στιγμή αυγά στις ωοθήκες, αναδύεται από την κοιλιά μιας κοινής μύγας φρούτων. Οι μύγες, ιδίως του είδους Δροσοφίλη μελανογάστωρ, έχουν εξελιχθεί σε σπουδαίους και καλά μελετημένους πειραματικούς οργανισμούς, ιδίως από άποψη γενετικής και εμβρυολογίας, εξ ου και πολλές γνώσεις μας για το πώς λειτουργούν τα ζώα έχουν συναχθεί από αυτούς τους οργανισμούς που μπορούν να καλλιεργηθούν εύκολα και γρήγορα στο εργαστήριο και επίσης εύκολα να χειραγωγηθούν.

Η δομή του αυγού μπορεί να φαίνεται απλή, είναι όμως κάτι παραπάνω από απλή βιολογική οντότητα που εμπεριέχει το γενετικό υλικό του DNA. Πριν ακόμα αρχίσει να αναπτύσσεται το έμβρυο της προνύμφης, ακόμα και πριν γονιμοποιηθεί το αυγό από το σπέρμα, έχει καθοριστεί το εμπρόσθιο, οπίσθιο, άνω, κάτω, δεξί και αριστερό που αργότερα θα μεταφραστούν στους αντίστοιχους άξονες συμμετρίας του ακμαίου, όταν τελικά αναδυθεί μετά την επιτυχή μεταμόρφωσή του και εκατοντάδες χιλιάδες κυτταρικές διαιρέσεις.

Ο μηχανισμός μορφογένεσης και δημιουργίας των αξόνων ακόμα εξετάζονται από τους επιστήμονες, αλλά χρησιμοποιώντας έναν σχετικά απλό οργανισμό, όπως η Δροσοφίλη, κατανόησαν ορισμένα θεμελιώδη πράγματα. Πριν από τη γονιμοποίησή του το αυγό της μύγας των φρούτων αποτελείται από 16 επιφανειακά ταυτόσημα κύτταρα. Ένα από αυτά γίνεται ωοκύτταρο (το θηλυκό ωοκύτταρο που γονιμοποιείται από το σπέρμα), ενώ τα άλλα 15 γίνονται οι «τροφείς» του. Τα τροφοκύτταρα αυτά, εκτός του ότι προμηθεύουν θρεπτικές ουσίες στο ωοκύτταρο, ταυτόχρονα μεταφέρουν μια βαθμίδα πρωτεΐνης και γενετικές σημάνσεις που επηρεάζουν το τελικό σχέδιο του σώματος της μελλοντικής μύγας.

ΔΕΞΙΑ
Ο αιδοιαγός (φαλλός) αρσενικού ζυγόπτερου όχι μόνο γονιμοποιεί το θηλυκό, αλλά και το καθαρίζει από το ανταγωνιστικό σπέρμα προηγούμενων εντόμων.

ΑΡΙΣΤΕΡΑ
Μολονότι μικρότερα και κομψότερα από τα ανισόπτερα (λιβελούλες), τα ζυγόπτερα έχουν παρόμοια υδρόβια στάδια μεταμόρφωσης και ως ακμαία έντομα κυνηγούν στον αέρα μικρότερα έντομα.

ΔΕΞΙΑ
Ο εύκαμπτος ωοθέτης της μύγας των φρούτων συσπάται για να εκβάλει ένα από τα αυγά που ωριμάζουν στις ωοθήκες της.

ΑΡΙΣΤΕΡΑ
Στην απλή βιογραφία της μύγας του είδους Δροσοφίλη μελανογάστωρ και στην εύκολη και γρήγορη καλλιέργειά της οφείλεται το γεγονός ότι το έντομο αυτό έχει εξελιχθεί σε ένα από τα μείζονα εργαλεία της βιολογίας και ειδικά της μελέτης των γονιδίων.

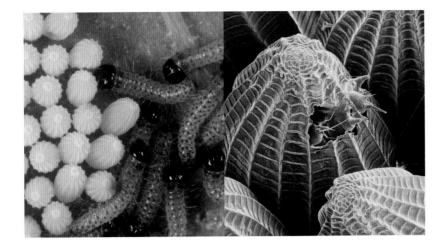

Αυτοί οι λεπτεπίλεπτοι, ημιδιάφανοι θόλοι με τις νευρώσεις και τις πολλαπλές έδρες που μοιάζουν με υψηλής τεχνολογίας γυάλινους πύργους, κρύβουν ένα μυστικό: μέσα στον καθένα περιμένει να βγει στον κόσμο ένα τέρας, ένα από τα οποία έχει ήδη ξεκινήσει να διαρρηγνύει το κέλυφός του. Με ένα μήκος μόλις 2 χιλιοστά η κάμπια της εικόνας δεν είναι ακόμα τερατώδης, αλλά κάποτε θα εξελιχθεί σε μεγάλη πληγή των καλλιεργειών, στη μεγάλη λευκή πεταλούδα, κοινώς λαχανοπεταλούδα (Pieris brassicae) που είναι ο εφιάλτης των παραγωγών λαχανοκομικών.

Τα αυγά με το ανάγλυφο χόριο, που όταν ήταν εν ζωή είχαν χρώμα κίτρινο ανοιχτό, ανήκουν σε μια γέννα 20-100 συγκολλημένων αυγών που εναποτέθηκαν πριν από 15 περίπου ημέρες στην κάτω επιφάνεια του φύλλου ενός λάχανου. Τα αυγά της ίδιας γέννας εκκολάπτονται σχεδόν ταυτόχρονα, οπότε δεν αργεί να εκστρατεύσει ένας ολόκληρος λόχος κάμπιες. Αρχικά βόσκουν στην κατώτερη στιβάδα των φυτικών κυττάρων, αφήνοντας διάφανα παράθυρα στο φύλλο. Αργότερα,

όταν οι κάτω γνάθοι τους μεγαλώσουν αρκετά ώστε να μπορούν να ανταπεξέλθουν στο πάχος του φύλλου, θα αρχίσουν να καταβροχθίζουν κυριολεκτικά το φυτό, μετατρέποντάς το σε σκελετό αποτελούμενο από κεντρικά νεύρα φύλλων και στελέχη.

Αυτή η κοινωνικότητα οφείλεται στη διατροφή τους. Παρότι ο άνθρωπος θεωρεί τα λάχανα νόστιμα, τα ωμά φύλλα τους περιέχουν υψηλές συγκεντρώσεις τοξικών θειογλυκοζιτών (glucosinolates) που είναι δηλητηριώδεις για πολλά ζώα, όχι όμως και για την κάμπια της λευκής πεταλούδας. Η λευκή πεταλούδα όχι μόνο έχει ανοσία στους θειογλυκοζίτες, αλλά και τους συλλέγει, ιδίως τη σινιγρίνη, την οποία αποθηκεύει στο σώμα της. Έτσι αποκτά γεύση δυσάρεστη για κάθε ζώο ή πουλί που θα δοκιμάσει να τη φάει.

Η κάμπια διαφημίζει το πόσο επικίνδυνη είναι υιοθετώντας προειδοποιητικά χρώματα: φωτεινό κίτρινο με μαύρες κηλίδες. Δεν έχει ανάγκη να κρύβεται από αρπακτικά, αντίθετα αποκτά πρόσθετη προστασία τρεφόμενη εν μέσω μιας ομάδας που φέρει χρώματα ακόμα πιο αποκρουστικά.

Δεν έχει τίποτε το αστείο αυτό το καπέλο γελωτοποιού με τα καμπυλωτά κωνικά δερματοειδή κέρατά του και τις σκληρές σαν βούρτσας τρίχες του, διότι πρόκειται για ό,τι πολυτιμότερο έχει ο κηφήνας, τον φαλλό του.

Ένα μελίσσι περνά την ημέρα του δίχως αρσενικά. Ένα μόνο γόνιμο θηλυκό έντομο (η βασίλισσα) περνά τον καιρό του γεννώντας αυγά, ενώ πολλές δεκάδες χιλιάδες στείρων θηλυκών (οι εργάτριες) συλλέγουν γύρη ή νέκταρ, ταΐζουν τα μωρά, κατασκευάζουν κηρήθρες, καθαρίζουν την κυψέλη και προστατεύουν το μελίσσι από τους κλέφτες του μελιού. Στις εξημερωμένες κυψέλες οι μελισσουργοί αφήνουν τα πράγματα έτσι όσο περισσότερο γίνεται, ελέγχοντας το μέγεθος του μελισσιού για να αποτρέψουν την αποδυνάμωσή του μέσω αφεσμού (σμηνουργίας), πράγμα που συμβαίνει όταν ο αριθμός των μελισσών αυξάνει υπερβολικά.

Κάποια στιγμή είτε ο αριθμός των εργατριών είτε το μέγεθος της κυψέλης φτάνει σε ένα οριακό σημείο πέρα από το οποίο χημικά σινιάλα της βασίλισσας εξασθενούν πολύ, οπότε οι εργάτριες αλλάζουν συμπεριφορά. Αρχίζουν να κατασκευάζουν κελιά διαφορετι-

κού σχήματος στην κηρήθρα. Ορισμένα με πλατύτερα ανοίγματα υποδέχονται από τη βασίλισσα αγονιμοποίητα αυγά από τα οποία θα γεννηθούν οι κηφήνες, άλλα μεγαλύτερα θα υποδεχτούν αυγά από τα οποία θα εκκολαφτούν οι προνύμφες που θα εξελιχθούν σε νέες βασίλισσες, καθώς οι εργάτριες τις ταΐζουν μόνο με βασιλικό πολτό, ένα έκκριμα με υψηλές συγκεντρώσεις πρωτεΐνης.

Η πρώτη ακμαία βασίλισσα βρίσκει και θανατώνει όλες τις άλλες νύμφες βασιλισσών κεντρίζοντάς τες, έπειτα αφήνει την κυψέλη για να ζευγαρώσει ακολουθούμενη από οιστρήλατους κηφήνες. Το ζευγάρωμα λαμβάνει χώρα εν πτήσει. Ο κηφήνας μετά την εκσπερμάτωση αποχωρεί, αλλά ο ενδοφαλλός του, το μέρος του φαλλού που διεισδύει στο θηλυκό κατά τη σύζευξη, αποσπάται. Ο κηφήνας μετά τον οδυνηρό ευνουχισμό του πεθαίνει. Ο επόμενος που θα ζευγαρώσει με τη βασίλισσα αποξύει τον αποσπασμένο ενδοφαλλό του προηγούμενου από τη βασίλισσα και εναποθέτει το δικό του σπέρμα. Αφού ζευγαρώσει κάμποσες φορές, η βασίλισσα έχει πλέον τόση ποσότητα σπέρματος στη σπερματοθήκη της που φτάνει για όλη της τη ζωή.

ΑΝΑΠΑΡΑΓΩΓΗ

ΔΕΞΙΑ
Τα εύθραυστα αυγά της πεταλούδας έχουν ανάγλυφα κελύφη με ραφές και πτυχές που τα ισχυροποιούν.

ΑΡΙΣΤΕΡΑ
Οι μεγάλες λευκές πεταλούδες τρώνε παρέα, αναζητώντας ασφάλεια στο πλήθος και διαφημίζοντας την άσχημη γεύση τους με τα χρώματά τους.

ΔΕΞΙΑ
Ο φαλλός του κηφήνα μένει μέσα στη βασίλισσα και μετά την οχεία, αλλά ο επόμενος που θα ζευγαρώσει μαζί της, μπορεί να τον σαρώσει έξω από το σώμα της, προσθέτοντας και το δικό του σπέρμα σε αυτό που έχει ήδη αποθηκευτεί.

ΑΡΙΣΤΕΡΑ
Εκτός από το να ζευγαρώνουν με τη βασίλισσα, οι κηφήνες δεν έχουν κανέναν άλλο σκοπό στην κυψέλη.

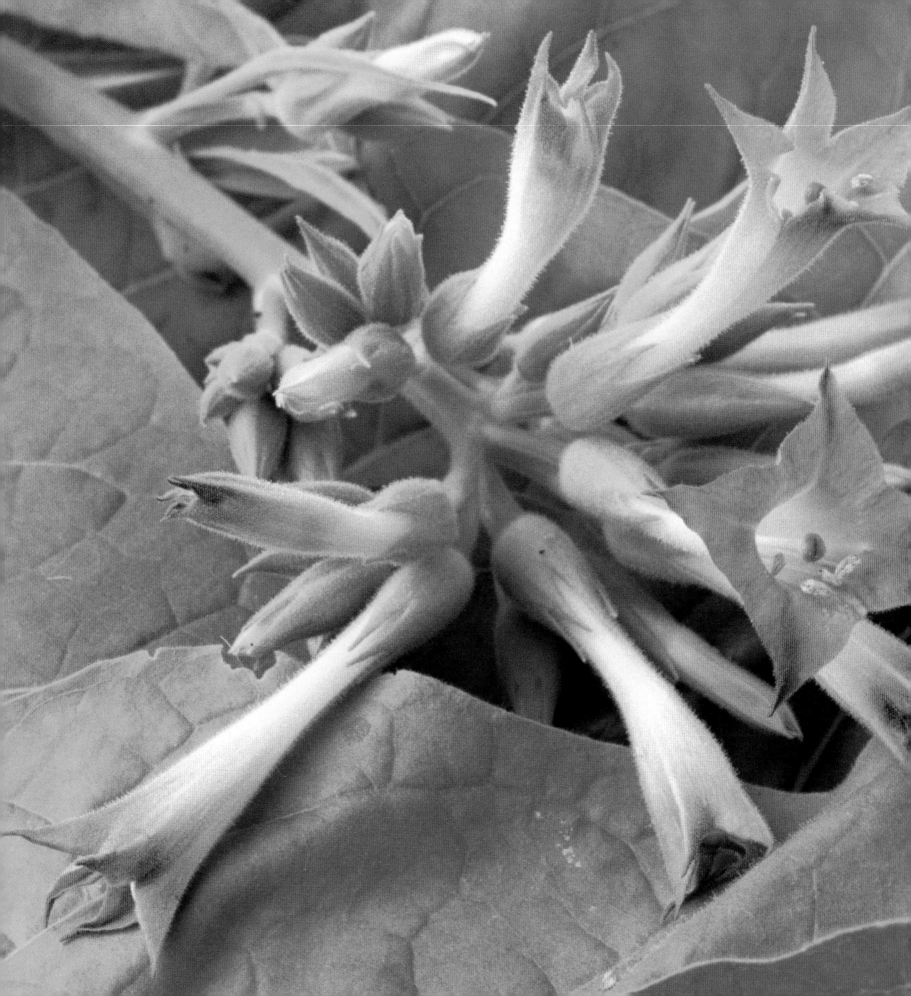

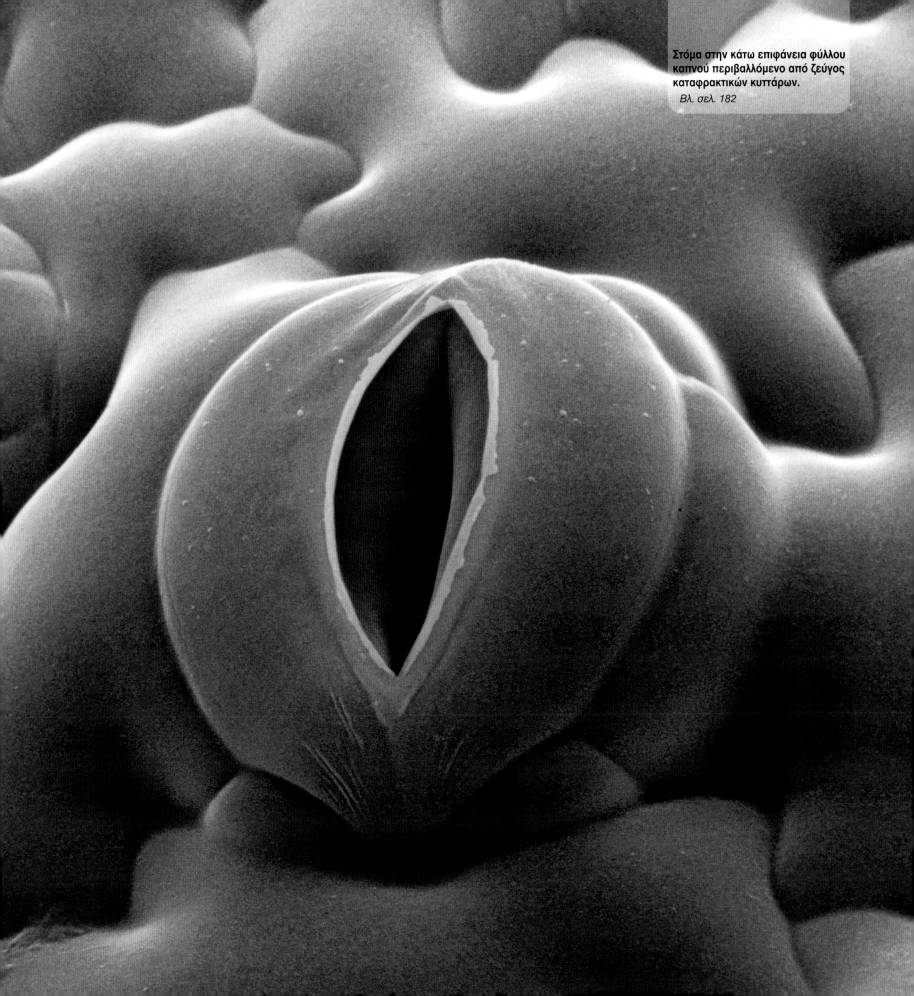

Στόμα στην κάτω επιφάνεια φύλλου καπνού περιβαλλόμενο από ζεύγος καταφρακτικών κυττάρων.

Βλ. σελ. 182

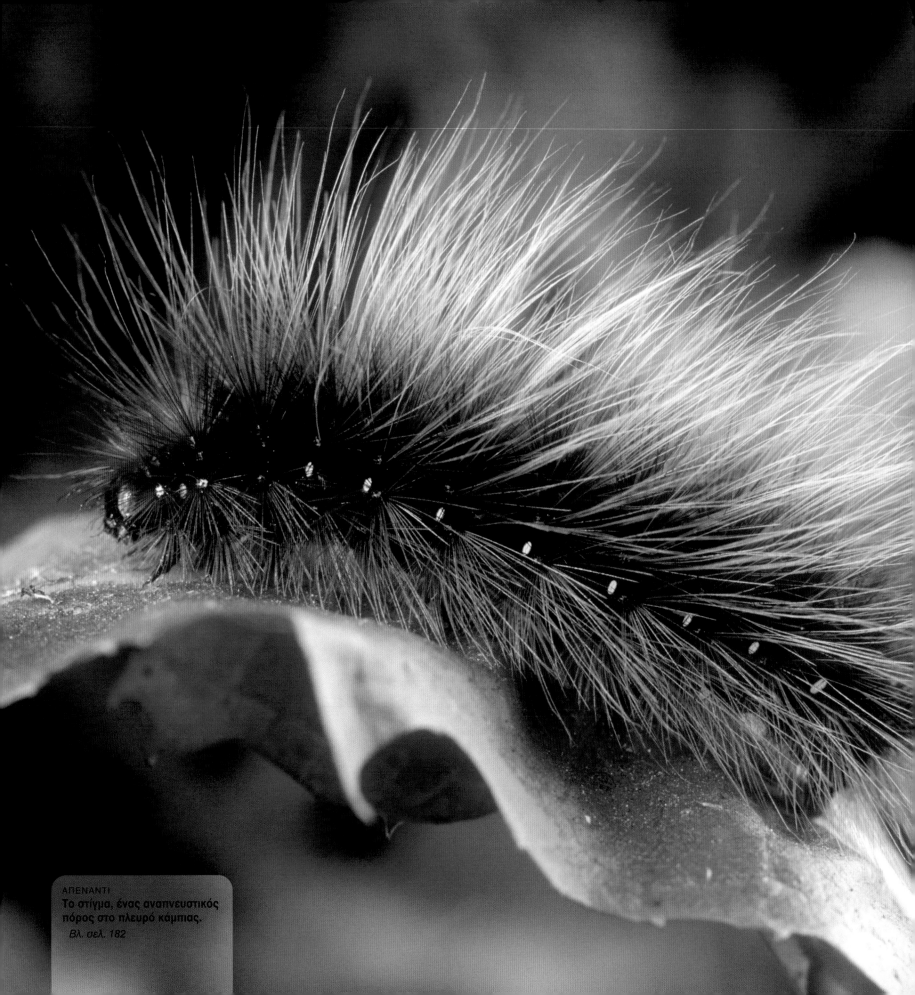

ΑΠΕΝΑΝΤΙ
Το στίγμα, ένας αναπνευστικός
πόρος στο πλευρό κάμπιας.
Βλ. σελ. 182

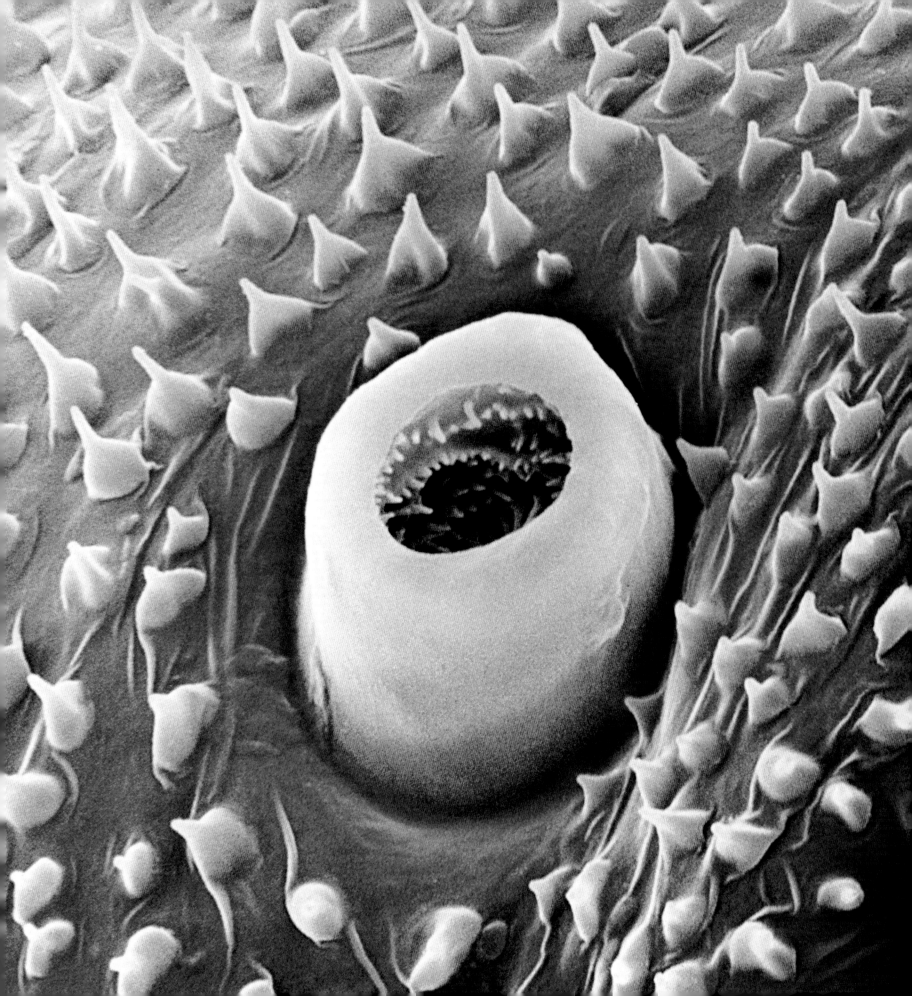

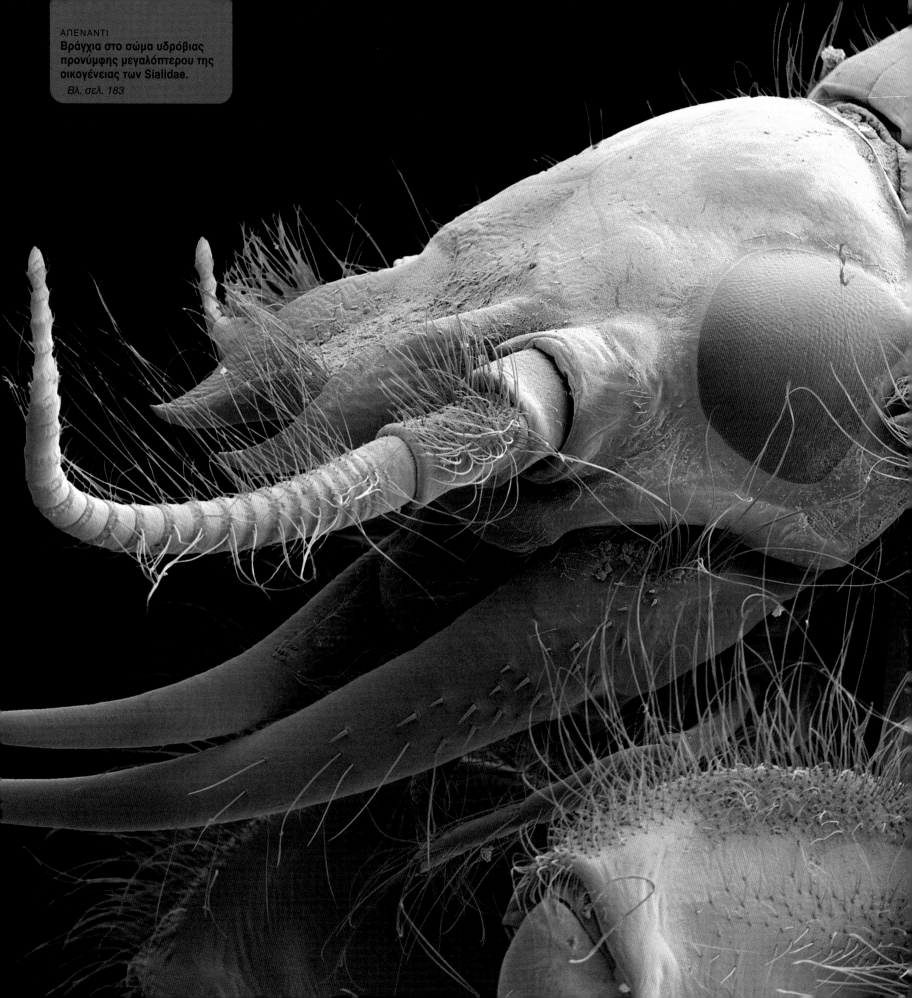

ΑΠΕΝΑΝΤΙ
Βράγχια στο σώμα υδρόβιας προνύμφης μεγαλόπτερου της οικογένειας των Sialidae.
Βλ. σελ. 183

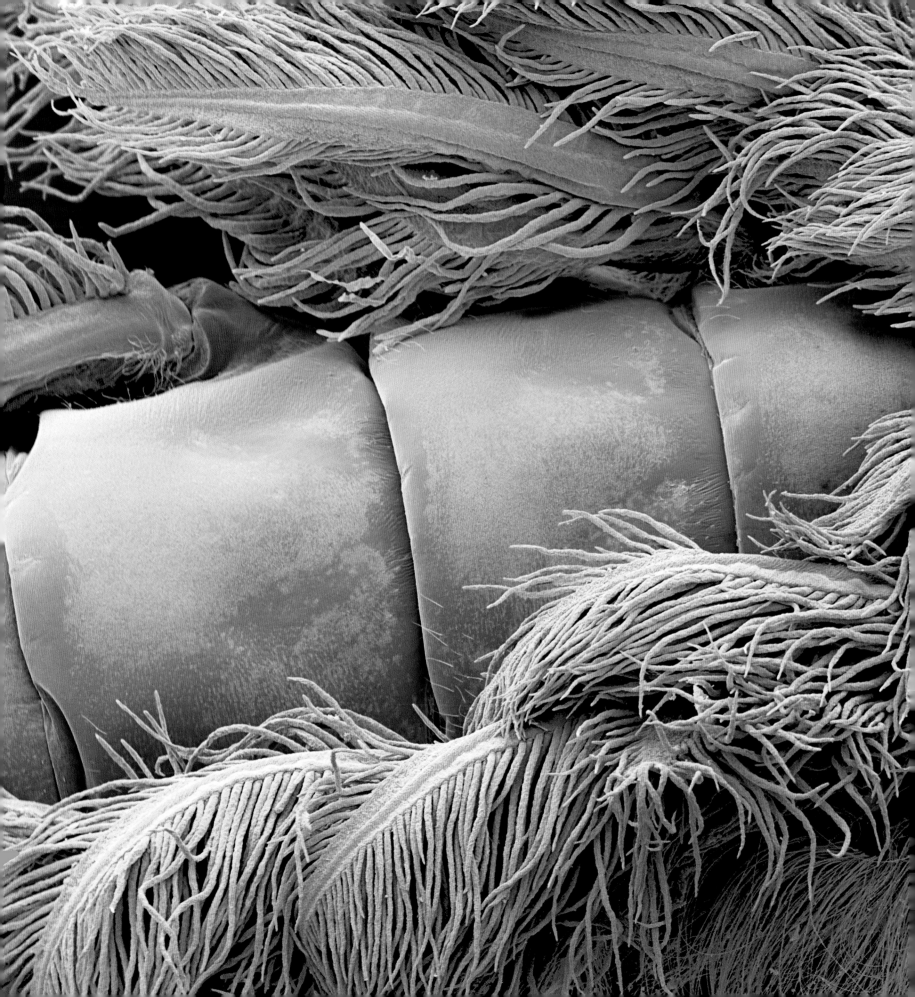

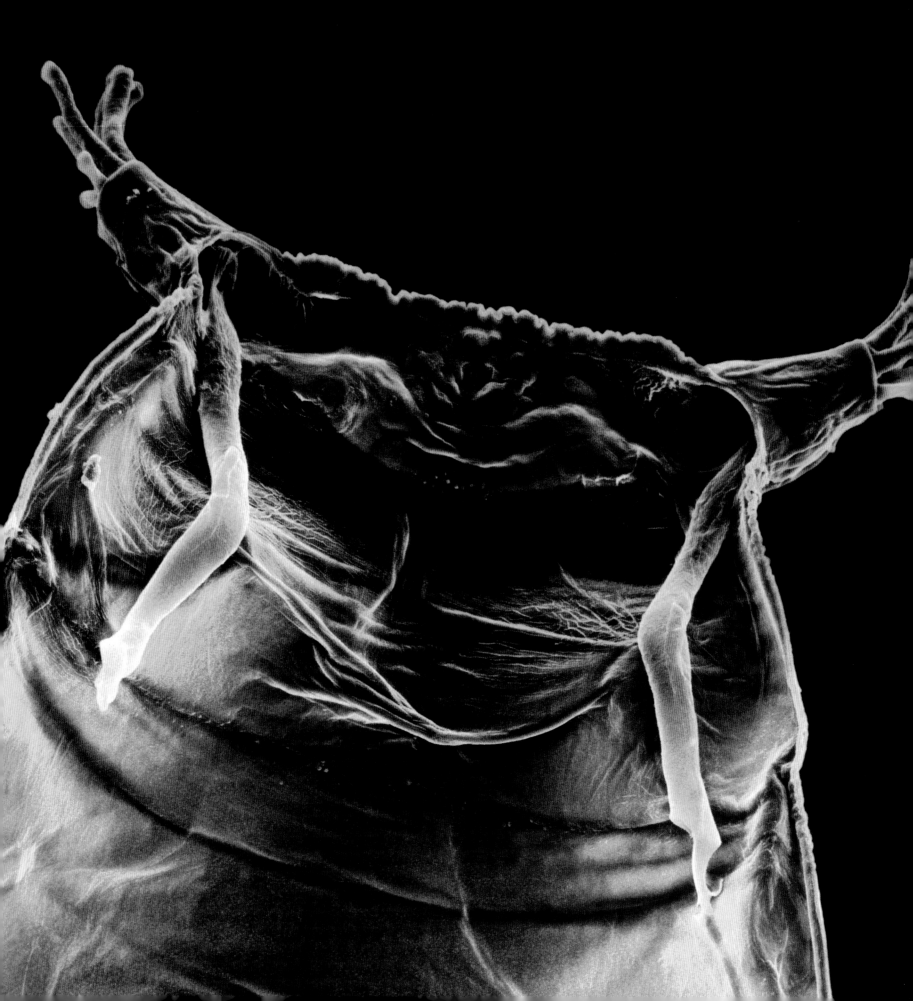

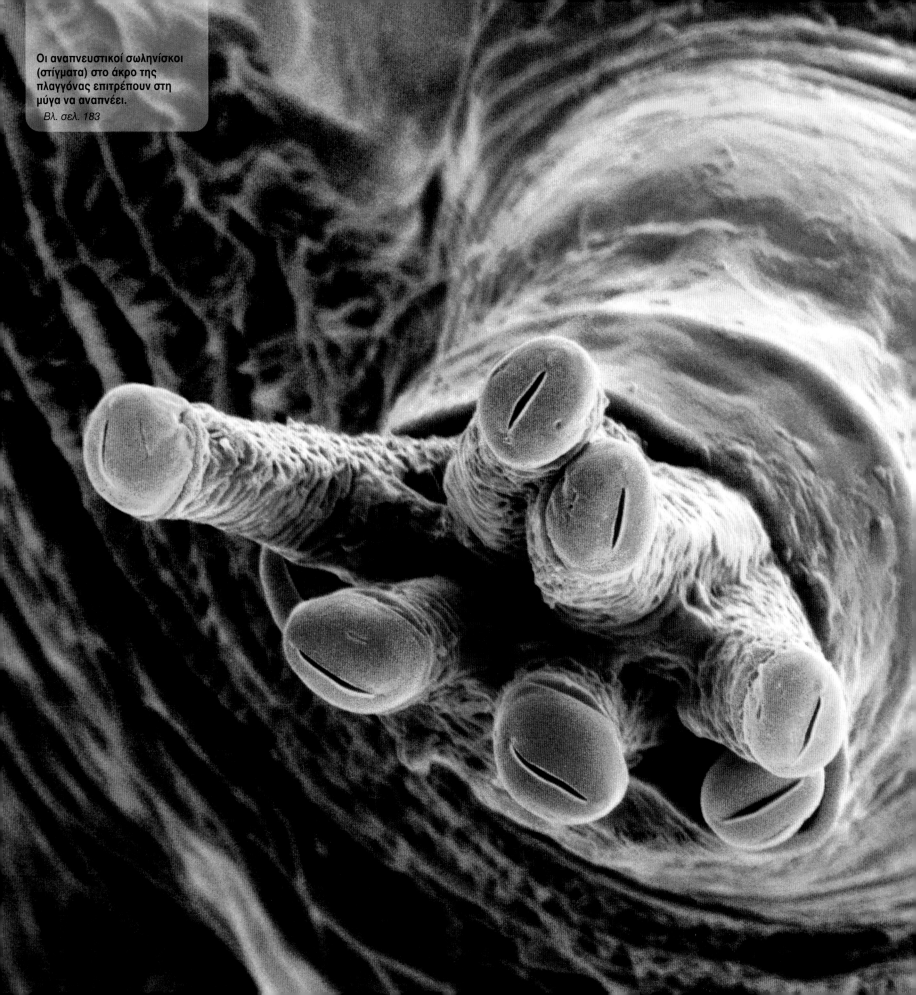

Οι αναπνευστικοί σωληνίσκοι (στίγματα) στο άκρο της πλαγγόνας επιτρέπουν στη μύγα να αναπνέει.

Βλ. σελ. 183

Όπου και να είναι προσαρτημένη αυτή η δομή, πρόκειται για χείλη, αυθάδη και τουρλωτά. Και, όπως σε όλα τα χείλη, το άνοιγμά τους είναι ακριβώς όσο χρειάζεται για να επιτρέπει την είσοδο του αέρα. Αυτά τα χείλη όμως δεν βγάζουν άχνα, διότι απλούστατα ανήκουν σε ένα στόμα, δηλαδή σε έναν πόρο διαπνοής ενός φύλλου καπνού.

Τα φυτά ρυθμίζουν την απώλεια νερού και την ανταλλαγή αερίων μέσω αυτών των στομάτων. Στα δικοτυλήδονα (τη μεγαλύτερη κλάση των αγγειόσπερμων) η πλειονότητα των στομάτων είναι στην κάτω επιφάνεια των φύλλων (υποστοματικά φύλλα)· στα μονοκοτυλήδονα (αγρωστώδη, ίριδες, κρίνους, κ.λπ.) εμφανίζονται εξίσου και στην άνω και στην κάτω επιφάνεια (αμφιστοματικά φύλλα).

Όταν είναι ανοιχτά ελευθερώνουν νερό μέσω εξάτμισης, με αποτέλεσμα να δημιουργείται υποπίεση εντός του φυτού, που το βοηθά να απορροφά περισσότερο νερό και ανόργανες θρεπτικές ουσίες με τις ρίζες του. Το στόμα βοηθά επίσης το φυτό να απορροφά από την ατμόσφαιρα διοξείδιο του άνθρακα. Στη συνέχεια κατά τη σύνθετη διαδικασία της φωτοσύνθεσης το φυτό συνδυάζει χημικά το διοξείδιο του άνθρακα

με το νερό, οπότε παράγεται ο μονοσακχαρίτης γλυκόζη και οξυγόνο.

Κάθε στόμα περικλείεται από δύο καταφρακτικά κύτταρα, τα «χείλη» στην εικόνα. Τα ανοίγματα των στομάτων ελέγχονται από τη ροή μορίων νερού μέσα στα καταφρακτικά κύτταρα, που φουσκώνουν και προεξέχουν δημιουργώντας ένα άνοιγμα σχήματος οβάλ. Όταν τα αποφρακτικά κύτταρα αποβάλλουν μόρια του νερού, χαλαρώνουν και ξεφουσκώνουν, οπότε το κενό ανάμεσά τους κλείνει.

Ο ακριβής μηχανισμός της ροής του νερού δεν έχει γίνει ακόμα πλήρως κατανοητός. Παλαιότερα υπέθεταν ότι τα αποφρακτικά κύτταρα συνέθεταν υδατάνθρακες μέσω φωτοσύνθεσης κατά τη διάρκεια της ημέρας, καθώς περιέχουν χλωροφύλλη (την πράσινη χρωστική που δεσμεύει το φως), ενώ άλλα κύτταρα της επιφάνειας των φύλλων δεν περιέχουν, και ότι, καθώς η συγκέντρωση υδατανθράκων μεγάλωνε, τα κύτταρα αυτά απορροφούσαν μόρια νερού από το περιβάλλον τους μέσω όσμωσης. Πρόσφατες μελέτες, ωστόσο, θεωρούν ότι αυτός ο μηχανισμός δεν είναι αρκετά ταχύς ή ισχυρός ώστε να ελέγχει το άνοιγμα και το κλείσιμο των στομάτων.

Το σαν ντόνατ αυτό κουλουράκι που περιβάλλεται από πλήθος διακοσμητικά γλασέ ροζ μυτάκια, θα ταίριαζε θαυμάσια σε τούρτα παιδικών γενεθλίων. Αυτή η διακόσμηση, ωστόσο, δεν καλύπτει απλώς κάποια εξωτερική επιφάνεια· είναι ο εξωτερικός προστατευτικός δακτύλιος ενός σωλήνα που εκτείνεται πολύ πιο κάτω από την επιφάνεια – ο αναπνευστικός πόρος μιας κάμπιας.

Όλα τα έντομα έχουν αναπνευστικές οπές, τα στίγματα, κατά μήκος των πλευρών του σώματός τους. Οι κάμπιες των νυχτοπεταλούδων έχουν εννέα ζεύγη – οκτώ στα τμήματα της κοιλιάς και ένα ζεύγος στο πρόσθιο θωρακικό τάγμα (τα αναπτυσσόμενα εξογκώματα φτερών αντικαθιστούν τα στίγματα στο μεσαίο και το πίσω τμήμα του θώρακα). Κάθε στίγμα είναι η είσοδος σε έναν σωλήνα που διακλαδίζεται όλο και περισσότερο, καθώς διεισδύει στο μεταμερές. Οι σωλήνες αυτοί, οι τραχείες, επιτρέπουν στο οξυγόνο της ατμόσφαιρας να φτάσει στο εσωτερικό της κάμπιας για να χρησιμοποιηθεί στον μεταβολισμό του εντόμου και έπειτα να αποβληθεί το παραγόμενο διοξείδιο του άνθρακα.

Οι κινήσεις των μυών της κάμπιας, καθώς περιφέρεται στο φυτό με το οποίο τρέφεται, βοηθούν να αντλούν και να εξάγουν τον αέρα κατά μήκος των τραχειών. Επιπλέον, μια υποτυπώδης αντλία στο κεφάλι απομυζά αιμολέμφη (το αντίστοιχο του αίματος στα έντομα) κατά μήκος του μόνου πραγματικά αιμοφόρου αγγείου στη ράχη της κάμπιας και το διοχετεύει στην κοιλότητα του σώματος. Καθώς η αιμολέμφη επιστρέφει ρέοντας παθητικά προς το ουραίο τμήμα της κάμπιας αφομοιώνει και μεταφέρει μέρος του οξυγόνου, εξασφαλίζοντας πως κανένα τμήμα του εντόμου δεν θα πάθει ασφυξία.

Τα έντομα, περιλαμβανομένης και της κάμπιας, ελέγχουν το άνοιγμα και το κλείσιμο των στιγμάτων με μια βαλβίδα ακριβώς κάτω από την επιφάνεια (σχεδόν αόρατη στην εικόνα). Οι βαλβίδες στις κάμπιες κλείνουν κυρίως για να περιοριστεί η απώλεια νερού όταν κάνει ζέστη αλλά και για να μην πνιγούν σε περίπτωση πλημμύρας. Η ικανότητα αυτή επιτρέπει σε πολλά έντομα να ζουν σε παλιρροϊκές ζώνες ή σε ελώδεις εκβολές ποταμών.

ΔΕΞΙΑ
Στο κάτω μέρος του φύλλου δύο καταφρακτικά κύτταρα που περιβάλλουν το στόμα τεντώνουν ή χαλαρώνουν για να το ανοίξουν ή να το κλείσουν.

ΑΡΙΣΤΕΡΑ
Ο καπνός, όπως όλοι οι φωτοσυνθετικοί οργανισμοί, συνθέτει υδατάνθρακες από διοξείδιο του άνθρακα και νερό.

ΔΕΞΙΑ
Ο προεξέχων δακτύλιος είναι το άνοιγμα ενός από τους εννέα αναπνευστικούς πόρους (στίγματα) της κάμπιας του λεπιδόπτερου Arctia caja.

ΑΡΙΣΤΕΡΑ
Η αστεία γούνα της κάμπιας του λεπιδόπτερου (κοινώς «μαλλιαρό αρκουδάκι») την προστατεύει κάπως από τα αρπακτικά.

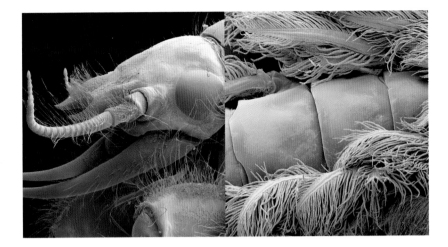
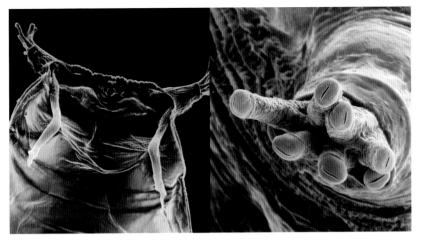

Έργο αυτών των φανταχτερών φτερών δεν είναι να ζεσταίνουν ή να στολίζουν κάποιο πουλί, ούτε φτερουγίζουν ελαφρά στον αέρα, καθώς ανήκουν σε έναν υδρόβιο οργανισμό: πρόκειται για όργανα αναπνοής, δηλαδή βράγχια.

Τα έντομα της οικογένειας Sialicidae αποτελούν μια ολιγομελή ομάδα της τάξης των Μεγαλόπτερων. Τα ακμαία έχουν τέσσερα μεγάλα φτερά που τα κινούν αργά, και μοιάζουν με τους μυρμηκολέοντες, τους χρύσωπες και τις λιβελούλες. Απαντώνται κοντά σε νερά γιατί οι υδρόβιες προνύμφες τους ζουν σε λίμνες και ρεύματα που συνήθως βρίθουν εντόμων· πολλά όμως από αυτά τα υδρόβια έντομα, όπως οι προνύμφες του κουνουπιού ή οι κωπηλάτες, πρέπει να ανεβαίνουν στην επιφάνεια για να αναπνεύσουν. Πραγματικά υδρόβιοι οργανισμοί, όπως οι προνύμφες του συγκεκριμένου εντόμου, έχουν βράγχια για να απορροφούν οξυγόνο διαλυμένο στο νερό.

Το ποσοστό του οξυγόνου στην ατμόσφαιρα είναι περίπου 200.000 προς ένα εκατομμύριο μέρη, δηλαδή αποτελεί το 20% του ατμοσφαιρικού αέρα. Το αντίστοιχο ποσοστό οξυγόνου σε νερό κορεσμένο με διαλυμένο οξυγόνο είναι μόλις 15 μέρη. Δεν είναι, όμως, μόνο αυτή η διαφορά που δυσχεραίνει τόσο την αναπνοή των υδρόβιων εντόμων, είναι και η μεγαλύτερη πυκνότητα του νερού. Το βάρος του νερού είναι τέτοιο που είναι αδύνατο να το αντλεί και να το αποβάλλει αρκετά γρήγορα, ώστε να αποσπά το αναγκαίο οξυγόνο.

Τα έντομα με βράγχια λύνουν το πρόβλημα αναπτύσσοντας εξωτερικά στο σώμα τους τεράστια και φυλλοειδή βράγχια, προλαβαίνοντας έτσι να απορροφήσουν αρκετά μόρια οξυγόνου.

Η ύπαρξη ενός ζεύγους βραγχίων σε κάθε τμήμα του σώματος είναι απόηχος της καταγωγής τους από τις τραχείες, τους εσωτερικούς αναπνευστικούς σωλήνες που απαντώνται σε χερσαίες προνύμφες και σε ακμαία έντομα, κάτι που επιβεβαιώνουν και οι γεμάτοι αέρα σωλήνες μεταφοράς μέσα στα βράγχια. Η παθητική μεταφορά του οξυγόνου μέσω του αέρα είναι εκατό χιλιάδες φορές ταχύτερη από ό,τι μέσω του νερού.

Αυτές οι προεκβολές μοιάζουν με δάχτυλα που αν σηκωθούν θα δείξουν απευθείας τον παρατηρητή τους. Ίσως, όμως, είναι άλλου είδους αισθητήριο όργανο σαν τις οφθαλμικές κεραίες του σαλιγκαριού, σχιστά μάτια που τεντώνουν το λαιμό για να έχουν καλύτερη θέα. Όμως, αυτοί οι σωλήνες βρίσκονται στο πίσω άκρο μιας πλαγγόνας και επιτελούν μια άλλη λειτουργία: είναι οι αναπνευστικοί σωλήνες της μύγας των φρούτων (οικογένεια Tephritidae) και οι σχισμές είναι τα στενά ανοίγματα από όπου εισπνέει οξυγόνο και αποβάλλει διοξείδιο του άνθρακα.

Σε αντίθεση με τις κάμπιες, που έχουν στίγματα σε κάθε τμήμα του σώματος, οι πλαγγόνες της μύγας συνήθως περιορίζονται στα στίγματα που φέρουν στο πίσω άκρο τους (αν και μερικές έχουν και στο πρόσθιο τμήμα). Τα στίγματα απεικονίζουν τον τρόπο ζωής της νύμφης και αυτό συνήθως σημαίνει ότι τρέφεται με ρευστές ή ημίρρευστες ύλες, ψοφίμια, κοπριά, οργανικά λιπάσματα ή στάσιμα νερά. Άλλες είναι κρυμμένες στο έδαφος ή μέσα σε φυτά. Η προνύμφη έχοντας ένα στίγμα στην ουρά μπορεί να τρώει με το κεφάλι κάτω. Στην προνύμφη του κουνουπιού τα πίσω στίγματα περιβάλλονται από τρίχες, που όταν αυτό βυθίζεται στο νερό κλείνουν σαν βαλβίδα, και όταν επιστρέφει στην επιφάνεια τινάζονται απότομα σχηματίζοντας αναπνευστήρα. Οι προνύμφες με τις ποντικοουρές (είδος Συρφίδες) ζουν όπου υπάρχουν υγρά απόβλητα και γι' αυτό οι αναπνευστικοί τους σωλήνες (οι «ποντικοουρές») φτάνουν μέχρι και τα 30 εκατοστά μήκος.

Εδώ εικονίζεται η πλαγγόνα μιας μύγας των φρούτων. Η προνύμφη έχει τραφεί με το σάπιο φρούτο και μολονότι πρέπει να μετακινήθηκε λίγο για να μεταμορφωθεί σε πλαγγόνα, μια δέσμη όρθιων αναπνευστικών σωλήνων θα τη βοηθήσουν να επιζήσει σε περίπτωση που οι χυμοί του σάπιου φρούτου απειλήσουν να την κατακλύσουν.

Για να είμαστε ακριβείς, το σκληρό κέλυφος μέσα στο οποίο θα αναπτυχθεί το ακμαίο έντομο είναι το δέρμα της προνύμφης που ερεθίστηκε και σκλήρυνε· η πλαγγόνα ή χρυσαλλίδα ζει μέσα στο κέλυφος. Συνεπώς, οι σωλήνες διοχετεύουν αέρα μέσα στο κέλυφος, ώστε η πλαγγόνα να αναπνέει και κατά το τελικό στάδιο της μεταμόρφωσής της.

ΔΕΞΙΑ
Φυλλοειδή βράγχια εκτείνονται σε όλο το σώμα της υδρόβιας προνύμφης της μύγας των φρούτων. Καθώς η επιφάνειά τους είναι μεγάλη, το έντομο προλαβαίνει να απορροφήσει από το νερό το αναγκαίο για την επιβίωσή του οξυγόνο.

ΑΡΙΣΤΕΡΑ
Οι υδρόβιες προνύμφες της μύγας των φρούτων (οικογένεια Tephritidae) είναι άγρια αρπακτικά, όπως και του συγγενικού της χρυσώπου.

183

ΔΕΞΙΑ
Οι αναπνευστικοί σωλήνες της μύγας των φρούτων στο πίσω άκρο του βομβυκιού της (puparium), τα στίγματα, επιτρέπουν στο έντομο την αναπνοή κατά τη μεταμόρφωσή του σε ακμαίο.

ΑΡΙΣΤΕΡΑ
Το βομβύκιο της μύγας των φρούτων προέρχεται από το δέρμα της προνύμφης που ερεθίστηκε και σκλήρυνε και το οποίο έτσι μετατράπηκε σε κέλυφος μέσα στο οποίο το έντομο υφίσταται την τελική του μεταμόρφωση.

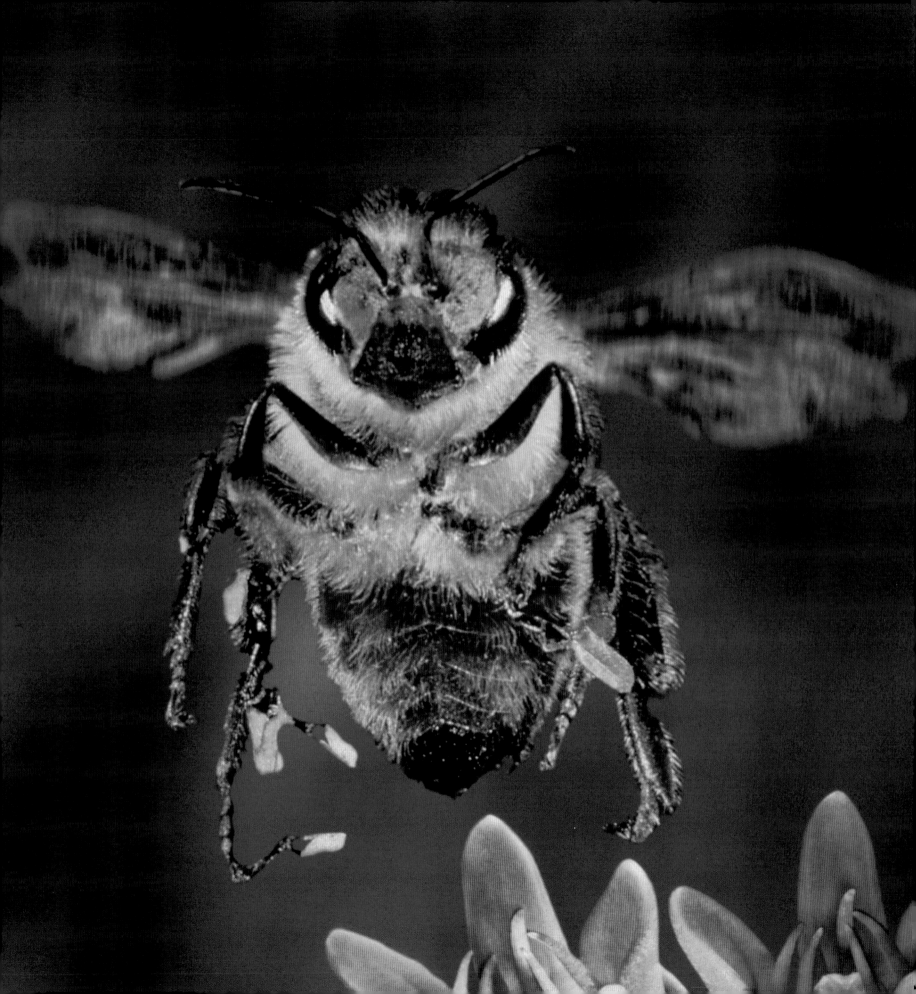

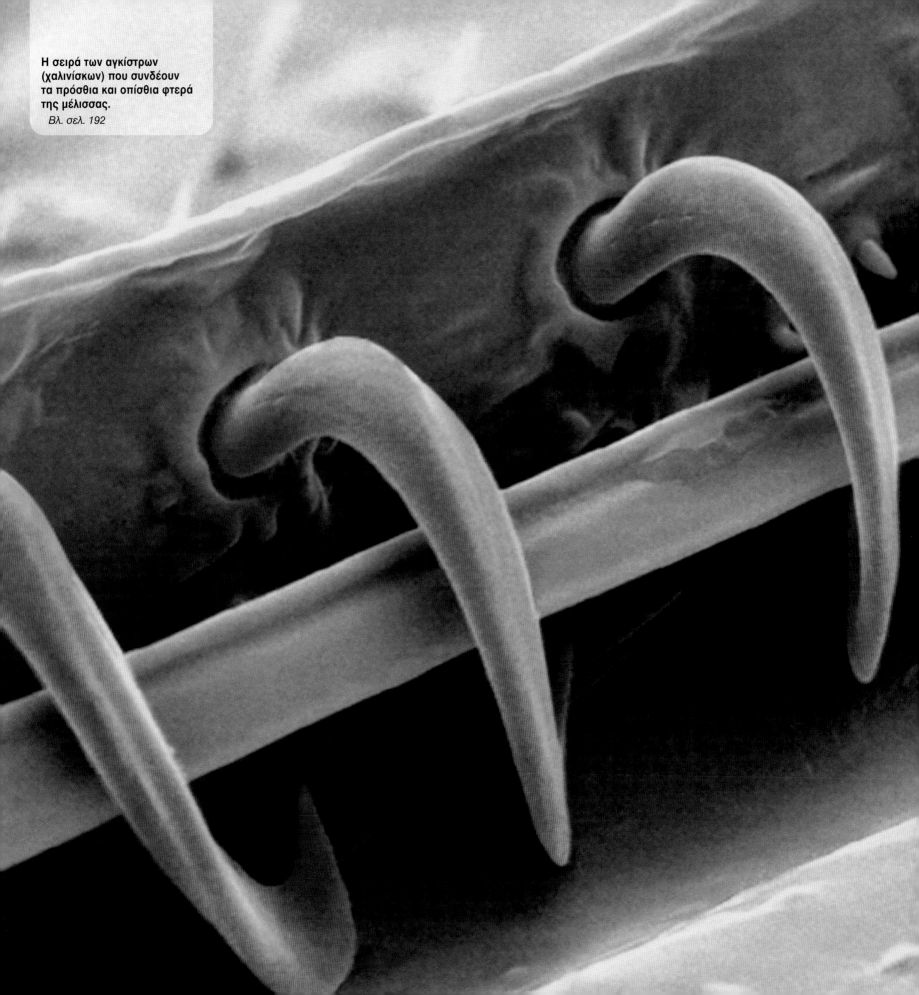

Η σειρά των αγκίστρων (χαλινίσκων) που συνδέουν τα πρόσθια και οπίσθια φτερά της μέλισσας.

Βλ. σελ. 192

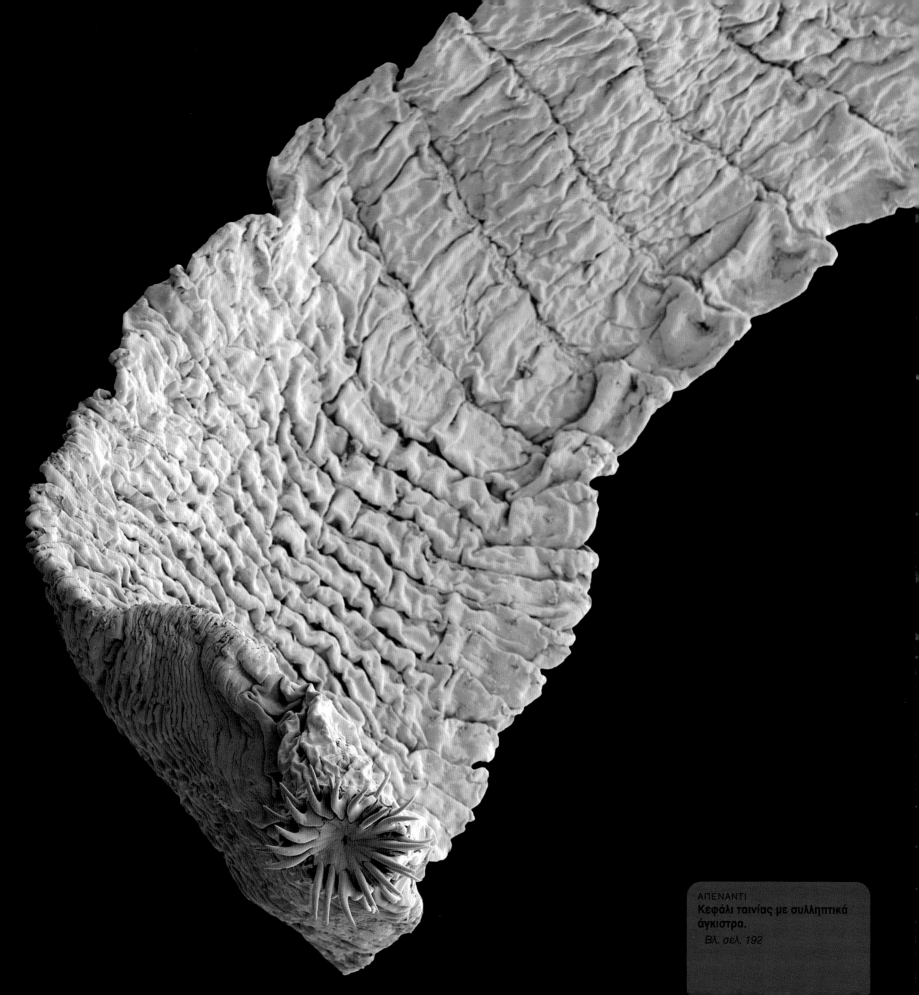

ΑΠΕΝΑΝΤΙ
Κεφάλι ταινίας με συλληπτικά άγκιστρα.
Βλ. σελ. 192

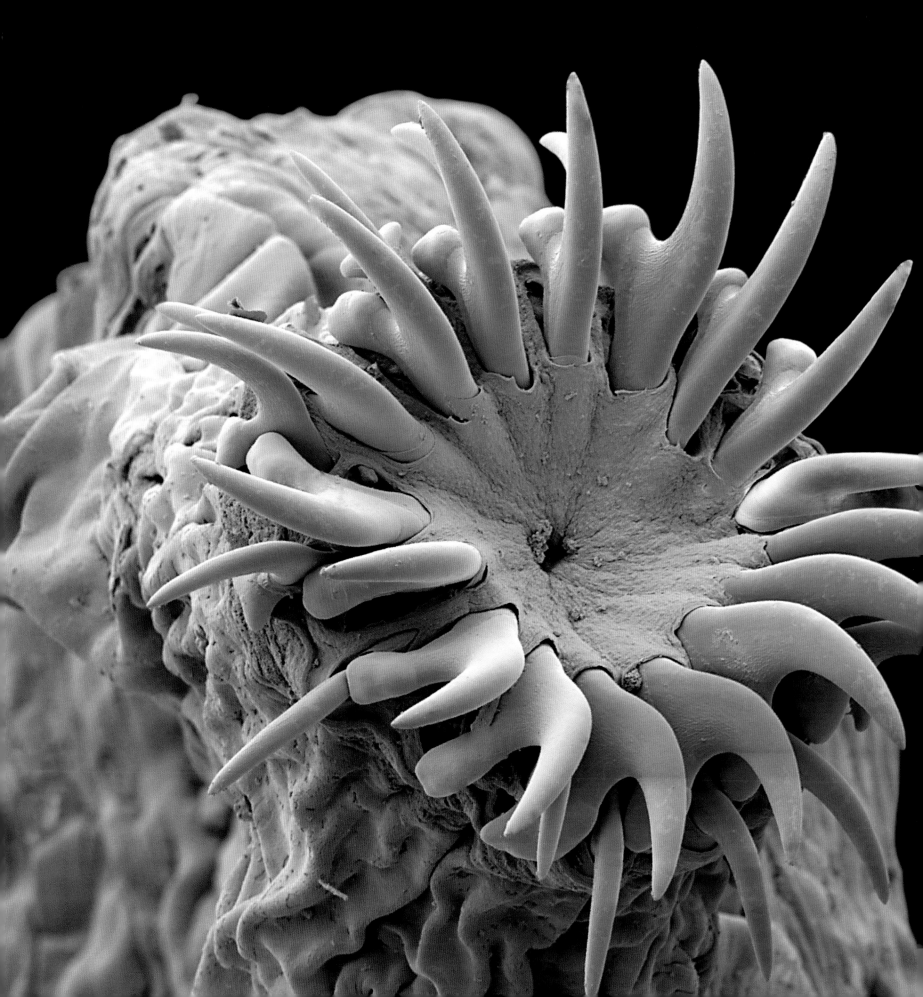

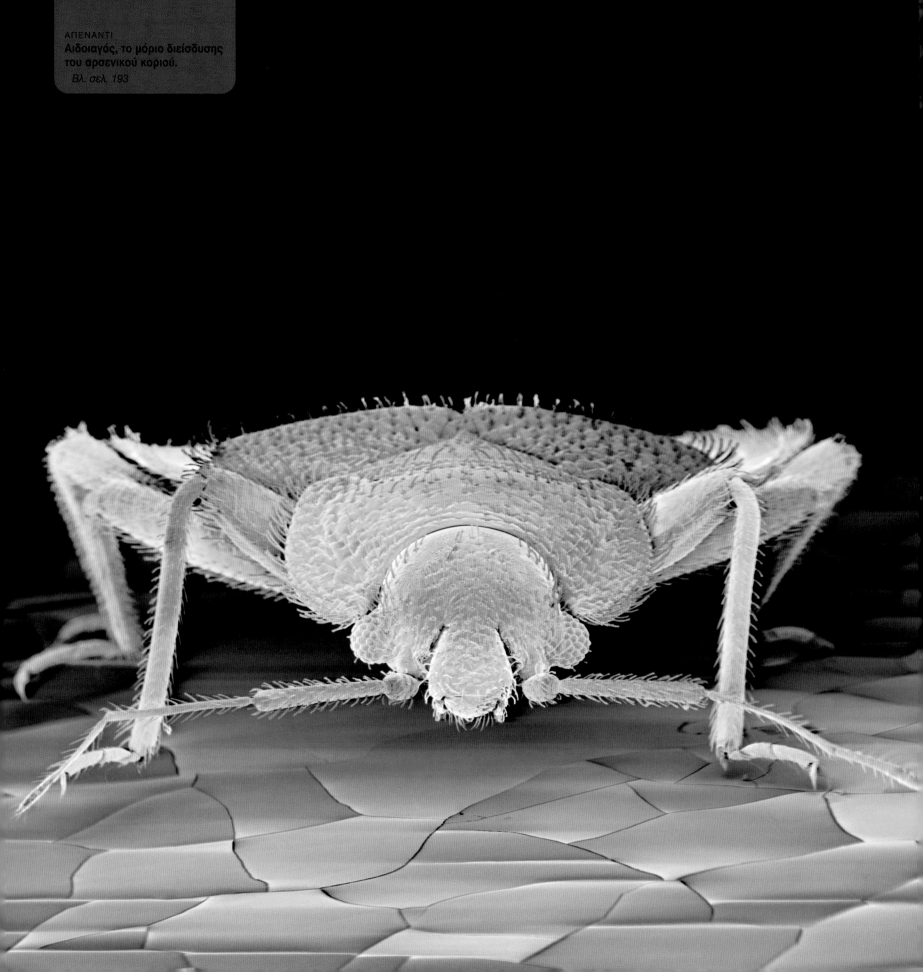

ΑΠΕΝΑΝΤΙ
Αιδοιαγός, το μόριο διείσδυσης του αρσενικού κοριού.
Βλ. σελ. 193

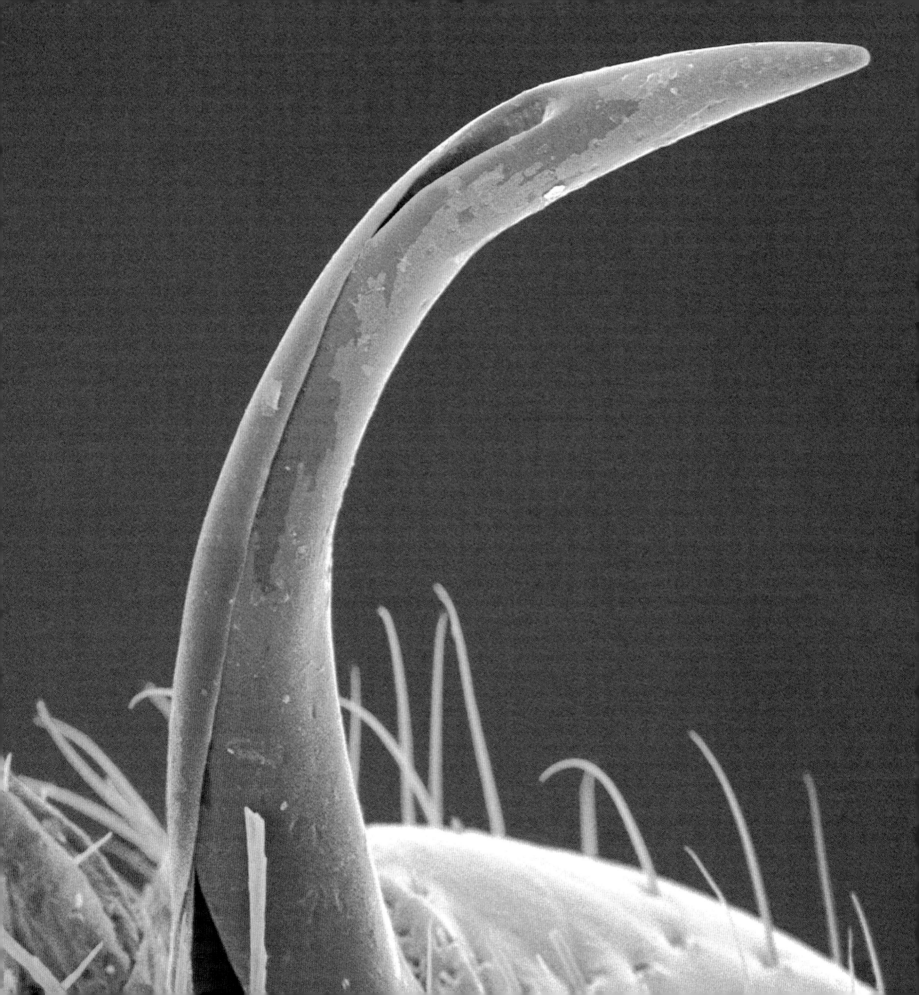

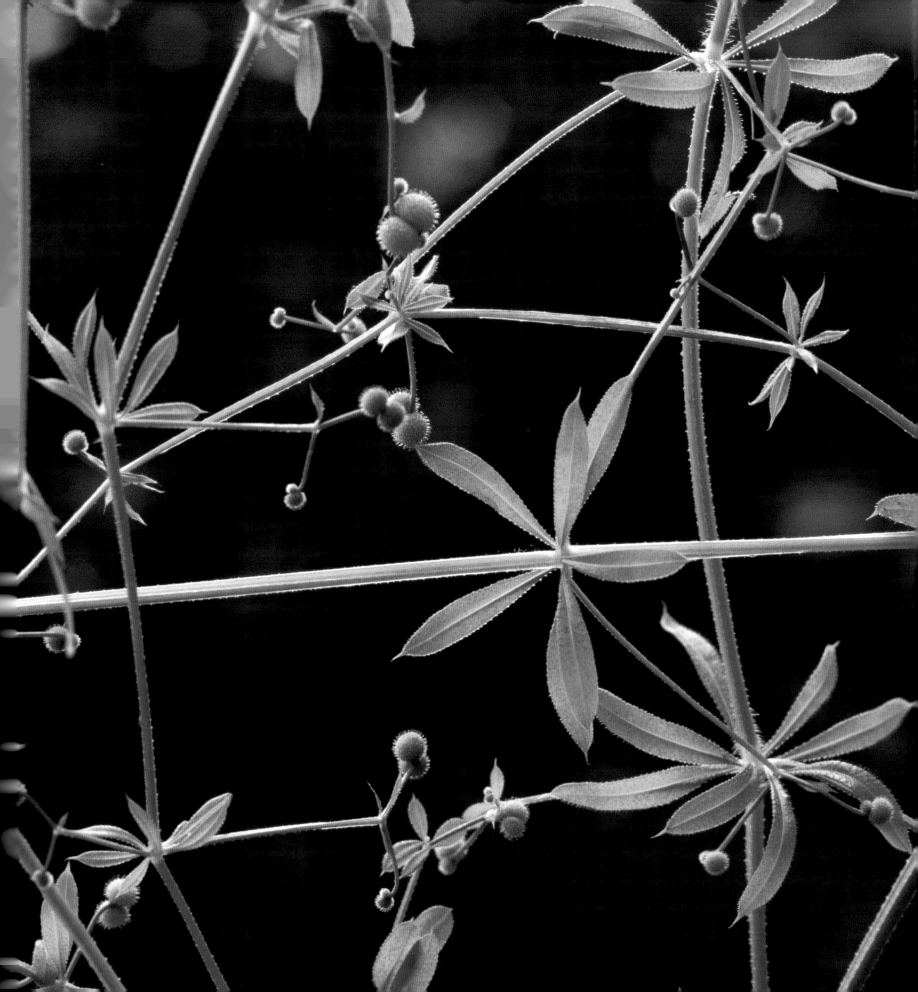

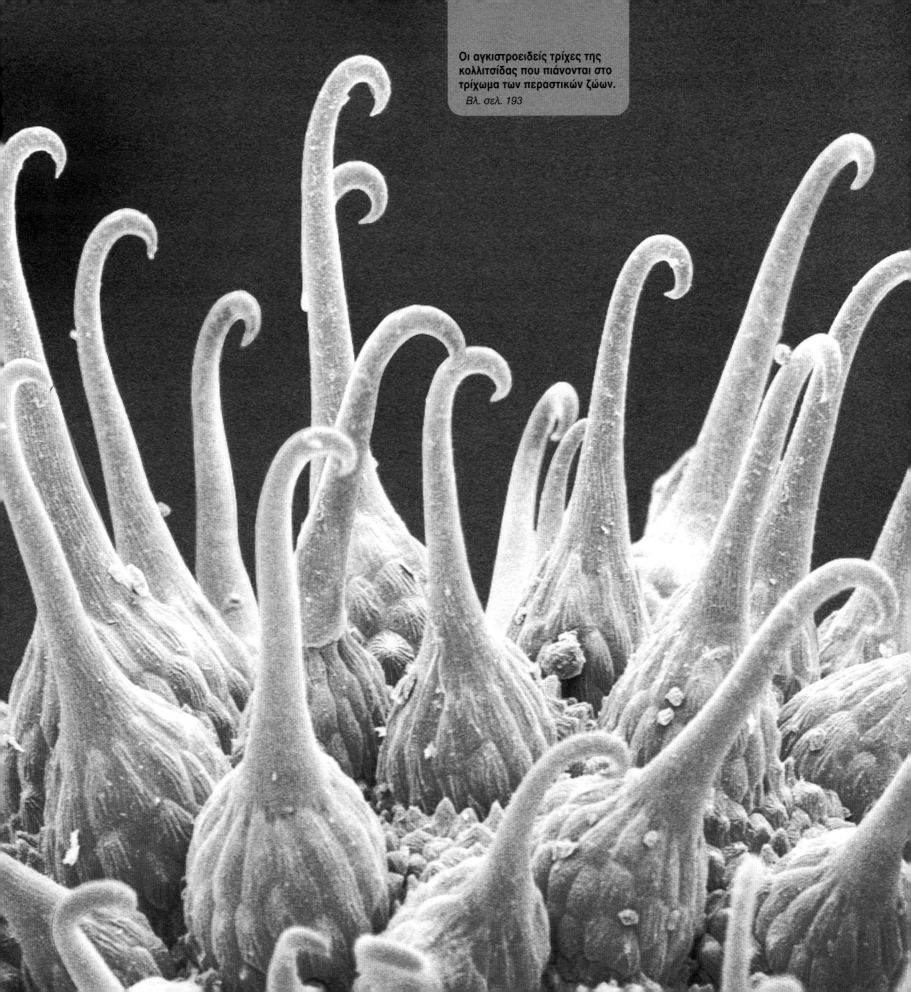

Οι αγκιστροειδείς τρίχες της κολλιτσίδας που πιάνονται στο τρίχωμα των περαστικών ζώων.
Βλ. σελ. 193

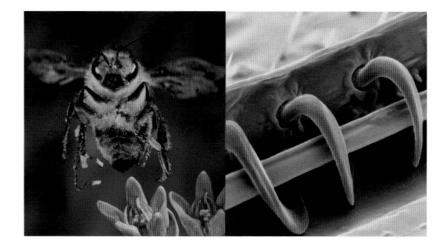

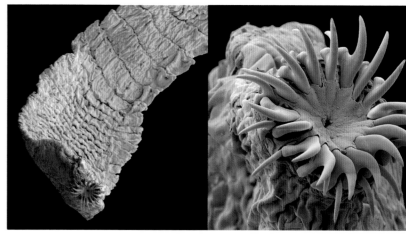

Αυτά που βλέπεις και μοιάζουν με το εξάρτημα μιας πόρτας κήπου, σφυρήλατα αγκίστρια που συγκρατούν μια ράβδο, ή το σπιράλ ενός τετραδίου, δεν είναι παρά άγκιστρα στις άκρες του φτερού μέλισσας.

Τα περισσότερα έντομα φέρουν δύο ζεύγη φτερών, το ένα στον μεσοθώρακα, το άλλο στον μεταθώρακα (μόνο οι μύγες είναι δίπτερα, καθώς το ζεύγος του μεταθώρακα έχει εκφυλιστεί σε όργανο εξισορρόπησης, βλ. σελ. 151). Σε πιο πρωτόγονες ομάδες, όπως οι λιβελούλες, η κίνηση κάθε ζεύγους είναι ίδια – πάνω-κάτω – και συγχρονισμένη με του άλλου αλλά ανεξάρτητη.

Στα πολυάριθμα έντομα της τάξης των Υμενόπτερων (μέλισσες, σφήκες, μυρμήγκια) το πρόσθιο και το οπίσθιο ζεύγος κινούνται ενωμένα σαν ένα όργανο. Τα πρόσθια είναι μεγαλύτερα από τα οπίσθια που λειτουργούν σαν προέκτασή τους. Συγκρατούνται μαζί από τα άγκιστρα, τους χαλινίσκους (hamuli) που πιάνονται στις ενισχυμένες παρυφές των προσθίων. Έτσι αυξάνει η αεροδυναμική ισχύς του συστήματος των φτερών, καθώς ισχυροί μυικοί κινητήρες θέτουν σε ενέργεια μια ενιαία μεμβράνη.

Ο μηχανισμός σύνδεσης των φτερών εμφανίζεται στις περισσότερες άλλες ομάδες εντόμων και μοιάζει να έχει αναπτυχθεί ανεξάρτητα. Στις πεταλούδες μια προεξοχή, ο βραχιόνιος λοβός (humeral lobe), πιάνεται από το οπίσθιο άκρο του πρόσθιου φτερού. Στους σκόρους τον ίδιο ρόλο παίζει ο χαλινίσκος (frenulum) στην κάτω επιφάνεια του οπίσθιου φτερού που πιάνεται από μια θηλιά (retinaculum) στην κάτω επιφάνεια του πρόσθιου φτερού.

Ο διπλός αυτός δακτύλιος αγκίστρων είναι ζωτικής σημασίας για την τρηματώδη πλατυέλμινθα: είναι η άγκυρα με την οποία η ταινία γαντζώνεται στα έντερα του ξενιστή της, καθώς πρέπει να πιάνεται γερά στα τοιχώματα για να μην παρασύρεται από τις μισοχωνεμένες τροφές. Το όνομα του παρασίτου αυτού οφείλεται στο σχήμα του σώματός του που φτάνει σε μήκος τα 18 μέτρα. Όλες οι ταινίες είναι παράσιτα στα έντερα των σπονδυλωτών, που απέκτησαν πεπλατυσμένο σχήμα για να απορροφούν εύκολα θρεπτικές ουσίες μέσω του δέρματός τους από τα έντερα του ξενιστή τους. Το σώμα τους χωρίζεται σε εκατοντάδες τμήματα, τις προγλωττίδες. Κάθε προγλωττίδα φέρει μήτρα που περιέχει μέχρι 50.000 αυγά. Όταν η ταινία ωριμάζει απορρίπτει προγλωττίδες από το πίσω μέρος της μαζί με τα περιττώματα.

Τα μικροσκοπικά αυγά περνούν στο περιβάλλον και ένας δεύτερος ξενιστής θα τα φάει άθελά του. Άμεσοι φορείς της ταινίας σκύλου ή αλεπούς είναι τα κουνέλια και οι λαγοί. Τα μικροσκοπικά αυγά γλιτώνουν το μάσημα και στο στομάχι αντιδρούν στα ένζυμα της πέψης, εισβάλλοντας στα τοιχώματα των εντέρων και μεταναστεύοντας έξω στον μυικό ιστό. Εδώ σχηματίζουν μικρές κύστεις, τους κυστίκερκους, που όταν τους καταπιεί ο σκύλος μαζί με το κρέας μολύνεται από το παράσιτο.

Οι άνθρωποι προσβάλλονται από δύο είδη ταινίας, την Taenia saginata και την Taenia solium· δευτερεύων ξενιστής της πρώτης είναι τα βοοειδή και της δεύτερης οι χοίροι. Η ταινία λοιπόν μεταδίδεται με το κρέας, εάν δεν είναι καλά ψημένο.

Δύο από τα συμπτώματα που προκαλεί αυτό το παράσιτο είναι αδυνάτισμα και δυσκοιλιότητα.

ΔΕΞΙΑ
Μια σειρά χαλινίσκων κατά μήκος του οπίσθιου φτερού μέλισσας πιάνονται από το πρόσθιο, σχηματίζοντας ενιαία πτητική μεμβράνη.

ΑΡΙΣΤΕΡΑ
Οι μέλισσες είναι δυνατές και συχνά πετούν αρκετά χιλιόμετρα μακριά από την κυψέλη για να βρουν νέκταρ και γύρη.

ΔΕΞΙΑ
Ο δακτύλιος με τα άγκιστρα στο κεφάλι μιας ταινίας σκύλου χρησιμεύει για να γαντζώνεται στα τοιχώματα των εντέρων, ενώ το υπόλοιπο του σώματός του απορροφά τις θρεπτικές ουσίες από τις μισοχωνεμένες τροφές.

ΑΡΙΣΤΕΡΑ
Το πλατύ σώμα προσφέρει στην ταινία μεγάλη επιφάνεια απορρόφησης ουσιών από τα έντερα του ξενιστή.

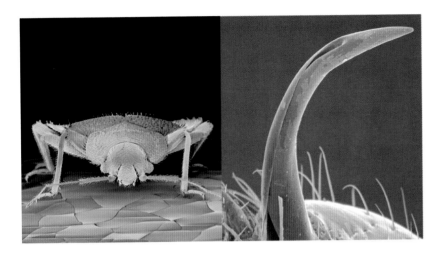

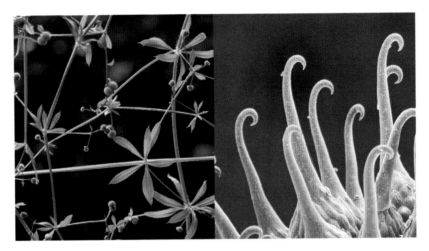

Αυτό το άγκιστρο σαν βελόνα ιστιοράφτη που την έχει σηκώσει ψηλά για να περάσει κλωστή, μοιάζει ικανό να τρυπήσει ακόμα και το πιο σκληρό πανί. Τα άγκιστρα είναι χρήσιμα εργαλεία, ευρέως διαδεδομένα στο ζωικό και φυτικό βασίλειο. Χρησιμοποιούνται για να συγκρατούν, αλλά και σαν όπλα. Στην προκειμένη περίπτωση ο φαλλός του κοριού – περί αυτού πρόκειται – έχει και τις δύο λειτουργίες: στο ζευγάρωμα τον χρησιμοποιεί για να διαρρήξει την κοιλιά του θηλυκού και συνάμα για να εγχύσει το σπέρμα του στο θηλυκό, παρακάμπτοντας τα γεννητικά του όργανα.

Το αγκιστροειδές εξάρτημα της εικόνας λέγεται παραμερές και είναι μέρος των γεννητικών οργάνων του κοριού. Στα περισσότερα έντομα δύο παραμερή σχηματίζουν τον αιδοιαγό, το όργανο διείσδυσης του αρσενικού. Κατά την οχεία το παραμερές του κοριού τρυπά την κοιλιά του θηλυκού από κάτω ανάμεσα σε δύο μεταμερή

του σώματός του. Διεισδύει όμως όχι όπως θέλει, αλλά καθοδηγούμενο από μια βαθιά κοιλότητα στο σώμα του θηλυκού που οδηγεί το παραμερές σε ένα σημείο από όπου το σπέρμα φτάνει εύκολα στις ωοθήκες.

Η στρατηγική οχείας του κοριού είναι γνωστή ως τραυματική γονιμοποίηση και οι μόνοι άλλοι οργανισμοί που την εφαρμόζουν είναι τα στρεψίπτερα, μικροσκοπικά παράσιτα συγγενή των σκαθαριών που ξενιστές τους είναι κυρίως οι μέλισσες, και τα υμενόπτερα. Παρότι βίαιη, η συμπεριφορά αυτή λέγεται ότι είναι απόρροια της σύγκρουσης μεταξύ αρσενικού και θηλυκού σε όλα τα είδη: τα αρσενικά επιδιώκουν συνεχώς την αναπαραγωγή του είδους, αφού άλλωστε το κόστος της ενέργειας που αναλώνουν για την παραγωγή σπέρματος είναι μικρό, ενώ τα θηλυκά μπορεί να εξαντληθούν ή και να σακατευτούν από τα επανειλημμένα ζευγαρώματα.

Η εντυπωσιακή αυτή παράταξη αγκίστρων είναι έτοιμη να αρπάξει οποιονδήποτε διαβάτη. Αλλά αντί να συλλάβει αυτή κάποιο ταλαίπωρο θύμα, θα πιαστεί η ίδια από κάποιον περαστικό. Πρόκειται, βλέπετε, για τα μικροσκοπικά άγκιστρα που περιβάλλουν το σπέρμα του φυτού γάλλιον η απαρίνη, κοινώς κολλιτσίδα. Οι καρποί με τις αγκιστροειδείς αυτές τρίχες μόλις πιαστούν στο τρίχωμα κάποιου περαστικού ζώου κρατιούνται γερά πάνω του, ώσπου να φτάσουν σε νέα βοσκοτόπια.

Η κολλιτσίδα δεν είναι φυτό της τάξης των Αγρωστωδών, είναι ζιζάνιο με στενά φύλλα και μικρά λευκά άνθη που φυτρώνει σε φράχτες, χέρσα χωράφια, θαμνότοπους, στις άκρες των δρόμων, σε λιβάδια. Αναπτύσσεται γρήγορα και σύντομα σκιάζει άλλα φυτά. Εάν αρκούνταν στο να ρίχνει τα σπέρματά της καταγής, η κολλιτσίδα θα είχε εκλείψει, γιατί αυτά θα σκιάζονταν από το μητρικό φυτό και δεν θα φύτρωναν.

Γι' αυτό ο μικρός καρπός της που περιέχει τρία σπέρματα καλύπτεται ολόκληρος από τις αγκιστροειδείς άκανθες. Ακανθώδη περιβλήματα καρπών απαντώνται σε διαφορετικές ομάδες φυτών. Κολλούν στο τρίχωμα περαστικών ζώων, αλλά και στα ρούχα των ανθρώπων που άθελά τους διασπείρουν τους σπόρους τους.

Τα άγκιστρα δεν κοιτούν όπου θέλουν: όλα έχουν λίγο πολύ την ίδια κατεύθυνση, ώστε κάποια στιγμή να ξεσκαλώνει ο σπόρος. Είναι σημαντικό οι σπόροι να προσκολληθούν στο ζώο, αλλά εξίσου σημαντικό είναι κάποια στιγμή να πέσουν στη γη για να φυτρώσουν.

Η διασπορά τους σε μεγάλη ακτίνα συμβάλλει στη γενετική μείξη παρεμποδίζοντας την τοπική ενδο-αναπαραγωγή και αποτρέπει την εξαφάνιση του φυτού εγκαθιστώντας απόκεντρες αποικίες. Η κολλιτσίδα έχει πετύχει θαυμάσια αυτούς τους στόχους και γι' αυτό είναι ζιζάνιο ευρέως διαδεδομένο σε όλο το βόρειο ημισφαίριο.

ΔΕΞΙΑ
Ο αρσενικός κοριός χρησιμοποιεί τον φαλλό του για να διαρρήξει την κοιλιά του θηλυκού και να διοχετεύσει το σπέρμα του.

ΑΡΙΣΤΕΡΑ
Ο κοριός απαντάται σε κατοικίες σε όλο τον κόσμο. Έχει πεπλατυσμένο σώμα για να κρύβεται σε ρωγμές κρεβατιών, πίσω από ταπετσαρίες και γενικά σε σχισμές.

ΔΕΞΙΑ
Τα αγκιστροειδή αγκάθια της κολλιτσίδας πιάνονται στο τρίχωμα περαστικών ζώων (και στα ρούχα) και έτσι οι σπόροι διασπείρονται μακριά από τον γονέα τους.

ΑΡΙΣΤΕΡΑ
Η κολλιτσίδα δεν είναι αγρωστώδες, αλλά φυτό δικοτυλήδονο που ανήκει στην οικογένεια των Ρουβιιδών.

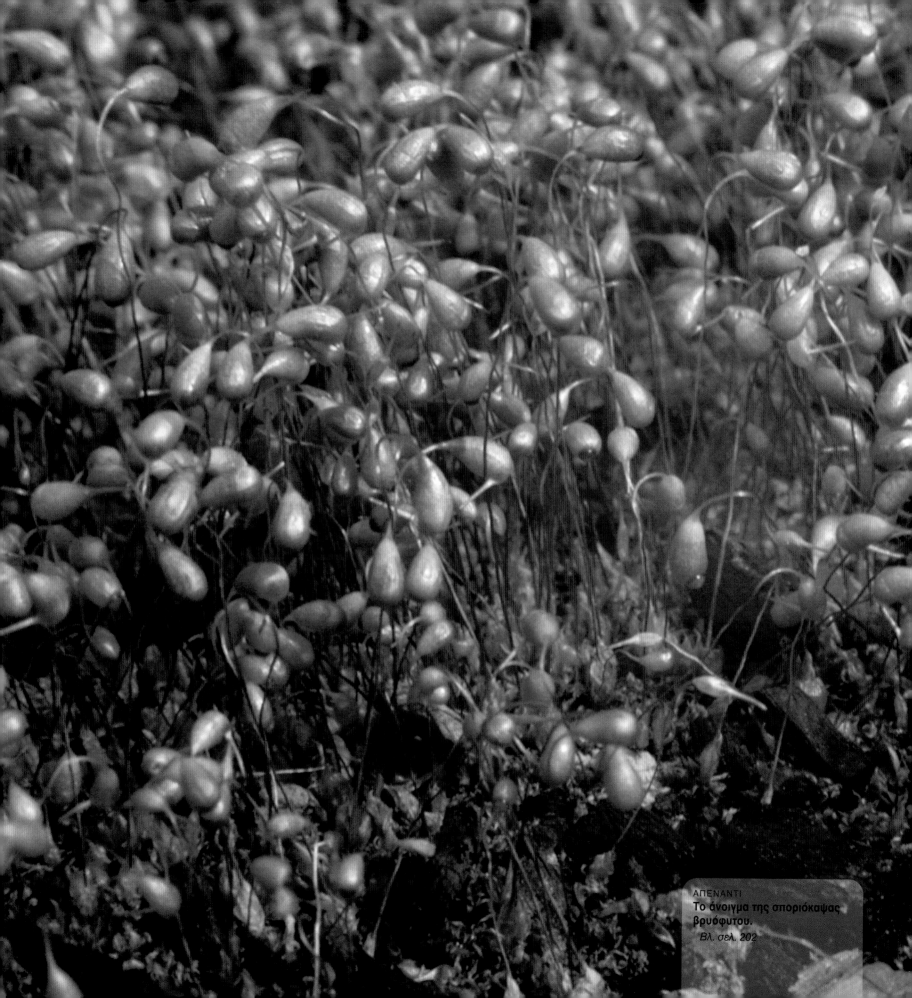

ΑΠΕΝΑΝΤΙ
Το άνοιγμα της σποριόκαψας βρυόφυτου.
Βλ. σελ. 202

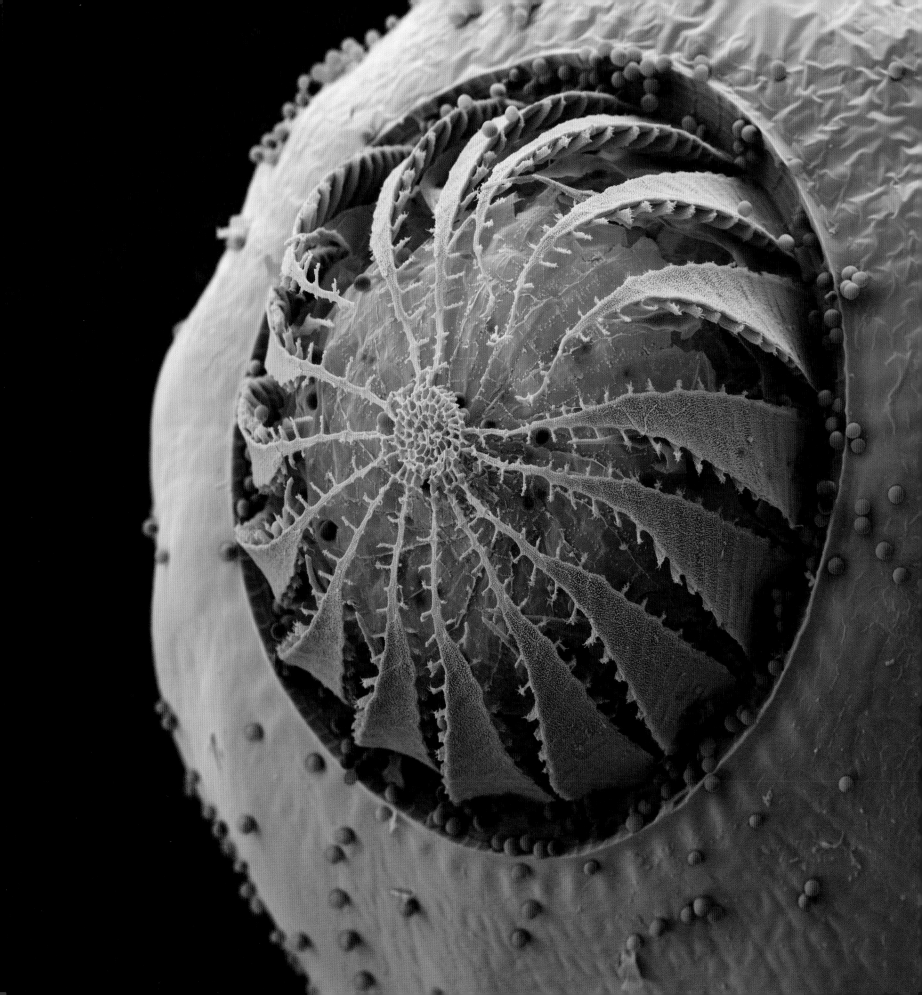

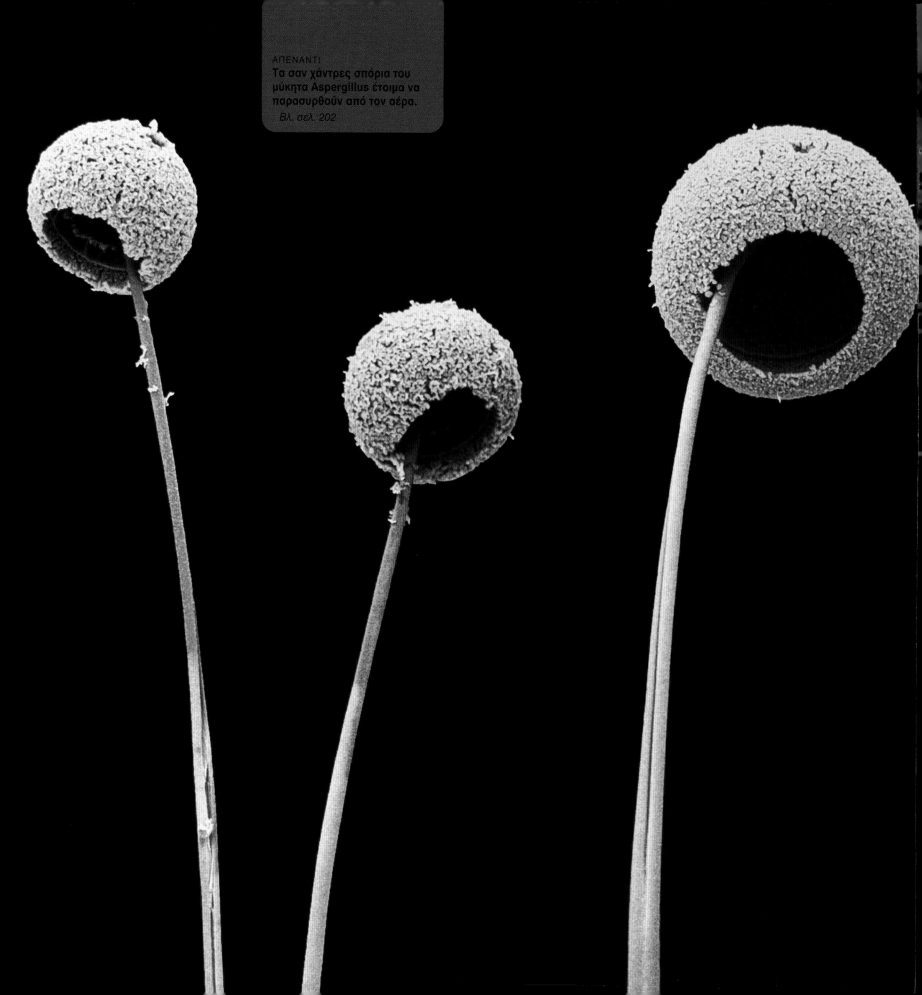

ΑΠΕΝΑΝΤΙ
Τα σαν χάντρες σπόρια του
μύκητα Aspergillus έτοιμα να
παρασυρθούν από τον αέρα.
Βλ. σελ. 202

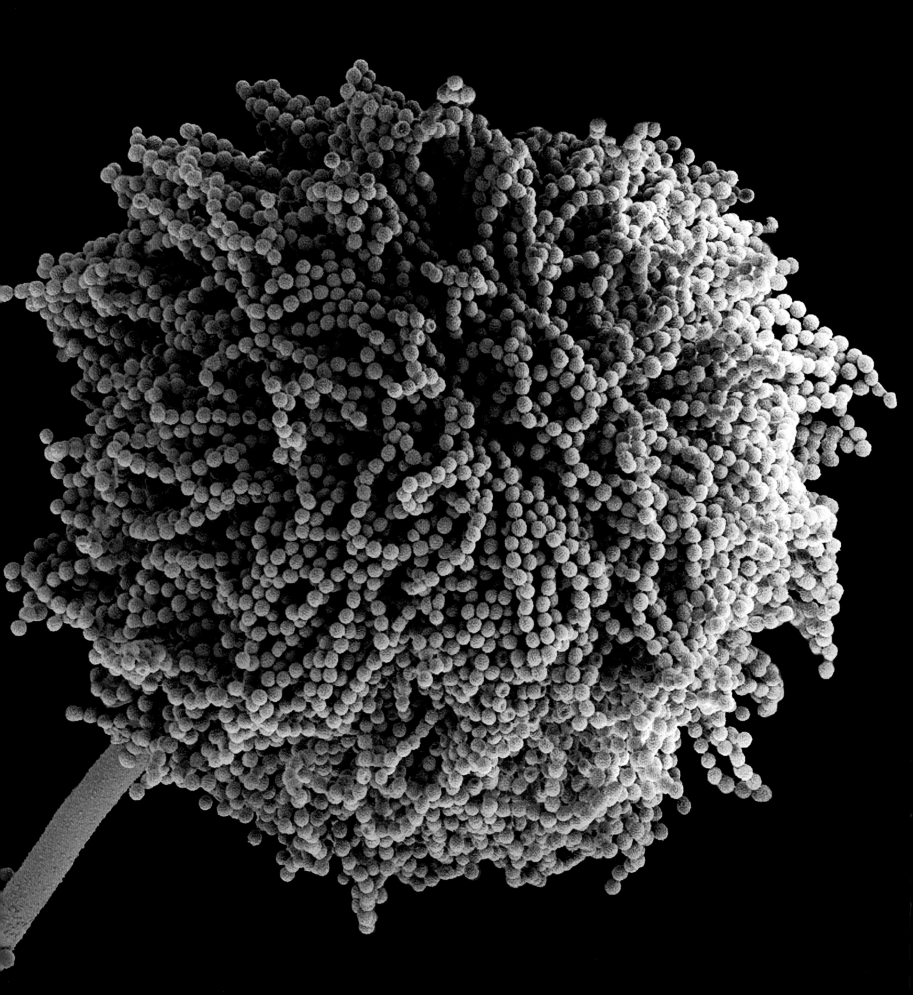

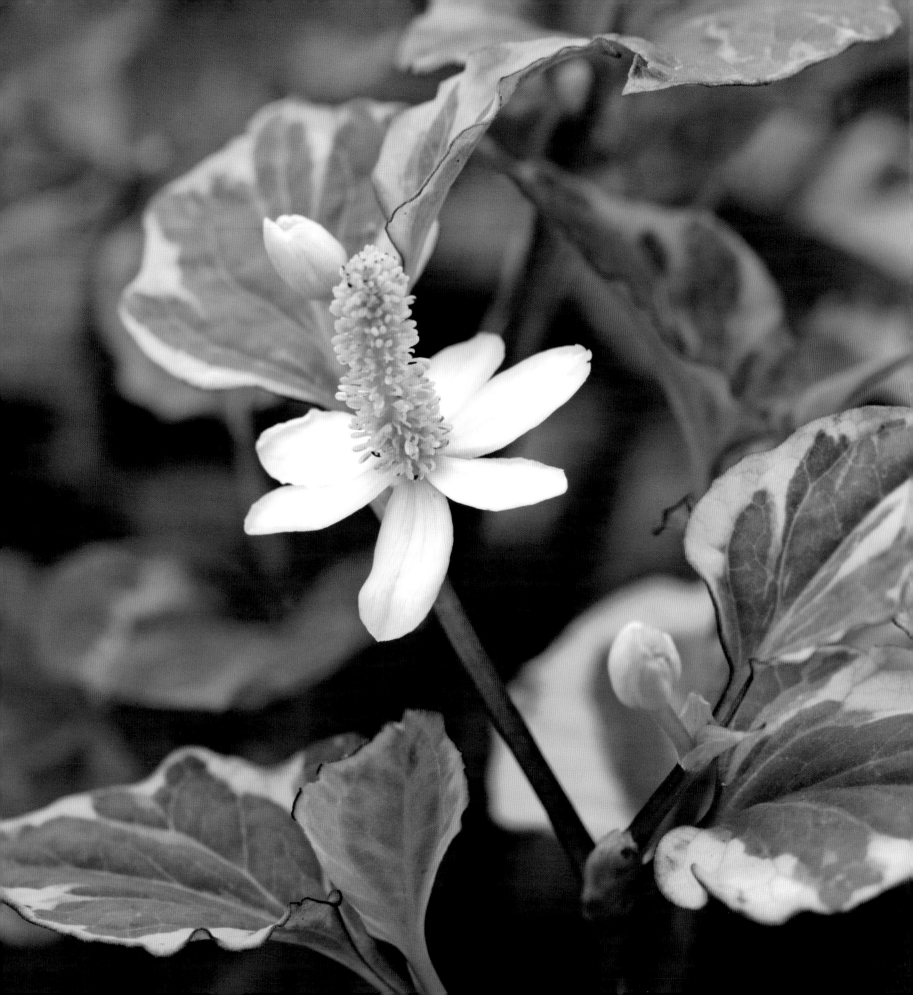

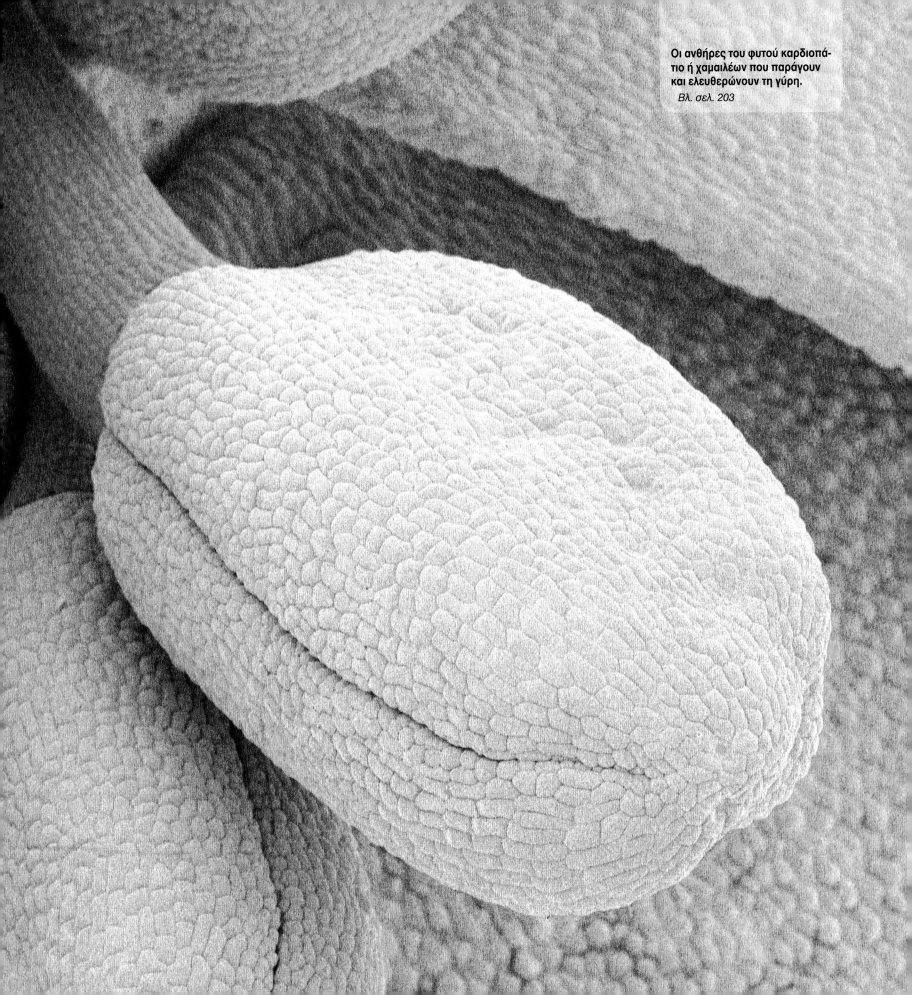

Οι ανθήρες του φυτού καρδιοπά-
τιο ή χαμαιλέων που παράγουν
και ελευθερώνουν τη γύρη.

Βλ. σελ. 203

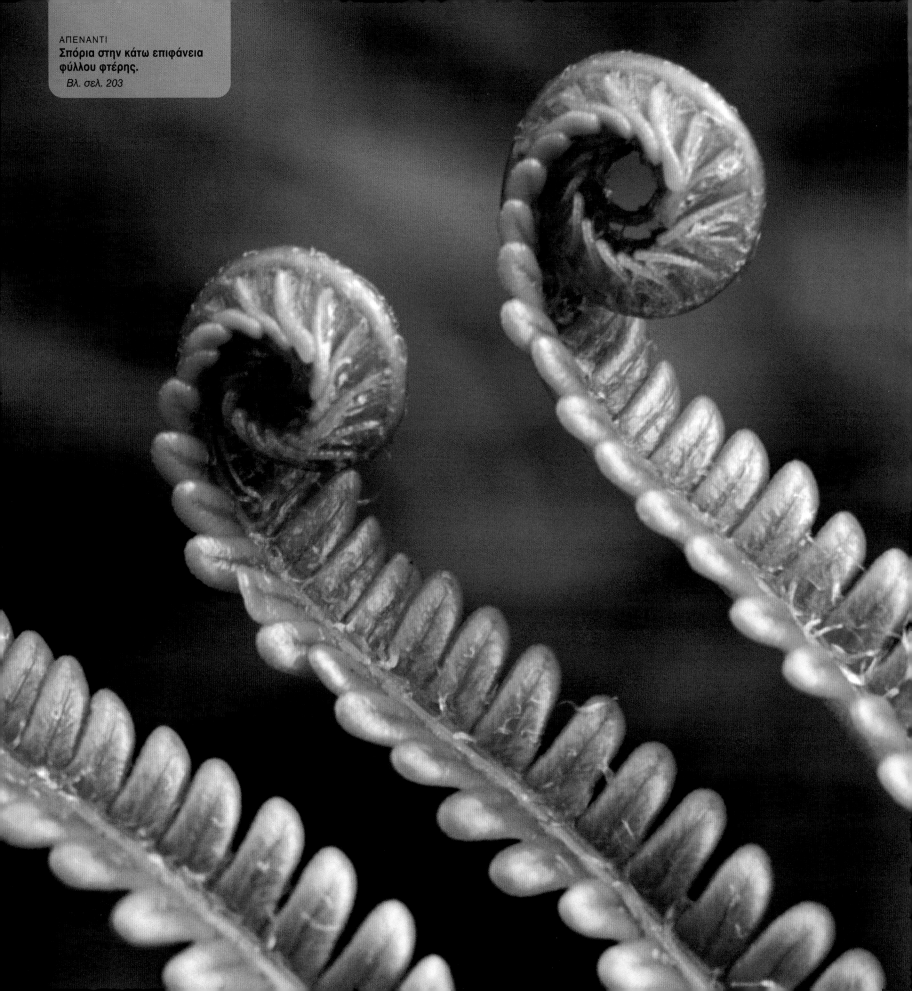

ΑΠΕΝΑΝΤΙ
Σπόρια στην κάτω επιφάνεια
φύλλου φτέρης.
Βλ. σελ. 203

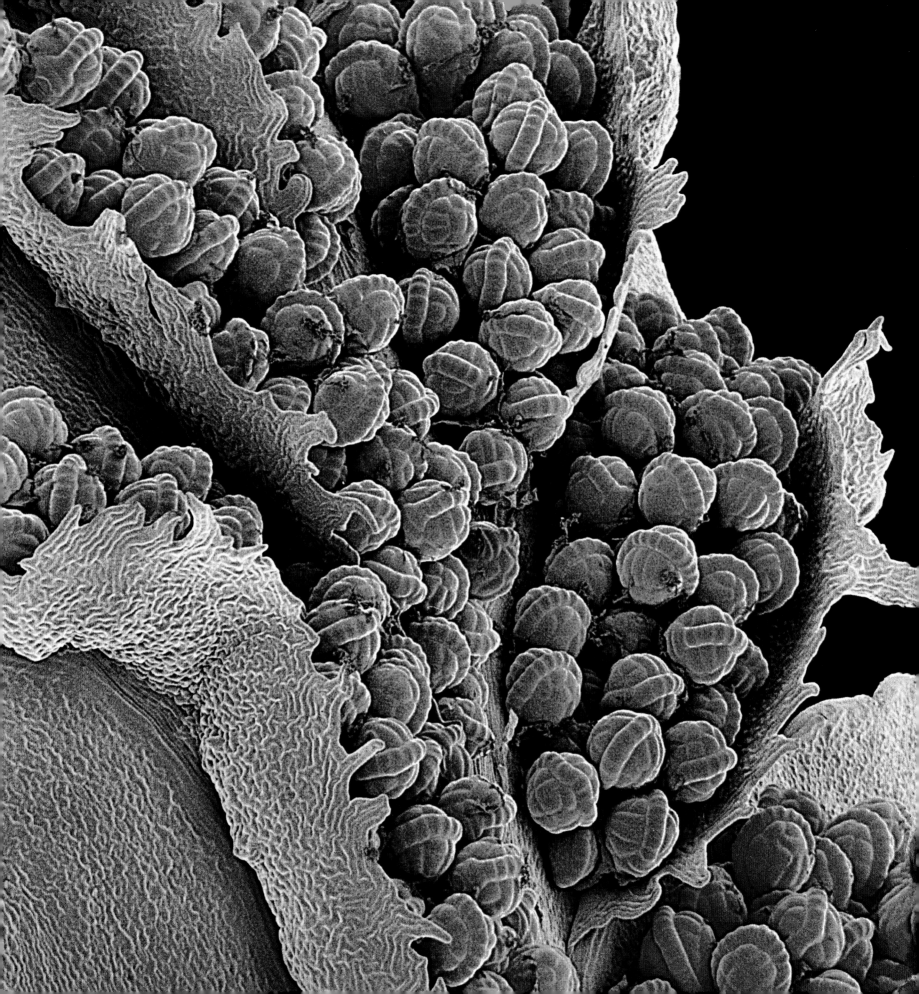

Τα οδοντωτά, κεκλιμένα τριγωνικά ελάσματα της εικόνας αυτής μοιάζουν με στόμιο εισαγωγής στροβιλοκινητήρα, με τη διαφορά πως πρόκειται για το λεγόμενο περιστόμιο που δεν ελέγχει την είσοδο αλλά την έξοδο μικροσκοπικών σπορίων από την κάψα ενός βρυόφυτου.

Τα βρύα ή μούσκλια είναι φυτά χωρίς αγγειακό αγωγό σύστημα, δηλαδή χωρίς τα αγγεία που διέρχονται μέσα από τις ρίζες και τους βλαστούς του φυτού μεταφέροντας θρεπτικές ουσίες και νερό. Συνήθως, δεν είναι παρά πυκνές συστάδες φύλλων που σχηματίζουν τάπητες με «πέλος» ύψους μόλις λίγων εκατοστών. Τα μόνα εξέχοντα χαρακτηριστικά τους είναι τα σποριόφυτα, «καρποί» που φέρουν σπόρια και αποτελούνται από ένα μακρύ στέλεχος που την επιστέφει η σποριόκαψα.

Σε αντίθεση με άλλα πράσινα φυτά, τα βρυόφυτα δεν έχουν άνθη και τα σπόριά τους διαφέρουν από τα σπέρματα (τους σπόρους), γιατί δεν έχουν αποθηκευμένες θρεπτικές ουσίες. Παρ' όλα αυτά τα σπόρια γεννούν φυτοειδείς οργανισμούς, τα γαμέφυτα ή προθάλλια, που έπειτα εξελίσσονται αποκτώντας τους βλαστούς και τα φύλλα που διακρίνουμε. Όπως άλλα πράσινα φυτά, χρησιμοποιούν την ηλιακή ενέργεια για να φωτοσυνθέτουν θρεπτικές ουσίες. Τα γαμετόφυτα περιέχουν ανθηρίδια και αρχεγόνια, τα αρσενικά και θηλυκά όργανα πολλαπλασιασμού του φυτού.

Τα βρυόφυτα φύονται κυρίως σε υγρούς τόπους γιατί χρειάζονται υγρασία κατά τη διαδικασία του εγγενούς πολλαπλασιασμού τους. Τα σπερμοζωίδια του σπέρματος των βρύων, του ανθηρίδιου, εξωτερικά μοιάζουν πολύ με αυτά ζώου, με τη διαφορά πως τα σπερμοζωίδια έχουν δύο βλεφαρίδες αντί για μία. Αυτά πρέπει να διασχίσουν κολυμπώντας το λεπτό υδάτινο στρώμα στην επιφάνεια του φύλλου για να γονιμοποιήσουν τα θηλυκά αρχεγόνια. Από το γονιμοποιημένο ωοκύτταρο προέρχεται το σποριόφυτο, δηλαδή η διπλοειδής γενεά του βρυόφυτου που φέρει τα σπόρια.

Υπάρχουν 10.000 είδη βρυόφυτων στον κόσμο. Το είδος Φουναρία η υγρομετρική είναι διαδεδομένη σε όλο τον κόσμο. Φύεται παντού και ιδίως σε διαταραγμένα εδάφη, σε κήπους και θερμοκήπια. Είναι είδη «σκαπανέων» αποικίζοντας χερσότοπους και συχνά καμένες περιοχές.

ΔΕΞΙΑ
Σπόρια και προστατευτικό περιστόμιο σποριόκαψας του βρυόφυτου Φουναρία η υγρομετρική.

ΑΡΙΣΤΕΡΑ
Τα βρυόφυτα αναπτύσσονται σε γυμνά υποστρώματα, όπως σε βράχια, πέτρες, τοίχους και σκεπές, όπου δεν σκιάζονται από άλλα φυτά.

Αυτός ο σφαιρικός θύσανος από λεπτές χάντρες περασμένες σε κλωστή μοιάζει με κόσμημα ή αξεσουάρ φορέματος. Οι χάντρες σχηματίζουν νήματα αλλά σύντομα θα αρχίσουν να αποσπώνται η μία μετά την άλλη, καθώς το θέμα της εικόνας είναι ο καρπός του μύκητα Aspergillus και οι χάντρες είναι τα σπόρια του που είναι έτοιμα να πετάξουν.

Νηματοειδείς σχηματισμοί του μύκητα Aspergillus υπάρχουν παντού. Τα σπόρια του μπορούν να αναπτυχθούν σε κάθε σχεδόν οργανική ύλη και ορισμένα σε στερούμενα τροφής σημεία, όπως σε υγρούς τοίχους όπου αποτελούν μείζον συστατικό της μούχλας. Ιδιαίτερα, ωστόσο, συνδέονται με βρεγμένο σανό, ειδικά όταν έχει ζεσταθεί για να στεγνώσει. Όπως όλοι οι μύκητες, έτσι και ο ασπέργιλλος έχει σώμα αποτελούμενο από λεπτά διακλαδιζόμενα νημάτια, τις υφές, που όλες μαζί λέγονται μυκήλιο. Οι υφές διεισδύουν στην τροφή και απορροφούν θρεπτικές ουσίες ώσπου να έρθει η ώρα του πολλαπλασιασμού τους μέσω εξειδικευμένων υφών που λέγονται κονιδιοφόροι. Οι κονιδιοφόροι δεν είναι προϊόν γονιμοποίησης, γι' αυτό κάθε σπόριο ταυτίζεται γενετικά με το σώμα του γονέα από το οποίο προήλθε.

Τα μικροσποπικά σπόρια είναι αερόβια αποτελώντας μέρος ενός πλαγκτόν διαφορετικού από αυτό των υδάτων. Είναι τόσο μικρά που τα εισπνέουμε δίχως να το αντιλαμβανόμαστε. Όταν ένα σπόριο φτάσει στους πνεύμονες απομακρύνεται πάραυτα από το ανοσοποιητικό σύστημα του σώματος. Ορισμένα άτομα, όμως, για διάφορους λόγους δεν έχουν ανοσία στον ασπέργιλλο, σε ένα από τα λίγα είδη που αναπτύσσονται στη σχετικά υψηλή θερμοκρασία του ανθρώπινου σώματος. Η λοίμωξη ονομάζεται ασπεργίλλωση και μπορεί να αποβεί μοιραία. Ένα άλλο πλάσμα στο οποίο επιτίθεται είναι η μέλισσα. Προνύμφες που έχουν πάθει μυκητίαση είναι μαύρες και σκληρές μετά το θάνατο, γι' αυτό και αποκαλούνται λιθώδεις γόνοι.

ΔΕΞΙΑ
Τα όμοια με χάντρες σπόρια ενός είδους ασπέργιλλου είναι έτοιμα να πετάξουν στον αέρα.

ΑΡΙΣΤΕΡΑ
Παρότι αβλαβής σε υγιή άτομα, ο ασπέργιλλος είναι επικίνδυνος για άτομα με αναπνευστικά προβλήματα ή εξασθενημένο ανοσοποιητικό σύστημα.

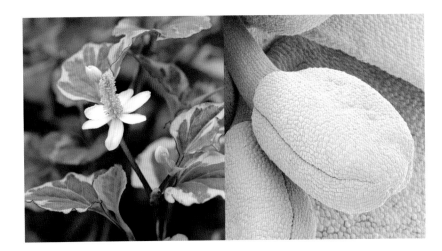

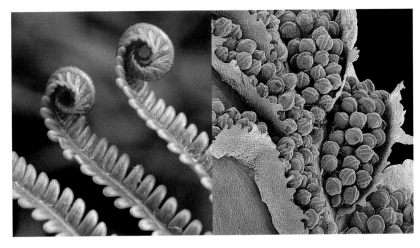

Δύο απλές βολβοειδείς μπαλίτσες, όμως οι σχισμές στο πλάι υπόσχονται πως κάτι κρύβουν μέσα τους. Και πράγματι, κρύβουν το αρσενικό γενετικό υλικό του φυτού, καθώς αυτό που βλέπουμε είναι οι ανθήρες που φέρουν τους γυρεόκοκκους.

Τα άρρενα όργανα αναπαραγωγής του φυτού είναι οι στήμονες που το σύνολό τους λέγεται ανδρείο ή ανδρώνας. Κάθε στήμονας αποτελείται από ένα λεπτό στέλεχος, το νήμα, και τον ανθήρα στην κορυφή του, τα σπόρια του οποίου (οι άρρενες γαμέτες) γονιμοποιούν τους γαμέτες του άλλου φύλου (σπερματοβλάστες). Ανάλογα με το είδος του φυτού, οι γυρεόκοκκοι μεταφέρονται με τον αέρα, από επικονιαστές ή με άλλο τρόπο.

Οι γυρεόκοκκοι είναι μικροσκοπικοί και δεν περιέχουν παρά σχεδόν μόνο γενετικό υλικό. Εντός του ανθήρα τα κύτταρα διαιρούνται μέσω μιας διεργασίας που λέγεται μείωση, παράγουν δηλαδή αναπαραγωγικά κύτταρα (γαμέτες) που φέρουν τον μισό αριθμό χρωμοσωμάτων από τον κανονικό,

δηλαδή τα λεγόμενα απλοειδή κύτταρα. Η ίδια διεργασία μείωσης επαναλαμβάνεται και κατά την παραγωγή σπερματοβλαστών στις ωοθήκες του θηλυκού φυτού. Έτσι, όταν ένας απλοειδής αρσενικός γαμέτης (ο γυρεόκοκκος) γονιμοποιεί έναν θηλυκό απλοειδή γαμέτη (σπερματοβλάστη) γεννιέται ένα διπλοειδές κύτταρο, που περιέχει δηλαδή δύο σειρές χρωμοσωμάτων, και ο σπόρος του φυτού είναι έτοιμος να φυτρώσει.

Οι γυρεόκοκκοι μέσα στον ανθήρα κάποια στιγμή ωριμάζουν, οπότε ο ανθήρας ανοίγει. Στην περίπτωση των φυτών που χρειάζονται επικονιαστές η χρονική αυτή στιγμή συμπίπτει με την ύπαρξη νέκταρος, ώστε να προσελκυστούν οι επίδοξοι επικονιαστές.

Ο αριθμός των στημόνων και ο αντίστοιχος των ωοθηκών ήταν στο παρελθόν ένα από τα κριτήρια ταξινόμησης των φυτών, αλλά και η αιτία ζωηρής διαφωνίας μεταξύ των κυρίων που ξάπλωναν πάνω σε στρώμα λουλουδιών με τόσο πολλές κυρίες.

Σαν τοποθετημένα ωραία καρύδια στον πάγκο κάποιου μανάβη αυτοί οι καρποί μοιάζουν ώριμοι για μάζεμα. Ωστόσο, δεν είναι καρποί που θα πέσουν στο έδαφος μόλις ωριμάσουν, αλλά θα τους πάρει ο αέρας. Τα σπόρια στα σποριάγγεια της φτέρης (Pteridion) είναι μικροσκοπικά σαν κόκκοι σκόνης και μεταφέρονται πολλά χιλιόμετρα μακριά.

Όπως στα βρυόφυτα, έτσι και στα φυτά της κλάσης των Πτεριδικών έχουμε το φαινόμενο της εναλλαγής γενεών, δηλαδή ενώ η μία γενεά πολλαπλασιάζεται με παρθενογένεση, η επόμενη αναπτύσσει σπόρια με τα οποία πολλαπλασιάζεται. Από τα σπόρια γεννιούνται πράσινα κύτταρα που αποκαλούνται προθαλλός και τα οποία φέρουν και αρσενικά και θηλυκά όργανα αναπαραγωγής. Οι αρσενικοί γαμέτες γονιμοποιούν τους θηλυκούς, κολυμπώντας έως αυτούς στο νερό πάνω στο φύλλο του φυτού. Σε αντίθεση με τα βρυόφυτα που παράγουν εξειδικευμένες σποριόκαψες (βλ. σελ. 195), τα πτεριδικά φέρουν σπόρια σε όλο τους το φύλλωμα και δη μέσα σε προστατευτικές θήκες (σποριάγγεια) στο κάτω μέρος των πτεριδίων των φύλλων τους.

Η φτέρη, ένα από τα πιο διαδεδομένα

πτεριδικά στον κόσμο, είναι αυτοφυές όλων των ηπείρων με εξαίρεση την Ανταρκτική, όπου σχηματίζει πυκνές λόχμες συνήθως σε όξινο έδαφος. Παραδόξως, γενεές που παράγονται από σπόρους στην περίπτωση της οικογένειας των Πτεριδίων (Pteridion) είναι πολύ σπάνιες. Αντί αυτού πολλαπλασιάζεται με ριζώματα από όπου φυτρώνουν νέα φυτά. Οι σπόροι φαίνεται πως δημιουργούν νέα φυτά μόνο σε πολύ άγονες περιοχές όπου δεν απειλούνται από μύκητες, όπως σε περιοχές που έχουν καεί.

Τα φύλλα των περισσότερων ειδών φτέρης είναι τοξικά για τα ζώα και τους ανθρώπους, αλλά στη Ιαπωνία καμιά φορά τρώνε μαγειρεμένους τους νεαρούς τους βλαστούς, παρότι έχει διαπιστωθεί πως είναι καρκινογόνοι. Αλλά και τα σπόρια τους περιέχουν καρκινογόνες χημικές ουσίες και γι' αυτό υπάρχει ο φόβος ότι όσοι περπατούν συχνά ή δουλεύουν σε δασικές περιοχές με πυκνή τέτοια βλάστηση κινδυνεύουν ελαφρώς. Παρά τους φόβους αυτούς και το γεγονός ότι σε πολλές χώρες θεωρούνται φυτά επιζήμια, παραμένουν σημαντικό και πολύτιμο χαρακτηριστικό των τοπίων, παρέχοντας τροφή και στέγη σε πολλά ζώα.

ΔΕΞΙΑ
Ανθήρες, βολβοειδείς δομές με στέλεχος που παράγουν και ελευθερώνουν τους αρσενικούς γαμέτες των φυτών, τους γυρεόκοκκους.

ΑΡΙΣΤΕΡΑ
Το φυτό χαμαιλέων είναι αυτοφυές της Ιαπωνίας, της Κίνας και της Νοτιοανατολικής Ασίας, που καλλιεργείται πλέον σε κήπους σε όλο τον κόσμο για τα ωραία φύλλα και άνθη που προσελκύουν έντομα.

ΔΕΞΙΑ
Στο κάτω μέρος του σύνθετου φύλλου μιας φτέρης τα σποριάγγεια έχουν ανοίξει και τραβηχτεί πίσω, φανερώνοντας τα μικροσκοπικά σπόρια έτοιμα πλέον να πετάξουν μακριά.

ΑΡΙΣΤΕΡΑ
Παρότι καρκινογόνα, σε μερικά μέρη της Ανατολικής Ασίας τα νεαρά φύλλα της φτέρης αποτελούν τροφή.

Άγκιστρα
Σειρά μικρών αγκίστρων στα υποτυπώδη φτερά της μέλισσας, της σφήκας και του μυρμηγκιού, που συνδέουν εμπρόσθια και οπίσθια φτερά κατά την πτήση.

Αιδοιαγός ή φαλλός
Το σκληρό όργανο οχείας (σύζευξης) του αρσενικού εντόμου.

Αιμολέμφος
Υγρό που κυκλοφορεί ελεύθερα, δηλαδή όχι σε αγγεία, στο σώμα των εντόμων.

Αιμοσφαιρίνη
Πρωτεΐνη του αίματος και των σωματικών υγρών ζωικών οργανισμών, η οποία περιέχει σίδηρο και χρησιμεύει στη μεταφορά οξυγόνου και διοξειδίου του άνθρακα.

Αισθητίδιο (sensillum)
Μικροσκοπικό αισθητήριο όργανο στο σώμα και ειδικά στις κεραίες εντόμου.

Ακετυλοχολίνη
Νευροδιαβιβαστής, δηλαδή βιοχημική ένωση που απελευθερώνεται από τις απολήξεις των νευρώνων όταν ενεργοποιούν κάποιον μυ.

Ακτινόζωο
Μονοκύτταρο ζώο με κυκλικό ή σφαιρικό σκελετό.

Αλτήρες
Οπίσθια φτερά της μύγας που έχουν μετασχηματιστεί σε λεπτά, ροπαλοειδή εξαρτήματα και χρησιμεύουν σαν αισθητήρια και όργανα εξισορρόπησης κατά την πτήση.

Αμφιβληστροειδής χιτώνας
Ο ευαίσθητος στο φως χιτώνας του ματιού.

Ανδρώνας (ή «ανδρείο»)
Το σύνολο των στημόνων, δηλαδή των αρρένων αναπαραγωγικών οργάνων του άνθους. Κάθε στήμονας αποτελείται από το νήμα και τον ανθήρα εντός του οποίου παράγεται η γύρη.

Απλή διαίρεση (διχοτόμηση)
Μονογονική αναπαραγωγή μονοκύτταρων οργανισμών κατά την οποία το σώμα τους μεγαλώνει και στη συνέχεια διαιρείται σε δύο (θυγατρικά) κύτταρα.

Απλοειδής
Ο οργανισμός που έχει τα μισά από τα κανονικά χρωμοσώματα.

Αρόλειο
Προσκολλητικός λοβός ανάμεσα στα δύο νύχια του ταρσού εντόμου.

Βλεφαρίδα
Τριχίδιο στην εξωτερική επιφάνεια κυττάρου.

Βομβύκιο
Το τελευταίο, διογκωμένο και σκληρό περίβλημα εντόμου και ειδικά της προνύμφης μύγας, που προστατεύει την πλαγγόνα ή χρυσαλλίδα καθώς αναπτύσσεται.

Γνάθος, κάτω (maxilla)
Μέρος στοματικού μορίου εντόμου ή άλλου αρθρόποδου, που λειτουργεί μαζί με τις δύο άνω γνάθους (mandibulae).

Γυναικοφόρος πόρος
Εγκοπή τρηματώδους πλατυέλμινθος όπου ενοικεί το θηλυκό.

Γυναικώνας
Το σύνολο των καρπόφυλλων, δηλαδή των θηλυκών οργάνων αναπαραγωγής του άνθους που σχηματίζουν τον ύπερο και τις ωοθήκες.

Δερμίδα
Σκληρός αλλά ελαστικός ιστός.

Δεσμός (retinaculum)
Θηλιά στο κάτω μέρος του εμπρόσθιου φτερού ορισμένων πεταλούδων, στην οποία γαντζώνει ο χαλινίσκος (frenulum) ή αγκίστρι ή άκανθα, συνδέοντας τα εμπρόσθια με τα οπίσθια φτερά κατά την πτήση του εντόμου.

Διάτομο
Μονοκύτταρος ευκαριωτικός οργανισμός που χαρακτηριστικό του είναι το πυριτικό θωράκιο του κυττάρου του (frustule), το οποίο αποτελεί θήκη από δύο κάψες.

Δικοτυλήδονα
Μεγάλη ομάδα φυτών που οι σπόροι τους περιέχουν δύο αντί ένα εμβρυακά φύλλα (κοτυλήδονες).

Διπλοειδής
Ο οργανισμός που στο γενετικό υλικό του κάθε χρωμόσωμα αντιπροσωπεύεται δύο φορές.

DNA
Συντομογραφία του δεσοξυριβοζονουκλεϊνικού οξέως. Κοίλο μόριο διπλής έλικας που εντοπίστηκε στα χρωμοσώματα φυτών και ζώων και είναι φορέας της γενετικής πληροφορίας.

Δυνάμεις Van der Waals
Ασθενείς διαμοριακές δυνάμεις.

Έμβολο
Διχαλωτό όργανο αναπήδησης των κολλέμβολων· επίσης το οστό «γιάντες» των πουλερικών.

Ενδόπλασμα
Εσωτερικό τμήμα του κυτοπλάσματος κυττάρου.

Ενδοσπέρμιο
Αποταμιευτικός ιστός που προορίζεται για τροφή του εμβρύου φυτικού καρπού.

Ενδοφαλλός
Εύκαμπτο και ελαστικό μόριο των γεννητικών οργάνων του εντόμου μέσω του οποίου εγχέεται σπέρμα.

Εξίνη
Σκληρό εξωτερικό τοίχωμα του κόκκου της γύρης.

Εξώπλασμα
Εξωτερική επίστρωση κυτοπλάσματος κυττάρου ζωικού οργανισμού.

Εξωσκελετός
Σκληρό, συνήθως αποτελούμενο από άρθρα εξωτερικό κέλυφος των εντόμων, καρκινοειδών, σκορπιών και άλλων ζώων.

Επισπέρμιο
Σπερματικό κέλυφος.

Θειογλυκοζίτες
Τοξικοί υδατάνθρακες που εντοπίστηκαν σε ωμά λάχανα.

Θηλή
Μικρό εξόγκωμα.

Θωράκιο
(πρβλ. διάτομο).

Ισταμίνη
Δραστική βιολογική ένωση που συσσωρεύεται κατά τις αλλεργικές αντιδράσεις προκαλώντας διαστολή των αιμοφόρων αγγείων.

Κάλυμμα
Εξωτερική στιβάδα κυτοπλάσματος που καλύπτει τον πυριτικό σκελετό ακτινόζωου (πρβλ. εξώπλασμα).

Καταφρακτικά κύτταρα
Τα κύτταρα που περιβάλλουν τα στόματα στα φύλλα των φυτών, δηλαδή ελέγχουν τη λειτουργία της διαπνοής.

Κερατίνη
Ινώδης ζωική πρωτεΐνη που υπάρχει στις τρίχες των μαλλιών, στο μαλλί, τα κέρατα, τα νύχια, τις δαγκάνες, τις οπλές, τα λέπια και τα φτερά.

Κερκάρια
Τελικό στάδιο προνύμφης τρηματώδους πλατυέλμινθος.

Κεφαλοθώρακας
Μεταμερές αραχνών, σκορπιών και άλλων αραχνοειδών.

Κινητόσωμα
Πόρος από τον οποίο φυτρώνουν μία ή περισσότερες τριχοειδείς βλεφαρίδες στην εξωτερική επιφάνεια ενός μονοκύτταρου οργανισμού.

Κοινοβιωτικός ή παραβιωτικός
Ο οργανισμός που ζει από τον ξενιστή του χωρίς να τον βλάπτει.

Κολλαγόνο
Πρωτεΐνη ινώδους συνδετικού ιστού.

Κόλπος (sinus)
Χώρος γεμάτος αέρα ή υγρό.

Κονίδιο
Σπόριο μυκήτων, προϊόν αγενούς πολλαπλασιασμού.

Κοτύλη (acetabulum)
Η κοιλότητα στο κεφάλι των εντόμων που υποδέχεται τον σκήπο ή σκάπο, δηλαδή το πρώτο άρθρο της κεραίας που συναρθρώνεται με το κεφάλι του (το δεύτερο μέρος της κεραίας είναι ο μίσχος ή ποδίσκος και το τρίτο το μαστίγιο).

Κοτύλη (infundibulum)
Η εσωτερική κοιλότητα μυζητήρα (βεντούζας).

Κυστίκερκος
Στάδιο προνύμφης ορισμένων ειδών τρηματώδους πλατυέλμινθος.

Κυτόπλασμα ή κυτταρόπλασμα
Η ημίρρευστη, ζελατινώδης πρωτεϊνική μήτρα που μαζί με τον πυρήνα αποτελεί το πρωτόπλασμα του κυττάρου.

Κυτόστομα
Τροφοληπτικό άνοιγμα παρόμοιο με στόμα μονοκύτταρων οργανισμών.

Λοβός (galea)
Εύκαμπτη επιμήκης απόφυση κάτω γνάθου πεταλούδας ή νυχτοπεταλούδας. Δύο τέτοιες αποφύσεις μαζί σχηματίζουν τη μυζητική προβοσκίδα.

Μαστίγιο
Μακριά βλεφαρίδα ή τρίχα ζωικού κυττάρου· επίσης το όμοιο με μαστίγιο μέρος της κεραίας των εντόμων.

Μειρακίδιο
Πρώτο στάδιο προνύμφης της τρηματώδους πλατυέλμινθος (κοινώς ταινίας).

Μελανίνη
Σκούρα χρωστική ουσία που απαντάται παντού στο φυτικό και ζωικό βασίλειο.

Μελιτίνη
Το κύριο συστατικό του δηλητηρίου της μέλισσας.

Μεταμόρφωση
Στα έντομα σημαίνει ειδικότερα τη μεταμόρφωση της προνύμφης σε ενήλικο άτομο.

Μικρογράφημα
Απεικόνιση μικροσκοπίου· μπορεί να είναι μικροφωτογραφία ή όχι.

Μικρόζωα
Μικροσκοπικοί οργανισμοί ορατοί μόνο με το μικροσκόπιο.

Μικροϊνώδης
Μικροσκοπική ή υποκυτταρική ίνα.

Μικροτριχίδια
Μικροσκοπικά τριχίδια στα φτερά εντόμων.

Μιτοχόνδριο
Οργανίδιο του κυττάρου όπου μεταβολίζονται θρεπτικές ουσίες παράγοντας ενέργεια.

Μονοκοτυλήδονα
Μεγάλη ομάδα αγγειόσπερμων (περιλαμβάνει τα αγρωστώδη, τα σιτηρά, το σπαθόχορτο, τις ορχιδέες, τους κρίνους, τις ίριδες, κ.λπ.), που οι σπόροι τους έχουν μόνο ένα εμβρυακό φύλλο (κοτυλήδονα).

Μύστακες φτερού (μικροί)
Μύστακες με άγκιστρα ή κοίλης διατομής που ξεκινούν από τους κυρίως μύστακες εκατέρωθεν της ράχης του φτερού και τους συναρθρώνουν.

Νηματοειδής
Δομή που μοιάζει με μακρύ, λεπτό νήμα.

Ξέστρο ή ρόστρο
Η σαν λίμα περιοχή στη γλώσσα μαλακίου.

Ξύλωμα
Σύνθετος ιστός που μέσω των τραχείδων και αγγείων μεταφέρει άλατα και νερό από τις ρίζες στο φυτό, και ο οποίος επίσης το στηρίζει.

Οδοντίνη
Σκληρός ασβεστούχος ιστός του δοντιού.

Ομματίδιο
(πρβλ. οφθαλμός, σύνθετος).

Οργανίδιο
Διακριτή εξειδικευμένη δομή φυτικού ή ζωικού κυττάρου.

Οφθαλμός, σύνθετος
Οφθαλμός των εντόμων και μερικών άλλων ζώων αποτελούμενος από πλήθος ομματίδια, το καθένα με τους δικούς του φακούς και αισθητήρια φωτός.

Παράσιτο
Οργανισμός που ζει σε βάρος κάποιου άλλου τρεφόμενος από αυτόν ή κλέβοντάς του θρεπτικές ουσίες, χωρίς όμως να σκοτώνει τον ξενιστή του.

Παρασιτοειδές
Επιβλαβές ή επικίνδυνο ενδοπαράσιτο. Οργανισμός που ζει και τρέφεται στο σώμα άλλου οργανισμού και τελικά τον σκοτώνει.

Περιχαρακωμένο
Περικλειόμενο από στεφάνη ή τοίχωμα.

Πλαγγόνα
Το ανώριμο ακόμα έντομο μέσα σε σκληρό περίβλημα στο στάδιο της μεταμόρφωσής του από προνύμφη σε ενήλικο άτομο.

Πλακοειδή
Λέπια σε ορισμένους καρχαρίες, σελάχια και άλλα είδη ιχθύων, που δεν αλληλοεπικαλύπτονται.

Ποδίσκος ή μίσχος
Το δεύτερο άρθρο κεραίας εντόμου μεταξύ σκήπου ή σκάπου, το άρθρο σε επαφή με το κεφάλι του εντόμου και μαστιγίου (flagellum).

Πολυμερή
Χημικές ενώσεις μεγάλων μορίων που σχηματίζονται από τη σύνδεση πολλών μικρών μορίων.

Πολυσακχαρίτης
Μόριο όπως του αμύλου αποτελούμενο από επαναλαμβανόμενες μονάδες σακχάρου.

Πολυταινικό
Γιγαντιαία ή αλλιώς πολυταινικά χρωμοσώματα που σχηματίζονται από αναδιπλασιασμούς των χρωμονημάτων σε ορισμένα είδη, αλλά χωρίς διαχωρισμό θυγατρικών χρωμοσωμάτων και χωρίς κυτταρική διαίρεση.

Προγλωττίδα
Αποσπώμενο μέρος του παράσιτου που περιέχει τα θηλυκά και αρσενικά αναπαραγωγικά του όργανα.

Προθάλλιο
Τα προθάλλια ή γαμετόφυτα είναι μικρές πράσινες φύτρες σαν φύλλα στον βιολογικό κύκλο των φυτών (φτέρη, βρύα, κ.λπ.), όπου αρσενικά και θηλυκά κύτταρα ενώνονται παράγοντας δομές που φέρουν σπόρια (σποριόφυτα).

Προσκεφάλι
Λοβός σαν μαξιλαράκι ανάμεσα στα νύχια του ταρσού εντόμου.

Προσκολλητικές σμήριγγες
Τριχίδια πεπλατυσμένα στο άκρο σαν σπάτουλες στον ταρσό εντόμου που το βοηθά να προσκολλάται σε επίπεδες επιφάνειες.

Πρωτόζωο
Τα πρωτόζωα είναι μονοκύτταροι οργανισμοί ορατοί μόνο με το μικροσκόπιο, στους οποίους περιλαμβάνεται και η αμοιβάδα.

Ράβδωμα
Φωτοευαίσθητο οργανίδιο κάθε ομματίδιου σύνθετου οφθαλμού κάτω από τον φακό και τον κωνικό κρύσταλλό του.

Ράχη
Το μη κοίλο μέρος του άξονα φτερού από το οποίο εκφύονται οι μύστακές του.

Σαγρέ (δέρμα)
Αρχικά σήμαινε ανεπεξέργαστο δέρμα αλόγου ή γαϊδάρου, σήμερα καρχαρία ή σελαχιού.

Σάλπιγγα
Σωλήνας μέσα από τον οποίο τα ωάρια περνούν από την ωοθήκη στη μήτρα.

Σαπροφάγος ή νεκροφάγος
Ο οργανισμός που τρέφεται με φυτικά ή ζωικά υπολείμματα σε αποσύνθεση.

Σεροτονίνη
Νευροδιαβιβαστής, δηλαδή βιοχημική ένωση που απελευθερώνεται από τις απολήξεις των νευρώνων.

Σινιγρίνη
Τοξική ουσία στα φύλλα του λάχανου που τη συλλέγουν μεγάλες λευκές κάμπιες ορισμένων ειδών πεταλούδας για να αηδιάζουν τους θηρευτές τους.

Σκήπος ή σκάπος
Το πρώτο, συνήθως μακρύτερο άρθρο κεραίας εντόμου.

Σκληρές τρίχες (vibrissae)
Ευαίσθητες τρίχες θηλαστικών και πολλών άλλων ζώων, όπως οι τρίχες στα μουστάκια της γάτας.

Σμήριγγα
Τριχοειδής δομή στην επιφάνεια οργανισμού.

Σπερματοβλάστης
Θηλυκό ωοκύτταρο που περιμένει να γονιμοποιηθεί από σπέρμα ή γύρη.

Σπερματοθήκη
Όργανο στο σώμα του θηλυκού εντόμου, όπου αποθηκεύει σπέρμα μετά τη σύζευξη.

Σπιδροΐνη
Βασική πρωτεΐνη του ιστού της αράχνης.

Σποριοπολλενίνη
Το κύριο συστατικό του εξωτερικού περιβλήματος των γυρεόκοκκων.

Σποριόφυτο
Η φάση του κύκλου ζωής που παράγει τα σπόρια στα πτεριδόφυτα (φτέρες) ή στα βρυόφυτα (βρύα).

Στίγμα
Οι πόροι στον θώρακα και το κοιλιακό τμήμα εντόμων μέσω των οποίων αναπνέουν.

Στόμα
Πόρος διαπνοής φυτού.

Στύλος
Μικρό αιχμηρό μέρος και ειδικότερα ένα από τα σωληνωτά διατρητικά μέρη του στοματικού μορίου ορισμένων εντόμων.

Συμβίωση
Το φαινόμενο αρμονικής συμβίωσης δύο οργανισμών προς αμοιβαίο όφελος.

Ταρσομερή
Τα άρθρα του ταρσού εντόμου ή άλλου ζώου.

Τερπένιο
Ουσία που περιέχεται στα αιθέρια έλαια ορισμένων φυτών.

Τραχεία
Εσωτερικός σωλήνας αναπνοής.

Τριχίο (trichion)
Τριχοειδής δομή στην επιφάνεια οργανισμών.

Υδατάνθρακες
Ενώσεις άνθρακα, υδρογόνου και οξυγόνου, και ειδικότερα σάκχαρα και άμυλα.

Υπερπλασία ή υπερτροφία
Μη φυσιολογική ανάπτυξη φυτού που έχει προσβληθεί από έντομο ή άλλο μικροοργανισμό που τρέφεται πάνω ή μέσα στον ιστό των φύλλων, του κορμού, του οφθαλμού, κ.λπ.

Υφή
Νηματοειδείς σωλήνες από τους οποίους αποτελείται ο θαλλός ή το μυκήλιο και όχι το καρπόσωμα του μύκητα.

Φερομόνη
Χημική ουσία που απελευθερώνεται από ένα ζώο όταν θέλει να μηνύσει κάτι σε άλλα ζώα του είδους του ή να επηρεάσει τη συμπεριφορά τους, μέσω της οσμής.

Φλοίωμα
Σύνθετος ιστός που μέσω ηθμωδών σωλήνων μεταφέρει στο φυτό τις οργανικές ουσίες που παράγει το ίδιο.

Φολίδα ή έλασμα
Λεπτή πλάκα ή λέπι και ειδικά τα επίπεδα καταληκτικά τμήματα ενός ορισμένου είδους κεραίας.

Φύκος, το (πληθ. φύκη)
Απλοί φυτικοί οργανισμοί στους οποίους περιλαμβάνονται και μονοκύτταρες μορφές.

Φυτοπλαγκτόν
Μονοκύτταρα θαλάσσια φύκη.

Φωτοσύνθεση
Σύνθετη παραγωγή οργανικών υλών από ανόργανες πρώτες ύλες, διοξείδιο του άνθρακα και νερό, στα πράσινα φυτά μέσω της χλωροφύλλης η οποία απορροφά το ηλιακό φως.

Χαλινίσκος
Κεκαμμένη σαν αγκίστρι τρίχα στο οπίσθιο φτερό νυχτοπεταλούδας, που γαντζώνεται από μια θηλιά (retinaculum) συνδέοντας τα εμπρόσθια και οπίσθια φτερά κατά την πτήση.

Χείλος
Στα έντομα, ειδικά, το κάτω χείλος του στοματικού μορίου.

Χημιοϋποδοχείς
Αισθητήριο νεύρο που αντιδρά σε χημικές διεγέρσεις.

Χίμαιρα
Φυτό ή ζώο αποτελούμενο από δύο διαφορετικούς γενετικά ιστούς.

Χιτίνη
Σύνθετο μόριο υδατάνθρακα που σχηματίζει επάλληλες στιβάδες ή πλάκες στον εξωσκελετό εντόμων και άλλων ζώων.

Χλωροφύλλη
Πράσινη χρωστική ουσία στα φυτά που περιέχει μαγνήσιο και χρησιμεύει στη φωτοσύνθεση.

Χοάνη
Χοανοειδής κοιλότητα και ειδικότερα μέρος της βεντούζας στο πλοκάμι του χταποδιού.

Χόνδρος
Εύκαμπτος σκελετικός ιστός· στα σπονδυλωτά –με εξαίρεση τους ιχθείς– ο εμβρυακός σκελετός που το μεγαλύτερο μέρος του οστεοποιείται.

Χορδή, νωτιαία
Χορδή χόνδρου στο έμβρυο που στα σπονδυλωτά μετασχηματίζεται σε νωτιαίο μυελό.

Χρωμόσωμα
Συμπυκνωμένες συσσωματώσεις του DNA, ορατές συνήθως κατά την κυτταρική διαίρεση.

Ψευδοπόδια (Pseudopodia)
Προεκβολές μονοκύτταρων οργανισμών που τους μετακινούν ή απλώνονται, περιβάλλουν και αφομοιώνουν σωματίδια τροφής.

Ψευδοπόδιο (Proleg)
Πόδι στο κοιλιακό μεταμερές μιας προνύμφης εντόμου, που διαφέρει από το πραγματικό θωρακικό πόδι.

Εικόνες εξωφύλλου: Εμπροσθόφυλλο © Manfred Kage/Science Photo Library· Οπισθόφυλλο και ράχη: © Susumu Nishinaga/Science Photo Library· Αυτιά © David McCarthy/Science Photo Library· σ. 12 © Dr Tony Brain/Science Photo Library· σ. 13 © Volker Steger/Christian Bardele/Science Photo Library· σ. 14, 15, 23, 32, 33, 35, 37, 39, 47, 49, 63, 97, 109, 111, 119, 124, 125, 127, 135, 146, 147, 149, 151, 154, 155, 158, 159, 161, 178, 179, 186, 187, 197 © Steve Gschmeissner/Science Photo Library· σ. 16 © Alfred Pasieka/Science Photo Library· σ. 17, 148 © Manfred Kage/Science Photo Library· σ. 18, 25, 29, 45, 73, 75, 79, 114, 141, 145, 195 © Eye of Science/Science Photo Library· σ. 19, 26, 57, 59, 77, 82, 83, 93, 99, 121, 129, 131, 157, 165, 171, 185, 189, 191 © Andrew Syred/Science Photo Library· σ. 22 © Darrell Gulin/Corbis· σ. 24 © K H Kjeldsen/Science Photo Library· σ. 27, 43, 53, 55, 65, 67, 69, 87, 95, 115, 117, 137, 144, 199, 201 © Susumu Nishinaga/Science Photo Library· σ. 28 © Jeffrey L Rotman/Corbis· σ. 34 © Cordelia Molloy/Science Photo Library· σ. 36, 46, 156, 166 © Claude Nuridsany & Marie Perennou/Science Photo Library· σ. 38 © Ingo Arndt/Foto Natura/Minden Pictures/FLPA· σ. 42 © David Aubrey/Science Photo Library· σ. 44, 62, 164, 168, 176 © Nigel Cattlin/FLPA· σ. 48 © B Borrell Casals/FLPA· σ. 52 © Dr Keith Wheeler/Science Photo Library· σ. 54 © Georgette Douwma/Science Photo Library· σ. 56 © Michael Durham/Minden Pictures/FLPA· σ. 58, 78 © Geoff Kidd/Science Photo Library· σ. 64 © Andreas Lander/dpa/Corbis· σ. 66 © Dr John Brackenbury/Science Photo Library· σ. 68 © Maria Mosolova/Science Photo Library· σ. 72 © Stephen Harley-Sloman/Science Photo Library· σ. 74 © Bjorn Svensson/Science Photo Library· σ. 76 © Adrian Thomas/Science Photo Library· σ. 84 © Douglas P Wilson/Frank Lane Picture Agency/Corbis· σ. 85 © Lucent Technologies Bell Labs/Science Photo Library· σ. 86 © Mark Moffett/Minden Pictures/Getty· σ. 88 © Richard Becker/FLPA· σ. 89 © Science Photo Library· σ. 92 © The Picture Store/Science Photo Library· σ. 94 © Mark Moffett/Minden Pictures/FLPA· σ. 96, 128, 167 © David Scharf/Science Photo Library· σ. 98, 107, 169, 175, 180, 181 © Dr Jeremy Burgess/Science Photo Library· σ. 104 © Sinclair Stammers/Science Photo Library· σ. 105 © Thierry Berrod/Mona Lisa Production/Science Photo Library· σ. 106 © Envision/Corbis· σ. 110 © Malcolm Schuyl/FLPA· σ. 116 © Michael Gore/FLPA· σ. 118 © Chris Hellier/Science Photo Library· σ. 120 © Michio Hoshino/Minden Pictures/FLPA· σ. 126 © Kim Taylor/naturepl.com· σ. 130 © Bob Gibbons/Science Photo Library· σ. 134 © David Aubrey/Corbis· σ. 136 © Birgitte Wilms/Minden Pictures/FLPA· σ. 138 © NIBSC/Science Photo Library· σ. 139 © National Cancer Institute/Science Photo Library· σ. 140 © David Hosking/FLPA· σ. 150 © André Skonieczny/Imagebroker/FLPA· σ. 160 © Colin Milkens/photolibrary.com· σ. 170 © Hans Pfletschinger/Getty· σ. 174 © TH Foto-Werbung/Science Photo Library· σ. 177 Microfield Scientific Ltd/Science Photo Library· σ. 184 © Darwin Dale/Science Photo Library· σ. 188 © Volker Steger/Science Photo Library· σ. 190 © Laurie Campbell/NHPA· σ. 194 © D P Wilson/FLPA· σ. 196 © Juergen Berger/Science Photo Library· σ. 198 © Juergen & Christine Sohns/FLPA· σ. 200 © W Perry Conway/Corbis